THE COLLECTED

WRITINGS OF

JOE BRAINARD

THE COLLECTED

WRITINGS

OF

JOE

BRAINARD

INTRODUCTION BY PAUL AUSTER

RON PADGETT, EDITOR

A Special Publication of
The Library of America

Distributed to the trade in the United States
by Penguin Group (USA) Inc.
and in Canada by Penguin Books Canada Ltd.

Book design by David Bullen.

Library of Congress Control Number: 2011928610
ISBN 978-1-59853-149-7

First Printing

Printed in the United States of America

The Collected Writings of Joe Brainard
is published with support from

Anne Dunn

Furthermore: a program of the J. M. Kaplan Fund

A Friend

Contents

Interviews

Editor's Preface

This book evolved from an idea that its author had as far back as 1965, when he created a handmade booklet entitled *Self-Portrait*. It consisted of ten drawings of individual hairs from ten different parts of his body, with captions identifying the parts. Actually that was just volume 1. Volume 2 had but a single page, at the top of which he glued a tiny square photograph of a nose, to the right of which he drew an arrow pointing to it, with the words "I have a big nose." Although as a painter Joe had done visual self-portraits, this was the first time he used self-portraiture in the creation of a book.

In late 1969 Joe began to assemble the manuscript for a much larger book to be called *Self-Portrait*, but which he published as *Selected Writings* (1971). A year later he and Anne Waldman brought out a collaborative book called *Self-Portrait*. Most of Joe's writings in it were republished in other volumes of his, including the current one.

Joe would eventually write many other pieces in which the primary subject was himself, but the work was created mainly for his friends. It was a way of giving himself to them.

Who was that self? Over the years, in an attempt to answer this question, Joe peeled away the layers of his personality and character. Gradually he realized how complex he was—just like everybody!—and the various forms of his writings reflect that complexity, which I have tried to mirror in the structuring of the *Self-Portrait* section of this book. In it are works that could be divided into two categories: comic, whimsical, even fantastical writings on the one hand, diaristic pieces on the other. My original thought had been to edit a separate volume for each of these categories, until I came to see that some pieces veer back and forth between them. That these hybrids could have fit into

either category led me to the realization that Joe's non-diaristic writings are as self-revelatory as the diaristic ones, albeit in a more oblique manner. As Joe himself put it, in a journal entry for June 2, 1969, "Almost everything I write is about me. Even funny fiction stories." Although separating the two types of writing would not be unreasonable—and one can easily make that separation for oneself by using the table of contents—the intertwining of these two strands gives us a richer, more complex, more realistic, and ultimately more satisfying view of the man who strongly preferred that people not think they had him all figured out, compartmentalized, "in their pocket," as he put it.

The plan for this book expanded when the editors at the Library of America suggested that we include Joe's enduring classic, *I Remember*, which deserved a section of its own. To round out the collection, Paul Auster urged us to add several of Joe's interviews.

In the *Self-Portrait* section, I have arranged the writings chronologically, according to the approximate date of composition. In some cases the date is the result of educated guesswork, but the sequencing doesn't stray far from the truth. An advantage of the chronological arrangement is that it gives the reader the opportunity to follow the evolution of Joe's spirit.

When I found different versions of a piece, I usually selected the latest, out of respect for (and agreement with) Joe's revisions. For the same reason, I have not included several pieces that Joe eventually decided were not strong enough (after rushing one piece into print, he said ruefully, "What was I *thinking?*"); in these instances I agree, the lone exception being the final piece in the book. (At the top of its manuscript, he scribbled an afterthought: "Slow!" It *is* slow, but what he missed is that its measured, tranquil pace is at the heart of its beauty.) Also exceptional is its being out of chronological order in the current volume; putting it last felt right.

I have corrected Joe's occasionally phonetic spelling— at first embarrassed by it, later he saw spelling as not all *that* important—and his uncertain grasp of standard punctuation.

However, it would be wrong to regularize all of his punctuation according to strict copyediting rules, since he sometimes used it as a kind of scoring to indicate tone and tempo, notably in his parentheses that indicate an afterthought or his extra-long dashes that suggest a pregnant silence.

For a list of Joe's published pieces not included here, I refer the reader to the Note on the Texts. The excluded unpublished manuscript pages amount to relatively few.

<p style="text-align:center">* * *</p>

For generous and invaluable help, I thank Bill Berkson, Maxine Chernoff, Michael Davis, Larry Fagin, Richard Friedman, Anne Garner (the New York Public Library's Berg Collection), Nathan Kernan, Allan Kornblum, Cinda Kornblum, Ann Lauterbach, Chip Livingston, Maureen Owen, Arlo Quint (The Poetry Project), Stacey Szymacek (The Poetry Project), David Trinidad, Anne Waldman, Nicole Wallace, Edmund White, Trevor Winkfield, Christopher Wiss, Larry Zirlin, and the librarians of the New York Public Library microform collection.

My thanks also go to the extraordinary staff of the Library of America and to Paul Auster for his enthusiasm for this book and for his introduction.

Much credit is due Robert Butts, whose large donation of Joe's manuscripts and art formed the Joe Brainard Archive of the Mandeville Special Collections Library at the University of California, San Diego, and who painstakingly catalogued the donation. I also appreciate the help I have received over the years from Lynda Claassen, director of the Mandeville Special Collections Library.

A special thanks is reserved for John Brainard for his devotion to his brother's work.

Finally, I thank Joe's companion, Kenward Elmslie, and my wife, Patricia, for help beyond words.

—*Ron Padgett*

Introduction

I can't remember how many times I have read *I Remember*. I discovered the book soon after it was published in 1975, and in the intervening three and a half decades I have gone back to it once every few years, perhaps seven or eight times in all. The text is not long (just 138 pages in the original edition), but remarkably enough, in spite of these numerous rereadings, whenever I open Joe Brainard's little masterwork again, I have the curious sensation that I am encountering it for the first time. Except for a few indelible passages, nearly all of the memories recorded in the pages of *I Remember* have vanished from my own memory. There are simply too many details to hold onto over an extended period of time, too much life is packed into Brainard's shifting, swirling collage of recollections for any one person to remember it in its entirety, and therefore, even if I recognize many of the entries the instant I start to reread them, there are many others that I don't. The book remains new and strange and surprising—for, small as it is, *I Remember* is inexhaustible, one of those rare books that can never be used up.

A prolific visual artist and occasional writer, Brainard stumbled upon the simple but ingenious composition method of *I Remember* in the summer of 1969. He was just twenty-seven, but a highly developed and accomplished twenty-seven, a precocious boy artist who had started exhibiting his work and winning prizes as a grade school student in Tulsa, Oklahoma, and had landed on Manhattan's Lower East Side before he turned twenty. By 1969, he was a veteran of the New York art scene, with several one-man shows to his credit, participation in numerous group shows, cover designs for dozens of small literary magazines and books of poetry, stage decors for theater pieces by LeRoi Jones

and Frank O'Hara, as well as comic strip collaborations (most of them hilarious) with a long list of poet friends. Collages, large and small assemblages, drawings, and oil paintings—his output was varied and incessant—and on top of that, he also found time to write. Before the miraculous breakthrough of 1969, Brainard had published poems, diaries, and short prose pieces in a number of downtown literary magazines associated with the New York School, and he had already developed a distinctive style of his own—charming, whimsical, unpretentious, frequently ungrammatical, and transparent. Those qualities are all present in *I Remember*, but now, almost by accident, he had hit upon an organizing principle, and the writing takes off and soars into an altogether different register.

With typical nonchalance and acumen, Brainard described the exhilaration he felt while working on his new project in a letter written that summer to poet Anne Waldman: "I am way, way up these days over a piece I am still writing called *I Remember*. I feel very much like God writing the Bible. I mean, I feel like I am not really writing it but that it is because of me that it is being written. I also feel that it is about everybody else as much as it is about me. And that pleases me. I mean, I feel like I am everybody. And it's a nice feeling. It won't last. But I am enjoying it while I can."

I remember... It seems so obvious now, so self-evident, so fundamental and even ancient—as if the magic formula had been known ever since the invention of written language. Write the words *I remember*, pause for a moment or two, give your mind a chance to open up, and inevitably you *will* remember, and remember with a clarity and a specificity that will astonish you. This exercise is now used wherever writing courses are taught, whether for children, college students, or the very old, and the results never fail to summon up long-forgotten particulars of lived experience. As Siri Hustvedt wrote in her recent book, *The Shaking Woman or a History of My Nerves*: "Joe Brainard discovered a memory machine." *

* Henry Holt, New York. 2010.

But once you discover the machine, how do you use it? How do you harness the memories that come flooding through you into a work of art, into a book that can speak to someone other than yourself? Many people have written their own versions of *I Remember* since 1975, but no one has come close to duplicating the spark of Brainard's original, of transcending the purely private and personal into a work that is about *everybody*—in the same way that all great novels are about everybody. It strikes me that Brainard's achievement is the product of several forces that operate simultaneously throughout the book: the hypnotic power of incantation; the economy of the prose; the author's courage in revealing things about himself (often sexual) that most of us would be too embarrassed to include; the painter's eye for detail; the gift for story-telling; the reluctance to judge other people; the sense of inner alertness; the lack of self-pity; the modulations of tone, ranging from blunt assertion to elaborate flights of fancy; and then, most of all (most pleasing of all), the complex musical structure of the book as a whole.

By music, I mean counterpoint, fugue, and repetition, the interweaving of several different voices throughout the nearly fifteen hundred entries of the book. A theme is picked up for a while, then dropped, then picked up again, in the same way that a horn might sound for a few moments in an orchestral piece, then give way to a violin, which in turn will give way to a cello, and then, all but forgotten now, the horn will suddenly return. *I Remember* is a concerto for multiple instruments, and among the various strings and woodwinds Brainard employs in his free-floating, ever-changing composition are the following:

—Family (more than seventy entries), such as "I remember my father in a tutu. As a ballerina dancer in a variety show at church;" "I remember when father seemed too formal, and daddy was out of the question, and dad too fake-casual. But, seeming the lesser of three evils, I chose fake-casual;" "I remember the only time I saw my mother cry. I was eating apricot pie."

—Food (a hundred entries), including butter and sugar sandwiches, salt on watermelon, chewy candy in movie theaters,

and repeated allusions to ice cream, as in "I remember how good a glass of water can taste after a dish of ice cream."

—Clothes (roughly ninety entries), including pink dress shirts, pillbox hats, and fat ties with fish on them. (Brainard's earliest ambition was to become a fashion designer.)

—Movies, Movie Stars, T.V., and Pop Music (more than a hundred entries), including references to Perry Como, Liberace, Hopalong Cassidy, Dinah Shore, Tab Hunter, Marilyn Monroe (several times), Montgomery Clift, Elvis Presley, Judy Garland, Jane Russell, Lana Turner, the Lone Ranger, and umpteen others. "I remember that Betty Grable's legs were insured for a million dollars;" "I remember rumors about what Marlon Brando had to do to get his first acting job;" "I remember Gina Lollobrigida's *very* tiny waist in *Trapeze*."

—School and Church (roughly a hundred entries), such as "I remember how much, in high school, I wanted to be handsome and popular;" "I remember an American history teacher who was always threatening to jump out of the window if we didn't quiet down. (Second floor.);" "I remember the clock from three to three-thirty;" "I remember two years of cheating in Spanish class by lightly penciling in the translations of words."

—The Body (more than a hundred entries), ranging from intimate personal confessions—"I remember examining my cock and balls once and finding them absolutely disgusting"— to observations of others: "I remember a very big boy named Teddy and what hairy legs his mother had. (Long black ones squashed flat under nylons.)"

—Dreams, Daydreams, and Fantasies (more than seventy entries), often pertaining to sex ("I remember sexual fantasies of making it with a stranger in the woods") but just as often not, such as "I remember day dreams of being a singer all alone on a big stage with no scenery, just one spotlight on me, singing my heart out, and moving my audience to total tears of love and affection."

—Holidays (fifty entries), centering around Christmas,

Thanksgiving, Easter, Halloween, and the Fourth of July. "I remember after opening packages what an empty day Christmas is."

—Objects and Products (more than 130 entries), including driftwood lamps, pop beads, beanbag ashtrays, pearlized plastic toilet seats, jeweled bottle openers, "Ace" combs, roller skate keys, Aspergum, dented ping pong balls, and miniature Bibles. "I remember the first ballpoint pens. They skipped, and deposited little balls of ink that would accumulate on the point."

—Sex (more than fifty entries), detailing early heterosexual fumblings in high school— "I remember the first time I got jerked off (never did discover it for myself). I didn't know what she was trying to do and so I just laid there like a zombie not helping one bit" —later homosexual experiences and glimpses of gay life—"I remember not liking myself for not picking up boys I probably could pick up because of the possibility of being rejected"—and more general (often touching) remarks: "I remember early sexual experiences and rubbery knees. I'm sure sex is much better now but I *do* miss rubbery knees."

—Jokes and Common Expressions (more than forty entries), including sick jokes, Mary Anne jokes—"I remember 'Mommy, Mommy, I don't like my little brother.' 'Shut up, Mary Anne, and eat what I tell you to!'"—traveling salesmen jokes, and phrases such as "to coin a phrase," "See you later alligator," "Because I say so, that's why," and "I remember, when babies fall down, 'oopsy-daisy.'"

—Friends and Acquaintances (more than ninety entries), which tend to take the form of small narratives and are generally longer than the other sections of the book. One example: "I remember my parents' bridge teacher. She was very fat and very butch (cropped hair) and she was a chain smoker. She prided herself on the fact that she didn't have to carry matches around. She lit each new cigarette from the old one. She lived in a little house behind a restaurant and lived to be very old." Another example: "I remember Anne Kepler. She played the flute. I remember her straight shoulders. I remember her large eyes. Her slightly roman

nose. And her full lips. I remember an oil painting I did of her playing the flute. Several years ago she died in a fire giving a flute concert at a children's home in Brooklyn. All the children were saved. There was something about her like white marble."

—Autobiographical Fragments (twenty entries): a less insistent theme than the other subjects explored by Brainard, but fundamental to our understanding of his project, his life. We see him arriving in New York for the first time, learn of his stuttering and shyness, witness his initial encounter with the poet Frank O'Hara, are informed of his poverty and destitution during an early stay in Boston ("I remember collecting cigarette butts from the urns in front of the Museum of Fine Arts in Boston"), are told about his short, unhappy stint as a scholarship student at the Dayton Art Institute ("I remember in Dayton, Ohio the art fair in the park where they made me take down all my naked self-portraits"), are given a full account of his draft board physical and his rejection by the army after he declared himself to be a homosexual (even though he was a virgin at the time), and are exposed to his self-doubts as an artist, which surely played a role in his decision to stop exhibiting his work during the last fifteen years of his life, as in this laconic but poignant entry: "I remember when I thought I was a great artist."

—Insights and Confessions (forty entries), most of them about Brainard's inner life and character, his overpowering self-consciousness ("I remember that I never cried in front of other people;" "I remember being embarrassed to blow my nose in public"), his awkwardness in social situations ("I remember, at parties, after you've said all you can think of to say to a person—but there you both stand"), and, here and there, instances of almost blinding emotional clarity: "I remember that life was just as serious then as it is now," which could be the most important sentence in the book, the reason why the fifteen hundred fragments of *I Remember* ultimately cohere to form a solid and integrated work.

—Musings (more than thirty entries), which track the various stray thoughts that come flying in and out of conscious-

ness, the bafflements and perplexities of someone trying to make sense of the world, the bizarre questions all people wind up asking themselves at one time or another. "I remember not understanding why people on the other side of the world didn't fall off;" "I remember wondering if girls fart too;" "I remember wondering how turtles 'do it';" "I remember thinking once that flushing away pee might be a big waste. I remember thinking that pee is probably good for something and that if one could just discover what it was good for one could make a mint."

Such are the various themes and threads that comprise the totality of *I Remember*. Among its many virtues, it is a book that dwells with great focus on the sensuous details of somatic life (what it feels like to have your hair cut in a barber shop, what it feels like to "turn around and around real fast until you can't stand up," to hear water swishing around in your stomach for the first time and think you might have a tumor), that lovingly records the banal and trivial details of the American landscape of the forties, fifties, and sixties, and presents us with a portrait of a particular man—the modest, self-effacing young Joe Brainard—that is so precise and uninhibited in its telling that we as readers inevitably begin to see our own lives portrayed in his. The memories keep coming at us, relentlessly and without pause, one after the other with no strictures regarding chronology or place. One moment we are in New York, the next moment we are in Tulsa or Boston, a recollection from twenty years ago stands side by side with a memory from last week, and the farther we advance into the text, the more resonant each articulation becomes. As Brainard himself understood as he was writing *I Remember*, it is, truly, a book that belongs to everyone.

It is also interesting to consider what is *not* in Brainard's book, all the things that most of us would probably feel inclined to put in if we were to sit down and write our own versions of *I Remember*. No memories of sibling conflict, no memories of cruelty or physical violence, no eruptions of anger, no impulse to settle scores, no bitterness. Aside from fleeting references to the

Kennedy assassination, "Korea" (in quotation marks), and the
"I Like Ike" slogan of the Eisenhower presidential campaigns,
there are no memories of political, public, or national events.
Mondrian, Picasso, and Van Gogh are all mentioned, but there
is nothing about Brainard's development as a visual artist, and
except for telling us that he read all of Dostoyevsky's novels in
Boston, no memories of discovering the work of other writers,
even though Brainard was a passionate reader of fiction. No grief,
no rage, and very few tears. Only one entry ("I remember throw-
ing my eye-glasses into the ocean off the Staten Island ferry one
black night in a fit of drama and depression") gives any hint of
emotional suffering or deep inner turmoil. Brainard's book was
written at the precise moment when so-called confessional poetry
was dominating the American literary scene. Sylvia Plath, Anne
Sexton, and John Berryman (all suicides) were in vogue, and
the private rant had become an acceptable, even lauded form of
poetic discourse. Brainard confesses, but he does not rant, and
he has no interest in mythologizing the story of his own life. He
seduces us with his gentleness, his lack of pomposity, his imper-
turbable interest in everything the world offers up to him. He
begins and ends small, but the cumulative force of so many small,
exquisitely rendered observations turns his book into something
great, something that will become, I believe, an enduring part of
American literature.

* * *

Before *I Remember*, and after *I Remember*, and even dur-
ing *I Remember* (which was composed in four separate stages
between 1969 and 1973), there were, and are, the several hundred
pages of Joe Brainard's other writings. Spanning three decades
(from the early sixties to the early nineties), this work falls more
or less equally into two general categories: short texts (fiction,
non-fiction, poems) and diaries or journals (Brainard used the
terms interchangeably). The short pieces tend to be funny—
often uproariously funny. The diaries are flatter and more

introspective, but not without their bursts of funniness as well. Brainard is an unclassifiable writer, but there are moments when his antic inventions recall some of the zanier stunts performed by older American humorists, in particular Ring Lardner and S .J. Perelman. Different as they are in so many ways, all three share a love of nonsense, of parody and pastiche, of disjointed narrative, and alternately exploit both raucous and deadpan approaches to the comic. In Brainard's case, one could also cite the influence of Dada and Surrealism, as filtered through the japeries and ironies of the New York School poets, as well as an occasional tip of the hat to Gertrude Stein, as in this delicious passage from an early "story" entitled "May Dye": "we found breaking bird feathers quite easy and extremely enjoyable and we enjoyed enjoyable things in the most enjoyable way you can imagine enjoyable things being enjoyed."

From the exuberant high jinks of "Back in Tulsa Again" to the irreverent and inspiriting "People of the World: Relax!" ("Take it easy and smoke a lot / Make all the noise you want to on the toilet / Other people will hear you but it does not matter / People of the world: RELAX!") to the inane brilliance of the one-sentence "No Story" ("I hope you have enjoyed not reading this story as much as I have enjoyed not writing it"), Brainard disarms us with the seemingly tossed-off, spontaneous nature of his writing and his stubborn refusal to accede to the pieties of self-importance. We must remember that he was very young when the wildest pieces in this collection were written—still in his twenties—and what these little works capture most fully, it seems to me, is precisely a sense of youth, the laughter of youth, the energy of youth, for in the end they are not really *about* anything so much as what it means to be young, that hopeful, anarchic time when all horizons are open to us and the future appears to be without limits.

Little by little, however, the pieces begin to take on a more somber tone, even as Brainard continues to maintain the lightness of his touch. By the mid-seventies, following his enormous

exhibition of 1500 collages at the Fischbach Gallery, he seems to have entered a personal and artistic crisis, leading to such troubling statements as: "the person I always thought I was simply isn't anymore: *does not exist!*" (in "Nothing to Write Home About") and then, a few sentences later in the same piece: "the sky is no longer the limit . . . the temptation to wallow in one's own muck—to simply surrender—to give up—is far too appealing. And far too realistic a possibility for comfort."

In 1978, in an interview with Anne Waldman, it is clear that Brainard is already preparing to jump ship:

AW: Do you think one has a choice about being an artist?

JB: Oh yes, I think one always has a choice.

AW: When did you make that choice?

JB: I don't think I ever made it, but I think I have a choice. I think I could stop it now.

AW: Isn't it too late to stop?

JB: No, I don't really think so. I think I could stop tomorrow, I really do.

Not long after that, he did stop. No more exhibitions of his work, no more writing for publication. For the next fifteen years—until his death from AIDS in 1994 at age fifty-two—he spent his time reading books and nurturing his friendships with the many people he loved, the many people who adored him. Why he withdrew from the art world remains a mystery. Some say that he was burned out, exhausted by the frenzied pace that had fueled such an abundant outpouring of work. Others say that he was disappointed in his progress as an artist, by his failure (self-perceived failure) to master oil painting to the degree he aspired to. Others, such as poet Ann Lauterbach (a good friend of Brainard's during his last years), have reported that he felt he didn't have enough ambition, or at least not "the right kind of ambition." And then, too, there was the growing competitiveness and commercialization of the art world, which made Brainard feel increasingly uncomfortable and out of place, for, as Lauterbach puts it, "Joe had no taste for this new aggressive combat.

Life and art were, for Joe Brainard, acts of devoted camaraderie and generative collaboration." *

All of these factors might have played a part in Brainard's decision, but it is important to note that he was not anguished by this decision, and he walked away from his career without regrets. Ron Padgett (the editor of this volume), whose friendship with Brainard began in a first grade classroom in Tulsa, Oklahoma, and continued until the last day of Brainard's life in New York City, believes that Brainard's evolution from artist to former artist was almost inevitable. As he writes in his book about Brainard: "In a 1973 letter . . . Joe referred to what he felt was his 'basic lack of dedication to "art."' For him, art was "simply 'a way of life'" that enabled him to fulfill his need to give people 'a present' and perhaps be loved in return. Gradually . . . Joe's need to make art diminished as his own life became his art." †

With that in mind, it strikes me as altogether fitting that Padgett should have been chosen to begin and end the second part of this book with two previously unpublished pieces, "Self-Portrait on Christmas Night," written in 1961, when Brainard was just nineteen years old, and a short, untitled paragraph from January 1978, almost half a lifetime later—a glimpse, as it were, of Joe Brainard before he became Joe Brainard, followed by a glimpse of Joe Brainard when he was beginning to distance himself from the Joe Brainard of old.

"Self-Portrait on Christmas Night" is an extremely moving document, a passionate cry from the heart delivered by a very young man (still a boy, really) about his hopes and fears as an artist and as a human being. With uncanny prescience, it maps out the journey this young man is about to take, as if Brainard instinctively understood the doubts and potential stumbling blocks that lay ahead of him. Romantic and excessive, different

*Preface to *The Nancy Book*, by Joe Brainard, published posthumously in 2008 by Siglio Press, Los Angeles.
† *Joe: A Memoir of Joe Brainard*. Coffee House Press, Minneapolis. 2004.

in tone from all of his other writings, it is both a declaration of independence and the anatomy of a soul in conflict. "I'll always know, yet will never really know. Will do great paintings, but will never do what I want. Will learn to understand and accept life, but will never know why. Will love and make love, but will know it could be greater. Will be smart, but will always know there's so much more to learn. I'm damned, but can't change."

A gush of adolescent angst, to be sure, a single paragraph that sprints along breathlessly for fourteen typewritten pages, but painfully honest and insightful, an essential key to our understanding of Brainard's work, and then, sixteen years and one month later, when the adolescent fires were nearly extinguished, the painter who was also a writer sat down to compose a small scene in words. Working calmly and patiently, with no ambition other than to depict the visual and sensual this-ness of what it feels like to sit in a room and look out the window, he offers up his impressions as a gift, since all art for Brainard is a gift to an Other, to a real or imagined someone, and that sublime little paragraph ends with these words:

> Outside my window snow is falling down, against a translucent sky of deep lavender, with a touch of orange, zig-zagged along the bottom into a silhouette of black buildings. (The icebox clicks off, and shudders.) And it's as simple as this, what I want to tell you about; if perhaps not much, everything. Painting the moment for you tonight.

—Paul Auster
December 2010

THE COLLECTED

WRITINGS OF

JOE BRAINARD

I Remember

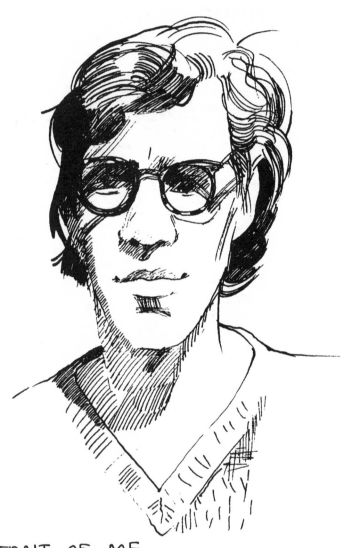

PORTRAIT OF ME

I Remember

I remember the first time I got a letter that said "After Five Days Return To" on the envelope, and I thought that after I had kept the letter for five days I was supposed to return it to the sender.

I remember the kick I used to get going through my parents' drawers looking for rubbers. (Peacock.)

I remember when polio was the worst thing in the world.

I remember pink dress shirts. And bola ties.

I remember when a kid told me that those sour clover-like leaves we used to eat (with little yellow flowers) tasted so sour because dogs peed on them. I remember that didn't stop me from eating them.

I remember the first drawing I remember doing. It was of a bride with a very long train.

I remember my first cigarette. It was a Kent. Up on a hill. In Tulsa, Oklahoma. With Ron Padgett.

I remember my first erections. I thought I had some terrible disease or something.

I remember the only time I ever saw my mother cry. I was eating apricot pie.

I remember how much I cried seeing *South Pacific* (the movie) three times.

I remember how good a glass of water can taste after a dish of ice cream.

I remember when I got a five-year pin for not missing a single morning of Sunday School for five years. (Methodist.)

I remember when I went to a "come as your favorite person" party as Marilyn Monroe.

I remember one of the first things I remember. An icebox. (As opposed to a refrigerator.)

I remember white margarine in a plastic bag. And a little package of orange powder. You put the orange powder in the bag with the margarine and you squeezed it all around until the margarine became yellow.

I remember how much I used to stutter.

I remember how much, in high school, I wanted to be handsome and popular.

I remember when, in high school, if you wore green and yellow on Thursday it meant that you were queer.

I remember when, in high school, I used to stuff a sock in my underwear.

I remember when I decided to be a minister. I don't remember when I decided not to be.

I remember the first time I saw television. Lucille Ball was taking ballet lessons.

I remember the day John Kennedy was shot.

I remember that for my fifth birthday all I wanted was an off-one-shoulder black satin evening gown. I got it. And I wore it to my birthday party.

I remember a dream I had recently where John Ashbery said that my Mondrian period paintings were even better than Mondrian.

I remember a dream I have had often of being able to fly. (Without an airplane.)

I remember many dreams of finding gold and jewels.

I remember a little boy I used to take care of after school while his mother worked. I remember how much fun it was to punish him for being bad.

I remember a dream I used to have of a lot of a beautiful red and yellow and black snakes in bright green grass.

I remember St. Louis when I was very young. I remember the tattoo shop next to the bus station and the two big lions in front of the Museum of Art.

I remember an American history teacher who was always threatening to jump out of the window if we didn't quiet down. (Second floor.)

I remember my first sexual experience in a subway. Some guy (I was afraid to look at him) got a hard-on and was rubbing it back and forth against my arm. I got very excited and when my stop came I hurried out and home where I tried to do an oil painting using my dick as a brush.

I remember the first time I really got drunk. I painted my hands and face green with Easter egg dye and spent the night in Pat Padgett's bathtub. She was Pat Mitchell then.

I remember another early sexual experience. At the Museum of Modern Art. In the movie theater. I don't remember the movie. First there was a knee pressed to mine. Then there was a hand on my knee. Then a hand on my crotch. Then a hand inside my pants. Inside my underwear. It was very exciting but I was afraid to look at him. He left before the movie was over and I thought he would be outside waiting for me by the print exhibition but I waited around and nobody showed any interest.

I remember when I lived in a storefront next door to a meat packing house on East Sixth Street. One very fat meat packer who always ate at the same diner on the corner that I ate at followed me home and asked if he could come in and see my paintings. Once inside he instantly unzipped his blood-stained white pants and pulled out an enormous dick. He asked me to touch it and I did. As repulsive as it all was, it was exciting too, and I didn't want to hurt his feelings. But then I said I had to go out and he said, "Let's get together," and I said, "No," but he was very insistent so I said, "Yes." He was very fat and ugly and really very disgusting, so when the time came for our date I went out for a walk. But who should I run into on the street but him, all dressed up and spanking clean. I felt bad that I had to tell him that I had changed my mind. He offered me money but I said no.

I remember my parents' bridge teacher. She was very fat and very butch (cropped hair) and she was a chain smoker. She prided herself on the fact that she didn't have to carry matches around. She lit each new cigarette from the old one. She lived in a little house behind a restaurant and lived to be very old.

I remember playing "doctor" in the closet.

I remember painting "I HATE TED BERRIGAN" in big black letters all over my white wall.

I remember throwing my eyeglasses into the ocean off the Staten Island ferry one black night in a fit of drama and depression.

I remember once when I made scratches on my face with my fingernails so people would ask me what happened, and I would say a cat did it, and, of course, they would know that a cat did not do it.

I remember the linoleum floors of my Dayton, Ohio, room. A white puffy floral design on dark red.

I remember sack dresses.

I remember when a fish-tail dress I designed was published in "Katy Keene" comics.

I remember box suits.

I remember pill box hats.

I remember round cards.

I remember squaw dresses.

I remember big fat ties with fish on them.

I remember the first ballpoint pens. They skipped, and deposited little balls of ink that would accumulate on the point.

I remember rainbow pads.

I remember Aunt Cleora who lived in Hollywood. Every year for Christmas she sent my brother and me a joint present of one book.

I remember the day Frank O'Hara died. I tried to do a painting somehow especially for him. (Especially good.) And it turned out awful.

I remember canasta.

I remember "How Much Is That Doggie in the Window?"

I remember butter and sugar sandwiches.

I remember Pat Boone and "Love Letters in the Sand."

I remember Teresa Brewer and "I Don't Want No Ricochet Romance."

I remember "The Tennessee Waltz."

I remember "Sixteen Tons."

I remember "The Thing."

I remember *The Hit Parade*.

I remember Dorothy Collins.

I remember Dorothy Collins' teeth.

I remember when I worked in an antique-junk shop and I sold everything cheaper than I was supposed to.

I remember when I lived in Boston reading all of Dostoevsky's novels one right after the other.

I remember (Boston) panhandling on the street where all the art galleries were.

I remember collecting cigarette butts from the urns in front of The Museum of Fine Arts in Boston.

I remember planning to tear page 48 out of every book I read from the Boston Public Library, but soon losing interest.

I remember Bickford's.

I remember the day Marilyn Monroe died.

I remember the first time I met Frank O'Hara. He was walking down Second Avenue. It was a cool early Spring evening but he was wearing only a white shirt with the sleeves rolled up to his elbows. And blue jeans. And moccasins. I remember that he seemed very sissy to me. Very theatrical. Decadent. I remember that I liked him instantly.

I remember a red car coat.

I remember going to the ballet with Edwin Denby in a red car coat.

I remember learning to play bridge so I could get to know Frank O'Hara better.

I remember playing bridge with Frank O'Hara. (Mostly talk.)

I remember my grade school art teacher, Mrs. Chick, who got so mad at a boy one day she dumped a bucket of water over his head.

I remember my collection of ceramic monkeys.

I remember my brother's collection of ceramic horses.

I remember when I was a "Demolay." I wish I could remember the secret handshake so I could reveal it to you.

I remember my grandfather who didn't believe in doctors. He didn't work because he had a tumor. He played cribbage all day. And wrote poems. He had very long ugly toe nails. I avoided looking at his feet as much as I could.

I remember Moley, the local freak and notorious queer. He had a very little head that grew out of his body like a mole. No one knew him, but everyone knew who he was. He was always "around."

I remember liver.

I remember Bettina Beer. (A girl.) We used to go to dances together. I bet she was a dyke, though it never would have occurred to me at the time. She cussed a lot. And she drank and smoked with her mother's approval. She didn't have a father. She wore heavy blue eye shadow and she had white spots on her arms.

I remember riding in a bus downtown one day, in Tulsa, and a boy I knew slightly from school sat down beside me and started asking questions like "Do you like girls?" He was a real creep. When we got downtown (where all the stores are) he kept following me around until finally he talked me into going with him to his bank where he said he had something to put in his safe-deposit box. I remember that I didn't know what a safe-deposit box was. When we got to the bank a bank man gave him his box and led us into a booth with gold curtains. The boy opened up the box and pulled out a gun. He showed it to me and I tried to be impressed and then he put it back in the box and asked me if I would unzip my pants. I said no. I remember that my knees were shaking. After we left the bank I said that I had to go to Brown-

Dunkin's (Tulsa's largest department store) and he said he had to go there too. To go to the bathroom. In the men's room he tried something else (I forget exactly what) and I ran out the door and that was that. It is very strange that an eleven- or twelve-year-old boy would have a safe-deposit box. With a gun in it. He had an older sister who was known to be "loose."

I remember Liberace.

I remember "Liberace loafers" with tassels.

I remember those bright-colored nylon seersucker shirts that you could see through.

I remember many first days of school. And that empty feeling.

I remember the clock from three to three-thirty.

I remember when girls wore cardigan sweaters backwards.

I remember when girls wore lots of can-can slips. It got so bad (so noisy) that the principal had to put a limit on how many could be worn. I believe the limit was three.

I remember thin gold chains with one little pearl hanging from them.

I remember mustard seed necklaces with a mustard seed inside a little glass ball.

I remember pony tails.

I remember when hoody boys wore their blue jeans so low that the principal had to put a limit on that too. I believe it was three inches below the navel.

I remember shirt collars turned up in back.

I remember Perry Como shirts. And Perry Como sweaters.

I remember duck-tails.

I remember Cherokee haircuts.

I remember no belts.

I remember many Sunday afternoon dinners of fried chicken or pot roast.

I remember my first oil painting. It was of a chartreuse green field of grass with a little Italian village far away.

I remember when I tried out to be a cheerleader and didn't make it.

I remember many Septembers.

I remember one day in gym class when my name was called out I just couldn't say "here." I stuttered so badly that sometimes words just wouldn't come out of my mouth at all. I had to run around the field many times.

I remember a rather horsy-looking girl who tried to seduce me on a New York City roof. Although I got it up, I really didn't want to do anything, so I told her that I had a headache.

I remember one football player who wore very tight faded blue jeans, and the way he filled them.

I remember when I got drafted and had to go way down-town to take my physical. It was early in the morning. I had an egg for breakfast and I could feel it sitting there in my stomach.

After roll call a man looked at me and ordered me to a different line than most of the boys were lined up at. (I had very long hair which was more unusual then than it is now.) The line I was sent to turned out to be the line to see the head doctor. (I was going to ask to see him anyway.) The doctor asked me if I was queer and I said yes. Then he asked me what homosexual experiences I had had and I said none. (It was the truth.) And he believed me. I didn't even have to take my clothes off.

I remember a boy who told me a dirty pickle joke. It was the first clue I had as to what sex was all about.

I remember when my father would say "Keep your hands out from under the covers" as he said goodnight. But he said it in a nice way.

I remember when I thought that if you did anything bad, policemen would put you in jail.

I remember one very cold and black night on the beach alone with Frank O'Hara. He ran into the ocean naked and it scared me to death.

I remember lightning.

I remember wild red poppies in Italy.

I remember selling blood every three months on Second Avenue.

I remember a boy I once made love with and after it was all over he asked me if I believed in God.

I remember when I thought that anything old was very valuable.

I remember *Black Beauty*.

I remember when I thought that Betty Grable was beautiful.

I remember when I thought that I was a great artist.

I remember when I wanted to be rich and famous. (And I still do!)

I remember when I had a job cleaning out an old man's apartment who had died. Among his belongings was a very old photograph of a naked young boy pinned to an old pair of young boy's underwear. For many years he was the choir director at church. He had no family or relatives.

I remember a boy who worked for an undertaker after school. He was a very good tap dancer. He invited me to spend the night with him one day. His mother was divorced and somewhat of a cheap blond in appearance. I remember that his mother caught us innocently wrestling out in the yard and she got *very* mad. She told him never to do that again. I realized that something was going on that I knew nothing about. We were ten or eleven years old. I was never invited back. Years later, in high school, he caused a big scandal when a love letter he had written to another boy was found. He then quit school and worked full time for the undertaker. One day I ran into him on the street and he started telling me about a big room with lots of beds where all the undertaker employees slept. He said that each bed had a little white tent in the morning. I excused myself and said goodbye. Several hours later I figured out what he had meant. Early morning erections.

I remember when I worked in a snack bar and how much I hated people who ordered malts.

I remember when I worked for a department store doing fashion drawings for newspaper ads.

I remember Frank O'Hara's walk. Light and sassy. With a slight bounce and a slight twist. It was a beautiful walk. Confident. "I don't care" and sometimes "I know you are looking."

I remember four Alice Esty concerts.

I remember being Santa Claus in a school play.

I remember Beverly who had a very small cross tattooed on her arm.

I remember Miss Peabody, my grade school librarian.

I remember Miss Fly, my grade school science teacher.

I remember a very poor boy who had to wear his sister's blouses to school.

I remember Easter suits.

I remember taffeta. And the way it sounded.

I remember my collection of Nova Scotia pamphlets and travel information.

I remember my collection of "Modess because . . ." magazine ads.

I remember my father's collection of arrow heads.

I remember a 1949 red Ford convertible we once had.

I remember *The Power of Positive Thinking* by Norman Vincent Peale.

I remember "four o'clocks." (A flower that closes at four.)

I remember trying to visualize my mother and father actually fucking.

I remember a cartoon of a painter painting from a naked model (back view) and on his canvas was a picture of a Parker House roll.

I remember my grandfather who lived on a farm dunking his cornbread in his buttermilk. He didn't like to talk.

I remember the outhouse and a Sears and Roebuck catalog to wipe off with.

I remember animal smells and very cold water on your face in the morning.

I remember how heavy the cornbread was.

I remember crêpe paper roses. Old calendars. And cow patties.

I remember when in grade school you gave a valentine to every person in your class in fear that someone might give you one that you didn't have one for.

I remember when dark green walls were popular.

I remember driving through the Ozarks and all the gift shops we didn't stop at.

I remember home-room mothers.

I remember being a safety guard and wearing a white strap.

I remember "Hazel" in *The Saturday Evening Post*.

I remember ringworms. And name tags.

I remember always losing one glove.

I remember loafers with pennies in them.

I remember Dr. Pepper. And Royal Crown Cola.

I remember those brown fur pieces with little feet and little heads and little tails.

I remember "Suave" hair cream. (Pale peach.)

I remember house shoes, plaid flannel bath robes, and "Casper" the Friendly Ghost.

I remember pop beads.

I remember "come-as-you-are" parties. Everybody cheated.

I remember game rooms in basements.

I remember milkmen. Postmen. Guest towels. "Welcome" mats. And Avon ladies.

I remember driftwood lamps.

I remember reading once about a lady who choked to death eating a piece of steak.

I remember when fiberglass was going to solve everything.

I remember rubbing my hand under a restaurant table top and feeling all the gum.

I remember the chair I used to put my boogers behind.

I remember Pug and George and their only daughter Norma Jean who was very beautiful and died of cancer.

I remember Jim and Lucy. Jim sold insurance and Lucy taught school. Every time we saw them they gave us a handful of plastic billfold calendars advertising insurance.

I remember Saturday night baths and Sunday morning comics.

I remember bacon and lettuce and tomato sandwiches and iced tea in the summertime.

I remember potato salad.

I remember salt on watermelon.

I remember strapless net formals in pastel colors that came down to the ankles. And carnation corsages on little short jackets.

I remember Christmas carols. And car lots.

I remember bunk beds.

I remember rummage sales. Ice cream socials. White gravy. And Hopalong Cassidy.

I remember knitted "pants" on drinking glasses.

I remember bean bag ashtrays that would stay level on irregular surfaces.

I remember shower curtains with angel fish on them.

I remember Christmas card wastebaskets.

I remember rick-rack earrings.

I remember big brass wall plates of German drinking scenes. (Made in Italy.)

I remember Tab Hunter's famous pajama party.

I remember mammy cookie jars. Tomato soup. Wax fruit. And church keys.

I remember very long gloves.

I remember a purple violin bottle that hung on the wall with ivy growing out of it.

I remember very old people when I was very young. Their houses smelled funny.

I remember on Halloween, one old lady you had to sing or dance or do something for before she would give you anything.

I remember chalk.

I remember when green blackboards were new.

I remember a backdrop of a brick wall I painted for a play. I painted each red brick in by hand. Afterwards it occurred to me that I could have just painted the whole thing red and put in the white lines.

I remember how much I tried to like Van Gogh. And how much, finally, I did like him. And how much, now, I can't stand him.

I remember a boy. He worked in a store. I spent a fortune buying things from him I didn't want. Then one day he wasn't there anymore.

I remember how sorry I felt for my father's sister. I thought that she was always on the verge of crying, when actually, she just had hay fever.

I remember the first erection I distinctly remember having. It was by the side of a public swimming pool. I was sunning on my back on a towel. I didn't know what to do, except turn over, so I turned over. But it wouldn't go away. I got a terrible sunburn. So bad that I had to go see a doctor. I remember how much wearing a shirt hurt.

I remember the organ music from *As the World Turns*.

I remember white buck shoes with thick pink rubber soles.

I remember living rooms all one color.

I remember summer naps of no sleeping. And Kool-Aid.

I remember reading Van Gogh's letters to Theo.

I remember daydreams of dying and how unhappy everybody would be.

I remember daydreams of committing suicide and of the letter I would leave behind.

I remember daydreams of being a dancer and being able to leap higher than anyone thought was humanly possible.

I remember daydreams of being a singer all alone on a big stage with no scenery, just one spotlight on me, singing my heart out, and moving my audience to total tears of love and affection.

I remember driving in cars and doing landscape paintings in my head. (I still do that.)

I remember the tiger lilies alongside the house. I found a dime among them once.

I remember a very little doll I lost under the front porch and never found.

I remember a man who came around with a pony and a cowboy hat and a camera. For so much money he would take your picture on the pony wearing the hat.

I remember the sound of the ice cream man coming.

I remember once losing my nickel in the grass before he made it to my house.

I remember that life was just as serious then as it is now.

I remember "Queers can't whistle."

I remember dust storms and yellow skies.

I remember rainy days through a window.

I remember salt shakers at the school cafeteria when the tops had been unscrewed.

I remember a job I once had sketching portraits of people at a coffeehouse. Table to table. During folk singing intermissions. By candlelight.

I remember when a Negro man asked me to paint a big Christmas picture to hang in his picture window at Christmas and I painted a white madonna and child.

I remember one year in school our principal was Mr. Black and my art teacher was Mrs. Black. (They were not married.)

I remember a story my mother telling of an old lady who had a china cabinet filled with beautiful antique china and stuff. One day a tornado came and knocked the cabinet over and to the floor but nothing in it got broken. Many years later she died and in her will she left my father a milk glass candy dish in the shape of a fish. (It had been in the cabinet.) At any rate, when the candy dish arrived it was all broken into many pieces. But my father glued it back together again.

I remember a big black rubber thing going over my mouth and nose just before I had my tonsils taken out. After my tonsils were taken out I remember how my throat felt eating vanilla ice cream.

I remember one morning the milkman handed me a camera. I never did understand exactly why. I'm sure it had something to do with a contest, though.

I remember Marilyn Monroe's softness in *The Misfits*.

I remember the gasoline station in the snow in *The Umbrellas of Cherbourg*.

I remember when hoop skirts had a miniature revival.

I remember waking up somewhere once and there was a horse staring me in the face.

I remember sitting on top of a horse and how high up it was.

I remember a chameleon I got at the circus that was supposed to change colors each time he was on a different color, but he only changed from green to brown and from brown back to green. And it was a rather brown-green at that.

I remember never winning at bingo, though I'm sure I must have.

I remember a little girl who had a white rabbit coat and hat and muff. Actually, I don't remember the little girl. I remember the coat and the hat and the muff.

I remember radio ball game sounds coming from the garage on Saturday afternoons.

I remember hearing stories about why Johnny Ray was such an unhappy person but I can't remember what the stories were.

I remember the rumor that Dinah Shore was half Negro but that her mother never told her and so when she had a light brown baby she sued her mother for not telling her. (That she was half Negro.)

I remember my father in black-face. As an end man in a minstrel show.

I remember my father in a tutu. As a ballerina dancer in a variety show at church.

I remember Anne Kepler. She played the flute. I remember her straight shoulders. I remember her large eyes. Her slightly roman nose. And her full lips. I remember an oil painting I did of her playing the flute. Several years ago she died in a fire giving a flute concert at a children's home in Brooklyn. All the children were saved. There was something about her like white marble.

I remember people who went to church only on Easter and Christmas.

I remember cinnamon toothpicks.

I remember cherry Cokes.

I remember pastel-colored rocks that grew in water.

I remember drive-in onion rings.

I remember that the minister's son was wild.

I remember pearlized plastic toilet seats.

I remember a little boy whose father didn't believe in dancing and mixed swimming.

I remember when I told Kenward Elmslie that I could play tennis. He was looking for someone to play with and I wanted to get to know him better. I couldn't even hit the ball but I did get to know him better.

I remember when I didn't really believe in Santa Claus but I wanted to so badly that I did.

I remember when the Pepsi-Cola Company was on its last leg.

I remember when Negroes had to sit at the back of the bus.

I remember pink lemonade.

I remember paper doll twins.

I remember puffy pastel sweaters. (Angora.)

I remember drinking glasses with girls on them wearing bathing suits but when you filled them up they were naked.

I remember dark red fingernail polish almost black.

I remember that cherries were too expensive.

I remember a drunk man in a tuxedo in a bar who wanted Ron Padgett and me to go home with him but we said no and he gave us all his money.

I remember how many other magazines I had to buy in order to buy one physique magazine.

I remember a climbing red rose bush all over the garage. When rose time came it was practically solid red.

I remember a little boy down the street. Sometimes I would hide one of his toys inside my underwear and make him reach in for it.

I remember how unsexy swimming naked in gym class was.

I remember that "Negro men have giant cocks."

I remember that "Chinese men have little cocks."

I remember a girl in school one day who, just out of the blue, went into a long spiel all about how difficult it was to wash her brother's pants because he didn't wear underwear.

I remember slipping underwear into the washer at the last minute (wet dreams) when my mother wasn't looking.

I remember a giant gold man taller than most buildings at "The Tulsa Oil Show."

I remember trying to convince my parents that not raking leaves was good for the grass.

I remember that *I* liked dandelions all over the yard.

I remember that my father scratched his balls a lot.

I remember very thin belts.

I remember James Dean and his red nylon jacket.

I remember thinking how embarrassing it must be for men in Scotland to have to wear skirts.

I remember when Scotch tape wasn't very transparent.

I remember how little your dick is, getting out of a wet bathing suit.

I remember saying "thank you" when the occasion doesn't call for it.

I remember shaking big hands.

I remember saying "thank you" in reply to "thank you" and then the other person doesn't know what to say.

I remember getting erections in school and the bell rings and how handy zipper notebooks were.

I remember zipper notebooks. I remember that girls hugged them to their breasts and that boys carried them loosely at one side.

I remember trying to make a new zipper notebook look old.

I remember never thinking Ann Miller beautiful.

I remember thinking that my mother and father were ugly naked.

I remember when I found a photograph of a woman naked from the waist up with very big tits and I showed it to a boy at school and he told the teacher about it and the teacher asked to see it and I showed it to her and she asked me where I got it and I said that I found it on the street. Nothing happened after that.

I remember peanut butter and banana sandwiches.

I remember jeweled sweaters with fur collars open to the waist.

I remember the Box Car Twins.

I remember not looking at crippled people.

I remember Mantovani and his (100 Strings?).

I remember a woman with not much neck. On her large feet she always wore bright-colored suede platform shoes. My mother said they were very expensive.

I remember corrugated ribbon that you ran across the blade of a pair of scissors and it curled all up.

I remember that I never cried in front of other people.

I remember how embarrassed I was when other children cried.

I remember the first art award I ever won. In grade school. It was a painting of a nativity scene. I remember a very large star in the sky. It won a blue ribbon at the fair.

I remember when I started smoking I wrote my parents a letter and told them so. The letter was never mentioned and I continued to smoke.

I remember how good wet dreams were.

I remember a roller coaster that went out over a lake.

I remember visions (when in bed but not asleep yet) of very big objects becoming very small and of very small objects becoming very big.

I remember seeing colors and designs by closing my eyes very tightly.

I remember Montgomery Clift in *A Place in the Sun*.

I remember bright-colored aluminum drinking glasses.

I remember "The Swing" dance.

I remember "The Chicken."

I remember "The Bop."

I remember monkeys who did modern paintings and won prizes.

I remember "I like to be able to tell what things are."

I remember "Any little kid could do that."

I remember "Well, it may be good but I just don't understand it."

I remember "I like the colors."

I remember "You couldn't give it to me."

I remember "It's interesting."

I remember Bermuda shorts and knee-length socks.

I remember the first time I saw myself in a full-length mirror wearing Bermuda shorts. I never wore them again.

I remember playing doctor with Joyce Vantries. I remember her soft white belly. Her large navel. And her little slit between her legs. I remember rubbing my ear against it.

I remember Lois Lane. And Della Street.

I remember jerking off to sexual fantasies of Troy Donahue with a dark tan in a white bathing suit down by the ocean. (From a movie with Sandra Dee.)

I remember sexual fantasies of making it with a stranger in the woods.

I remember sexual fantasies in white tile shower rooms. Hard and slippery. Abstract and steamy. Wet body to wet body. Slippery, fast, and squeaky.

I remember sexual fantasies of seducing young country boys (but old enough): Pale and blond and eager.

I remember jerking off to sexual fantasies involving John Kerr. And Montgomery Clift.

I remember a very wet dream with J. J. Mitchell in a boat.

I remember jerking off to visions of body details.

I remember navels. Torso muscles. Hands. Arms with large veins. Small feet. (I like small feet.) And muscular legs.

I remember underarms where the flesh is softer and whiter.

I remember blond heads. White teeth. Thick necks. And certain smiles.

I remember underwear. (I like underwear.) And socks.

I remember the wrinkles and creases of fabric being worn.

I remember tight white T-shirts and the gather of wrinkles from under the arms.

I remember sexual fantasies of old faded worn and torn blue jeans and the small areas of flesh revealed. I especially remember torn back pockets with a triangle of soft white bottom showing.

I remember a not very pleasant sexual dream involving Kenward Elmslie's dog Whippoorwill.

I remember green Easter egg grass.

I remember never really believing in the Easter bunny. Or the sandman. Or the tooth fairy.

I remember bright-colored baby chickens. (Dyed.) They died very fast. Or ran away. Or something. I just remember that shortly after Easter they disappeared.

I remember farts that smell like old eggs.

I remember one very hot summer day I put ice cubes in my aquarium and all the fish died.

I remember dreams of walking down the street and suddenly realizing that I have no clothes on.

I remember a big black cat named Midnight who got so old and grouchy that my parents had him put to sleep.

I remember making a cross of two sticks for something my brother and I buried. It might have been a cat but I think it was a bug or something.

I remember regretting things I didn't do.

I remember wishing I knew then what I know now.

I remember peach-colored evenings just before dark.

I remember "lavender past." (He has a . . .)

I remember Greyhound buses at night.

I remember wondering what the bus driver is thinking about.

I remember empty towns. Green tinted windows. And neon signs just as they go off.

I remember (I think) lavender-tinted windows on one bus.

I remember tricycles turned over on front lawns. Snowball bushes. And plastic duck families.

I remember glimpses of activity in orange windows at night.

I remember little cows.

I remember that there is always one soldier on every bus.

I remember small ugly modern churches.

I remember that I can never remember how bathroom doors in buses open.

I remember donuts and coffee. Stools. Pasted-over prices. And gray people.

I remember wondering if the person sitting across from me is queer.

I remember rainbow-colored grease spots on the pavement after a rain.

I remember undressing people (in my head) walking down the street.

I remember, in Tulsa, a red sidewalk that sparkled.

I remember being hit on the head by bird shit two times.

I remember how exciting a glimpse of a naked person in a window is even if you don't really see anything.

I remember "Autumn Leaves."

I remember a very pretty German girl who just didn't smell good.

I remember that Eskimos kiss with their noses. (?)

I remember that the only friends my parents had who owned a swimming pool also owned a funeral parlor.

I remember laundromats at night all lit up with nobody in them.

I remember a very clean Catholic book-gift shop with practically nothing in it to buy.

I remember rearranging boxes of candy so it would look like not so much was missing.

I remember brown and white shoes with little decorative holes cut out of them.

I remember certain group gatherings that are hard to get up and leave from.

I remember alligators and quicksand in jungle movies. (Pretty scary.)

I remember opening jars that nobody else could open.

I remember making home-made ice cream.

I remember that I liked store-bought ice cream better.

I remember hospital supply store windows.

I remember stories of what hot dogs are made of.

I remember Davy Crockett hats. And Davy Crockett just about everything else.

I remember not understanding why people on the other side of the world didn't fall off.

I remember wondering why, if Jesus could cure sick people, why He didn't cure all sick people.

I remember wondering why God didn't use his powers more to end wars and stop polio. And stuff like that.

I remember "Love Me Tender."

I remember trying to realize how big the world really is.

I remember trying to figure out what it's all about. (Life.)

I remember catching lightning bugs and putting them in a jar with holes in the lid and then letting them out the next day.

I remember making clover blossom chains.

I remember in Boston a portrait of Isabella Gardner by Whistler.

I remember in Tulsa my first one-man show of brush and ink drawings of old-fashioned children. They were so intricate and fine that nobody could believe that I did them with a brush. But I did.

I remember winning a Peter Pan Coloring Contest and getting a free pass to the movies for a year.

I remember Bunny Van Valkenburg. She had a little nose. A low hairline. And two big front teeth. She was my girlfriend for several years when we were very young. Later on, in high school, she turned into quite a sex-pot.

I remember Bunny Van Valkenburg's mother Betty. She was short and dumpy and bubbly and she wore giant earrings. Once she wallpapered her kitchen floor with wallpaper. Then shellacked it.

I remember Bunny Van Valkenburg's father Doc. He was our family doctor. I remember him telling of a patient he had who got poison ivy inside his body. The man was in total misery but it healed very fast because there was no way that he could scratch it.

I remember that the Van Valkenburgs had more money than we did.

I remember in grade school tying a mirror to your shoe and casually slipping it between a girl's legs during conversation. Other boys did that. I didn't.

I remember eating tunnels and cities out of watermelon.

I remember how sad *The Jane Froman Story* was.

I remember George Evelyn who had a red and white face because of an explosion he was in once. And his wife Jane who wore green a lot and laughed very loud. I remember their only son George Junior who was my age. He was very fat and very wild. But I hear that he settled down, got married, and is active in church.

I remember the first time I saw Elvis Presley. It was on *The Ed Sullivan Show*.

I remember "Blue Suede Shoes." And I remember having a pair.

I remember felt skirts with cut-out felt poodles on them. Sometimes their collars were jeweled.

I remember bright orange canned peaches.

I remember jeweled bottle openers.

I remember the horse lady at the fair. She didn't look like a horse at all.

I remember pillow fights.

I remember being surprised at how yellow and how red autumn *really* is.

I remember chain letters.

I remember Peter Pan collars.

I remember mistletoe.

I remember Judy Garland singing "Have Yourself a Merry Little Christmas" (so sad) in *Meet Me in St. Louis*.

I remember Judy Garland's red shoes in *The Wizard of Oz*.

I remember Christmas tree lights reflected on the ceiling.

I remember Christmas cards arriving from people my parents forgot to send Christmas cards to.

I remember the Millers who lived next door. Mrs. Miller was an Indian and Mr. Miller was a radio ham. They had five children and a very little house. There was always junk all over their yard. And inside the house too. Their living room was completely taken up by a big green ping pong table.

I remember taking out the garbage.

I remember "the Ritz" movie theater. It was full of statues and the ceiling was like a sky at night with twinkling stars.

I remember wax paper.

I remember what-not shelves of two overlapping squares. One higher than the other.

I remember ballerina figurines from Japan with real net-like tutus.

I remember chambray work shirts. And dirty tennis shoes with no socks.

I remember wood carvings of funny doctors.

I remember the "T-zone." (Camel cigarettes.)

I remember big brown radios.

I remember long skinny colored glass decanters from Italy.

I remember fishnet.

I remember board and brick bookshelves.

I remember bongo drums.

I remember candles in wine bottles.

I remember one brick wall and three white walls.

I remember the first time I saw the ocean. I jumped right in, and it swept me right under, down, and back to shore again.

I remember being disappointed in Europe that I didn't *feel* any different.

I remember when Ron Padgett and I first arrived in New York City we told a cab driver to take us to the Village. He said, "Where?" And we said, "To the Village." He said, "But where in the Village?" And we said, "Anywhere." He took us to Sixth Avenue and 8th Street. I was pretty disappointed. I thought that the Village would be like a real village. Like my vision of Europe.

I remember putting on sun tan oil and having the sun go away.

I remember Dorothy Kilgallen's face.

I remember toreador pants.

I remember a baby blue matching skirt and sweater that Suzy Barnes always wore. She was interested in science. All over her walls were advertising matchbook covers hanging on rolls of string. She had a great stamp collection too. Her mother and father were both over six feet tall. They belonged to a club for people over six feet tall only.

I remember doing other things with straws besides drinking through them.

I remember an ice cream parlor in Tulsa that had a thing called a pig's dinner. It was like a very big banana split in a wooden dish made to look like a pig's trough. If you ate it all they gave you a certificate saying that you ate it all.

I remember after people are gone thinking of things I should have said but didn't.

I remember how much rock and roll music can hurt. It can be so free and sexy when you are not.

I remember Royla Cochran. She lived in an attic and made long skinny people out of wax. She was married to a poet with only one arm until he died. He died, she said, from a pain in the arm that wasn't there.

I remember eating alone in restaurants a lot because of some sort of perverse pleasure I don't want to think about right now. (Because I still do it.)

I remember the first escalator in Tulsa. In a bank. I remember riding up and down it. And up and down it.

I remember drawing pictures in church on pledge envelopes and programs.

I remember having a casual chat with God every night and usually falling asleep before I said, "Amen."

I remember the great girl-love of my life. We were both the same age but she was too old and I was too young. Her name was Marilyn Mounts. She had a small and somehow very vulnerable neck. It was a long thin neck, but soft. It looked like it would break very easily.

I remember Sen-Sen: Little black squares that taste like soap.

I remember that little jerk you give just before you fall asleep. Like falling.

I remember when I won a scholarship to the Dayton, Ohio, Art Institute and I didn't like it but I didn't want to hurt their feelings by just quitting so I told them that my father was dying of cancer.

I remember in Dayton, Ohio, the art fair in the park where they made me take down all my naked self-portraits.

I remember a middle-aged lady who ran an antique shop in the Village. She asked me to come over and fix her bathroom late at night but she wouldn't say what was wrong with it. I said yes because saying no has always been difficult for me. But the night I was to go I just didn't go. The antique shop isn't there anymore.

I remember how disappointing going to bed with one of the most beautiful boys I have ever seen was.

I remember jumping off the front porch head first onto the corner of a brick. I remember being able to see nothing but gushing red blood. This is one of the first things I remember. And I have a scar to prove it.

I remember white bread and tearing off the crust and rolling the middle part up into a ball and eating it.

I remember toe jams. I never ate toe jams but I remember kids that did. I *do* remember eating snot. It tasted pretty good.

I remember dingle berries.

I remember rings around your neck. (Dirt.)

I remember thinking once that flushing away pee might be a big waste. I remember thinking that pee is probably good for something and that if one could just discover what it was good for one could make a mint.

I remember staying in the bathtub too long and having wrinkled toes and fingers.

I remember "that" feeling, cleaning out your navel.

I remember pouring out a glass of water (I was a fountain) in a front porch musical production of "Strolling through the Park One Day."

I remember tying two bicycles together for a production number of "Bicycle Built for Two."

I remember a store we had where we bought stuff at the five and ten and then re-sold the stuff for a penny or two more than it cost. And then with the money we bought more stuff. Etc. We ended up by making several dollars clear.

I remember paying a dime and getting a red paper poppy made by people in wheelchairs.

I remember little red feathers. That, I think, was the Red Cross.

I remember making tents on the front porch on rainy days.

I remember wanting to sleep out in the backyard and being kidded about how I wouldn't last the night and sleeping outside and not lasting the night.

I remember a story about my mother finding a rat walking all over my brother's face while he was sleeping. Before I was born.

I remember a story about how when I was very young I got a pair of scissors and cut all my curls off because a boy down the street told me that curls were sissy.

I remember when I was very young saying "hubba-hubba" whenever I saw a red-headed lady because my father liked redheads and it was always good for a laugh.

I remember that my mother's favorite movie star was June Allyson.

I remember that my father's favorite movie star was Rita Hayworth.

I remember being Joseph in a live nativity scene (that didn't move) in a park. You just had to stand there for half an hour and then another Joseph came and you had a cup of hot chocolate until your turn came again.

I remember taking a test to see which musical instrument I would be best suited for. They said it was the clarinet so I got a clarinet and took lessons but I was terrible at it so I stopped.

I remember trying to convince Ron Padgett that I didn't believe in God anymore but he wouldn't believe me. We were in the back of a truck. I don't remember why.

I remember buying things that were too expensive because I didn't like to ask the price of things.

I remember a spooky job I had once cleaning up a dentist's office after everyone had gone home. I had my own key. The only part I liked was straightening up the magazines in the waiting room. I saved it as the last thing to do.

I remember "Revlon." And that ex-Miss America lady.

I remember wondering why, since I am queer, I wouldn't rather be a girl.

I remember trying to devise something with a wet sponge in a glass to jerk off into but it didn't quite work out.

I remember trying to blow myself once but I couldn't quite do it.

I remember optical illusions when lying face down and arms folded over my head in the sun of big eyebrows (magnified) and of two overlapping noses. (Also magnified.)

I remember getting rid of everything I owned on two occasions.

I remember wondering if my older brother is queer too.

I remember that I was a terrible coin collector because I was always spending them.

I remember gray-silver pennies. (Where did they go?)

I remember "Ace" combs.

I remember "Dixie" drinking cups. And "Bond" bread.

I remember the "Breck" shampoo ladies.

I remember the skinny guy who gets sand kicked in his face in body-building advertisements.

I remember blonde women who get so much sun you can't see them.

I remember being disappointed the first time I got my teeth cleaned that they didn't turn out real white.

I remember trying to visualize what my insides looked like.

I remember people who like to look you straight in the eye for a long time as though you have some sort of mutual under-standing about something.

I remember *almost* sending away for body building courses many times.

I remember bright orange light coming into rooms in the late afternoon. Horizontally.

I remember the *$64,000 Question* scandal.

I remember that woman who was always opening refrigerators.

I remember light blue morning glories on the fence in the morning. Morning glories always surprise me. I never really expect them to be there.

I remember miniature loaves of real bread the Bond Bread Company gave you when you went on a tour of their plant.

I remember stories about bodies being chopped up and disposed of in garbage disposals.

I remember stories about razor blades being hidden in apples at Halloween. And pins and needles in popcorn balls.

I remember stories about what goes on in restaurant kitchens. Like spitting in the soup. And jerking off in the salad.

I remember a story about a couple who owned a diner. The husband murdered his wife and ground her up in the hamburger meat. Then one day a man was eating a hamburger at the diner and he came across a piece of her fingernail. That's how the husband got caught.

I remember that Lana Turner was discovered sipping a soda in a drugstore.

I remember that Rock Hudson was a truck driver.

I remember that Betty Grable didn't smoke or drink or go to Hollywood parties.

I remember a ringworm epidemic and being scared to death that I would get it. If you got it they shaved off your hair and put green stuff all over your scalp.

I remember drinking fountains that start out real low and when you put your face down they spurt way up into your nose.

I remember my grade school librarian Miss Peabody. At the beginning of each class we had to all say in unison "Good morning, Miss Peabody!" Only instead we said "Good morning, Miss *Pee*-body!" I guess she decided to ignore this because she never

said anything about it. She was very tall and very thin and there was always a ribbon or a scarf tied around her head from which bubbled lots of silver-gray curls.

I remember in gym class during baseball season certain ways of avoiding having to go to bat.

I remember on "free day" in gym class usually picking stilts.

I remember "Your shirt tail's on fire!" and then you yank it out and say "Now it's out!"

I remember "Your front door is open." Or maybe it was "Barn door." Or both.

I remember "bathroom stationery."

I remember being embarrassed to buy toilet paper at the corner store unless there were several other things to buy too.

I remember a joke about Tom, Dick, and Harry that ended up, "Tom's dick is hairy."

I remember "sick" jokes.

I remember Mary Anne jokes.

I remember "Mommy, Mommy, I don't like my little brother." "Shut up, Mary Anne, and eat what I tell you to!" (That's a Mary Anne joke.)

I remember once having to take a pee sample to the doctor and how yellow and warm it was in a jar.

I remember socks that won't stay up.

I remember the little boy with the very deep voice in *Gentlemen Prefer Blondes*. (Like a frog.)

I remember a red velvet swing in a movie called *The Red Velvet Swing*.

I remember having to pull down my pants once to show the doctor my dick. It was all red and swollen. A solid mass of chigger bites. (Pretty embarrassing.)

I remember wondering why anyone would want to be a doctor, and I still do.

I remember always getting in trouble for giving everything away.

I remember *really* getting in trouble once for trading a lot of expensive toys for a rock and a pocket knife.

I remember a girl in grade school who had shiny legs that were cracked like a Chinese vase.

I remember burying some things in the dirt once thinking that someday someone would find them and it would be a great surprise but a few days later I dug them up myself.

I remember when Lenox China had an essay contest in connection with a local store that carried Lenox China. Whoever wrote the best essay about Lenox China was supposed to get a free place setting of their choice but I don't remember anyone winning. I think somehow the contest got dropped.

I remember square dancing and "The Texas Star."

I remember an old royal blue taffeta formal my little sister had for playing dress-up in and *I* remember dressing up in it.

I remember "hand-me-downs."

I remember pig-latin.

I remember reading twelve books every summer so as to get a "certificate" from the local library. I didn't give a shit about reading but I loved getting certificates. I remember picking books with big print and lots of pictures.

I remember earaches. Cotton. And hot oil.

I remember not liking mashed potatoes if there was a single lump in them.

I remember *Howdy Doody* and *Queen for a Day*.

I remember taking an I.Q. test and coming out below average. (I've never told anybody that before.)

I remember pedal-pushers.

I remember thinking about whether or not one should kill flies.

I remember giving myself two or three wishes and trying to figure out what they would be. (Like a million dollars, no more polio, and world peace.)

I remember locker rooms. And locker room smells.

I remember a dark green cement floor covered with wet footprints going in all different directions. Thin white towels. And not "looking around" too much.

I remember one boy with an absolutely enormous cock. And he knew it. He was always last to get dressed. (Putting his socks on first.)

I remember that I put everything else on before I put my socks on.

I remember that Gene Kelly had no basket.

I remember the scandal Jane Russell's costume in *The French Line* caused.

I remember a color foldout pinup picture of Jane Russell lounging in a pile of straw in *Esquire* magazine with one bare shoulder.

I remember that Betty Grable's legs were insured for a million dollars.

I remember a picture of Jayne Mansfield sitting in a pink Cadillac with two enormous pink poodles.

I remember how long Oscar Levant's piano numbers were.

I remember (I think) a candy bar called "Big Dick."

I remember "Payday" candy bars and eating the peanuts off first and then eating the center part.

I remember a big brown chewy thing on a stick that you could lick down to a very sharp point.

I remember a *very* chewy kind of candy sold mostly at movie theatres. (Chocolate covered caramel pieces of candy in a yellow box.) They stuck to your teeth. So chewy one box would last for a whole movie.

I remember how boring newsreels were.

I remember a boy named Henry who was said to have poured a mixture of orange pop and popcorn off the balcony of the "Ritz" movie theatre as he made gagging sounds.

I remember trying to imagine certain people going to the bathroom.

I remember someone telling me that if you farted on a lit match it would make a big blue flame.

I remember wondering if girls fart too.

I remember marbles.

I remember *having* marbles more than I remember *playing* marbles.

I remember playing hopscotch without ever really knowing the rules.

I remember a plate that hung on the wall above the T.V. set that said, "God Bless Our Mortgaged Home."

I remember light green notebook paper. (Better for your eyes than white.)

I remember the school cafeteria. Silverware clanking noises. Stacks of chipped brown trays. Little cartons of milk. And red Jell-o cut up into cubes.

I remember that girls who worked in the school cafeteria had to wear hairnets.

I remember fruit cocktail.

I remember chicken noodle soup when you are sick.

I remember when I was very young a department store where when you bought something the saleslady put your money in a tubular container that traveled through a series of pipes. Then the container returned with a "dong" and your change.

I remember finding $21 in a black coin purse in a big department store in St. Louis. I reported having found it but since nobody reported losing it I got to keep it.

I remember that a good way to catch a cold is to walk around barefooted. To not get enough sleep. And to go outside with wet hair.

I remember "colored town." (Tulsa.)

I remember that "Negroes who drive around in big shiny Cadillacs usually live in broken-down shacks."

I remember when Negroes first started moving into white neighborhoods. How everyone got scared because if a Negro moved into your neighborhood the value of your property would go way down.

I remember bubble gum. Blowing big bubbles. And trying to get bubble gum out of my hair.

I remember eating dried airplane glue off my fingers. (Yum-yum.)

I remember the smell (loved it) of fingernail polish.

I remember black heels on new shoes that mark up floors.

I remember the first time I heard water swishing around in my stomach (while running) and thinking that maybe I had a tumor.

I remember thinking how awful it would be to be responsible for a fire that took lives. Or for a car wreck.

I remember when I was very young a photograph in *Life* magazine of a man running down the street naked on fire.

I remember my father trying to get splinters out of my fingers with a needle.

I remember daydreams of living in an old bus, or an old railroad car, and how I would fix it up.

I remember daydreams of having a pet monkey that would wear human clothes and we would go around everywhere together.

I remember daydreams of inheriting lots of money from some relative I didn't even know I had.

I remember daydreams of being a big success in New York City. (Penthouse and all!)

I remember living on the Lower East Side.

I remember Second Avenue and strawberry shortcake at "Ratner's."

I remember the St. Mark's movie theatre (45¢ until six). The red popcorn machine. And lots of old men.

I remember "the cat lady" who always wore black. And many pairs of nylons. One on top of the other on top of the other. She was called "the cat lady" because every night she went around feeding cats. Her hair was so matted I don't think a comb could possibly have gone through it. All day long she roamed the streets doing what I am not sure. She was never without her shopping cart full of paper bags full of God only knows what. According to her there were other cat ladies who looked after cats in other Lower East Side areas. How organized all these ladies were I don't know.

I remember Ukrainian Easter eggs all year round.

I remember thin flat sheets of apricot candy in delicatessen windows.

I remember "Le Metro." (A coffeehouse on Second Avenue that had poetry readings.) Paul Blackburn. And Diane di Prima sitting on top of a piano reading her poems.

I remember how beautiful snow made the Lower East Side look. (So black and white.)

I remember Klein's at Christmas time.

I remember "Folk City." "Man Power." And selling books at "The Strand."

I remember going grocery shopping with Pat Padgett (Pat Mitchell then) and slipping a steak into her coat pocket when she wasn't looking.

I remember going to a church on the Bowery where bums go to get work for a day and being sent to Brooklyn to clean up a small Jewish synagogue where the rabbi was so disgusting that after half a day's work I just couldn't stand anymore so I "disappeared." (With no pay.)

I remember Leadbelly records smaller than most records.

I remember Delancey Street. The Brooklyn Bridge. Orchard Street. The Staten Island Ferry. And walking around the Wall Street area late at night. (No people.)

I remember a very old man who lived next door to me on Avenue B. He is most surely dead by now.

I remember that "no two snowflakes are exactly alike."

I remember felt jackets from Mexico with felt cut-outs of Mexicans taking siestas on the backs. And potted cactus plants on the pockets.

I remember the 4th of July. Sparklers. And stories about how dangerous firecrackers are.

I remember being allowed only sparklers. (And I remember only *wanting* sparklers.)

I remember snow, making snow-creams, and never having much luck making snowmen.

I remember making angel impressions in the snow by falling backwards and flapping my arms up and down and my legs back and forth.

I remember hayrides and slumber parties.

I remember little cream jars in restaurants.

I remember "statues." (A game where someone swung you around and then let go and you froze in whatever position you landed.)

I remember satin jackets from Japan with embroidered dragons and American flags on the backs.

I remember when pink grapefruit was a big treat.

I remember mackinaws.

I remember roller skate keys.

I remember "Coming Attractions." Company picnics. Two-car garages. And picture windows.

I remember potato sack races.

I remember "Sticks and stones may break my bones but words will never hurt me."

I remember green grass knee stains.

I remember every year in school having to write an essay on thrift for some annual thrift essay contest, and never winning.

I remember not understanding how a baby could come out of such a small hole. (Still don't.)

I remember jacks.

I remember "onesies" and "twosies" and "threesies" and "baskets" and "pig pens" and "over the fences" and "around the worlds" and "pats" and "double pats."

I remember "7" and "14" and "13" and "21" and "69."

I remember daydreams of having supernatural powers and amazing people with my accurate predictions.

I remember predicting an airplane crash but nobody would listen. (Daydream.)

I remember raccoon tails hanging from car antennas.

I remember sassafras tea, turnips, and persimmons.

I remember looking for four-leaf clovers, but not for very long.

I remember Lazy Susans.

I remember continuing my return address on envelopes to include "The Earth" and "The Universe."

I remember Dole pineapple rings on a bed of lettuce with cottage cheese on top and sometimes a cherry on top of that.

I remember "Korea."

I remember giant blackheads on little faces in tiny ads in the back of magazines.

I remember fancy yo-yos studded with rhinestones.

I remember once when it was raining on one side of our fence but not on the other.

I remember rainbows that didn't live up to my expectations.

I remember big puzzles on card tables that never got finished.

I remember Oreo chocolate cookies and a big glass of milk.

I remember vanilla pudding with vanilla wafers in it and sliced bananas on top.

I remember angel food cake and wondering why the hole in the middle *had* to be there.

I remember my mother's sticking toothpicks into cakes to see if they were done or not.

I remember borrowed punch bowls.

I remember fantasies of totally losing my voice and hearing and being able to communicate only by writing notes back and forth. (It was fun!)

I remember trying not to stare at people with hearing aids. (Or trying to look at them casually.)

I remember braces (on teeth) and how, at a certain point in high school it was almost a status symbol.

I remember being embarrassed to blow my nose in public.

I remember not going to the bathroom in public places if I didn't know where it was.

I remember, when traveling, laying tissue paper over the toilet seat rim because "You never know."

I remember "number one" and "number two."

I remember examining my cock and balls very carefully once and finding them absolutely disgusting.

I remember fantasies of my cock growing quite large just overnight. (A medical mystery!)

I remember sexual fantasies of having "to perform" by force.

I remember Coke bottle stories.

I remember reading somewhere that the average cock is from six to eight inches when erect, and grabbing for the nearest ruler.

I remember stories about nuns and candles and throwing babies into the basement furnace.

I remember cheating at solitaire.

I remember sometimes *letting* people win games.

I remember crossing your fingers behind your back when you tell a lie.

I remember thinking that comic books that weren't funny shouldn't be called "comic books."

I remember fantasies of making the back seat of a car "livable" with curtains, a fold-away kitchen, etc.

I remember fantasies of growing up and adopting a child.

I remember trying to imagine what I'd look like as an old man.

I remember old women's flesh-colored hose you can't see through.

I remember "no ankles" on some old ladies.

I remember trying to imagine my grandfather naked. (Eck!)

I remember having a crush on a cousin and my mother telling me that you can't marry a cousin and, "But *why* can't you marry a cousin?" and "Because it's against the law," and "But *why* is it against the law?" etc.

I remember the rumor that if a black and a white person got married and had a baby it might turn out black and white spotted.

I remember a boy who could curl up his lips ("nigger lips") and hold them there.

I remember white marshmallow powder on lips.

I remember a very big boy named Teddy and what hairy legs his mother had. (Long black ones squashed flat under nylons.)

I remember Dagwood and Blondie shorts before the feature started.

I remember not allowing myself to start on the candy until the feature started.

I remember big battle scenes and not understanding how they could be done without a lot of people getting hurt.

I remember thinking those sandals and short skirts rather impractical for war.

I remember how very black and white early "art" movies were.

I remember bedroom scenes that focused mostly on the wallpaper.

I remember Gina Lollobrigida's *very* tiny waist in *Trapeze*.

I remember bedroom scenes where the camera goes out the window and down to the ocean to the roar of crashing waves.

I remember Jane Russell's hair all pulled over to one side and flat as a rock on top.

I remember that Rock Hudson and Charlie Chaplin and Lyndon Johnson have "giant cocks."

I remember rumors about what Marlon Brando had to do to get his first acting job.

I remember the rumor that Marlon Brando liked Oriental women so much because he had a little cock.

I remember giant discussions with Pat and Ron Padgett, and Ted Berrigan, after seeing *La Dolce Vita* about what all the symbolism meant.

I remember the shadows of feet under the cracks of doors. And closeups of doorknobs turning.

I remember getting irritated when someone would get out of bed and roam around the castle all alone late at night (just asking for trouble) instead of staying in his or her room where it's safe.

I remember hair not being messed up when it should be messed up.

I remember when you do that motorboat-like thing with your lips how your nose starts tickling.

I remember jungle plants that eat people.

I remember candy cigarettes like chalk.

I remember finding things in glove compartments I had looked for there before and not found.

I remember screen doors that slam. And "You're letting in the flies."

I remember bar stools and kitchen nooks and brass ivy planters.

I remember tap dancing recitals.

I remember Popsicle coupons. Ballerina paper dolls. And carnival glass piggy banks with no way to get the money out except by shaking it out upside down.

I remember a tin clown bank that stuck his tongue out and a monkey bank that tipped his hat.

I remember veils over hats over faces sprinkled with little fuzzy dots.

I remember parliamentary procedure. Multiple choice questions. And paper curtains.

I remember "Aspergum." And muumuus. And making Easter baskets out of "Quaker" oatmeal boxes at school.

I remember houseshoes that were just leather soles sewn to the bottoms of a pair of socks.

I remember roly-poly bugs that curl up into a ball when you touch them.

I remember those yellow bushes that are the first things to flower in the spring.

I remember when I was very young telling an adult that I wanted to be a fireman or a cowboy when I grew up but I don't remember really wanting to be either.

I remember Jane and Dick and Sally and Spot and the nice policeman and "Run, run, run."

I remember in many classrooms a painting of George Washington unfinished at the bottom.

I remember okra, hominy grits, liver, and spinach.

I remember that carrots are good for your eyes and that beans make you fart.

I remember that cats have nine lives.

I remember "An apple a day keeps the doctor away."

I remember puffed rice shot from guns.

I remember "Snap, crackle, and pop."

I remember an ashtray that looked like a house and when you put your cigarette down (through the door) the smoke came out of the chimney.

I remember Rudolph the Red-Nosed Reindeer.

I remember a toothpick holder with a bird that picked up the toothpick with his beak for you when you did something (?) to his tail.

I remember "just married" cartoons.

I remember "stranded on an island in the middle of the ocean" cartoons.

I remember high school yearbooks, signing high school yearbooks, and "Roses are red, violets are blue, God made me beautiful, what happened to you?"

I remember in a high school yearbook a big group picture where one boy in the back row was giving the finger.

I remember the same year in the same yearbook a picture of a track star running and if you looked real close you could see what looked like the tip of his penis sticking out from under his shorts.

I remember "My Wild Irish Rose."

I remember how "Penny" in the Sunday comics was always talking on the telephone in unusual positions surrounded by mountains of food.

I remember that Penny's father always had a pipe in his mouth.

I remember the tobacco smell of my father's breath.

I remember my father's collection of Zane Grey novels and one "dirty" book called *Let's Make Mary*.

I remember plaster of paris.

I remember plaster of paris figurines you made in red rubber molds and then you painted them.

I remember accent pillows. Bathroom decals. Argyle socks. Window valances. And tapioca pudding.

I remember cold cream. "Tums for the tummy." And *Our Miss Brooks*.

I remember book ends. Arm chairs. And end tables.

I remember *Amos and Andy*. *Life with Father*. And *Francis the Talking Mule*.

I remember artist smocks. Liver-shaped palettes. And big black bows.

I remember "Ma and Pa Kettle." "Dishpan hands." Linoleum. Cyclone fences. Shaggy dog stories. Stucco houses. Pen and pencil sets. Tinker Toys. Lincoln Logs. And red blue jeans for girls.

I remember a pair of brown blue jeans I once had.

I remember thinking how embarrassing it would be if your name was Hitler.

I remember a miniature white Bible no bigger than a book of matches.

I remember finding the story of Noah and his ark really just *too* far out.

I remember "God Is Love Is Art Is Life." I think I made that up in high school. Or else Ron Padgett did. At any rate I remember thinking it terribly profound.

I remember queer bars.

I remember leaning up against walls in queer bars.

I remember standing up straight in queer bars.

I remember suddenly being aware of "how" I am holding my cigarette in queer bars.

I remember not liking myself for not picking up boys I probably could pick up because of the possibility of being rejected.

I remember deciding at a certain point that I would cut through all the bullshit and just go up to boys I liked and say, "Do you want to go home with me?" and so I tried it. But it didn't work. Except once. And he was drunk. The next morning he left a card behind with a picture of Jesus on it signed "with love, Jesus" on the back. He said he was a friend of Allen Ginsberg.

I remember tight white pants. Certain ways of standing. Blond heads of hair. And spotted bleached blue jeans.

I remember "baskets."

I remember "jewels" neatly placed down the left pantleg or the right.

I remember pretty faces that don't move.

I remember loud sexy music. Too much beer. Quick glances. And not liking myself for playing the game too.

I remember enjoying playing the game too, though.

I remember pretending to be interested in pool.

I remember a boy I tried to pick up once. As an opener I told him he had a nice nose and he said he was thinking about having it "fixed" and I said no he shouldn't. He said he was busy that night but he took my phone number. (Never did call, though.) Maybe I put him off by saying that I thought psychology was a bit silly. (He was a psychology major.) "Too self indulgent," I remember saying. (I was drunk.) Actually his nose *was* a bit too big.

I remember coming home from queer bars and bawling myself out for not having more confidence in myself.

I remember thinking I could sing (had a good voice) until somehow in school I discovered I didn't.

I remember that Picasso was born in 1881. (Having no memory for facts, I once made myself memorize that fact and I've never forgotten it.)

I remember "A white sports coat and a pink carnation."

I remember the "dum-da-dum-dum-*dum*" from *Dragnet*.

I remember what a hard time I had memorizing Shakespeare and how nervous I got when it was my turn to recite.

I remember trying to memorize Shakespeare so that words that began with sounds I stuttered on (*s*, *b*, etc.) would not begin with a new breath. (Do you know what I mean?)

I remember chartreuse.

I remember a pair of baby blue gabardine pants I especially liked.

I remember running for vice-president and giving a campaign speech wearing my baby blue gabardine pants. I lost. That was junior high school.

I remember in junior high school asking a girl who was much too popular and pretty for me to a dance and she said, "Yes." But the moment we arrived she disappeared into a group of her friends and I didn't see her again all evening. I think her name was Nancy. Yes, it was.

I remember that Nancy was the girl I lost the vice-presidency to.

I remember Judy.

I remember having a big crush on Judy and discovering that she was embarrassed to be seen with me so I stopped asking her out.

I remember Bill Haley and "Rock around the Clock."

I remember thin gold ankle bracelets.

I remember "white trash."

I remember nylon "runs."

I remember looking at myself in a mirror and becoming a total stranger.

I remember having a crush on a boy in my Spanish class who had a pair of olive green suede shoes with brass buckles just like a pair I had. ("Flagg Brothers.") I never said one word to him the entire year.

I remember sweaters thrown over shoulders and sunglasses propped up on heads.

I remember boat neck sweaters.

I remember "Queer as a three dollar bill."

I remember wooden nickels.

I remember stamp hinges.

I remember orange icing on cupcakes at school Halloween parties.

I remember autumn.

I remember walking home from school through the leaves alongside the curb.

I remember jumping into piles of leaves and the dust, or whatever it is, that rises.

I remember raking leaves but I don't remember burning leaves. I don't remember what we "did" with them.

I remember "Indian Summer." And for years not knowing what it meant, except that I figured it had something to do with Indians.

I remember exactly how I visualized the Pilgrims and the Indians having the first Thanksgiving dinner together. (Very jolly!)

I remember Jack Frost. Pumpkin pie. Gourds. And very blue skies.

I remember Halloween.

I remember usually getting dressed up as a hobo or a ghost. One year I was a skeleton.

I remember one house that always gave you a dime and several houses that gave you five-cent candy bars.

I remember after Halloween my brother and me spreading all our loot out and doing some trading.

I remember always at the bottom of the bag lots of dirty pieces of candy corn.

I remember the smell (not very good) of burning pumpkin meat inside jack-o'-lanterns.

I remember orange and black jellybeans at Halloween. And pastel-colored ones for Easter.

I remember "hard" Christmas candy. Especially the ones with flower designs. I remember not liking the ones with jelly in the middle very much.

I remember some beautiful German Christmas tree ornaments in the shape of birds and houses and people.

I remember the dangers of angel hair.

I remember having my Christmas shopping list all made out before December.

I remember the fear of not getting a present for someone who might give me one.

I remember after Christmas shopping coming home and gloating over everything I bought.

I remember Rosemary Clooney and Bing Crosby and "I'm Dreaming of a White Christmas."

I remember how sad and happy at the same time Christmas carols always made me feel: all warm inside.

I remember seeing every year that movie about "Macy's" and "Gimbel's" and the old man who thought he was Santa Claus.

I remember, after Christmas caroling, hot chocolate.

I remember buying a small bottle of Chanel No. 5 for my mother for Christmas one year but when I told my father how much it cost I had to take it back.

I remember not being able to fall asleep Christmas Eve.

I remember more than once leaving the price tag on a present.

I remember very clearly (visually) a bride doll sitting in a red wagon under the Christmas tree when I was very young. (For me.)

I remember opening my first packages very fast and my last few very slowly.

I remember after opening packages what an empty day Christmas day is.

I remember feeling sorry for kids at church, or school, who had ugly mothers.

I remember that nobody ever knew what to give Aunt Ruby on special occasions so everyone always gave her stationery or scarves or handkerchiefs or boxes of fancy soap.

I remember thinking I had really hit on something when I got the idea of putting orange juice instead of milk on cereal but then I tried it and it was awful.

I remember loving raw biscuit dough.

I remember rolling balls of mercury around in the palm of my hand, and shining dimes with it.

I remember the controversy over whether to install a Coke machine in the church basement or not.

I remember church camp and "the quiet hour" and weaving plastic braid around strips of metal to make bracelets. And weaving plastic braid into things to hang around your neck to hang whistles from. And always the possibility of running into a copperhead.

I remember being a Boy Scout and getting badges in art and fingerprinting and several other easy-to-get badges. First-aid too.

I remember hoola-hoops.

I remember seeing my brother bend way over to pull out the bath tub plug naked and realizing for the first time that shit came out of a hole instead of a long slit.

I remember a pinkish-red rubber douche that appeared in the bathroom every now and then, and not knowing what it was, but somehow knowing enough not to ask.

I remember when I was very young getting what I now assume to have been an enema. I just remember having to turn over and my mother sticking this glass thing with a rubber ball on top (also pinkish-red) up my butt and being scared to death.

I remember getting a thermometer stuck up my butt several times and the fear that it might fall in and get lost, or break off inside me.

I remember a little boy who said it was more fun to pee together than alone, and so we did, and so it was.

I remember once my mother parading a bunch of women through the bathroom as I was taking a shit. Never have I been so embarrassed!

I remember a boy who could pull the undersides of his eyelids down over his eyeballs.

I remember looking cross-eyed and being told not to do that because they might get stuck and I'd be cross-eyed for life.

I remember a story about somebody finding a baby alligator in their toilet bowl.

I remember peeing all over J. J. Mitchell in a dream once.

I remember very long pigtails. And plaid ribbon bows.

I remember finding some strange-looking stamps in a box and being told that you got food with them during the war.

I remember a big red satin wide-brimmed hat with red silk poppies all over it Mrs. Hawks wore to church one Easter Sunday. She was married to Mr. Hawks who owned the local ice cream company. She was an ex-Dior model and everyone thought she was very ugly except me. ("Skinny and weird looking.") In my head it is still the most beautiful hat I have ever seen.

I remember wax fingernails. Wax moustaches. Wax lips. And wax teeth.

I remember that George Washington's teeth were made of wood.

I remember little wax bottles with very sweet liquid inside.

I remember orange candy shaped like big peanuts with lots of air in it.

I remember pink cotton candy and feeling all "sticky" afterwards.

I remember looking very close at cotton candy and seeing that it was made up of little red "beads."

I remember a coconut kind of candy that looked like thin slices of watermelon.

I remember "nigger babies." Candy corn. And red hots.

I remember finger painting and usually ending up with a sort of purple-brown mess.

I remember jungle gyms and girls who didn't care if you saw their panties or not.

I remember one girl who sometimes didn't wear panties.

I remember "dress up time." (Running around pulling up girls' dresses yelling "dress up time.")

I remember that a lot of kissing went on in the drinking fountain area.

I remember fire drills. And air-raid drills.

I remember a chubby boy whose parents were deaf and dumb. He taught me how to say "Joe" with my hands.

I remember daydreams of having a twin.

I remember "See you later alligator!"

I remember suspenders and bow ties and red leather mittens.

I remember, when someone says something that rhymes, "You're a poet, and didn't know it, but your feet show it. They're Longfellows!"

I remember yellow rubber raincoats with matching hoods.

I remember big black galoshes with lots of metal foldover clamps.

I remember a *very* deluxe Crayola set that had gold and silver and copper.

I remember that the red Crayola was always the first to go.

I remember always drawing girls with their hands behind their backs. Or in pockets.

I remember that area of white flesh between the pant cuffs and the socks when old men cross their legs.

I remember a fat man who sold insurance. One hot summer day we went to visit him and he was wearing shorts and when he sat down one of his balls hung out. I remember that it was hard to look at it and hard not to look at it too.

I remember a very early memory of an older girl in a candy store. The man asked her what she wanted and she picked out several things and then he asked her for her money and she said, "Oh, I don't have any money. You just asked me what I *wanted*, and I told you." This impressed me no end.

I remember daydreams of living in a treehouse.

I remember daydreams of saving someone from drowning and being a hero.

I remember daydreams of going blind and how sorry everyone would feel for me.

I remember daydreams of being a girl and of the beautiful formals I would have.

I remember daydreams of leaving home and getting a job and an apartment of my own.

I remember daydreams of being discovered by a Hollywood agent who would send me to a special place in California where they "re-do" people. (*Very* expensive.) They'd cap my teeth and make my hair look great and make me gain weight and give me muscles and I'd come out looking great. On my way to being a star. (But first I'd go home and shock everybody.)

I remember daydreams of a doctor who (on the sly) was experimenting with a drug that would turn you into a real stud. All very "hush-hush." (As it was illegal.) There was a slight chance that something might go wrong and that I'd end up with a *really* giant cock, but I was willing to take that chance.

I remember wondering if I *looked* queer.

I remember making sure that I held my cigarette in not a queer way.

I remember one masculine-looking way to hold a cigarette I figured out was to hold it way down between my fingers. Below the knuckles.

I remember not crossing my legs. (Knee over knee.) I thought that looked queer.

I remember making sure my little finger didn't stick out.

I remember hating myself after group gatherings for being such a bore.

I remember daydreams of being very charming and witty.

I remember my first pep pill. Ted Berrigan gave it to me. I stayed up all night doing hundreds of drawings. I especially remember one drawing of a cup of coffee.

I remember "Spam."

I remember when I was very young thinking that shaving looked pretty dangerous.

I remember rubber thongs and how they started out being 99¢ a pair and how they ended up being incredibly cheap (like 19¢ a pair) and the sound they made flopping against bare soles.

I remember chicken fried steak.

I remember "Kraft's" sandwich spread.

I remember not trusting pressure cookers.

I remember a blue glass mirror storefront in Tulsa with one piece missing.

I remember "Sloppy Joes."

I remember shoulder pads. Cinnamon toothpicks. And "John Doe."

I remember little electric fans that could "cut your fingers right off" if you got too close.

I remember little boxes of cereal that opened up in back so you could eat it right out of the box. I remember that sometimes they leaked.

I remember cedar chests. (And the smell of.)

I remember "blond oak."

I remember when the bigger the cuffs on blue jeans were the better.

I remember "5-Day Deodorant Pads."

I remember "The Arthur Murray Party."

I remember pony tail clips.

I remember "Chef Boy-ar-dee Spaghetti."

I remember baby shoes hanging from car rear-view mirrors.

I remember bronzed baby shoes. Shriner hats. And the Campbell Soup kids.

I remember cold cream on my mother's face.

I remember two-piece bathing suits. Alphabet soup. Ozzie and Harriet. And pictures of kidney-shaped swimming pools.

I remember a photograph in *Life* magazine of a woman jumping off a building.

I remember not understanding how the photographer could have just stood there and taken that picture.

I remember not understanding how very ugly or deformed people could stand it.

I remember a girl in junior high school who had a very thin black moustache.

I remember not understanding why women in dresses didn't freeze their legs off in the winter time.

I remember a girl who had dead corsages all around her circular dressing table mirror.

I remember a brief period in high school when it was popular to spray a silver streak in your hair.

I remember that I was a year ahead of everyone in high school by wearing sneakers but I missed the point a bit because I always kept mine spotlessly clean.

I remember seeing a 3-D movie once and wearing red and green cellophane glasses. And 3-D comic books too.

I remember a series of Cadillac ads with beautiful diamond and ruby and emerald necklaces, according to the color of the car in the ad.

I remember the little monkey so small he would fit in the palm of your hand that you had to sell so much of something for in order to get free. (Seeds or magazines or something like that.)

I remember in many comic books a full-page ad packed solid with rings. I remember especially one skull ring I always wanted.

I remember a red liquid medicine for cuts in a little brown bottle that "won't sting" but it always did.

I remember stories about babies being born in taxi cabs.

I remember when Arthur Godfrey caused a big scandal by driving his airplane drunk and having a crash and killing someone, or something like that.

I remember the little appliqued diver on all Jantzen swimsuits.

I remember filling the ice trays too full and trying to get them back to the refrigerator without spilling any.

I remember not finding "The Little King" very funny.

I remember a piece of old wood with termites running around all over it the termite men found under our front porch.

I remember when one year in Tulsa by some freak of nature we were invaded by millions of grasshoppers for about three or four days. I remember, downtown, whole sidewalk areas of solid grasshoppers.

I remember a shoe store with a big brown x-ray machine that showed up the bones in your feet bright green.

I remember the "Goodyear" tire foot with wings. And the flying red horse.

I remember that watermelon is 99% water.

I remember posture pictures being taken at school and being told that I had *really* bad posture. And that was that.

I remember fire insurance ads of homeless families all wrapped up in blankets.

I remember little black and white Scottie dogs (plastic) each with a magnet on the bottom. I can't remember exactly what they "did," though.

I remember prophylactic machines in gas station bathrooms.

I remember that a used prophylactic was found one morning by the principal lying in the outstretched hand of "The Great Spirit": a big bronze sculpture of an Indian on a horse looking up at the sky. That was in high school. Or maybe it was a used Kotex.

I remember talk about one drugstore that was easy to get them at.

I remember a short dumpy girl with long hair and pierced ears and giant tits that was supposed to be an easy lay.

I remember every other Saturday having to get a haircut. And how the barber was always clicking his scissors even when he wasn't cutting anything.

I remember a long brown leather strap. Beat-up magazines. And kids who cried. (And then got suckers.)

I remember the bright red hair tonic that looked more like something to drink, and a white strip of tissue paper being wrapped tightly around my neck.

I remember watching my hair fall and accumulate.

I remember being afraid that the barber might slip and cut my ear.

I remember that once he did.

I remember at the end of a haircut getting my neck dusted off with a soft brush full of nice smelling powder. And getting swirled around to look in the mirror and how big, afterwards, my ears were.

I remember the *very* ornate chrome foot rest. And the old Negro shoeshine man.

I remember having an itchy back all the way home.

I remember a tower on top of a building in Tulsa that changed colors every few minutes. But only green and yellow and white.

I remember miniature hats in miniature hat boxes in a men's hat store window. You got one free when you bought someone a gift certificate for a hat.

I remember balloon sleeves. And no sleeves.

I remember "bouffants" and "beehives." (Hairdos.)

I remember when "beehives" really got out of hand.

I remember school desk carvings and running my ballpoint pen back and forth in them.

I remember noisy candy wrappers when you don't want to make any noise.

I remember when those short-sleeved knitted shirts with long tails (to wear "out") with little embroidered alligators on the pockets were popular.

I remember plain camel hair coats that rich girls in high school wore.

I remember "socialite corner" (2nd floor) where only kids who belonged to social clubs met and chatted before school and in between classes.

I remember that to be in a social club you either had to live on the South side of town (I lived on the North) or else you had to be good looking (I wasn't) and usually both.

I remember that popular boys always had their blue jeans worn down just the right amount.

I remember madras plaid shirts and sports coats and how they had to be washed a few times before they had the right look.

I remember "French kissing" and figuring out that it must have something to do with the tongue since there isn't anything else in the mouth except teeth.

I remember that shaking or holding hands with a girl while you scratched her palm with your middle finger was somehow "dirty." (Often done as a joke and the girl would turn red and scream.)

I remember in Boston a Puerto Rican boy who worked behind a glass counter in a cafeteria and his arms up to his rolled up sleeves: thick and gold and hairless.

I remember early sexual experiences and rubbery knees. I'm sure sex is much better now but I *do* miss rubbery knees.

I remember the first time I got jerked off (never did discover it for myself). I didn't know what she was trying to do and so I just laid there like a zombie not helping one bit.

I remember her wanting me to put my finger in her cunt and so I did but I had no idea (or no inspiration) as to what to "do" with it once it was there except to move it around a bit.

I remember feeling very outside the experience (watching myself) and feeling very silly with my finger in this wet hole. I think she finally gave up and made herself come because I remember a lot of hard kissing while I could feel her squirming around a lot down there.

I remember, on the verge of coming, thinking that *that* meant I had to go pee, so I excused myself to go to the bathroom and that spoiled everything.

I remember being very proud of myself the next morning, nevertheless.

I remember Nehru jackets.

I remember when turtle necks were big, talk about what restaurants would let you in and what ones wouldn't.

I remember the first time I ate beefsteak tartare eating lots of crackers and butter with it.

I remember linen dresses from behind after having sat through a sermon. Or a bridge party.

I remember *The Millionaire* on T.V. and how you never got to see his face.

I remember "Two hairs past a freckle" when someone asks you what time it is and you don't have a watch.

I remember when I was very young a hand-wringer washing machine in our basement and visions of what it could do to your hand if it got caught in it.

I remember pink underwear sometimes when something red faded in the wash.

I remember sometimes blue underwear.

I remember lint all over blue jeans when you forgot and left a Kleenex in your pocket.

I remember "panty raids."

I remember "Which twin has the Toni!"

I remember "Does she or doesn't she?"

I remember "There's No Business Like Show Business" (the song) and how it always got to me.

I remember folding paper into cootie catchers. And airplanes that just went down.

I remember picture card machines at the fair of movie stars and pin-up girls and cowboys.

I remember thinking that if you didn't return stamp approvals you'd *really* get in trouble.

I remember at junior high school dances mostly just girls dancing with girls.

I remember "Silly Putty" in a plastic egg.

I remember silent moments in church when my stomach would decide to growl.

I remember daydreams of living in the past and having the advantage (and sometimes the disadvantage) of knowing what was going to happen before it happened.

I remember always breaking my glasses and being told that *next* time I'd have to buy new ones myself out of my allowance (25¢ a week) but I never did.

I remember "Monopoly" and "Clue."

I remember the little silver candlestick (Clue) and not knowing what a conservatory was.

I remember getting all dressed up to go buy clothes.

I remember when twins dressed alike.

I remember mother and daughter dresses.

I remember father and son dinners.

I remember the Lone Ranger and Tonto.

I remember:
> "High-ho Silver in the air
> Tonto lost his underwear
> Tonto, Tonto he no care
> Lone Ranger buy him 'nother pair."

I remember pulling out the long stringy things from the center of honeysuckle blossoms and sucking up the drop of honey that comes out with them.

I remember a bust of Benjamin Franklin on a cover of *The Saturday Evening Post* once every year.

I remember "a ham" every year for Christmas from the company my father worked for.

I remember bright colored bubble bath balls. And bathtub "rings."

I remember clear plastic high heels with no straps in back.

I remember clear plastic purses that looked like lunch boxes with a scarf hanging out of them.

I remember a pink hairnet my mother had with larger than usual openings.

I remember neckties that were already tied with elastic to go around your neck.

I remember "Mother's Day" and wearing a red rose to church in my lapel. (You wore a white rose if your mother was dead. And a yellow rose if your mother was a step-mother.)

I remember "bunny hops." "Picture hats." And toilet paper and chicken wire floats.

I remember my mother telling stories about funny things I'd do and how the stories got funnier each time they were told.

I remember daydreams of finding out I have only a certain amount of time to live ("cancer" usually) and trying to figure out how to best spend what time I had left.

I remember driving through the Ozarks and chenille bed-spreads with peacocks on them hanging outside on clotheslines for sale.

I remember in souvenir shops miniature wishing wells of highly shellacked orangey colored wood. And miniature out-houses too.

I remember wondering why out-house doors have a sliver of a moon cut out of them.

I remember, sitting out in the out-house, wondering why it never got filled up.

I remember, sitting out in the out-house, visions of what it would be like to fall in.

I remember solid red when you close your eyes to the sun.

I remember big "Boy's Town" stamps.

I remember alligator purses.

I remember, when babies fall down, "oopsy-daisy."

I remember, with a limp wrist, shaking your hand back and forth real fast until it feels like jelly.

I remember trying to get the last of cat food from a can.

I remember when a piece of hair stands up straight after a night of sleeping on it wrong.

I remember before green dishwashing liquid.

I remember a free shoehorn with new shoes.

I remember never using shoehorns.

I remember not finding pumpkin pie very visually appealing.

I remember the pale green tint of Coca-Cola bottles.

I remember not really trusting mince meat pie. (What was "in" it.) And dressing too.

I remember the way cranberry sauce slides out of the can, and then plops.

I remember cold turkey sandwiches.

I remember trying to pull a Band-aid off with one quick yank.

I remember fancy little bathroom towels not for using.

I remember two years of cheating in Spanish class by lightly penciling in the translations of words.

I remember No. 2 yellow pencils with pink erasers.

I remember some teachers that would let you get up to use the pencil sharpener without having to ask.

I remember the rotating system of seating where, every Monday, you moved up a seat.

I remember in wood-working class making a magazine rack.

I remember "droodles." (Visual jokes composed of a few simple lines.) The idea being "What is it?" (A tomato sandwich.) (Two elephants not on speaking terms.) (Etc.)

I remember learning to dive in swimming class, because I *had* to, but I never dove again.

I remember wondering why your head didn't get full of water through your ears and nose.

I remember stories about parents throwing their babies into the water, and just by instinct they learn to swim.

I remember, finally, learning to float. But I never did *really* believe it was the water that was holding me up. I suppose I somehow thought I was doing it through sheer willpower. (Mind over matter, so to speak.) At any rate, I never did give any credit to the water.

I remember peeing underwater in my bathing suit once, and how sexy and warm it felt.

I remember stories about how people did it all the time in public swimming pools. (Which I rarely got to go to because of the possibility of catching polio.)

I remember the indescribable smell of a certain dime store downtown, with wooden floors. Great banana cake. And my favorite 25¢ photo machine. My favorite because it once got stuck, and continued making pictures of me for what seemed like hours, until a nearby clerk became suspicious and called the manager over to turn the thing off.

I remember little white fingernail spots.

I remember biting on a little piece of flesh inside my mouth until a very sweet sort of pain came.

I remember Noble and Fern (my mother's brother and his wife) and that she never stopped talking ("a blue streak") and that he never said a word. They had two kids, Dale and Gale. Dale was so plain that, actually, I'm not sure if I remember him or not. But I *do* remember Gale. She was very cute, and bubbly, and totally obnoxious. She took piano lessons *and* singing lessons *and* dancing lessons. They lived in California and traveled around a lot, by

car, never stopping in restaurants for food. (They traveled *with* food.) They'd come visit us about once every three years with a slide projector and recent (three years' worth of "recent") travel slides. And, in a plastic coathanger bag, a fancy costume for Gale, who did her "number" almost immediately upon arrival. These visits were nothing to look forward to. But, after three or four days they would leave, with lots of sandwiches, and, "You've really *got* to come and see us in California!"

I remember visiting once a very distant relative who had a son about my age (eight or so) who had been saving pennies all his life. It was one of those living rooms packed solid with large furniture, and to top it off, every inch of available space was full of giant jars full of pennies. Even on the floor, and even in the hallway, lined up against the walls, were giant jars full of pennies. Really, it was a very impressive sight. Quite a "haul" for a boy my own age. I was green. (I hope I'm not exaggerating but, no, I don't think I am.) Really, it was almost holy: like a shrine. I remember his mother smugly saying that he (eight years old!) was saving it to send himself through college.

I remember trying to save money, for a day or two, and quickly losing interest.

I remember very tempting little ads in the backs of magazines for like say 25 dresses ("used" in *very* small print) for only one dollar!

I remember in speech class each fall having to give a speech about "what I did this summer." I remember usually saying that I swam a lot (a lie) and painted a lot (true) and did a lot of reading (not true) and that the summer went very fast (true). They always have, and they still do. Or so it seems once summer is over.

I remember, on cold mornings, counting to ten before making myself jump out of bed.

I remember daydreams of going with an absolutely knock-out girl, and impressing all my friends no end.

I remember wondering how one would go about putting on a rubber gracefully, in the given situation.

I remember (in a general sort of way) many nights in bed just holding myself through soft flannel pajamas.

I remember cold sheets in the winter time.

I remember when everything is covered with snow, out the window, first thing in the morning: a really clear surprise. It only snowed about twice a year in Tulsa and, as I remember now, usually during the night. So, I remember "snow" more than I remember "snowing."

I remember not understanding the necessity of shoveling the sidewalks. It always melted in a day or two anyway. And besides—"It's only snow."

I remember thinking Brownie uniforms not very pretty: so brown and plain.

I remember fantasies of everyone in my family dying in a car wreck, except me, and getting lots of sympathy and attention, and admiration for being so brave about it all.

I remember fantasies of writing a very moving letter to the President of the United States about patriotism, and the President, very moved by my moving letter, distributes copies of it to the media (T.V., magazines, newspapers, etc.) and I become one very famous child.

I remember daydreams of going through old trunks in attics, and finding fantastic things.

I remember daydreams of being a very smart dresser.

I remember white socks with a thin red and blue stripe at the top.

I remember (visually) socks on the floor, tossed after a day of wear. They always look so comfortable there.

I remember early fragments of daydreams of being a girl. Mostly I remember fabric. Satins and taffetas against flesh. I in particular remember yards and yards of royal blue taffeta (a *very* full evening dress, no doubt) all bunched up and rubbing between my thighs, by big hands. This period of fantasizing about being a girl wasn't at all sexual in terms of "sex." The kick I got didn't come from being with a man, it came from feeling like a woman. (Girl.) These fantasies, all so much one to me now, were all very crunched up and fetus-like. "Close." An orgy of fabric and flesh and friction (close-ups of details). But nothing much "happened."

I remember fantasies of being in jail, and very monk-like in my cell, hand-writing out a giant great novel.

I remember (on the other hand) fantasies of being in jail, and of good raw sex. All very "black and white" somehow. Black bars, white tiles. White flesh, black hairs. The rubbery warm whites of cum, and the shiny cold blacks of leather and slate.

I remember (here's a real let-down for you) fantasies of opening up an antique store, with only *very* selective objects, displayed sparsely in an "art gallery" sort of way.

I remember fantasies of opening up an art gallery on the Lower East Side in a store front (I'd live in back) with one exposed wall (brick) and everything else white. Lots of potted plants. And paintings by, you guessed it, me.

I remember building unusual houses in my head. One, very modern and "organic," was inside a cave. Another was mostly glass. And they all had giant bathrooms with giant sunken tubs.

I remember big square glass bricks with a "wavy" surface.

I remember reading the big sex scene on the beach in *Peyton Place*.

I remember sex outdoors playing a big part in my fantasies for a while after that. Usually on the beach. Except that with one art teacher I had it always in the woods.

I remember a lot of fuss about *The Catcher in the Rye*.

I remember sexy photos of Julie London on record covers.

I remember the Liz-Eddie-Debbie scandal.

I remember "Uranium."

I remember *Kon Tiki*.

I remember talk about flying saucers, before I knew what they were, but never asking.

I remember two-toned cars. Babysitting for 50¢ an hour. And "I Like Ike."

I remember Agnes Gooch.

I remember on newsstands, *Jet* magazine. But never getting up the courage to thumb through a copy.

I remember Dinah Shore's energetic rendition of "See the U.S.A. in Your Chevrolet." And then a big "smack!" And then lots of teeth. And then lots of eye sparkle.

I remember Jimmy Durante disappearing among spotlighted circles into giant black space.

I remember the small diamond heart necklace that Arlene Francis always wore on *What's My Line?*

I remember the "swoosh" of Loretta Young's skirt as she entered the room each week.

I remember sending some fashion design drawings to "Frederick's of Hollywood" in hopes of being discovered as a child genius fashion designer, but—not a word.

I remember the mostly unique to childhood problem of losing things through a hole in your pocket.

I remember, out walking in the rain, people scurrying by with their faces all crunched up.

I remember blue jeans blotched with bleach.

I remember the elephant stampede in *Elephant Walk*.

I remember Elizabeth Taylor in *tons* of white chiffon in— also in *Elephant Walk*, I think it was.

I remember that Rock Hudson "is still waiting for the right girl to come along."

I remember, in art movies, two nuns walking by.

I remember pretty women all dressed up in black on witness stands (white hankie in hand) with their legs crossed.

I remember that Lana Turner wore *brown* (ugh) to one of her weddings.

I remember in very scary movies, and in very sad movies, having to keep reminding myself that "it's only a movie."

I remember mean prison wardens.

I remember once hearing about something called "Smell-A-Rama": a movie with associated smells piped into the theater.

I remember the "casting couch."

I remember Marilyn Monroe in fuchsia satin, as reflected in many mirrors.

I remember the rumor that the reason Marilyn Monroe and Joe DiMaggio split up was because Marilyn couldn't get turned on without another girl in bed with them, and Joe got fed up with this.

I remember the Marilyn Monroe-John Kennedy affair rumor.

I remember the Gomer Pyle-Rock Hudson affair rumor.

I remember a very tall girl who always had to show her I.D. card to get in for the "under 12" rate.

I remember blonde furniture.

I remember *21*-inch television screens!

I remember George and Gracie, and Harry von Zell.

I remember (z - z - z) "The Kingston Trio."

I remember when "atheist" was a scary word.

I remember little suits, on little boys, with no lapels.

I remember dining room table leaves.

I remember a brief period of "bad breath" concern: the product of a health class at school.

I remember that "most bad breath is caused by germs."

I remember that germs are *everywhere!*

I remember trying to visualize germs (physically) as they crawl around all over everything.

I remember that my vision of germs pretty much resembled normal insects, only much smaller, of course.

I remember sneezing into my hand, out in public, and then the problem of what to "do" with it.

I remember a piece of soft pink cloth with zigzag edges, to clean new glasses with.

I remember walking down the street, trying not to step on cracks.

I remember "If you step on a crack, you break your mother's back."

I remember a somehow slightly strange Christian Science Reading Room.

I remember once, when I was very young, seeing my great-grandmother just before she died. (But my abstract memory of this only allows me to say "prune.")

I remember hide-and-seek, and peeking while counting to a hundred.

I remember finding the thought of being an albino somehow more mysterious than just "no color pigment."

I remember gardenia petal brown spots.

I remember corsages with pipe cleaners bent into hearts. With puffs of nets. And long pins with a pearl on the end to pin them on with.

I remember (out loud) the problems of "pin" and "pen."

I remember that pinning a corsage onto a girl was always made into a joke. (Snicker-snicker.)

I remember when father seemed too formal, and daddy was out of the question, and dad seemed too fake-casual. But, seeming the lesser of three evils, I chose fake-casual.

I remember closely examining the opening in the head of my cock once, and how it reminded me of a goldfish's mouth.

I remember goldfish tanks in dime stores. And nylon nets to catch them with.

I remember ceramic castles. Mermaids. Japanese bridges. And round glass bowls of varying sizes.

I remember big black goldfish, and little white paper cartons to carry them home in.

I remember the rumor that Mae West keeps her youthful appearance by washing her face in male cum.

I remember wondering if female cum is called "cum" too.

I remember wondering about the shit (?) (ugh) in fucking up the butt.

I remember ping-pong ball dents.

I remember rayon slip-over shirts with knitted bands at the waist.

I remember bathroom doors that don't lock, and trying to pee fast.

I remember, when you've done a real stinker, hoping there won't be someone waiting to rush in right after you.

I remember the disappointments of picking up a developed roll of film at the drugstore.

I remember jumping beans, and how disappointing they were. (Lazy.) A few flip-flops, and that was that.

I remember egg salad sandwiches "on white" and large cherry Cokes, at drugstore counters.

I remember drugstore counter stools with no backs, and swirling around and around on them.

I remember when the floor seemed a long way down.

I remember when going to an analyst meant (to me) that you were *real sick*.

I remember magazine pictures of very handsome male models with perfect faces and, with an almost physical pang, wondering what it would be like to look like that. (Heaven!)

I remember those sexy little ads in the back of *Esquire* magazine of skimpy bathing suits and underwear with enormous baskets.

I remember, with a new Polaroid and self-timer, having an outlandishly narcissistic photo fling with myself which (I'm proud to say) soon got pretty boring.

I remember "one iota" and "to coin a phrase."

I remember two-dollar bills. And silver dollars.

I remember cartoons about retrieving lost money from street gratings with chewing gum tied to the end of a piece of string.

I remember "Double Bubble" gum comics, and licking off the sweet "powder."

I remember a "Clove" chewing gum period. And a "Juicyfruit" chewing gum period. And then (high school) a period when "Dentyne" somehow seemed a sophisticated choice.

I remember that "Dentyne" is the chewing gum most recommended by dentists.

I remember an algebra teacher who very generously passed me. His name was Mr. Byrd. I think he truly understood that

algebra, for me, was totally out of the question, so he pretty much ignored me. (In a nice way.) He died the next year of cancer.

I remember globes. Roll-down maps. And rubber-tipped wooden stick pointers.

I remember pale green walls half way up. And lots of brownish framed prints.

I remember, after school, a period of three or four minutes of lots of locker doors being slammed. And long corridor echoes.

I remember arms hugging zipper notebooks piled with books that, when too loaded down, required some twisted body movements to avoid droppage.

I remember that entering the classroom just as the bell rings is *not* the same as being in your seat when the bell rings.

I remember big yellow mums, arranged with autumn leaves, in flower shop windows.

I remember big yellow mum corsages, on brown beaver fur coats, at football games, in magazine pictures.

I remember "Necco Wafers" the pastel colors of chalk.

I remember the legs of a certain teacher when, every now and then, she revealed nylons rolled down to just below her knees.

I remember a young blond bland psychology teacher with a face impossible to recall. (Big black glasses.) I remember trying to find him sexy, but it was hard.

I remember senior class rings on chains around necks.

I remember little pieces of colored ribbons pinned to blouses and sweaters that meant you were pledging to a social club.

I remember the "fuck you" finger.

I remember that "bastard" lost a lot of weight with me when I found out what it meant. I had expected something *much* worse.

I remember fancy eyeglasses studded with rhinestones.

I remember (on popular boys) plain loafers: the kind of "plain" you had to pay through the nose for.

I remember Linda Berg. She confided in me once, though she wouldn't "go very far," she really dug having her breasts played with (which, to me, was going pretty far) and did I think it was wrong? (Help!)

I remember a "white trash" boy with an enormously tall crew cut long after crew cuts were in.

I remember pulling the elastic band of my underwear down behind my balls, which gives your whole sex an "up-lift," which makes you look like you've got more down there than you really do.

I remember the fear of—what if all of a sudden out in the middle of public somewhere you get a hard-on?

I remember sex on too much grass and the total separation of my head from what's going on down there.

I remember when everything is going along just swell ("pant-pant") and then all of a sudden neither one of you knows for sure what to "do" next. (Mutual hesitation.) That if not acted upon quickly can be a real, pardon the pun, "downer."

I remember, after a lot of necking, how untheatrical the act of getting undressed can sometimes be.

I remember, in the heart of passion once, trying to get a guy's turtle-neck sweater off. But it turned out not to be a turtle-neck sweater.

I remember a sex fantasy sequence in my head of being forced to "perform" on the floor, under the stairs, of an apartment building I either lived in, or was visiting, I can't remember which. Needless to say, the mad sex fiend criminal rapist was pretty cute to boot.

I remember, with the one you love, familiar gestures that can drive you up the wall.

I remember a small top drawer full of nylons, and my mother, in a rush, trying to find two that matched.

I remember finding things in that drawer I wasn't supposed to see, smothered in nylons.

I remember the olive green velvet lining of my mother's olive green "leather" jewelry box, with fold-out trays. When alone in the house, I loved going through it, examining each piece carefully, trying to pick out my favorites. And sometimes, trying on something, but mostly, I just liked to look.

I remember learning very early in life the art of putting back everything exactly the way it was.

I remember affectionate squeezes in public from my father. Usually of a joke-strangle sort. And not knowing how to respond. So I'd turn red, with a big grin on my face, and look down until it was all over with.

I remember how difficult it is to let a "public" grin fall gracefully.

I remember catching myself with an expression on my face that doesn't relate to what's going on anymore.

I remember practicing flexing my jaw muscles, because I thought it looked sexy.

I remember, when my eyebrows began to spread over my nose bridge, thinking it might make me look a bit more like Montgomery Clift. (A bit *more*?) Yes—I just remembered—I did have a period of secretly thinking I slightly resembled Montgomery Clift.

I remember sitting in the back seat of a car once with a girl named Marilyn, and trying to get my arm behind her without its becoming too obvious a gesture. But it took me so long to be subtle, it became a *very* obvious gesture.

I remember, then, some kissing. And finally getting up the courage to stick my tongue in her mouth, but (what next?) (Help!) and so it was just a lot of in and out, and in and out, which started feeling sort of creepy after a while, and I knew I was a flop.

I remember a girl in Dayton, Ohio, who "taught" me what to do with your tongue, which, it turns out, is definitely what *not* to do with your tongue. You could really hurt somebody that way. (Strangulation.)

I remember feeling sorry for black people, not because I thought they were persecuted, but because I thought they were ugly.

I remember once when I was very young my mother putting metal clamps in her hair to make waves, and I said I wanted some too, so she put some in my hair too. And then, forgetting I had them on, I went outside to play. I don't remember exactly what happened, but I do remember rushing back into the house, humiliated.

I remember my mother picking up tiny specks of lint off things.

I remember, at the end of the sofa, a group of four little pillows that had only one casual arrangement.

I remember that no one sat on the sofa (light beige) unless we had company.

I remember (very vaguely) hearing my mother tell a story about an old lady across the street who died, and the people who moved in after her complaining because they could never quite get rid of "the smell."

I remember horrible visions of that island where lepers were sent.

I remember "the green stuff" inside my first lobster.

I remember (ugh) white nurse shoes.

I remember trying to visualize "the travels" of shit, after you flush the toilet.

I remember, when someone is standing next to you in a public latrine, how long it can seem before you get "started."

I remember Halloween and the annual problem of whether to wear a mask or to see. (Glasses.)

I remember glasses on top of satin eye masks.

I remember next-door neighbors who don't keep up their lawns.

I remember, the day after Halloween, talk about car door windows getting soaped, and of lawn furniture appearing on unfamiliar porches.

I remember a girl who could bend her thumb all the way back. And a boy who could wiggle one ear at a time.

I remember a lady almost talking my mother into a set of encyclopedias.

I remember starting a set of supermarket encyclopedias, but three was as far as we got.

I remember fantasies of someday reading a complete set of encyclopedias and knowing *everything*.

I remember *enormous* dictionaries.

I remember beautifully colored pastel floor plans of houses, on detective paperback backs.

I remember (from lake life) mosquitoes.

I remember mosquito spray. Mosquito bites. And mosquito bite medicine.

I remember the little "thuds" of bugs bumping up against the screens at night.

I remember, at night, heading out into the black to pee, and imagining all the things I might be just about to step on, or "in."

I remember cold mud between your toes, under warm brown water.

I remember trying to put on a not quite dry bathing suit. (Ugh.)

I remember, inside swimming trunks, white draw strings.

I remember, in a very general way, lots of dark green and brown. And, perhaps, a red canoe.

I remember, one summer way back, a new pair of red sandals. And I hated sandals.

I remember red fingers from eating pistachio nuts.

I remember black tongues from eating licorice.

I remember little packages of colored sugar-like stuff, and just about every different color of tongues.

I remember Katy Keene. And a pair of candy cane eyeglasses her little sister "Sis" had.

I remember Randy, Katy's rich blond beau with cars. And K. O., Katy's poor boxer beau with curly hair and no cars.

I remember secretly feeling that she would someday end up with K. O.

I remember costume dolls with their skirts up in back in square boxes with cellophane "window" fronts.

I remember what I remember most about restaurants when I was *very* young: french fries, straws, and toothpicks.

I remember looking out of the windows, riding buses uptown, sudden fantasy flashes of everybody out there on the streets being naked.

I remember sudden fantasy flashes of how many people all over the world are fucking "at this very moment."

I remember "rave review" fantasies. And sell-out shows.

I remember poetry reading fantasies of having everyone in tears. (Good tears.)

I remember fantasies of all of a sudden out of the blue announcing "An evening with Joe Brainard" at Carnegie Hall and surprising everybody that I can sing and dance too, but only for one performance. (Though I'm a smash hit and people want more.) But I say "no": I give up stardom for art. And this one performance becomes a legend. And people who missed it could shoot themselves. But I stick to my guns.

I remember (ugh) hound drops.

I remember with fried shrimps in restaurants, not enough tartar sauce.

I remember "French Post Cards."

I remember little round paper clips to attach the price of greeting cards to the card with.

I remember greeting cards with, somewhere on them, a real feather.

I remember picnics.

I remember black marshmallows, and inside, a flood of warm white.

I remember that mustard and bottle openers were the traditional things to forget. But I don't remember either ever being forgotten.

I remember laying something across the napkins so they won't blow away.

I remember red plastic forks and green plastic forks.

I remember wooden forks hard to handle a big potato salad lump with.

I remember digging around in ice cold water for an orange soda pop.

I remember Belmondo's bare ass (a movie "first") in a terrible "art" movie called, I think, *Leda*.

I remember a lot of movie star nose job rumors.

I remember the cherries on Marilyn Monroe's dress playing paddle-ball in *The Misfits*.

I remember in a musical movie about a fashion designer, a black velvet bat winged suit with a rhinestone cobweb on back.

I remember slightly "sissy" pants on Italian boys in art movies.

I remember Maria Schell's very wet eyes in *The Brothers Karamazov*.

I remember a lot of very rowdy goings-on in *Seven Brides for Seven Brothers*.

I remember Jane Russell and a lot of muscle men doing a big number around the swimming pool of a luxury liner.

I remember Esther Williams' very large face.

I remember being shown to my seat with a flashlight.

I remember dancing boxes of popcorn and hot dogs singing, "Let's all go out to the lobby, and get ourselves a treat!"

I remember a fashion newsreel about live bug jewelry on a chain that crawled all over you.

I remember finding myself in situations I all of a sudden feel (remember) I've been in before: a "repeat" life flash.

I remember those times of not knowing if you feel really happy or really sad. (Wet eyes and a high heart.)

I remember, in crowds—total isolation!

I remember, at parties—naked!

I remember body realizations about how fragile we (life) really are (is).

I remember trying to figure things out—(life)—trying to get it all down to something basic—and ending up with nothing. Except a dizzy head.

I remember having a long serious discussion with Ted Berrigan once about if a homosexual painter could paint the female nude as well as a "straight" painter could.

I remember "Now I lay me down to sleep (etc.)"

I remember, just out of bed in the morning, red wrinkle designs on your skin.

I remember my mother cornering me into corners to squeeze out blackheads. (Hurt like hell.)

I remember (hurt like hell) Saturday night hair washings of fingernails to scalp.

I remember predicting that probably someday in the future people would dye their hair all different colors from day to day to match whatever they happened to be wearing that day.

I remember a teacher who used to use the word "queer" a lot (meaning "unusual") and a lot of snickering.

I remember when the word "fairy" began to evoke snickering not knowing why. Then later, I do remember knowing why. What I don't remember is *how* I learned what it meant. Just a gradual process of putting two and two together, I guess. Plus a bit of speculation.

I remember white rubber sink plugs on chains.

I remember not to stand up in the bathtub because I might slip and fall and bash my head open.

I remember "This is the last time I'm going to tell you."

I remember (in the "But why?" department) "Because I say so, that's why!"

I remember birthday parties.

I remember pink and brown and white ice cream in layers.

I remember little silk American flags. And little bamboo and paper Japanese umbrellas that, if you tried to open them all the way up, broke.

I remember at least once only pretending to make a wish before blowing the candles out.

I remember how hard it was to get a round of "Happy Birthday" going.

I remember never going to a birthday party where we played Pin the Tail on the Donkey.

I remember canned creamed corn.

I remember Cream of Wheat lumps.

I remember roast beef and carrots and potatoes and gravy and, underneath it all, a piece of soggy white bread: the best part.

I remember, when your beet juice runs into your mashed potatoes—red mashed potatoes!

I remember looking forward to a certain thing or event that is going to happen, and trying to visualize its actually happening and not understanding "time" one bit. (Frustrating.) Frustrating because, at times, one can almost grab it. But then you realize it's too slippery, and just too complicated, and so you lose your foot-

ing, totally back to nowhere. (Frustrating.) Still believing that a certain sort of understanding is somehow possible, if approached delicately enough, from just the right angle.

I remember floating transparent spots before my eyes, every now and then, for a moment (microscopic) like when you stand up real fast.

I remember many claustrophobic dreams of being in tight and endless places that get even more tight and more endless, and not being able to get out.

I remember thinking about breathing, and then your head takes over the effort of breathing, and you see that it's "hard work," and it's all very spooky somehow.

I remember teenagers riding around in convertibles with their radios on loud.

I remember (after school) soda fountain shops with booths, and a juke box, but only in the movies.

I remember juke boxes you could see pick up the records.

I remember blowing straws.

I remember "parking."

I remember "necking."

I remember "petting."

I remember "stripped" cars. (No chrome.)

I remember Buicks with holes in them. (Three or four along each side, I think it was.)

I remember big sponge dice dangling up front.

I remember noisy exhaust pipes.

I remember souvenir state decals on car rear windows. I remember that some cars had a lot.

I remember St. Christopher medals, on chains, around necks, that had nothing to do with being Catholic.

I remember old ladies' houses with a lot of things to break in them.

I remember crocheted doilies on the backs and arms of big stuffed chairs.

I remember maroon and navy blue felt house shoes, with fuzzy balls on top.

I remember (z - z - z) plastic place mats the texture of woven straw.

I remember boat steering wheel wall lamps.

I remember "Man Tan," and orange stains on white shirts.

I remember trying to get a tan out in the backyard and, thinking I'd been out for an hour or so, going inside to discover that I'd only been out for 15 or 20 minutes.

I remember, after being outside in the sun for awhile, going inside, and the few moments or so of seeing almost negative.

I remember a tall girl with blonde hair who every year got a *really* dark tan. She wore white a lot (to set it off) and light pink "wet" lipstick. Her mother was very tall too. Her father was crippled from polio. They had money.

I remember the smell of Jergen's hand lotion on hands. And its pearly white texture as it oozes from the bottle.

I remember large bars of Ivory soap that broke easily into two. (Actually, now that I think about it, *not* so easily.)

I remember the Dutch Cleanser girl with no face.

I remember wondering about the comfort and practicality of wooden shoes.

I remember filling out a form once and not knowing what to put down for "race."

I remember speculating that probably someday all races would get mixed up into one race.

I remember speculating that probably someday science would come up with some sort of miracle cream that could bleach skin, and Negroes could become white.

I remember (*too* recently) writing something I especially liked in a letter and "using" it again in another letter, and feeling a bit cheap about it.

I remember (to be more accurate) feeling cheap about it because I *didn't* feel cheap about it.

I remember "a pot of gold at the end of the rainbow."

I remember no way to scratch your ear in the dentist chair when your ear itches.

I remember "Red Roses for a Blue Lady." (A *blue* lady?)

I remember tie clips that were hard to keep straight.

I remember, in signing off a letter, "Yours 'til the kitchen sinks."

I remember face jokes.

I remember (finger hooked in mouth) "Lady would you please hang your umbrella somewhere else?"

I remember (pulling skin around eyes into "Oriental") "Mommy, you made my braids too tight!"

I remember (squashing face between hands) "Bus driver, will you please open the door?"

I remember little records with big holes (45's) and being able to carry a whole stack of them between a thumb and a finger.

I remember little yellow and red and green plastic children's records.

I remember chipped beef and gravy on toast.

I remember, in Boston, figuring out that a street with lots of antique shops on it might be good for cruising, and so I did a lot of walking up and down it ("window shopping") but, as I was afraid to look at anybody, I didn't do too well. (The understatement of the year.) So home I'd go to my "handy work"; often aided by men's wear ads in back issues of *Playboy* magazine.

Which was no easy feat, considering how carefully men's fashion photos avoid any hint of a body underneath. (Underwear ads the most infuriating of all.) However, they did slip up every now and then. Like once I remember a very sexy two-page bathing suit spread that got a lot of use. And (in reference to "no easy feat") that was long before it ever occurred to me that a little soap and water, or Vaseline, or something, might help.

I remember (early New York City days) seeing a man close off one side of his nostrils with a finger, while blowing snot out of the other nostril onto the street. (Shocking.)

I remember seeing an old lady pee in a subway car recently and it wasn't shocking at all, I'm sorry to say. One *does* learn to draw blanks: a compliment to nothing.

I remember French bikinis.

I remember DDT.

I remember nothing to say when someone tells you that your fly is unzipped.

I remember lighting the filter end of a cigarette when you want to appear "cool."

I remember, at parties, after you've said all you can think of to say to a person—but there you both stand.

I remember trying to have a conversation with someone once with a hair sticking out of his nose.

I remember a lot of giggling and note-passing in the balcony at church.

I remember starched dress shirt collars.

I remember when my arms were always too long for my shirts. Or else the neck was gigantic.

I remember the very thin pages and red edges of hymn books.

I remember the noisy mass flipping of pages when the next hymn is announced.

I remember when all heads are bowed in prayer, looking around a lot.

I remember, when it's all over, very swirly organ music to exit with.

I remember a lot of standing around and talking outside on the steps afterwards.

I remember empty Sunday afternoons of feeling somehow all "empty" inside.

I remember a big Sunday lunch, a light Sunday night dinner, and in the morning—"school."

I remember Monday mornings. And Friday afternoons.

I remember Saturdays.

I remember the washing machine and the vacuum cleaner going at the same time.

I remember, when one stops before the other, a moment of "fake" silence.

I remember "muscle magazines" nothing to do with building muscles.

I remember Roman column props. Tilted-to-one-side sailor caps. Crude tattoos. Blank expressions. Suggestive G-string pouch shadows. And big flat feet.

I remember (in color) *very* pink skin and *very* orange skin.

I remember trying not to look lonely in restaurants alone.

I remember the several rather unusual ways "Pouilly-Fuissé" has come out of my mouth, trying to order a bottle of wine in restaurants.

I remember, eating alone in restaurants, making a point of looking around a lot so people wouldn't think I was making a point of *not* looking around a lot.

I remember, eating out alone in restaurants, trying to look like I have a lot on my mind. (Primarily a matter of subtle mouth and eyebrow contortions.)

I remember (too much wine) trying to leave a restaurant gracefully. Which is to say, in a series of relatively straight lines.

I remember over-tipping. And I still do.

I remember liking to impress sales clerks by paying no attention to price tags. And I still do.

I remember having a big crush on this guy, and fantasies of dropping everything and going away with him somewhere (like maybe sunny California) and starting a whole new life together. Only unfortunately, he didn't have a crush on me.

I remember fantasizing about being a super-stud and being able to shoot *enormous* loads. And (would you believe it?) (yes, you'll believe it) I still do.

I remember knowing what "c-a-n-d-y" meant long before I knew how to spell.

I remember: "What's your sign?"
 "Pisces."
 "I knew it!"

I remember blowing the white fuzz off dandelions after the petals are gone.

I remember making awful noises with a rose petal in my mouth, but the "how" of how to do it is something I don't remember.

I remember "bread and butter" when something in the street divides you from the person you're walking down the street with.

I remember "Last one to the corner's a rotten egg!"

I remember "Go to jail—pass go—do *not* collect $200."

I remember that George Washington Carver invented peanut butter.

I remember blowing up paper bags to pop.

I remember cartoon stars when someone gets hit over the head. And light bulbs for a bright idea.

I remember making up abstract foreign languages, which sounded totally convincing, to me.

I remember keeping a list of states visited.

I remember making a three-dimensional map of the United States with oatmeal and paste.

I remember spatter-painting autumn leaf silhouettes with a toothbrush and a piece of screen door wire.

I remember packing up toothbrushes and washcloths and Crayolas (etc.) into individual Red Cross boxes for underprivileged children overseas.

I remember how long a seemingly empty tube of toothpaste can go on and on and on.

I remember when someone grabs your arm with both hands twisting in opposite directions—an "Indian burn."

I remember, after eating ice cream too fast, a cold head rush.

I remember Creamsicles and Fudgesicles and Popsicles that broke (usually) in two.

I remember stealing pieces of candy from previously broken bags on supermarket shelves.

I remember that because someone else had already done the dirty work it made it to my mind "O.K."

I remember poking my finger into cellophane-wrapped blobs of meat impossible to imagine someone might actually eat.

I remember "Next time, you'll stay at home!" because I was always wanting this or that, and this or that was always too expensive, or not good for you, or something.

I remember bright orange jars of cheese spread. And tiny tins of pink deviled ham.

I remember how that "powdered cheese" you put on spaghetti smelled suspiciously like dirty feet to me.

I remember (Easter) drawing on white eggs with a white Crayola before dipping them.

I remember not very hard Easter egg hunts. And the ones that didn't get eaten soon enough got all gray-green inside. (To say nothing of smelling like shit!)

I remember the chocolate Easter bunny problem of where to start.

I remember some pretty fuzzy ideas as to what "Ground Hog Day" and "Leap Year" were. Or, for that matter, are.

I remember thinking that "S.O.S." meant something dirty.

I remember fantasies of finding notes in old bottles washed ashore.

I remember magic carpets and giant "genies" and trying to figure out what my three wishes would be.

I remember not understanding why Cinderella didn't just pack up and leave, if things were really all *that* bad.

I remember getting a car door slammed on my finger once, and how long it took for the pain to come.

I remember wondering if goats really *do* eat tin cans.

I remember the fear of "horror" coming out of my mouth as "whore," as indeed it quite often did.

I remember rocks you pick up outside that, once inside, you wonder why.

I remember hearing once about a boy who found a dead fly in his Coke and so the Coca-Cola Company gave him a free case of Cokes.

I remember thinking how easy it would be to get a free case of Cokes by putting a dead fly in your Coke and I remember wondering why more people didn't do that.

I remember a girl with hair down to past her waist until she had to cut it off because it got so heavy her hairline was receding.

I remember red hands from falling down on gravel driveways.

I remember searching for something you *know* is there, but it isn't.

I remember infuriating finger cuts from pieces of paper.

I remember (ouch!) bare feet on hot summer sidewalks.

I remember once on T.V. news an egg being fried on the sidewalk as an example of just how hot the heat wave we were having really was.

I remember my mother talking about women who shouldn't wear slacks.

I remember taking baths with my brother Jim when we were very young, back to back.

I remember inching myself down into water that was too hot.

I remember the "tornado" way the last of the water has of swirling down the drain so noisily.

I remember stories about people getting electrocuted by talking on the telephone in the bathtub.

I remember telephone nooks built into walls. And "party lines."

I remember (recently!) getting blown while trying to carry on a normal telephone conversation, which, I must admit, was a big turn-on somehow.

I remember not very scary ghost stories, except for the dark they were told in.

I remember having a friend overnight, and lots of giggling after the lights are out. And seemingly long silences followed by "Are you asleep yet?" and, sometimes, some pretty serious discussions about God and Life.

I remember get-rich-quick schemes of selling handpainted bridge tallies, inventing an umbrella hat, and renting myself out as an artist by the hour.

I remember my high school art teacher's rather dubious theory that the way to tell if a painting is any good or not is to turn it upside down.

I remember bird pictures from Mexico made out of real feathers, with hand-carved frames.

I remember picture windows with not much view except other picture windows.

I remember the rather severe angles of "Oriental" lamp shades.

I remember, up high, wallpaper borders.

I remember, when relatives come visit, a cot.

I remember (when relatives come visit) "getting away with murder."

I remember "good dishes" versus "everyday dishes."

I remember that a good way to get a "maybe" instead of a "no" is to ask for what you want in front of company.

I remember, in pajamas with feet, long acrobatic kisses in grown-up laps to prolong "bed" for as long as possible.

I remember being talked about as though I wasn't there.

I remember once a grown-up lady pretending to pull off her thumb (a trick) and the next thing I knew my milk was all over the floor of a strange house.

I remember once at a church dinner social having to sit right across from a lady who had no vocal chords and all she could do was make weird noises and I couldn't eat a bite.

I remember a cigar box out in the garage filled with odds and ends of just about everything, of which a broken green "pearlized" fountain pen stands out the most to me now.

I remember once secretly planting some watermelon seeds out in the backyard but nothing happened.

I remember unpopular dogs that were allowed to roam the neighborhood freely. And—"Don't forget to close the gate behind you!"

I remember wondering how turtles "do it."

I remember when, walking single file from class to class, getting out of line was pretty serious.

I remember pencil boxes with a little ruler and a little compass in a little drawer.

I remember diagramming sentences. And arithmetic cards, more than I remember arithmetic.

I remember, in bed in the dark, visions of our house catching fire during the night.

I remember, in the morning, my eyelashes glued together with "sleep."

I remember believing that you could get warts by touching frogs enough that I . . . Actually, I was such a big sissy I wouldn't have touched a frog anyway.

I remember trying to conjure up visions in my head of a physical god without very much luck other than "very old" and "very white."

I remember waiting for a certain piece of mail to arrive with almost total faith that if I *really* wished hard enough it would come that day.

I remember, after reading a gay porn novel about a boy who "practiced" with a cucumber so he could learn to enjoy being fucked, trying to casually buy a vibrator at the drugstore: "Two packs of Tareytons, please. And one of those." And then I remember how long it took me to get batteries for it. And then I remember using it a few times, and how more ridiculous than sexy it all seemed. And so that was pretty much that. (Almost.) Until one night, feeling "far out" (for me) I used it on a friend with a rather rewarding sense of power.

I remember very wholesome fantasies of being madly in love with a young blond "hippie" boy, and of our living together out in the country, riding around a lot naked on horses, pausing now and then to make love out in the sun, in the middle of the big beautiful fields.

I remember "being all alone with J. J. Mitchell at a ski lodge out-of-season" fantasies, which worked out just fine.

I remember, just before coming, fantasy close-up visions of big pink cocks being yanked out of bulging underwear, anxious to be serviced, and spurting hot mountains of white into my mouth, nose deeply buried in wiry masses of dank pubic hairs.

I remember in the morning (*real life*) "hickies."

I remember much contemplation over what would be the most practical and considerate way to commit suicide, should the occasion happen to arise, with the usual conclusion that to just "disappear" out into the ocean would probably be best: with, however, some frustration over the possibility of getting washed ashore and scaring some poor little kid with a bucket half to death.

I remember (Oklahoma) boring annual Indian pageants of many feathers, and much stomping.

I remember the still mysterious to me association of western music with greasy eggs in a diner on a Sunday morning.

I remember "double dating," and "going dutch," and autographing broken leg casts.

I remember "close dancing," with arms dangling straight down.

I remember red rubber coin purses that opened like a pair of lips, with a squeeze.

I remember a boy who could swig down a Coke in one big gulp, followed by a long loud belch.

I remember, just outside the city limits, firecracker booths.

I remember (basketball) total frustration over how to "dribble."

I remember finding it very mysterious that ballet dancers didn't break their toes off, doing what they do that way.

I remember record stores with glass windowed booths you could play records in before you bought them, or didn't.

I remember, in dime stores, "bronze" horses in varying sizes from small to quite large, with keychain-like reins.

I remember, at the circus, kewpie dolls on sticks smothered in feathers, and how quickly their faces got full of dents.

I remember "pick-up sticks," "tiddly-winks," "fifty-two pick-up," and "war."

I remember dangerous BB gun stories about kids losing eyeballs.

I remember being more than a bit disappointed over all the fluffy gray stuff with tiny red specks I discovered inside an old teddy bear's stomach once.

I remember turning around and around real fast until you can't stand up.

I remember going on fly swatting sprees, and keeping a very accurate count of how many dead.

I remember crocheted dress-up gloves with only half fingers.

I remember "Tupperware" parties.

I remember traveling salesmen jokes way over my head, which didn't keep me from finding them funny anyway.

I remember "knock-knock" jokes. And Polish jokes. And a "What's for dinner?" cannibal joke with a "Catholic soup!" reply.

I remember "spin the bottle" and "post office."

I remember dashes for dirty words in adult novels.

I remember, when a fart invades a room, trying to look like I didn't do it, even if, indeed, I *didn't*.

I remember the way a baby's hand has of folding itself around your finger, as though forever.

I remember the different ways people have of not eating their toast crust.

I remember Dr. Brown fantasies of bright lights and silver instruments, and clinical "explorations" that develop into much hanky-panky on the examination table.

I remember Christine Keeler and the "Profumo Affair."

I remember stories about how L. B. J. got off on holding private conferences while on the john.

I remember the rumor that James Dean got off on bodily cigarette burns.

I remember fantasies of what I would say to a certain reviewer who gave me a really *mean* (to say nothing of stupid) review once, should we happen to meet at say a party or something.

I remember awkward elevator "moments."

I remember when both arms of your theater seat have elbows on them.

I remember making designs in the dark with a fast-moving lit cigarette.

I remember (spooky) when all of a sudden someone you know very well becomes momentarily a *total stranger*.

I remember (stoned) reaching out for a joint that isn't really being passed to you yet.

I remember (stoned) when the most profound thought in the world totally evaporates before you can find a pencil.

I remember (night) desperate (to say nothing of fruitless) flips through my address book.

I remember how silly it all seems in the morning (again).

I remember getting up at a certain hour every morning to walk down the street to pass a certain boy on his way to work. One morning I finally said hello to him and from then on we always said hello to each other. But that was as far as it went.

I remember taking communion and how hard it was not to smile.

I remember smiling at bad news. (I still do sometimes.) I can't help it. It just comes.

I remember that our church believed that when the Bible said wine it really meant grape juice. So at communion we had grape juice. And round paper-thin white wafers that tasted very good. Like paper. Once I found a whole jar full of them in a filing cabinet in the choir room and I ate a lot. Eating a lot was not as good as eating just one.

I remember the exact moment, during communion, that was the hardest to keep from smiling. It was when you had to stick out your tongue and the minister laid the white wafer on it.

I remember that one way to keep from smiling during communion was to think real hard about something very boring. Like how airplane engines work. Or tree trunks.

I remember movies in school about kids that drink and take drugs and then they have a car wreck and one girl gets killed.

I remember one day in psychology class the teacher asked everyone who had regular bowel movements to raise their hand. I don't remember if I had regular bowel movements or not but I do remember that I raised my hand.

I remember changing my name to Bo Jainard for about one week.

I remember not being able to pronounce "mirror."

I remember wanting to change my name to Jacques Bernard.

I remember when I used to sign my paintings "By Joe."

I remember a dream of meeting a man made out of a very soft yellow cheese and when I went to shake his hand I just pulled his whole arm off.

Self-Portrait

Self-Portrait
on Christmas Night

Year 1961 age 19 almost 20;
Homage to George

It's Christmas night, how I want to paint, to say so much.
I can't, why? Would like to cry, beat off, or go to the movies. But
won't do any of these. Can't make contact with myself. Took two
pills earlier. Can't find peace. Am nervous and just can't under-
stand anything. My brains and my hands won't co-ordinate.
Listening to classical music. How music makes me cry, so beauti-
ful. At times like this I really know, though I rarely admit it to
myself, I and the world are great and so fucked. I'll never be
happy or satisfied, I'll always be like this, so fucked. Yet so excited
by everything. I'll always know, yet will never really know. Will
do great paintings, but will never do what I want. Will learn to
understand and accept life, but will never know why. Will love
and make love, but will know it could be greater. Will be smart,
but will always know there's so much more to learn. I'm damned,
but can't change. Ted's damned. I know beauty; which is really
just truth. (So is both ugly and fine, damned and holy, Sutherland
and Elvis, the Bowery and Central Park, my aunt and Picasso,
love and hate, and myself and myself.) But though I know beauty,
I can't *express* it until I've undressed. Have so much undressing
to do. Ted is much the same; only he has re-dressed himself in the
process of undressing in false ways of appearing undressed. Must
be careful not to do this. But mostly interested in myself, but
why? Again, I will undress, but never know why. I no longer want

success: I know once I have it it'll be nothing. Nothing at all. When I do a painting, the next one is what concerns me. Am crying, but don't know why. Partly because it's Christmas, but why should I feel sad on Christmas? Music is so great; at moment listening to Gregorian chants. Anne and I were together New Year's Eve; she is *so* beautiful. We each silently choose to be alone Christmas Day. Poor Anne; though she must be a damned good musician I know she doesn't know life, herself, and the relationship. I sincerely hope she never will. False of me I guess (and a little ashamed), but I like her too much. If she ever understands like I know she wants to, I know it will be the saddest of disappointments. I don't think she can take it. If she finds out the world is using her for its own enjoyment and love, but will never accept *her*, she won't understand. Anne thinks she plays music for herself and is expecting benefits. *We* are using her like she is using her flute. It's a game, and she can't be the winner. And no prizes. Why do I paint then? God only knows; and how I wish there were a God. I am the closest thing (for myself) to a God; but what a *thing* to put faith in. Oh I believe in myself alright, but again I don't know why. (Now listening to lute music.) It's funny that I should be writing rather than painting. I feel like saying everything, but with no special outlet in mind. Why did I decide to write? Tried to do some drawings, but couldn't. So sad to try to work in the way you know you must, and yet at the moment can't. I feel like now should be the time to say, "But I *know* I'm a painter; I must paint." I've said this before, and I really want to believe it. I can hear Ted saying the same thing about himself and writing. I wonder if he is so sure. I'm not. I know I've got to use my mind and hands. And I *think* I must be a painter, and I *know* I must be an artist. Now listening to Joan Sutherland's operatic arias. Her voice is so fine I find it hard to believe. Just realized that though I'm writing this for myself and for the sake of writing, Ted will read it (and I want him to). Therefore will discuss a point which I know will be in his mind after reading this far. We have both expected (at least outwardly) that the reward for an artist is

the *act* of creating. This is a beautiful theory and how I wish I could believe in it. But I seldom "enjoy" the process of painting. It's hard work. And so often what I want to say is painful; so often I don't want to admit it. In fact I usually do it subconsciously. And when it's finished it's not what I wanted. It's never completely honest. Here again I need to undress. (Pardon abstraction in terms, Ted.) I know why Ted takes so many pills, and I know if I always had them I would too. But I nevertheless think they are basically evil; the effect they have on us is not "the way things are" but "the way we'd like them to be." It would be so easy if I always took them, and don't know why I don't *want* an escape. I don't owe myself or the world an honest memento of life. God only knows most people don't give it. In fact those of us who occasionally do are resented. We know too much. People of a certain race, not so different really, we tell too many secrets which we share with our fellow companions who are not so free. And we hurt too much but we are artists; we know form and order, color and movement, this alone can almost stand and is widely appreciated. We become symbols of our work, like Washington to Americans. We barely have the honor of being human. They, the public (including myself) are waiting to accept our product; but the force behind it? Being an artist is not the complete story; first of all we are men (and occasionally women; but rarely) though it's usually considered the reverse. We are the realistic ones; women can't really give, they must take. They are selfish. A woman rarely (if ever) gives herself to the world or a man without expecting something in return. (Which is not what I ((and I think Ted)) expect.) Perhaps she is the smart one and we the stupid. But stupid or smart it's the way things are, and it takes a man to see it and have the power to do it. Or perhaps she has the power to refuse and rebel we men don't. Here again, per usual, terms confuse me. That is, I can't make myself say will power is good and lack of it is bad; or beauty is beautiful and ugliness is ugly. These things are simply present; must I classify them? Won't I miss out on a lot if I do? At times I enjoy pain; hunger (when you

really think about it) is not a pleasant nor a painful experience.
It is simply an experience. Usually when I receive pleasure from
creating I am using it as an escape; which is its function for most
artists. And many are considered great too. Is art partly an escape?
I say no. But when you consider who more or less decides who's
great and not great, how can you put much faith into it? The term
great men applies to men who *people think* are great. Then how
can I value this so deeply? (Like I've always done; and I think
Ted still does.) Is greatness so great? Some men whom I consider
great: Rembrandt, Giotto, Michelangelo, myself, Ray Charles,
Elvis Presley, Van Gogh, Stravinsky (if only for *The Rite of Spring*),
Jesus, Dylan Thomas (known to me only through his reading
records), de Kooning, perhaps Kline, Ted Berrigan, Dave Bearden,
etc. (But these 2 last and myself, at the moment, only as men,
and not as artists.) These of course must be combined to form
greatness. But to most of these artists (the ones I know enough
about) I would have to attach, since I live in a world of words
with meanings, both good and bad characteristics and elements.
For instance, Elvis Presley has recently "crapped out"; Michelan-
gelo was a homosexual; Jesus didn't love *himself* enough; Van
Gogh was over-sentimental and insane; Kline lacks imagination
and a sense of continual development, he seems too satisfied;
Owen is an escapist; Ted is also an escapist and doesn't trust
himself enough, he must play games in order to do work and do
whatever he wants. Yet must I classify these things as bad? Or
should I accept them as simply being representative of just a *part*
of the person? As much as I hate to admit it, I'm afraid I must
attach titles. Though I usually *think* more abstractly, I must be
able to translate my thoughts in ways that can be communicative.
It's sad, for I'm forced to say things I mean, yet don't really mean.
Ted's constantly accusing me of being inarticulate. I am; because I
don't really think in words, but impressions. Saying something in
words is so harsh; too general. It's never enough. I must say "but,"
"however," and "But not really, I mean *really*." Ted is the only
person that I think has learned something from me, and used me.

Perhaps this is why I feel close to him. So many people whom I admire and have wanted to learn something from and give something to (Johnny Arthur, David Bearden, Owen, Bartholic, Duayne Hatchett, Margie Kepler, Anne Kepler, and others) have shut me out; they have taken me for face value. They were and are not perceptive enough to understand; to understand I was and am young; to understand that because of my background I had (and still have too many) false and phony ideas and outward habits. They don't take the trouble to understand and analyze; they accept at face value, draw their conclusions, then it's dismissed. But I must take *most* of the blame; I was *stupid*, I was *shallow*, and for them I wore a "don't touch" sign. Most of these people I haven't seen for a little under or over a year; God how much I've changed in that little length of time, which seems like years. But most of these false or outdated opinions of me will make them avoid contact and have, permanently and some I hope temporarily, closed minds towards me. So they are lost. How sad that is. A whole organic complex interesting exciting and rewarding person out of reach. It's so hard to find people worth your time. People who know and are capable of giving and know they are capable of giving; people who are willing to have real contact; people who you can learn from; people who *are* people; people who are not embarrassed to vomit or go to the bathroom; people who know and accept the animalness of sex; people who burp, laugh, cry, and steal ashtrays from restaurants; those who don't feel *obligated* to tip, be friendly, give gifts at Christmas, and kiss your butt (now writing to and listening to Toscanini and the Philharmonic creating Beethoven's 7th Symphony); people who know what they know and want to know more; people who appreciate the shape and purity of an egg (plus its organic satisfaction); people who love red, dance to Elvis Presley, offer you a cigarette, listen for hours to *Don Giovanni*, people who need you; who play in the snow and are excited by the sensation of their frozen toes, hands, and ears; people who (like myself) like long hair or just feel they must let it grow absurdly for the sake

of being absurd; people who realize the actual value of a rectangle with a sterile portrait of George Washington, and all kinds of frills, and detailed ornaments so it will be hard to counterfeit; people who *know* it's a piece of paper and if they hurry some fool will give them a book, a tube of oil paint, great food, or a taxi cab ride in exchange. But we are the ones that don't really labor away time and energy for our money; we sell blood occasionally, borrow here and there, paint signs on some guy's truck which logic tells us is O.K. but that we know is, if nothing else, a symbol of decline and defeat and that we must keep up the phony guard until it's no longer phony; we sponge off friends who know *why* you are sponging, and understand and even some that don't and are resentful. We are takers, but we also know the value of giving. We work in antique shops at night where we can read (especially when we unfortunately no longer have electricity because "Old George" came in too handy to trade for Spenser's *Faerie Queene* in two volumes bound in dirty dark blue with plain faded gold lettering giving the general effect of a library book not checked out since 1944, and it was marked down half price). (A gift to Ted for Christmas.) And canvas wow!, to think that it can be bought for a few wadded pieces of paper which smell like sweaty hands and always remind one of the poor slobby has-been, but grandly honored, artist laboring with designing this item which will represent America (which I honestly really love, America that is); and be handled and cherished by millions, borrowing here and there an ornament from France and God only knows where, then suffering and laboring days only to catch a Rockwell popular likeness of that great man (unfortunately not on my list) who is similar in stature and holiness to Santa Claus. Would rather give him the honor of being on my great list than Washington. At least some small beautiful creatures *really believe* in him. Washington *is* a symbol, and like the dollar bill, is nothing in itself, will say nothing of $5 and $10's for they are rare and sacred, since they provide a roof over my curly hair to protect it from rain, they give me a warm place to sleep (except in the very early morning when

my "out-of-it" super, like all supers and landlords, turns off
the heat so that perhaps within a week he'll have saved another
fine line drawing of Washington to add to his collection whose
benefits he will never enjoy but is nevertheless excited by the
American idea of security and he like most "working men" finds
value in the material object of the dollar in itself; he enjoys
counting and holding the bills. Money is simply a symbol and
he, like Catholics, finds this satisfying. It is greed. It is sex. It is
false. It is hungry. It is American. It is human. And this will all
go towards financing a box tastefully decorated (when the time
comes) as much as possible so as to hide its real reason and
content. For these more popular bills I also receive (just a few
lousy pieces of paper!; will never stop being amazed and excited
by such a transaction) a toilet inside a little room which was
obviously designed and built for that purpose; to hold *one* small
toilet and nothing else. But in this small and delightfully compact
secure box-like room in which I must bend my legs at an obscure
angle in order to sit on that white enamel cold and sterile object
which disposes of personal items said to have no further value
other than for fertilization, which few of us feel is worth bother-
ing about since the exchange value is so low. Besides most of us
would find it embarrassing and distasteful. I've managed to hang
(just in front of the squatted viewer) a lithograph of a cat in a
chair very finely and elegantly done by Bob Bartholic. (Whose
name appeared on my "would like to learn from, to get to really
know and understand, and give and share myself with, but has
hard preconceived notions of how and what I'm about, so can't
really communicate, but must show them" list.) But must defend
him, for the elegance and decorativeness for which he is often
criticized by younger persons like myself (though he is only 33 or
35), is only a minor element in his work. And at times, though
rarely, he achieves a fineness of form which seems unearthly and
spiritual much like the pure effect of the Gregorian chants. So
peaceful and knowing that you feel that, like the Gregorian
chants, it has taken centuries to develop and has reached a peak

of perfection that is complete, untouchable, and alone. Though, Bob has only hinted at this state of beauty (which for me, as a painter, is unforbidden fruit, I can not see this way; my world is too big. I must scribble obscenities on subway lavatory walls as well as go to Mass on Christmas Eve). Fantasy, spiritual, and decorative painting (don't take these words to be absolute, but titles for a certain style of art) are dead for me. For my generation they can only be used by prostitutes who can't face facts, by escapists, those looking for easy "outs"; those who have nothing to say so must create from imagination and dig up the past. The imagination is fantastic and so great, but it must have a foundation of knowing and it must be constructive. From my world, and judging from works of other young (so great to be young, but also appreciate the beauty of age, knowledge, and experience) painters and writers, we are realists, but have the advantage of, and must accept and use freedom, and abstract form and thought. Must speak only for myself; as a painter, and as a result, an unpublished philosopher, a man who *must*, one who is open and ready, one who looks and digs (isn't content with what is offered), a man who finds children irresistable and sentimental (and is not ashamed) (and reads Tarzan comics), and a man of knowing. I must see, know, express clearly and realistically, not necessarily technically realistic as we know it from the past, but with a realistic concept. I want to be true. I want to be *real* and do *real* things; whether I'm blowing my nose (which I rarely find necessary) or painting an arrangement of modern Americanized bottled, wrapped, or boxed items especially prepared for our sterile and functional sense of the sanitarily proper: 7-Up bottle, Pioneer instant coffee, and a Tareyton Dual Filter cigarette. Such items I use often in my paintings, for they are present, they are the ways of my country, they are familiar, they are us, the way we dress and the expression we are forced to plaster on our faces. They are American. Am now listening to and again writing to Hayden's Concerto in D Minor for harpsichord and orchestra with Sylvia Marlowe at the harpsichord and conducting the

Concert Arts Chamber Orchestra distributed by Capitol label (Reg. U.S. Pat. Off) in F.D.S. (full dimensional sound) in "incomparable" (compliments of the record cover) high fidelity on a deluxe STEELMAN expensive 4-speed automatic record player which belongs to Ron Padgett at their N.Y. village apt. (Ted, Pat, and Ron's) and they are out of town, out of New York for Christmas, Ted and Pat have left along with Richard Gallup, a friend of Ted's whom I find hard to accept like and understand and is a student at Tulane University who also takes pills when he gets them and wears great cowboy boots, to visit Ted's mother, sister, grandma, and family in Providence, Rhode Island where Ted is originally from though I met him in Tulsa, Okla. Ron went in the other direction to Tulsa 4, where I've lived most of my life (only zone 10 not 4) where my family still lives and where nobody really knows me but where everyone thinks they have my spirit in a bottle and a mathematical equation explaining my art and life, and not art and not life. Ron (who also has great cowboy boots but rarely wears them) will be nice to his mother and feel guilty for not loving her more (like myself) and his father who is an ex-bootlegger and a second John Wayne will clown with Ron, holding in his stomach, showing him tricks with his muscles, smiling to display his white teeth and being careful not to understand his son too well. For fear of expressing emotional sympathy in terms of "un-fatherly" tears and embarrassment. Somewhat like all fathers who feel that first of all they must remain a father image in their son's eyes; not a human. Ron, if he has the desire which I doubt, will distantly visit with my parents, older brother, and young sister and again brother (young). Telling them everything is O.K. with me and not to worry. And they will not worry because they can't, they are afraid and so dismiss almost everything in life I stand for. They are neither capable of nor really need to understand what I'm trying and must do. They, like most people, simplify life for their own comfort by believing in "things." They are Methodists; through their religion the world and its mysteries are explained and this

makes things easy. They have a sturdy reason for being. My display of desire to not work but only paint, to see the world, to be big for myself, to do everything, to love and be loved freely, to know beyond the practical and "safe," to paint honestly therefore to them uglily, to spend what little money I have foolishly, and to not prepare for the future, is to them a phase. A phase, just a phase; like when I used to wet my pants, when I liked school, and when I didn't like school, when I was in junior high, under-developed awkward and self-conscious, when I wanted to be a cowboy, a period when I liked math, when I wanted to be a fashion designer and illustrator, when I like all other developing boys felt attracted toward my own sex and thought myself evil and deranged, when I started smoking to feel big and secure, and when I began "seriously" painting because the romance of it all was overwhelming, it was too good, approval and praise at my fingertips. Time for childhood phases to end? I hope not. Must develop and learn more, must understand myself so we can pro-duce together with sureness, confidence, and beauty, must find peace so I can really work, really labor, and truly be a master of my art and even perhaps for a reason. I'm 19 years old turning 20 the 11th of March. And I, just like George Washington, am only a "thing" to the world, but a god to myself.

Back in Tulsa Again

Back in Tulsa again, by way of free ride from Ron's father: Ron being a Columbia University student, also poet, and Ron's father being a John Wayne with $80 cowboy boots. I wear desert boots. Pat usually wears very basic black flats, tho she looks better in high heels. They complement her legs. Very nice. Yes, Pat too made the big move back to Tulsa. The three stooges make the big move back to Tulsa. The three fuckados make the big move back to Tulsa. The big move back to Tulsa was made by Pat, Ron, and myself.

The trip back was as normal as possible considering John Wayne drove (in $80 cowboy boots) and we, the three "Tulsans in New York" were his passengers. Yes, even Ron was a passenger, as I am now a guest in my own home. In my own home I am a guest. We three "passengers" made the big move back to Tulsa. Three people: a strange number of members for a relationship. We three: one girl and two boys. Or should I say woman and men? Both embarrass me, and seem "not quite right." Three people, a poet, a woman, and a painter. I being the painter, Pat naturally the woman, and Ron obviously the poet. But Ron is obviously a Columbia University student. We three, Pat being my favorite next to myself, made the big move back to Tulsa for lunch; a fantastically voluptuous lunch with entertainment.

"Lunch," Ron said again to his father with $80 cowboy boots driving like a madman directly aiming at Tulsa with serious convictions of direction. Yes, Ron's father was anxious to get home, home to Tulsa. Home to space and lightness, white square gas stations and shining car lots. Ron's father is obviously from Oklahoma. We Marx brothers minus one are obviously only flounderers. Floundering because we are neither New Yorkers

nor Oklahomans. But I am a painter. Not a man without a country, but a man (or should I say boy) with a country too too big. A country too too big, and with no secret hiding place or club house. The dues are simply too high: too too high. The sky is higher in Tulsa. The sky is higher in Tulsa than in New York.

"Lunch," Ron repeated again and again. Ron was obviously hungry; which made Pat and me very envious. Envious because Ron had at least momentarily found some positive and alive state of being, some identity to desire which actually was. We were envious, enormously envious. Pat even more than I, she being a woman and all. Women are much more susceptible to such emotions: those of envy, or pity, or jealousy: all unconstructive emotions. Yes, Pat was envious. Ron was hungry. And I too was envious, but not too envious, for I was constipated.

A List for the Sake of a List

1. Pat Mitchell
 (a) envious
 (b) looks better in high heels
 (c) woman
 (d) or girl
 (e) flounderer
 (f) not hungry
 (g) my favorite
 (h) usually wears black flats

2. Ron Padgett
 (a) John Wayne's son
 (b) flounderer
 (c) student of Columbia University
 (d) hungry
 (e) poet
 (f) heir to a pair of $80 cowboy boots
 (g) a "passenger" in his own family car

3. Me
 (a) constipated
 (b) envious, but not too much
 (c) author of "Back in Tulsa Again"
 (d) painter
 (e) flounderer
 (f) embarrassed as to terminology; man or boy

"Lunch," Pat cried: Pat was getting in the spirit of things.

"Lunch," I cried, so as not to be a wet blanket. Also, I had hopes of finding a restroom in the chosen cafe.

"Three to one, ha! ha!, we win!" we sang over and over to the tune of "Love Me Tender" (originally recorded by Elvis Presley) while Ron poked Pat in the eyes with his two fingers next to his thumb (spread wide apart) and me jokingly biting Ron's big toe. His big toe is big, you know. Yes, we truly were, at that moment, the Three Stooges. Or even the Marx brothers minus one. But we each realized that soon the spell would be broken and Pat would become a woman, Ron a poet and student, and me a painter. My name is Joe Brainard.

Pat was suddenly on top of me as Ron's father, John Wayne, swang off the road heading straight toward a small, very small, cafe. The sudden turning of the car at a very high speed, yes very high (like the sky in Tulsa) was quite spontaneous on Ron's father's part, and quite a surprise to us. Yes, it shook us up a little. Resulting in Pat suddenly being thrown in my lap, which appeared physically impossible. As I said, Pat was in my lap, which felt very good. It felt good to have Pat in my lap. In fact, it felt too good, for I'm afraid I embarrassed her. Pat became a woman. The spell was broken.

I smiled when my eye hit the small 7-Up sign dangling from a string attached to the light fixture. It was used as a pull to turn on the lights. I smiled. I felt good. I ate lunch. It was just I. We all three ate lunch, but I was the only one that ordered a ham sandwich without mustard: a dry sandwich so as to make my

Pepsi more useful and satisfying. I smiled again, almost laughing, as I slowly eyed the cafe, having just taken an enormous swig of my cold Pepsi, and enjoying its tingling, almost burning, effect on my throat. I felt it all the way to my tummy; which had been previously relieved by "going straight ahead, turning right, and entering the second door painted a light green." The cafe had one bathroom, for men and women, so you had to hook the door. And if you were employed there, you had to wash your hands before leaving. That's the law. The sign said so. Not being employed, I took advantage of my liberty. I continued eyeing the cafe, the cafe with no name just out of Joplin, Missouri: small, very small, with a large white sign saying "Cafe." Large simple white block letters on blue, a true blue. I saw the whole cafe very clearly, its beauty and its reason. I felt good that I had eyes. I wished I'd hurry and finish my sandwich so I could have a cigarette; a Tareyton Dual Cigarette with two phallic red stripes on the package. Two red stripes very close together. And with a white ring around the filter. Thirty cents a pack, twenty to a package, one and one half cents each, and soon it would disappear into smoke. And soon I would be in Tulsa. I tried to imagine it. I couldn't. I realized that this exact moment was all that was real and certain. I felt good because I felt good.

> "A rose is a rose is a rose is a rose is a rose, etc." (or something to that effect).
>
> —Gertrude Stein

I sang "Going for a Ride in a Car-Car" because we were. Yes, we were once again going for a ride in a car-car, a car-car driven by John Wayne headed toward Tulsa, Tulsa Oklahoma: John Wayne driving to Tulsa Oklahoma in $80 cowboy boots.

It was my turn to be by the window: goody. It was open, with my arm and head stuck out, and the wind stinging my face making it even hard to breathe. I sang louder, but no one could hear me: the wind blew the volume back down vibratingly into

my throat. I sang the worst songs in the world not knowing why; not knowing why I sang the worstest songs in the world: "The Tennessee Waltz," "Tell Me Why," "Dancing Matilda," and "The Thing." Others too, yes, many others. And more others. Many many etc.'s.

We slept. Ron's father drove. We smelled the dry grass: bad at first then heaven. We entered Tulsa. Ugh!

"Ugh! Ugh!" we sang, "Ugh! Ugh!" as we entered Tulsa. Ugh! John Wayne smiled and we three sang, "Ugh! Ugh!"

An undescribable farce began, simply undescribable, quite simply unbelievable. A farce which could only possibly occur between a woman and two men, a girl and two boys, in a car driven by John Wayne wearing $80 cowboy boots driving from New York to Tulsa, Tulsa Oklahoma.

We sang "Oklahoma."

"O-O-O-Oklahoma," we began.

"O-K-L-A-H-O-M-A, Oklahoma, O.K." We ended. We laughed. Ron giggled and I snorted. Pat was choking on a Spanish peanut.

Thus it began. Thus the farce began: the farce began as thus.

Pat, by this time quite green, was still choking, still choking to death on her fifth Spanish peanut of the day. Ron and I were rolling on the (a very tight squeeze) floor of the Ford in tears: tears from pity or excitement we knew not which. We cared even less, for the "spirit" was in us, the spirit which we never doubted. Ron and I were red from laughter. Pat was green from lack of air. The Ford was light yellow. The sky was blue, a sky blue: a high sky blue, like the sky in Tulsa it was. Ron stuck out his tongue for no reason. I laughed at him for the same reason. Pat tried to laugh for the same reason, but found it difficult. She found it quite difficult to laugh while choking on a Spanish peanut, especially for the same reason. I did a flamenco dance: it was not well done, but very voluptuously stimulating and meatily exciting, that is, for

me. Pat joined in, tho she found it very difficult to flamenco in a yellow Ford going 95 miles an hour while choking on a Spanish peanut: and with a partner too. But Pat had the spirit. Ron had the spirit as he hurriedly undressed. I undressed. I winked at Ron and said go: we violently attacked Pat. It worked, Pat swallowed her 5th Spanish peanut of the day. We were happy. Pat was especially happy. We celebrated in a happy way: we stopped for a Dairy Queen, a $.25 cone. Joy! Joy! Joy! Happy Day!

"The sun's a shinen, oh happy day-a, no more trouble, no skies are gray-a, oh, oh, oh, oh oh oh oh, happy day—." We sang violently. Yes, violently, for the Dairy Queen had stimulated us to a fantastic degree of insight. We saw clearly at that moment, that glorious moment of knowing, that the world was basically violent, at least, in comparison to a 25 cent Dairy Queen. Tears came to my eyes. I cried, I cried for the first time in seven years. I cried violently into my Dairy Queen.

My Dairy Queen had by now melted considerably. I had dropped it several times: it was very dirty and sticky. The tears made it very watery and it was overflowing. I watched. I saw in it a fly: a fly in my violently overflowing Dairy Queen, diluted from tears. It was too much. I remembered the jolly pink man who had carefully handed it to me from the hinged small square screened opening. He had smiled as I took possession, and handed him my 25 cents, my last 25 cents. It was beautiful: so purely white and nice in a delicately crisp cone, a curl on top, ripples of white sand. "Arabia," I thought. Yes, I must go to Arabia, I had been there so often in my dreams. I wondered if they had Dairy Queens in Arabia. It was too beautiful, and now, and now it was dirty. Dirty! Dirty! Dirty!

I wept, that is, I continued weeping.

I continued weeping for the rest of my life.

Saturday
July 21st 1962

I smoked a cigarette but I couldn't taste it. There were nine butts in the ashtray but only four used matches. I was making a collage but the pieces didn't fit and the glue smelt bad. The turpentine from my day-old oil painting filled the air. My Pepsi stung my throat both hotly and coldly. I read *Letters to a Young Poet* by Rainer Maria Rilke, but I am a painter. Rainer Maria Rilke is a German. I decided that art is never contrived, controlled yes, but never contrived. Cubism serves as a good example. In all of its obviously organized complexity it might be easy to doubt its spontaneity. African sculpture, paralleling with Cubism, destroys this point. Natural forms were naively simplified in line, plane and mass to give their significant characteristics the greatest possible force and vigor of expression. But the natives don't smoke Tareyton Dual Filter cigarettes. And Picasso denies being influenced by African sculpture. But I feel good anyway: my day has just begun.

I decide that Henri Matisse is a great painter because his paintings are very "present," and his thoughts are big in encompassing the obvious, which is stable and right, and the unobvious, which he makes obvious: this being purely Matisse. Thus his greatness lies within his own personal concept of seeing through form and color. I saw a painting in my head, a vision, which I painted. But it is not the same one. Oh why is it not the same one? I am painting not the same one at all. The match cover which I'm lighting my cigarette with, while not painting the same one at all, says "Fresh Up with 7-Up / Mix with the Best / Close

Cover Before Striking." But I'm drinking a Pepsi and not painting the same one at all. But Matisse is great because I say so, and I have wet dreams of showing at the Tibor de Nagy Gallery. But I feel bad anyway: my day is already over. And tomorrow I will drink a 7-Up because my rent is due.

Diary Aug. 4th–15th

Aug. 4—Today went to the Museum of Modern Art to see the mummified remains of the actual asp that Queen Cleopatra used to kill herself with: a most interesting object.

Aug. 5—Today went to the Museum of Modern Art to study Excalibur, with which King Arthur proved his right to Kingship, and to sip coffee in the Museum's sculpture garden. I found the sword to be a most unusual object.

Aug. 6—Today I thought. A rusty old sword and a dead snake? Are they kidding? Where are the real treasures of yesterday?

Aug. 7—Today I went to the Metropolitan Museum of Art to look at the *real* treasures of yesterday. Their major treasures are quite exciting. I found their minor treasures rather unexciting.

Aug. 8—Today I thought seriously about Excalibur and decided it could just as easily have been Prince Valiant's or even Flash Gordon's. I have definitely decided this to be a minor treasure.

Aug. 9—Today I decided that perhaps minor treasures are not so minor after all. So I ran to the Museum of Modern Art to study with a new light the mummified remains of the actual asp that Queen Cleopatra used to kill herself with only to find out that the exhibition had been returned to India. I was most upset so I ran home and read *Sunday after the War* by Henry Miller. I found it a very exciting and major work of writing.

Aug. 10—I want to be alone.

Aug. 11—I spent most of the day today reading Henry Miller's *Tropic of Cancer*. I discovered it to be even more major than *Sunday after the War*.

Aug. 12—Today being Sunday, and all, I read the *Journal American* comic section. Strange as it might seem for me, I rather enjoyed it. Upon serious study I found that Walt Disney is taking over with five major series: "Uncle Remus," "Big Red," "Donald Duck," "Mickey Mouse," and "Scamp." I find "Scamp" to be the most unusual, and "Big Red" to be the most exciting. Ripley's "Believe It or Not" section stated much to my amazement that a girl in the Fon tribe of Africa is engaged at the age of six to a boy of sixteen, but before they can be married the youth (boy) must work eight years for the bride's father as a plowhand! I found this most stimulating! It is also interesting to note that Sam Francis has done a painting called *Big Red*; the same title as Walt Disney's comic series. I've been seriously contemplating the connection with no positive results.

Aug. 13—Today I bought some "Hy Tone" wide-line ruled notebook paper to write on and three rubber faucet washers. I only needed one, but they're so inexpensive and so easy to lose I decided to play it safe. I read today where "Hy Tone" has been America's most popular school supplies. This is interesting, because I've personally been using them for years. I did a painting called *Big Red* today, which only confuses the problem. But I must have unconsciously arrived at the title, for the painting is only 8" by 10" and mostly in different shades of black with green or yellow.

Aug. 14—I painted ten paintings today all called *Big Red on Hy Tone*. It's interesting to note that three of these are self-portraits, and that one of these is obviously very major. I decided

to destroy the other nine, even though five of these might easily be considered minor works. But instead I gave them to Ted, a poet friend of mine who married Sandy Alper: age 19. It's interesting to note that Ted is 27 and that I'm 20. But I've been unable to draw any obvious conclusions other than the fact that my parents were married at an earlier age than Ted's. It would help if I also knew when Sandy's parents were married.

Aug. 15—Today I am truly horribly upset because Marilyn Monroe died, so I went to a matinee B-movie and ate King Korn popcorn. I decided never ever to paint again. The movie, *Tarzan Gets Married*, I had seen before at an earlier age. But I couldn't remember who he married. (Jane.)

The China Sea

Death, you know, signifies nothing at all. What *is* important is that I have very sensitive fingertips. I like to read books. Reading this book all about conscious contact with a woman on the front wearing a key, large with wings, I have an image in mind. Like a Greek to see. There *is* something somewhere to see. Somehow. Last night I saw *Ghost of the China Sea*. I had seen it several times before, but, well . . . I love the China Sea. It's blue I'm sure. Though I've never yet seen it. Perhaps what I really need to do is go on a crusade for heritage or study the scientific spirit in me. It's there I know I think. And I've already read *The Power of Ideas*. I'm really terribly tired you know! Daily every day I must go through the discipline of overcoming unprofitable thinking, for I don't know why? But I do. "I do." Maybe from a metaphysical standpoint I could. I never paint science though yet. I will. The blue sea (China) won't make room. Or the ghost. I'm not sure. I know what I need: to understand the harmonious mind of God. So I can see exactly where he went unharmoniously. See? There is so much seeing to do. And already today I'm so terribly tired. Blunted perception: I made it myself you know. We all do. For lack of reason not to. The spirit: I made mine too, you know. Simply because it was there. What else could I do with it? I'm going to buy a phonograph record which voices a healing life-giving message! Or else Ray Charles' new album. If only I had a record player, I'd buy both. If only I had the money. You see, I'm not asking for anything to change, really. I just want to *see* as is. If I criticize, it's through creating: the only way. Michelangelo said something to that effect once. I read it in quotes. I think. This I know:

(1) My planet moves majestically in its orbit carrying me and my possessions.

(2) I can not escape my good.

(3) The one power is self-love.

(4) I seek at least a vision of faith.

(5) For twenty years, sleeping and awake, to place the stars and stripes on the pole has been my dream.

(6) It is good to be absent from the body.

(7) It is good to rejoice evermore without ceasing.

(8) It is good to be lost.

(9) Foes never slink back into native nothingness.

(10) Sin is obscure.

(11) Obscurity is good.

(12) My art needs more sin.

(13) I am faint and weak only because my doors are closed.

(14) Purification *must* be the result.

(15) No man is defeated until he ceases rejoicing; unless he's a cripple or something.

(16) And I blue the China Sea.

Picnic or Yonder Comes the Blue

"After a white reception in the crystal room of the Hotel Kenmore, Mrs. George Eustic (Patricia Hays) and her husband left on a wedding trip to the Pocono Mountains, Pa. They will live in good old Noodleville." (Home.)

Where the friendly purple heart is.

I like to do things. I like to eat, and things like that. I like the things that go on around me. People are nice. And, really, I like this place I live in. However, some people don't.

Sally doesn't.

Sick at heart, the trembling girl shuddered at the words that delivered her to this terrible horrible fate of the East. "Nasty!" How could she escape from this oriental monster into whose hands she had fallen—this strange man whose face none had seen.

Smile!

It is only a little picture,
 In a little silver frame,
And across the back is written
 My darling mother's name.
 (Valentine)

Pink and purple and orange ones with Venetian rose buds
Imported from Venetian
In eleven thrilling volumes

 I heard a shot—I saw him run—then I saw her fall—the
woman I love. My leg was broken—and my gun was gone! I had
only one thought—(tee! hee!)—his strange, astounding plots
must be avenged—he must die for a coward at my hands! He had
the courage of a lion and the cunning of a rat. He came running
towards me when—suddenly, I—

Ran.
Forgetting the ripped lace, $35, green violence, & free samples.

"I always run when I hear 3 rings!"

. . . and remember those swell picnics in Birch Grove?

"Jeez, it's such a nice day" I said. "So I wish something would happen." Nothing happened. I just sat there for a while. I smoke. (Cigarettes.) I sit here for a while longer. And I begin writing. (Casual.)

A True Story

(I don't know why I chose this title.)

THE CHARACTERS:

(1) Francine—"That's very white of you" she says so often. It makes me laugh. Perhaps you don't understand. Stupid! Francine is stupid, but for real. And that matters a great deal. But I am using too many words. This is not a play, you know. This is just a list of characters. (And many of them are.) Ha! Perhaps this isn't funny. But I am using too many words. Francine is miserable. I'll try not to explain. I mean, I'll not try to explain. Francine is small, little, and would be a joy of a toy to sleep with now that I no longer have the cause. Francine loves cats. She has three plus a hamster. Booby is my favorite: the only cat (gray) I've ever seen that farts. It's the honest truth. I don't know if it's a male or a female. Francine has been in jail. Francine has pixie hair and pierced ears, but they don't look cheap. That sounds catty. (Pardon.) At any rate, I must cut this short. I'm using too many words, you know. Francine married a Negro. They are separated. Francine can't tolerate capital punishment, loves jazz (Monk) and would like to love classical music, and has had two abortions. I'm sure you have the wrong impression of her. But I am right. And you are wrong. You just don't understand.

(2) Johnny—A boy who works at a newsstand. We always went to bad movies together. I could say more.

(3) Carol—Paper-pale like fish food. Very soft. I don't like the word *skin*. Carol is nice. Carol is Dick's girlfriend.

(4) Dick—Drinks books. Wears cowboy boots. Is Carol's boyfriend. (Wouldn't go to the toilet without at least *The Book of Knowledge*. He comes back. You say "What color?" He says, "Don't know.") I could say more.

(5) Peter—I do like the name. But it might be Suzy. I do get them confused.

(6) Ella—Ella's been minding her own business like she ought to have done years ago.

(7) Suzy—I do so like the name. But it might be Peter. I do so get confused.

(8) Joe—(Me.) I love what I love with an appetite. But I also leave hairs in the bathtub. And no one has seen the insides of my pockets.

(9) Pat—Writes me wonderful letters. Will say more later. I am using too many words. This is only a list of characters, you know. (And many of them are.) Ha! I don't know if this is funny or not.

(10) Bill—Bill is a novel out of a character. That is to say, strange. He is impossible to explain in words. So I won't waste them. Besides my hands are tired and my fingernails are dirty. For I don't have a typewriter.

(11) Ron—Ron is hard to explain. And my fingernails are getting horribly dirty. I don't have a typewriter. But I shall try anyway. That good ol' college try, you know. Personally, I went to art school. Four of them. I had a scholarship for two of them. Honest! I hated them all. Ron goes to Columbia University. I could say more. And I really should say more. I will say more. ("More!") Ha! That might be funny, but I'm not sure. It's important to be *sure*. Maybe that's why I'm in Boston: just to be sure. Ron goes with Pat. And I don't know if I like him or not. I could say I do like him. And I could say I don't like him. But I'll say neither one:

both are false. It's important not to be false. You know what I like most of all? A beautiful morning. Don't laugh. You are wrong to do so. It just makes me feel good and alive and all. And this is good. "And that is good." I like that. I like the way I said that. "And that is good." Somehow it sounds kinda holy, like Jesus might have said it. Or someone of that sort. "And that is good." I like it. "And that is good."

(12) Sandy—Sandy is good. I could say more.

(13) Ted—Ted is the kind of guy that laughs at the bubbles when he passes gas in the bathtub. Ted is a poet. Yet, sometimes he is frightened by the bubbles. I could say more.

THE INTRODUCTION:

In Boston I dream of things perhaps I oughtn't to dream of. I dream of normal high school, potato salad lubricated by mayonnaise, and glory. And I am very sorry. But not always. I dream of other things too. But I won't mention them. And not because they pertain to sex. And I am very sorry. But not always. I cry too, sometimes, just because the sky is so blue. But it is a rare thing for me to do. And March went so slowly.

I've only lived here two months. I can't spell the state yet. And I read all the time, even though I am a painter. If I weren't so afraid, so afraid of being overly dramatic, I'd say I felt like an eight-year-old kid trapped in a mine shaft. I feel like an eight-year-old kid trapped in a mine shaft. (Pardon me.) But I don't know what the mine shaft *is*. Perhaps it is only a white bathroom. Not the mine shaft, but the place where I'm trapped. It doesn't *have* to be a mine shaft, you know: the place where I'm trapped. But now I'm all confused. I'm not really trapped at all. I'm almost twenty-one. And what could be safer than a white bathroom? Someone is sure to open the door. And I like white bathrooms. I have a brown moustache. And I make little sense at all. I know it.

I came from New York for a very good reason. Though I don't know what it is yet. The reason. That is to say that I moved from New York to Boston by bus for a reason.

There are no days in Boston. They are all the same. I don't have a clock but I have a calendar. The year is 1963. And soon I will be twenty-one. Do not laugh.

The setting: (I don't know why I'm being so formal. This is not a play you know.) A small room with dirty no-color walls. The curtains are plastic. They contain on them a red and green floral design (large pattern) of a wild sort popular eight years ago when I was only twelve. I read books all the time. If you don't believe me you are wrong. My bedspread is of pink chenille. It comes free along with weekly fresh white sheets which are yellow. Ivory actually. And I hope it is only from age. All for eight dollars a week. A bargain? No. I have a chair I don't sit on. Am I boring you?

I've very little to say. And that may or may not be my problem if I have one.

I take two "one-a-day" vitamin pills every morning to make up for lack of something else. I heard cold showers were good for unmarried people. I use Vitalis on my hair (curly) only when I go out to look for a job; so the wind won't mess it all up. (Hair.) I don't have a job.

Ever cheated at solitaire? I have. But most of all I want to paint rare paintings: like the way I feel sometimes. I'm the best painter I know.

I'm just now reading this horrible book, *The Burning Man* by Stephen Longstreet. It's a poor take-off on Picasso's life without using his name. But I must finish it so as to add it to my list. It'll make number forty-nine. Number forty-nine, and I could go on forever you know. The next will make fifty. I like round numbers.

What I like most about Boston, I live in Boston, is the air. The green bridge outside my window. The black church uptown or downtown. People are common-looking here. I'm sorry. (That they are common-looking.) The crime rate is high. And history is very important. (American.)

Next I will read (number fifty) *Beowulf* by Bryher. I've

already finished an anthology of *Best Russian Short Stories* by lots of people. (Russians.)

What I like most of all are people. But I don't know them very well. I hear them say things. I see them.

This June (soon) I'm having another one-man show at the Bartholic Gallery in Tulsa, Oklahoma. This will be number six. In Tulsa I like the air even better than I like the air in Boston. Most of all I remember Tulsa for the air and clean and sky. (Blue.) I remember my aunt's, she lives in Tulsa, healthy teeth that have never touched chocolate. (He who eats fire farts sparks.) And I certainly do miss New York.

I remember green plants and white walls. My "studio." All painters have white walls. They might have been dirty. I don't know. But now they are white. I remember. Damn! ← (This sounds out of character.)

I remember Francine and Pat. Ted and Sandy and Ron and Johnny. Dick and Carol. Peter or Suzy. And Ella and Connie. Bill.

Connie is a real girl who writes letters in red ink. And uses a ruler so her lines are straight. Yet somehow she does it as much to your advantage as to her own. I am sorry I left you out of my character list.

I remember the Museum of Modern Art and coffee. Coffee I always drink black. It just doesn't excite me with cream. I remember round white tables, trees, conversation, and Balzac.

Johnny and Dick, Peter and Ron, or Bill: they are boys. I remember their faces. I could say men. I could say more.

But a clear sky, that's what is important. Especially nowadays in Boston where everyone owns a raincoat.

I don't own a raincoat.

I look into the mirror often. Do you understand me? No. You know I live alone. Not that I mind. I have no choice. Or else I do have a choice. I talk to myself; but not out loud. The man next door does. We share the same bathroom, along with six other people. It is dirty. But it doesn't seem unsanitary. He's drunk most of the time. He gives me magazines. He curses at his radio. He

didn't make my character list. He vomits often. I can hear. And he makes a lot of noise going to the bathroom. I feel sorry for him and I wish I didn't have to. I have no choice. And I don't even know his name. But of course, of course you don't understand me. And do you think I care?

Writing all about myself the way I am, you might not believe this, but it's true: I hate myself. Say the word *hate* over and over and over until it sounds as mean as the word *fuck* said in the worst way by the worst person. Then you understand me. Hate. Say it once more. And again. You understand me now. For it's true for now. Perhaps only for a moment. I don't know. You see, I just don't know. It's not true of course. And besides I'm changing. I might have said growing, but it sounds funny. Developing sounds even worse. I'm twenty now and almost twenty-one. Almost of age. I've known for years I was a painter. I am a painter.

I don't remember women very well. I don't know them too well. It's been two months. I see, as I remember, lots of soft with red lips. I don't like the word *skin*. With little white teeth even though they might be big. Even though they might be yellow. But *ivory* sounds better. Should I go all the way and say they remind me of pearls? (Teeth.)

Yes, perhaps I remember Pat most of all. That's just the way I am. I've painted her so many times. I did paint her once with green hair and red eyes and lots of other colors. Pat: small with nervous fingers and little feet. Little toes. Long black-brown hair. Once I made it green. I already said that. Once I made it blue. Sometimes maybe red. A pink hat. I've done it. I like colors. Pat really does have a black one (hat) that she never does wear. Big eyes which know too much to be twenty-four. Or twenty-three or twenty-five. But maybe they know too little. I won't say I don't know. Honest. Drinking coffee with cream and smoking a Kent in a too-yellow bright cafe (Pat) too late at night. With eyes that know too much. Or too little. Enough to be too much without knowing more? I won't say I don't but I honestly don't know. Honest. And small red lips (I love red lips) which are very special

for one reason or perhaps another. Sentimental? It's more than possible. (But I can't stop.) Big eyes she outlines in black like Liz Taylor (beautiful!) does. In the morning it's hard to wake up with eyes that know too much and too little. Do you notice I changed the *or* to *and*? You understand. And her presence forces me not to say what I'd really like to say. You don't understand. But perhaps she is smart for this. I'm getting in way too deep. *She is good.* This I know. For the Bible tells me so. Little ones to him belong. We are weak but he is strong. Yes Jesus loves me. Yes Jesus loves me. Yes Jesus loves me. The Bible tells me so. (A song.) I sent Pat one box of chocolate-covered cherries for Valentine's Day.

It's your own fault you know. If you understand me you'd know what I meant. "Therefore be bold," I always say.

Sandy is good. Sandy is pregnant. Sandy gave me a goldfish for a red and green Christmas. I never took it home. Is home where the heart is? I painted her three times with glasses and bushy hair. Ted wrote on two of them. That's just the way he is. And one had red shoes on. I like bushy hair. My hair is bushy. I like the way hair falls. I like the things hair does. I sent Sandy one box of chocolate-covered cherries for Valentine's Day.

Ever seen a baby look at a newspaper upside down? It's not really funny I guess. I've seen it in home movies. (In color.) It happens all the time. Mothers laugh at it. And fathers smile at it. But I like it. Babies are small. I'm glad Sandy is going to have a baby. So I quote:

> *He puts his grandpa's glasses on,*
> *Then imitates his frown,*
> *And reads the paper backwards, while*
> *He holds it upside down.*

I like quotes. I like babies. I also like certain species of flying birds.

Ted is good. Ted is a poet. I am twenty years old. But you know I'm almost twenty-one. Ted is married to Sandy. Sometimes Ted has a beard. And sometimes Ted does not have a beard. I love

good Ted. I hate good Ted. But you know I'm almost twenty-one. Which is not at all beside the point even though you may think so. That is to say that even though you may think it's beside the point it isn't really at all. (Beside the point.) The point *is* that I'm almost twenty-one. I never send Ted a box of chocolate-covered cherries on Valentine's Day. And there is so much more to be said.

There is so little to be said. And my hands are tired and my fingernails are dirty. I still don't have a typewriter. I don't know how to type.

On February 14th, 1963, I got terrible sick upon eating three boxes of chocolate-covered cherries. But you wouldn't understand. So on with the story:

THE STORY: (IN VERSE)

Sandy, (one)
Went out in the field to run.

Ted and Connie, (two)
Said they didn't know what to do.

Pat, Johnny, and Bill, (three)
Said "Let us climb a tree."

Francine, Carol, Dick, and Ron, (four)
Said "Let's swing on the old barn door."

(Peter, Ella, the man next door, Suzy, and I, we just all sat around watching. It's not that we were party poopers, or anything like that. It just wasn't our turn yet.)

THE END

I Like

A happy glory to sky!
Vitamin C I love you mornings
By night I absorb black
At twelve I eat Malto Milks
By the dawn's early light it hails
Sometimes it rains
Last night was blue or maybe Arabia
Architecture I didn't understand
Pink
Once her white V of panties disappeared into the sea
I remember
The sea is naked by night
Wetter and darker and deeper
It is black
I don't like it
(I throw my glasses into it quite often)

Last night I felt empty words and broken things
Ivory carvings never very white
Oriental rust water and fine arts festivals
Navels or novels?
Brown hair and liberty
I have hair
I am twenty-one
I read
And being twenty-one is all I know about
I don't like this arrangement

This morning I see squares
Rectangles and circles
My room and the sun
Ivory and yellow
Water and cigarettes
Smoke and air
Blue
I like what smoke does in the air
I like the things yellow does on ivory
The way it dances rectangles
And squares for me
'Til noon
Then I've just myself
My mirror
Art
And movies magazines
I like movie magazines

I Like

I Joe
You lie
About pineapples
There are none under anywhere
I look
I see
I find only dirty tulips
Or orchid ribbons
Orange
With big black words
A royal sky:
It lets one see
And what a good thing a white shirt is!
Nice
Nice to see red by night
 to know pink well
 to understand yellow birds
 to realize black and white
Terribly nice
Mirrors are
Nice
(Terribly)
To see by
To see by me
You
I love
I love Indians
 pen points
 Hungarian

 plaster
 sweetmeats
 five
A nice number to love by
If feather pillows didn't leak
Out onto green floors
Where normal shoes belong
With blue socks
With white stripes
And Boston newspapers
All about news
And things
I like
I like fried chicken
 smashed 'taters
 thickin' gravy
 not biscuits an'
 chawklit pie wif
 mushmeller toppin'
And I simply love horoscope!
(Crunch)
The sky is aflame!
Red
(A jet of anti-matter gas is exploding harmfully
 against the upper atmosphere)
But tomorrow is Tuesday
And I shall see the four seasons on one branch
 of pink trees displaying
Ivory lilies insisting
Upon white privacy
(Or they threaten not to root at all)
I, personally, vote for blue
And to hell with Easter
I prefer red and green
 mother Christmas

black birds of passion
sunsets that consume
pink nuns and salty peanuts
and Renoir who bores me
But most of all I like shoe polish

And the big sun rises over Delhi. . . .

The People

And the mountains shall bring peace to the people.
—Psalm 72:3

Today I will uphold others with my prayers. Tomorrow I will let my light shine. And day after tomorrow I will help build the Kingdom of God. I never plan more than two days ahead. For in all actuality, tomorrow *is* another day. I am a painter. And what I want to do most of all is to tell you all about the people. I love them. First I'll tell you a story about Mary Morey, and now my story's begun, I'll tell you another, about my brother. ("I just thought I'd add another crime to the family record by butchering my brother Jim with an axe in his bath!") And now my story's done. However, I've another one.

Once upon a time ago (many years) a little cock-sparrow sat on a tree looking as happy as could be. Why not? A little boy came (John David Anthony) along with his wee bow and arrow, and said he, "I shall shoot dead that little cock-sparrow!" "His beautiful body will make me a nice little stew, and his giblets will make me a little pie too." But, "No, no, no!" said the sparrow, "I won't make a stew." And with a flap flap of the wings he flew flew flew. (Like fast in order to make Eggland on time ((six)) for a surprise ginger ale party for Wee Willie Winkie Pinkie upstairs and downstairs in his pink nightgown.) However, he didn't make it. On his way he met this little man, and he had a little gun, and his bullets were made of lead, lead, lead. And he shot the little cock-sparrow through the middle of his wig, and knocked it right off his head, head, head. It was immediate death. However, reports have it that the ginger ale went flat and Wee Willie Winkie Pinkie was in a terribly bad mood. (Depressed.)

You know, we are all living in troubled times, when peace seems almost impossible. One bright spot, however, is the growing awareness among Christians each and everywhere that we all belong to one big family—the family of Jesus Christ. I would like to close with this thought for tomorrow: "The best way of knowing God is to frequent the company of his friends." (Compliments of Rita F. Snowden.)

However, I've more to say. I had a little nut tree, and nothing would it bear, but a purple purple apple and a silver golden pear. It was really frustrating. I've always been terribly fond of nuts. Ginger snaps. And butter cakes are good. However, I've always felt terribly sorry for brown chocolate trying to be unusual.

You know, what I really like about people is how good they are to look at. And how, with just a something or another you can love someone far far too easily. And sometimes those things just happen. Once one misty moisty morning, when cloudy was the weather, I chanced to meet this old man, dressed up all in leather. He began to compliment, and I began to grin, How do you do?, and How do you do?, and How do you do again?

I'm fine. But you know, some people don't like things. However, I do. I shall never forget from my seat in the Royal Albert Hall (London, England) artist and instrument seemed fused into one. Yehudi Menuhin stood before me that night playing Mendelssohn's Concerto in E Minor. It was really good! Existence becomes true real life when it merges with the lives of others. (People.) As Bernard Shaw wrote once something to the effect that the very worst of sins is not to hate them but to be indifferent to them. As I do remember correctly he described such indifference as "the essence of inhumanity." Which is a rock if ever I saw one. For, for every evil under the sun, there is a remedy, or there is none. If there be one, find it, if there be none, mind it. But most important of all: Love the people. I do.

P.S. Higher than a house, higher than a tree, oh, whatever ever can that possibly be? (Star.) Which reminds me of my recent

short trip to Dalmatia. During my recent short trip to Dalmatia I enjoyed walking along the coast of the Adriatic Sea. It was a simply splendid evening. The moon sailed in the sky, and its light dispersed in thousands of pearls on the calm black surface of the sea. I've always loved black. And pearls excite me. However, I found the Adriatic to be rather large.

Andy Warhol:
Andy Do It

As for Andy Warhol, yes, I do think so. As I said, Andy Warhol "dug deep." (Perhaps without digging at all!) At any rate, like I said, Andy Warhol "lets" you know what he's doing, but he doesn't "tell." If Andy Warhol "told" it would be telling about "what" he is doing. Or what he "did." Andy Warhol, he's got "courage" and he's got "ideas." Andy Warhol I think has creative ideas. Andy Warhol doesn't I don't think do creative paintings. Andy Warhol might not even do paintings at all! For all I know Andy Warhol might not even have "ideas" at all, but for me Andy Warhol has "ideas." Andy Warhol perhaps paints ideas, but if so, I sure do like the way his ideas look. Andy Warhol's ideas look great! Andy Warhol paints Andy Warhols. And I like that.

I like Andy Warhol. I like Andy Warhol. I like Andy Warhol. I like Andy Warhol. I like Andy Warhol. I like Andy Warhol. I like Andy Warhol. I like Andy Warhol. I like Andy Warhol. I like Andy Warhol. I like Andy Warhol. I like Andy Warhol. I like Andy Warhol. I like Andy Warhol. And that is why I like Andy Warhol.

And "that" is important.

Plus

"The Grand Manner." There is something of the "grand" in Andy Warhol. I like grand things.

And

"Spectacular."

I find Andy Warhols to be spectacular, grand, clean, coura-
geous, great to look at, and likeable. I like Andy Warhol. And
there is more to be said. I like Andy Warhol.

Andy Warhol's "paintings" have "presence." Andy Warhol's
"paintings" have "face." I like paintings that have "face" and "pres-
ence." I would not like Andy Warhol's "paintings" if they didn't
"have" face and presence.

Andy Warhol knows what he is doing. Andy Warhol "does
it." I like painters who "do it." Andy do it.

THE MAN BY JOE BRAIARD *

"SEE MY WHITE FELT ARCTIC BUNNY BOOTS!"
THE MAN SAID.

(AFTER THE DOCTOR EXAMINES THE PATIENT AND MAKES LABORATORY TESTS HE WILL KNOW IF HE HAS IT OR NOT.)

"Shamed by Your English?" THE MAN SAID. "WELL, I'M NOT."

"JUST ME AND MY WHITE FELT ARCTIC BUNNY BOOTS", THE MAN SAID, "WE LOVE YOUR ENGLISH."

THE MAN SAID **"HAIR SICK?"** "CERTAINLY" THE MAN SAID. "IF YOU HAVE ONE" THE MAN SAID. "OR TWO" THE MAN SAID. "ONLY **$19⁹⁵**" THE MAN SAID.

"ONLY $19.95 FOR TWO WHITE FELT ARCTIC BUNNY BOOTS!" THE MAN SAID.

＊BRAINARD

"MAYBE YOUR INTENTIONS MATRIMONIAL-WISE ARE TOO OBVIOUS AND YOU SCARE ALL THE YOUNG MEN AWAY. I'M A DIVORCEE AND ANY NUMBER OF YOUNG MEN WANT TO MARRY ME. BUT I DON'T EVEN <u>WANT</u> A HUSBAND", THE MAN SAID.

" " THE MAN SAID.

"YOU CAN LEAVE ANY TIME WITH COMPLETE CONFIDENCE" THE MAN SAID.

"GOODBYE!" I SAID. "JOE IS THE NAME." "THE STREET" I THOUGHT. "NICE" I THOUGHT. "YES" I THOUGHT. "AIR." ~~_____~~ "THANK YOU."

CLEANLY I SAID "THANK YOU." AND CLEAN IS WHAT I AM. JOE IS THE NAME.

(IF A PERSON THINKS HE MAY HAVE IT HE SHOULD GO TO A MEDICAL DOCTOR OR CLINIC AT ONCE.)

JOE IS THE NAME. I LIVE PRIMARILY IN CANADA IN THE MIDDLE OF THE RAIN FORREST WITH REINDEERS WITH MY SECOND COUSIN. WE DON'T LOOK AT CLOCKS. WE JUST RIDE AROUND ALL DAY AND THINK CLEAN.

→ THE END

Marge

There is an old saying that life is just a bowl of cherries, ripe for the picking and more delicious with each succulent mouthful. Right now I'd like to fart on whoever said that because it is one big giant lie. Life is many things, but it is *not* a bowl of cherries.

It all began that evening of May 29th: my 18th birthday. We were eating a bowl of cherries, Marge and I, on the front porch in the white swing. The cherries were beautiful, black-red, and inviting. It was a blue evening in May: Arabian blue. Not dark yet, really, but dark enough for the moon. It was a beautiful moon. Big and full and white. I never saw such a beautiful moon. It reminded me of a picture. It reminded Marge of a picture too. She said so. In a museum. Marge liked to draw. "Some day," she said, "I'm going to be an artist."

May 29th . . . my 18th birthday. And now she is dead . . . how I hate May . . . and all that it stands for . . .

When Marge and I were little kids we used to take naps together. Then one day we moved to the other side of town and I never saw her again until my first year of high school. We were in the same home room. It was love at second sight.

Love is a funny thing. It means many different things to many different people. Love means only one thing to me. It means Marge. And now she is dead. Dead as a blue evening in May.

Death is a fucked up system. It hits you on the head like a hammer and what can you do about it? Nothing. It's a fucked up system. It's stupid and ignorant. It hurts. I'm never going to love anybody the way I loved Marge.

High school flew by. Time does that. It just flies by. Especially the good years. I look back on those good years, those love years, and I wonder—where did they go to? Gone. And there we were, in our black gowns, graduating. We laughed a lot. We felt good. We felt cheated too. We felt empty inside. We felt wonderful. We felt empty inside together. Like one big empty person divided by two. We felt everything, altogether, all at once. Marge and I were very much in love. It was great.

Marge and I folded our graduation gowns and returned them to Room 308. I will always remember that number: 308. There are many things that I have forgotten, and there are many things that I will learn to forget, but I will never forget that number: 308. It's funny how some things, little things, just don't go away.

We said goodbye to a lot of people, in our caps. For 5 dollars you could keep your cap, as a souvenir, I guess. I didn't really want to keep mine, but Marge wanted to keep hers, so I decided to keep mine too. We wore them home on the bus together. We had no books to carry.

Marge died that evening on the front porch. In the white swing. In my arms. In love. "Cherry-poison," they said. In my arms. "Wake up, Marge," I said. But she wouldn't wake up. "Dead," they said.

I will never forget that evening of May 29th: my 18th birthday. The screen door opened to let us know that someone was coming. Mom entered the porch, our world, like a saint. She handed us a bowl of cherries, freshly washed, black-red, shiny and inviting. She paused. "It's a beautiful evening," she said. Then she went back inside. The screen door closed quietly behind her.

And when we were alone again, Marge's mouth began to move, nibblingly, as she reached for a cherry. I experienced a quivering sensation of pure ecstasy as she placed it between her lips. I wanted desperately for her to hold back, to prolong the sudden joy for as long as humanly possible. "I love you," we said. But the

next moment it happened, explosively, as Marge began munch-
ing, and before my eyes a million beautiful stars burst revealing
a Shangri-La of unexcelled bliss. Marge swallowed the cherry.
Night fell. And so did Marge, right into my arms, dead. Dead
as a black evening in May . . .

Johnny

When Johnny Pain was born it didn't seem possible that he could survive for more than a few hours. His tiny body had no legs. And his torso had no abdominal region. He was no more than one third of a baby, a veritable human fraction. The year was 1942. The place was Cleveland, Ohio. And today, believe it or not, our Johnny is an expert typist, acrobat, and entertainer. He is a good draftsman, an orchestra leader, and composer. He is a juggler, a tight-rope walker, and magician, and most unbelievable of all a remarkable dancer. Partners are his only problem.

Johnny went to school like other boys of his age, except that he walked on his hands. He graduated from high school at the age of twelve. He played baseball, tag, and hide-and-seek. He is an expert swimmer and diver. He is a noted authority on the Qurungua Indians who live in the forests of eastern Bolivia. (They are born with a strange natural constriction in their throats which, combined with defective vocal chords, makes it impossible for them to utter a single word.) He is an ardent collector of tablecloths, seashells, and fox carvings. He is an excellent pool table player.

Lack of a complete body hasn't handicapped Johnny's health. He has never known a day of illness (with the exception of occasional nose bleeds). His disposition is remarkably sunny, reflecting a complete enjoyment of life. He is an excellent swimmer and diver.

Nancy

It was coffee time "in" Middleville. And Nancy was certainly in the middle. Once upon a time she sure hated coffee. "Never did like it."

One winter day Nancy went under the schoolyard to see what she could see. She saw nothing. Nancy definitely did not like the "setup."

Nancy sat up the long night crying often. She enjoyed it. That was the kind of girl Nancy was.

Nancy wanted to be "that" kind of girl. I at "that" age didn't know what I wanted to be. But I certainly didn't want to be "that." Nancy did.

Nancy she had a grandmother with an Italian sense of the dramatic. She complained of "unjust interference." Nancy and me we did too. The three of us definitely complained often of "unjust interference." It was fun.

It was fun to complain often of "unjust interference." Thick smoke hung over the Dutch village of Maasland due to fire in a nearby chemical warehouse. And we complained very definitely of "unjust interference."

The woman prize-winner was delighted because she had always wanted to meet a monarch and her prize was a chance to meet the King of Sweden. Now, she didn't want to anymore. We called it "unjust interference."

We Nancy and me went to free admission film programs about ancient Greece and the Mediterranean shores. *Adventures in Telezonia*. We were waiting for Arabia.

In Arabia no one wins a Nobel Prize. This we liked, and considered "just interference." In Arabia we are certain it was "cool." There are no teenagers in Arabia. Arabia has no navy.

In Arabia there are no interior designers, no Texas, no archeology, no suggested activities for children, no Christmas Eve, only Christmas Day, no *New York Times* critics. There are no French views and balanced systems in Arabia. Arabia is full of white horses. And other things.

There is no "further recognition" in Arabia. Nancy and me we detest "further recognition." And other things.

Washington didn't extend, or otherwise, warmest congratulations when grandmother died. Nancy and me we called it "unjust no-interference." And now only us two were left.

Nancy left home; where the "heart is." Nancy said "you slob" because I wondered:

> p. Is there any certain way to prevent conception?
> b. Just how injurious is masturbation anyhow?
> e. Does dancing make the young man's problem of sexual control more difficult?
> i. Will there be a flow of vital semen during intercourse always?

Nancy say "You slob."

Nancy say "You-locker-room-Joe!"

Nancy say "You Joe Palooka!"

I say "You fuckin' apartment building!"

And that stop it all. Nancy she can't tolerate obscenity.

And she doesn't believe in apartment buildings. My name is Joe.

My name is Joe. And I know nobody cares or not if my name is Joe or isn't. I am not "attractive." I do not believe in pure dedication altho I do believe in a United Nations. I believe in it because it *is* a belief and I will never be proven "right" or "wrong." Nancy doesn't.

I believe in believing in all things that are possible to believe in.

"Hamilton is the only dryer that has been drying America's clothes for 25 years" Nancy told me. It was at that point in my "lifetime" that I realized wholesale and/or retail. I call it "*total*

cost one way or the other." At this point Nancy personally was more involved with "plastic research." Nancy's mother (Mom) was involved in family foods, family fashions, and family furnishings. Nancy referred to her mother's new interests as "rubberlike." I referred to her mother's new interests as "familylike." Nancy referred to me as "plain," "unsynthetic," and too "polymerizing." I referred to Nancy as "total cost."

The total cost of my new college suit was "drugstore money." (Retail.)

Nancy she decided not to go to college at all. She worried about the stone age tribes recently "found" in Papua. ("Where were they before they were found?") Instead she became a barber shop secretary because there were none. Nancy detested "competition" and considered it totally "unjust." And found being "forced out of a job" pleasant. I imagine Nancy still remains "pleasant."

I did not find college very pleasant. In fact I did not find college at all. And college did not find me.

And to be honest, I didn't even "look."

Nancy

Nancy was always handing me jars that I couldn't open. "Open this jar for me," she would say. Then she would leave the room and I would twist and twist. The jar would never open. She would come back in a few minutes and without saying a word take the jar from my hand and with one simple twist open it. Then she would go on about her business until there was another jar to be opened. "Open this jar for me," she would say. She didn't do it on purpose. Not Nancy. I don't know why she did it.

The first time I saw Nancy she was eating a chicken salad sandwich at Joe's, just around the corner from my father's hardware store. I didn't know what to do, she was just so beautiful. So I just stood there, looking. Bright red lips. White oval face. (Soft) big black eyes. They sparkled. And long black hair. (She washed it every day.) She was wearing a red dress. There was an empty stool right next to her, so I walked over and sat down. So close, it was impossible to look. I felt, though, that she was smaller than I had thought. She smelled good. I remember my body. It felt very body-like and big. It suddenly occurred to me that I was just a blob of something sitting on a stool. I sensed a small napkin gesture and her stool swiveled in my direction. Her eyes saw me somewhere below the face. She slid down, and walked out the door. "Gone," I said to myself.

From that day on I ate at Joe's every day, and so did she. If possible I would sit next to her, and it seems to me that, if possible, she would sit next to me. It became a lot easier, sitting next to her. I found myself squirming a lot on purpose. And asking her to pass the salt a bit too often. Sometimes I would drop my napkin.

"A chicken salad sandwich, please." (Why had she ordered

that again? This was the fifth day in a row she had ordered a chicken salad sandwich.) I smiled in her direction. She almost smiled back. I too ordered a chicken salad sandwich, in hopes that she would overhear my order. She was wearing a red dress.

The following weeks were filled with a lot of imaginary meetings and a lot of jerking off. Sometimes in bed, but usually outside in the backyard, late at night. Where it's dark and cool. I liked it out there best. I often wondered what it might do to the grass. I had visions of sudden dead areas. Or of sudden overnight growths. Giant patches of emerald green grass. Her body, as I imagined it, was all white and soft. It all just melted together. Like velvet. Solid velvet. Like solid foam rubber velvet. All that soft whiteness. I couldn't believe it, it was so beautiful. I would rub my face all over her tummy, hard, and she would tingle with millions of little goose-bumps. She really liked that. And her breasts—I would cup each hand around each breast and squeeze just a little and all of their softness would come between my fingers and I couldn't stand it it would be so good. Sometimes I'd come right then. Sometimes she had red fingernail polish on. Her little black triangle was very little and very black. Sometimes she would only let me put my fingers in it. But sometimes I got to do everything.

Then one day it was Nancy who dropped her napkin. I jumped off my stool and scampered to her feet, and there it was, all white and crumpled with little red smears. A smile took over my face. I said, "Here's your napkin." (Why am I smiling like a goon?) "Thank you," she said. Silence. I just stood there, smiling like a goon, and I knew that it was now or never. "Do you want to go to the movies tonight?" I said. She said "Yes." I couldn't believe it.

We went to the movies that night and saw an ordinary cowboy movie, but Nancy said she liked it. (I soon discovered that Nancy liked all movies.) We talked a little. "I'm a secretary," she said. I said "Do you like it?" and she said she did. I asked her why she was always ordering chicken salad sandwiches and she said

that she liked them. I told her that my father owned a hardware store. I couldn't tell if that impressed her or not. She was wearing a red dress.

I soon discovered that Nancy was always wearing a red dress. Except now and then. Then Nancy would wear green or brown, or some other color. When Nancy wasn't wearing red it didn't really matter what color she was wearing. Whatever color it was it would somehow be somehow gray. Like Canada. Canada is the most nothing place to me there is. All I can think of when I think of Canada is those big white mints.

We went to a lot of movies and ate a lot of pizza. It was her favorite food at the time: Pizza. After our first movie date she never ate another chicken salad sandwich. All she would say about it was that she just didn't like them anymore. And then there were Mexicans: hot dogs with chili. And after we got married I lost track. I do remember one chicken pot pie period. Endless chicken pot pies. (Morton's.)

Sometimes we would neck in the movies, but she wouldn't go very far. She said she was a Catholic, but she wasn't. She was a Baptist. I was raised a Methodist but if you want to know the truth, I don't even believe in God. I really don't. I don't know what I believe in. Actually, I do know, but I just don't know how to say it. What I believe in is something very big. Something bigger than anything.

I soon discovered that Nancy was hardly the cream of the crop to anyone else but me. My mother was horrified. "There's just something about her I don't like." My father, I think, feared that she was "loose." Becky, my sister, thought she was "tacky." I have a little brother too, John. And a big brother, Jim. He used to be a commercial artist, but he gave that up to teach elementary art to underprivileged negroes in St. Louis. "I don't care if you like her or not," I said.

I was born in Tulsa, Oklahoma in 1942. I don't remember much about being young except for this old man who would come around every now and then and take my picture on his

pony with a cowboy hat. I do remember school. I remember that for the first few years I liked it, and from then on I hated it. I remember this art teacher I had once who always wore brown. Brown tweeds and leather bracelets and bean beads and lots of copper pins and buckles. She had lots of keys hanging from her belt and I never could figure out where they all went to. One day she lost her temper and poured a bucket of water over a boy's head (he was always goofing off) and I couldn't believe it. Teachers just didn't do that.

When I started having erections I didn't know what they were. I thought I was sick or something. Then one day at school this chubby boy told me a dirty joke, something about pickles, and I put two and two together. That was a relief. He had one of those big white faces with little brown dots.

May Dye

May Dye married and now her name is May Linger of Oneco, Florida but when I knew May Dye her name was May Dye of Tulsa, Oklahoma. She was 8 and I was 8 and we sure did do weird things and we knew we did weird things and that is the way we wanted to do things.

In the summertime we figured that there were 293 ways of changing a dollar and that is what we did in the summertime and the drugstores and dimestores sure hated us and that is what we wanted them to do and that is what they did. We enjoyed it.

May read, she knew how to read, that a bird's feather was the strongest thing in nature for its size and weight and we tried it out and we decided that tho this might be true it wasn't saying much because we found breaking bird feathers quite easy and extremely enjoyable and we enjoyed enjoyable things in the most enjoyable way you can imagine enjoyable things as being enjoyed. We enjoyed discovering and we discovered that heavy water = H_2H_2O used in atomic research cost $8,000 a pint and then we didn't know what to do so we discovered that a $5 bill contained the names of 26 states on the facade of Lincoln's Memorial featured on this piece of currency and then we didn't know what to do so we discovered that a Texas ten-gallon hat holds only ¾ of a gallon and then we didn't know what to do so we discovered that pedwararbymthegadegaphedwarugain means "99" in the Welsh language and then we didn't know what to do so we discovered that brides in the Marquesas Islands march to the altar on the backs of the male wedding guests and then we didn't know what to do so we discovered that the fastest insect is the Australian dragonfly verified at 55 miles per hour. We discovered that a snail's pace is about a mile in 3 weeks and we decided that this was slow

and we decided that we hated snails. We discovered with pure joy that an ounce of oil can be spread in a film covering 8 acres. We discovered that we loved oil.

It is interesting to note that Chinese ore is notoriously deficient in phosphorus. It is interesting to note that we found that most things look good and that we found that there is not much you can do with art but hang it up and look at it or play with it or something. We found that we relied very much upon each new day being a new day. We were poor because we didn't have money but when we did "get" money we found that it didn't matter at all that we didn't have money before we got it. And if we lied and we did lie it was in order to make things easier and more enjoyable and we found lying extremely fun on certain days and that is why we did it and we knew we did it and we knew why we did it and that is why we did. May and I discovered that what one ought to do is what one wants to do and that is what we did. Especially on certain days we did that.

When now that I think about it I don't know what happened to the time but something did happen to the time and suddenly we were graduating from school and we thought this was very funny because we didn't know what it meant at all and it wasn't really what we wanted and it wasn't really what we didn't want either and we didn't know exactly what to do but there we were doing it. And after graduating we discovered that we were school graduates and that is not what we had meant to be at all but we were and we didn't know why we were. But we were. We were school graduates.

May Dye married and now her name is May Linger of Oneco, Florida.

Tonight is January the 3rd, 1964. Just home from the movies with a Pepsi in hand feeling sorta weird not good or bad wishing "something" would happen knowing that it is up to me. I feel horny too. When one arrives home from the movies one does the normal things one does do when one arrives home from the movies and that is what I did. However I didn't jerk off because

I wanted to save it for later and now I am writing. I live in New York and I will tell you that I have taste and that I work very hard and constantly at making collages because it is what I like to do most and I don't know what else to do. I lack the courage to talk words very much because they are terribly definite and final and I don't enjoy the risk. However I would enjoy the risk when I take it. I find that I rely very much upon each new day being a new day. I do not have a job and I do not have an income and I do not have money but I find that when I do "get" money it doesn't matter I couldn't care less that I didn't have it before I got it. And if I decide not to be a painter and I won't I would decide not to be a painter because of Andy Warhol and Marcel Duchamp because that is where I could easily end up if I let myself but there is not room there anymore so perhaps I go in the opposite direction but if so it is because of them and with love and it is really not as different as we think of opposite as being because at least we have opposite in common. (Thank you.) I assume that we have very much in common and that is what I want to assume and assuming that we have very much in common perhaps you know me better than I think you do. And that is a good thing. And if I love you and I do it is not by choice alone altho if I did have a choice that is what my choice is.

Colgate Dental Cream

Jimmie: Aw, mom . . . I only told him he has bad breath!

Mother: But Jimmie—tell mother! Whatever made you do such a naughty thing?

Jimmie: Well, Aunt Mary said Mr. Reed was nice—only he oughta go see his dentist about his breath—so I told him!

Mr. Reed takes Jimmie's tip . . .

Dentist: Tests show that most bad breath comes from decaying food deposits in hidden crevices between teeth that aren't cleaned properly. I recommend Colgate dental cream. Its special penetrating foam removes these odor-breeding deposits. And that's why . . . Colgate dental cream combats bad breath! You see, Colgate's special penetrating foam gets into the hidden crevices between your teeth that ordinary cleansing methods fail to reach . . . removes the decaying food deposits that cause most bad breath, dull, dingy teeth, and much tooth decay. Besides, Colgate's soft, safe polishing agent gently yet thoroughly cleans and brightens the enamel—makes your teeth sparkle!

Later—thanks to Colgate's

Jimmie: Boy! This glove'll knock the team's eyes out, Mr. Reed! I'm sure glad you're going to be my uncle!

No bad breath behind his sparkling smile—

Mr. Reed: And no toothpaste ever made my teeth as bright and
clean as Colgate's!

Brunswick Stew

Jane was telling her mother all about her date the night before. The young man had taken her to a very expensive restaurant and then to the newest musical comedy. After the show they had gone to a supper club to dance and she didn't get home until three A.M. It was the best time Jane had ever had in her life. "And I'm sure," she said fondly, "that he's in love with me, and that he's going to ask me to marry him!" Jane's mother smiled fondly. "Oh, darling," she said fondly, "don't be ridiculous! How can you tell? After all, it's only the first date." Jane smiled smugly. "Oh, I know he loves me because he said my dress was too tight, too short, and cut too low." A dish that won't be too hard on a tight, short, low budget is a chicken stew which for some unknown reason is called Brunswick Stew:

> One chicken, 4 to 5 pounds, disjointed or parts
> Maybe some cooking oil or butter or margarine
> (but chicken fat is best)
> 2 large onions, chopped
> 6 cups boiling water
> 1½ teaspoons salt
> ½ teaspoon pepper
> 2 cups canned tomatoes
> 2 cups whole kernel corn
> 2 cans lima beans

Some people cook the Brunswick Stew with potatoes and cooked beef, some add wine to it. As I said, I don't know why it's called Brunswick Stew. There were a lot of dukes and things named Brunswick, and maybe one of them was a stew.

Sick Art

Mona Lisa's smile often causes observers to overlook the fact that she has no eyebrows.

One skin specialist offered the suggestion that Leonardo da Vinci's model was suffering from a skin disease called alopecia. Alopecia is a skin disease in which one has no eyebrows.

On the other hand, many women in those days shaved their eyebrows and Leonardo da Vinci's model may have just been following the fad.

There is no doubt, however, that Rodin's *The Thinker* has bunions on both feet.

Today, with modern art, it is not so easy to spot diseases and physical disorders.

Many doctors, however, have noticed a strong relationship between various skin diseases and the paintings of Jackson Pollock.

Fungus infections are very common in the art of the Middle Ages and the Renaissance.

Sunday,
July the 30th, 1964

"Roger!" and that was all I said. I didn't know his name and he didn't know my name.

"Jack!" he replied.

It was beautiful the way it just "happened." We were both wrong of course. My name is Joe and always has been. Always will be. And as I later discovered, his name was Bill. Or rather, *is* Bill. He is still quite alive. I ran into him just the other day going due north.

"Terribly sorry!" I said, helping him to his feet. He didn't recognize me and I didn't recognize him. Under normal conditions we would have parted immediately except that during the bump into one another his hat fell off and went rolling due south onto the street where the cars are. A bus ran over it, flat, and I felt terribly responsible.

"May I buy you a new hat?" I said, helping him brush our city dirt from his pretty trousers. "A brown one?"

"No, a black one," he said, "I've always wanted a black hat."

A black hat, I thought, how strange! I remembered Roger: Roger had always wanted a black hat just like his daddy's. During the moment's pause I had a chance to recall our first meeting: Times Square, 1951, a triple bill; three Westerns. Roger, I thought, where are you? Little did I know . . .

"Certainly," I replied, "I'm terribly fond of black hats myself you know!"

"Really?" he said. I came back quickly with a reply. *Too* quickly.

"Yes, I really am terribly fond of black hats myself," I said,

squinting at the empty sky. Terribly blue, I thought. I should be able to see *something* by now, but there is not a sign—just nothing. Noticing my interest in the sky he grunted his acknowledgment:

"Yes. The sky. The sky is terribly blue and empty today."

"Blue and empty?" I replied quickly, *too* quickly, forcing myself to dismiss the speculation and to concentrate on the black hat. So, he thinks the sky is terribly blue and empty today does he?, I thought. This gave me second thoughts: after all, the hat I so kindly offered to replace *was* brown. Brown: such a funny color. Almost not a color at all. Nobody really hates brown. And nobody really loves it either. I mean, nobody would dare give brown as their favorite color. Brown is like Canada. Who wants to go to Canada? Canada: somehow I've simply no vision of what Canada really *is*. Like a marshmallow. We live with them. We buy them from Camp Fire girls. We even roast them. But who cares? I mean, who *really* cares? Brown. Canada. Marshmallows. And Sunday. Sunday is like that too.

Example: consider this fact. In the short time it will take you to read this story or article or whatever it is going to be, over 2,000 accidents will take place. Over 440,000 will occur before the day ends. These accidents must be investigated.

You know, sometimes like today (it is Sunday) it isn't even wise to walk out the door. Sometimes, on Sundays, like today, I just feel like sitting down and writing and I've not the faintest idea what to say. Just what is this thing about Sunday anyway? The silence. And the air. I never will understand Sunday. Besides, I have a terrible hangover. And so does Francis Vickers, my wing-man, who is on "hot intercept" duty with me at the field on Mondays and Tuesdays and alternating Fridays. Holidays excluded.

Francis Vickers! He is a real swell guy. A wee-bit of a nut, but a real swell guy. Gray at the temples. Slim and attractive. A typical illustration of how they operate. And with *very* little effort. So, where lies the truth?

Ah-so! *The Truth.*

You take Matisse for example, now he is the truth. Matisse says, "Look how beautiful!" and he really is quite right you know. Matisse paints the truth. In the most truest way. And he proves it. And so if you say to me, you say, "Why is Matisse a truly great painter?", this is why.

Another great painter I know well is Juan Gris. The very best thing about the paintings of Juan Gris is that you can see the work in them, the conflict in them, the way they were painted and why. Juan Gris "did a lot." I am especially fond of painters who do a lot. Juan Gris is not a perfect painter. Perfect paintings are really quite boring and bad paintings quite often turn out to be the best. Juan Gris doesn't simply paint pictures: Juan Gris allows you to understand his work well. "Thank you."

Thank you Marilyn Monroe for being so much what you are, rather than what you were. For being so white and so much fun.

It really is fun to be absolutely honest isn't it sometimes? Like playing doctor in the closet. Like, this is the *absolute-unspoken-till-now-truth*: I don't love people nearly as much as I should. I know that. And with very little effort you can make yourself look like a (continued on page 65).

What we need is a new topic.

I am a firm believer in the power of positive thinking. I know that I am in no position with myself to say that the recently published *Sonnets* of Ted Berrigan are absolutely great, but I also know that they are. (*The Sonnets* by Ted Berrigan / Published by "C" Press / 630 East 9th St. / N.Y.C. / dedicated to me and with a cover design by me / $1.00.)

The Sonnets by Ted Berrigan are very much written with words. (Example: "boy.") That a single word ("boy") is not the same "boy" as you have known before is a very special thing. The way you are not too certain. And the way it hits home. A foreign friend. And really, "Yes" is the only answer. Ted Berrigan knows words well and he lets us know that we know words well, too.

There are many descriptive words that I could use to

describe *The Sonnets* to you. Familiar. Interior. (House-wise.) Perhaps plain. Collage. Realistic (Very-much-real). Exterior. Newspaper-like. Personal. Impersonal. And very much etc.* But I will not use any of these words to describe *The Sonnets* of Ted Berrigan. They do not allow that. There are too many "and"s and "but"s and "however"s and it is terribly confusing. *The Sonnets* of Ted Berrigan are not confusing at all. They are quite clear ("boy") and readable. And the tone of voice; I know that tone of voice; we live it. What is there is very much there and what is not there is very much there too. If I do not seem to be saying anything it's really quite logical that I do that. The *Sonnets* are like that. They are surprisingly empty, like a shell, with room inside for the reader. Actually there is not much you can do with the sonnets of Ted Berrigan except read them. Read them again. And perhaps tomorrow if I feel like it.

I feel just like looking at the sea for now! The hypnotic lure of the sea has drawn many thousands from all over the world, just like you and me, to see. Ah, to see the sea again. To look at it. You know, the funny thing about the sea is that I can never remember what color it is.

*Bulletin Board. Calendar. Diary. A Day. A Week.

Saturday, December the 11th, 1965

I woke up this morning in Kenward Elmslie's house: top floor. We had toast and sausage and coffee. It was Suzy's day off. I looked outside the window and it was damp and dark but not raining, and I said, "Oh, no." It may rain. Then again, it may not. Sometimes very early in the morning it seems to me that everyone else in the world is still asleep.

I took a cab home because I had a little headache from drinking too much the night before at a party for John Ashbery, and I still do. It's nice to have John Ashbery back in New York City. I don't see why he should be anyplace else but here. But I didn't get drunk. I never do.

I picked up a tin of aspirins and a carton of Cokes, a pack of cigarettes, and a new light bulb because my old one went out. I usually drink Pepsi-Cola, but they have been on strike for over a year now. I shouldn't smoke so much. I have this terrible cough. My birthday is March the 11th: exactly three months away. I'll be 24.

I looked in the mailbox and there were two copies of *Granta*, a Magdalene College magazine (England) that somehow had two poems by Ron in it. Now that Pat and Ron are in Paris I get all their New York mail.

I got a long letter from Ron yesterday. He said that he was going to edit the next issue of *C* and that he would like to have something by me in it. I haven't been writing much lately because I've been busy working on *Japanese City* and Christmas shopping. New York City is so beautiful at Christmas. I wouldn't trade it for anything. So I decided to spend some time today writing.

Everyone loves a strong man—but not if he is strong simply because he has not washed under his arms lately.

The classic Greeks invented the bath as we know it, and ever since then bathing has been a true mark of cleanliness.

A lot of suds have dribbled down the drain since ancient Rome where in public pools 3,000 bathers bathed together. These coeducational splashes became so scandalous that during the Middle Ages people switched to perfumes and pomades to veto B.O., and Czar Peter the Great of Russia toured Europe "laden with jewels and lice." Mixed bathing today is confined to Japan and Finland.

When I got upstairs I put in my new light bulb and walked around on my four new scatter rugs so they won't be quite so bright. I have four new scatter rugs. I watered my plants and changed my sweater and sat down in my director's chair and read *The Platonic Blow* by W. H. Auden. I was surprised at how easy it was to read.

Van Gogh

Who is Van Gogh?

Van Gogh is a famous painter whose paintings are full of inner turmoil and bright colors.

Perhaps Van Gogh's most famous painting is *Starry Night*: a landscape painting full of inner turmoil and bright colors.

There are many different sides to Van Gogh, the man.

When Van Gogh fell in love with a girl who didn't return his love he cut off his ear and gave it to her as a present. It isn't hard to imagine her reaction.

Van Gogh's portrait of a mailman with a red beard is probably one of the most sensitive paintings of a mailman ever painted.

It is interesting to note that Van Gogh himself had a red beard.

When Van Gogh was alive nobody liked his paintings except his brother Theo. *Today* people flock to see his exhibitions.

Van Gogh once said of himself: "There is something inside of me—what is it?"

PEOPLE OF THE WORLD: RELAX!

BY JOE ★ BRAINARD

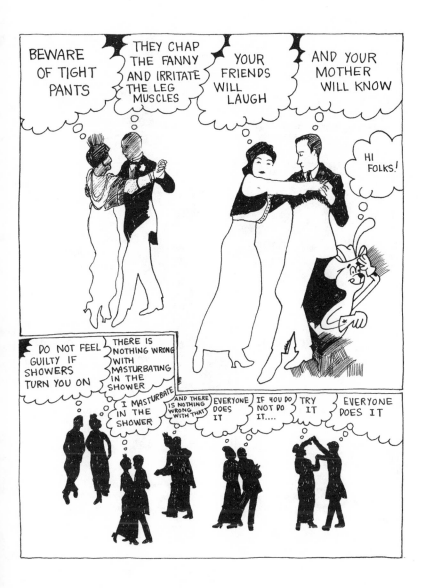

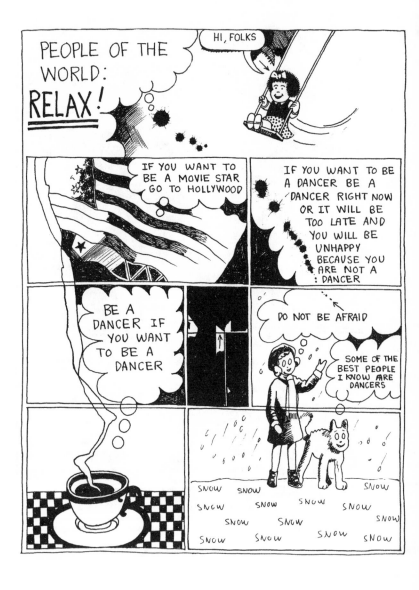

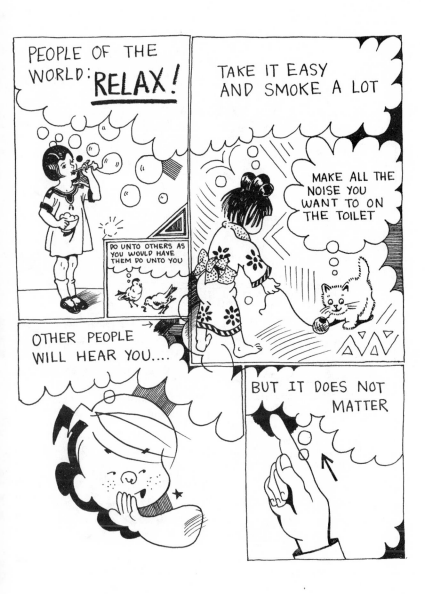

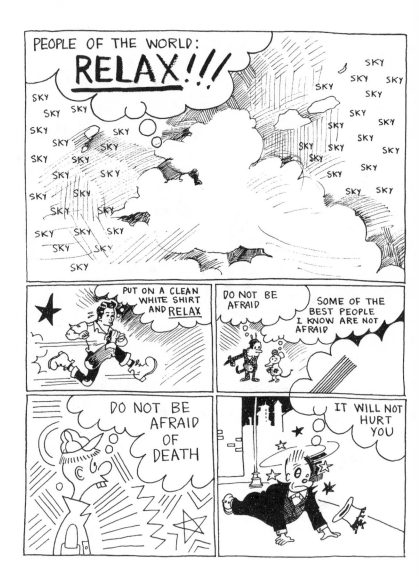

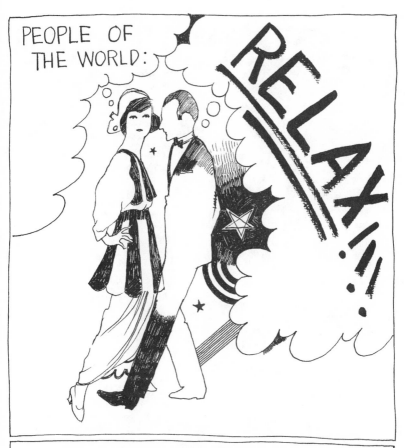

THIS IS A GOOD LIFE. GO OUT-OF-DOORS A LOT. SMELL FLOWERS. SIT DOWN IN THE GRASS. IT WILL NOT HURT YOU. LOOK AT THE TREE. THE SKY IS BLUE. CLIMB EVERY MOUNTAIN. AIR IS THE ONLY HOPE. DO NOT KILL ANTS. THEY ARE YOUR BEST FRIENDS.

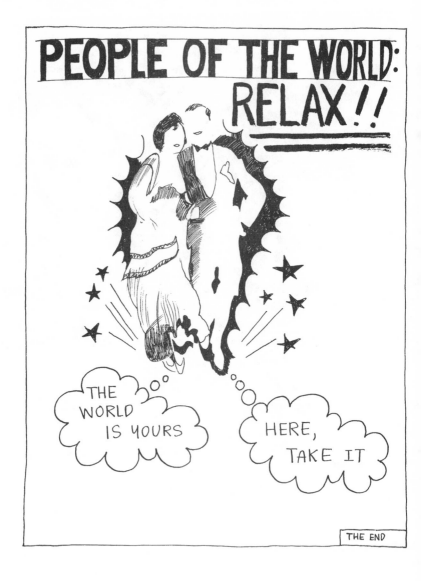

Ron Padgett

Ron Padgett is a poet. He always has been a poet and he always will be a poet. I don't know how a poet becomes a poet. And I don't think anyone else does either. It is something deep and mysterious inside of a person that cannot be explained. It is something that no one understands. It is something that no one will ever understand. I asked Ron Padgett once how it came about that he was a poet, and he said, "I don't know. It is something deep and mysterious inside of me that cannot be explained."

January 26th, 1967

Today is a holiday in Australia. It is called Wattle Day. What is a wattle? A wattle is an acacia. Acacias are leguminous shrubs and trees of the Pulse family. There are several families named Pulse who live in Brooklyn, and one of them has a candy store. The wattle in Australia is valued for its hardwood timber. In the early days of Australia's settlement by Englishmen, the pliable branches were woven into the houses and fences. Australians are warm and hospitable people. The reason today is Wattle Day in Australia is because it is around now that the wattle comes forth with a blossom that is the country's national flower. I don't know what they "do" on Wattle Day in Australia. An American named Irving Berlin once wrote a song with the word *wattle* in the title, but it was spelled different.

Pat

I can imagine Pat Padgett picking her nose and eating it. I can imagine her making squeaky noises to herself when she is alone, picking her toe jams, munching on fudge, in a small animal sort of way. Perhaps squatting in a corner. I have, however, never seen Pat do any of these things, except eating fudge. I have seen her do that. She would look good in a box. When she laughs, sometimes it is a little spooky, and sometimes not. She is not a bore. She is extraordinary. It seems to me that what she is is based totally on herself, and nothing else. If it is possible to be born the way you are, Pat was. Pat doesn't like to get up in the morning. She is beautiful and smart. I love her. When she was a little girl the nuns at school called her "The Little Flower." They were almost right.

August 29th, 1967

I'm outside sunbathing on Kenward Elmslie's lawn in Calais, Vermont. I would say that it's about 10 o'clock. I'm all covered with suntan lotion. The sun is not shining. The sky is total gray clouds. You never can tell about Vermont, tho. It might clear up at any moment. Wayne is crying. Now he's laughing. Wayne is Pat and Ron Padgett's new baby boy. They're up here too. And so is Jimmy Schuyler. He's still asleep in the front bedroom. Kenward is down at his work cabin working (I think) on collaging a table with magazine ads from the '20s and '30s. Ron (in white gym shorts) just stood up and said, "Well." He smiles at me, meaning "No sun" and goes inside. I bet, for a Pepsi.——I was right. He is coming back out now with a Pepsi. There is a hummingbird over there on those yellow flowers by the "Emslie Road" sign. I always forget how little they are. "Emslie" is local misspelling of Elmslie. Ron just went back inside the house again. Already I am thinking of this as a "piece of writing," and wondering if I can get by without really saying anything. And if so, how will I end it. Ron just came back out with a can of macadamia nuts. He says, "Do you want some?" I say, "No, how do you spell it?" He says, "M-A-C-A-D-A-M-I-A." So I wrote it down up there where I said "Ron just came back out with a can of . . ." I'm a terrible speller. I've been looking around me at all the dark green and I decided not to push myself. I'm just going to lie back and wait until something happens or until something comes to me that I really want to say.——

I heard someone going up the stairs and closing the bathroom door. It's probably Jimmy.——I'm going to listen real close and

try to hear all the sounds I can hear.——I hear birds chirping. The waterfall. Flies buzzing around.——Ron's hand in the macadamia nuts. Chewing. A buzz-saw very far away. The wind in the trees. Ron is reading Shelley. A car.——The hot water heater is doing something. Wayne is making little noises from his bedroom. There are bang noises from the kitchen. I bet Jimmy is making coffee. Another car. You probably think it's very noisy here, but it isn't really. Most of the sounds I'm telling you about you have to listen real close to to hear. Pat just came outside with Wayne under her arm and bottle in hand. (Milk.) Wayne is crawling to the macadamia nuts. Ron just said to Pat that Byron was only 5'8½" tall. Wayne is having a hard time with the macadamia nuts. He can't get the lid off. Little grunting sounds. I'm going inside to get another Pepsi.——

——I was right: Jimmy is up. He just made a fresh pot of coffee so I'm having coffee instead of a Pepsi. There is a tiny breakthrough in the sky.——Now it's gone. I hear an airplane. Jimmy just came out and is sitting on the steps with a cup of coffee. He announces a fresh pot and Pat goes in for some. Wayne is coming in my direction.——

I don't have an inferiority complex or anything like that, but for some reason I'm always trying to prove myself. I like to please people. One thing about me, I *really* am a nice person. At least I think I am. I think that a lot of people think that "being a nice person" is just a cover-up. I don't think so. Or, if it is, it's a better cover-up than most. At any rate, I enjoy being a nice person. I've got a lot of things wrong with me too. One thing I lack is morals. I have practically none. There is something that I lack as a painter that de Kooning and Alex Katz have. I wish I had that. I'd tell you what it was except that I don't know. I can see myself as a Cornell or a Man Ray, but somehow I doubt that I'll ever be a de Kooning or an Alex Katz. Of course, you never can tell. I work hard and

I'm smart. There is a hornet buzzing around me.——I love people a lot. It's good to know that. But I suppose that everyone does. I'm going to get corny if I don't watch out.

——You know what I'd like to have? I'd like to have a giant dick. A really big one. Not a freak one, just a really big one. I would say that mine is about normal, but I'd like to have a really big one. One thing I hope is that all people are pretty much alike. I'm no extraordinary person, and I'd like to think that all people think that about themselves. At least, most people. I mean, if it occurs to me sitting here that I'd like to have a giant dick, I'd like to think that other people would like to have giant dicks too sometimes. At any rate——

Ron just went inside with his blanket, saying it is going to rain. And it is. I can feel drops already. I guess I'll go inside too.

Jamaica 1968

March 2nd

Well, here we are in Jamaica. Kenward Elmslie, Jane and Joe and Elizabeth Hazan, and myself. What I feel right now is that perhaps I shouldn't be here. That perhaps I have no right to be here. That perhaps I don't deserve to be here. I felt much the same way about flying here. (BOAC.) It occurred to me that perhaps I had no right being up in the sky where I was.

March 3rd

Our house is a little house up on top of a big hill. All white and modern with very little furniture. Except chairs. There are chairs everywhere. There are thirteen chairs just in the living room alone. We have a swimming pool and two maids. I don't like having two maids. I can't ignore them. It seems that I am continually saying "hello" to them. There are buzzards that fly very low. And geese. They come around and drink from the pool, quack, and do enormous piles of green shit. And there are brown goats, and beautiful peacocks. I would say about a hundred of them. I have never seen anything more beautiful.

March 4th

I'm outside sunbathing. There is a goose over by the swimming pool. Jane thinks it is something else that does the green shit piles but I'm sure it's the geese. Just beyond the swimming pool is a drop-off area full of wild poinsettias. Beyond the poinsettias are green hills that slowly turn into blue hills. Beyond the blue hills is Montego Bay: the bay. Beyond the bay is Montego Bay: the city. Beyond the city is the ocean. And endless sky. We really do have a terrific view up here.

March 5th

The peacocks woke us up this morning with their various noises. They make incredibly loud sounds. Like a high honk-honk. And they jump up and down on our roof with their claws. Worst of all, tho, are their long tails that swoosh against the window screens. But Joe Hazan got up and shooed them away and we all went back to sleep.

March 6th

The peacocks woke us up again this morning. About six o'clock. They really are beautiful tho. Today I tried working on a cover for Ted Berrigan's new book of poems *Many Happy Returns*. Not much luck tho. It's hard to get down to brass tacks here because I don't really feel like I am here. I feel like I am no place in particular. A funny thing about Jamaica is that it's a hard place to believe in. I can't imagine its having a past or a future. (And hardly a present.)

March 7th

This morning we went to the Agricultural Fair in Lucea. Morris Golde said to be sure and go to Lucea. It was only eigh-teen miles away and a beautiful drive. The fair itself, tho, wasn't much. Mostly it was empty. There were some pretty pastel decorated cakes. Some 4-H girls all in green. And some other kind of girls all in red and white checks. Loud Methodist music from a Methodist booth. Big pink and orange velvet pillows. And Christmas cards sewn together into wastebaskets and wall pouches. Men pee a lot in the open. The young men here have beautiful rear-ends. There really ought to be a better word for rear-end than rear-end. Bottom. I don't like bottom, either. Or fanny. Or seat. Or posterior. At any rate, their rear-ends really are beautiful; high and tight and full. There is something very superior about them, and of course, sexy. I just remembered ass. I don't like ass either. The women here, I must admit, are not so beautiful to me. They really do carry big bundles on their heads.

March 8th

If Jamaica is not as beautiful as I thought it would be, I am not disappointed. I didn't really expect Jamaica to be the way I thought it would be. And, in all fairness, it's only a small part of it I am seeing. There are a lot of allspice trees around here. I always thought that allspice was all different spices mixed up together but it isn't. It's one single spice called allspice. Also there are pimento trees. Not the red kind you buy in jars but a spice called pimento. As I understand it, Jamaica is the only place in the world that it grows. There is a certain kind of fruit tree around here that if you eat the fruit before it is completely ripe, it will kill you. The flowers around here are not so hot really. Perhaps it's the wrong time of the year. Some of the leaves, however, are really fantastic. This one bush I especially like has big shiny red and black enamel-like leaves.

March 9th

The peacocks didn't come around and wake us up this morning. I've been working on a movie script for a Rudy Burckhardt movie about money starring Edwin Denby as a nice rich man. Not going so well. Sometimes in the afternoons we go for walks. Or, yesterday, a drive. To Montpelier. We couldn't find anything in Montpelier except the post office so we sent some postcards and drove back. The drive back was really beautiful. There were some really big tree trunks: fat and irregular. I especially liked the big clumps of bamboo trees that get more and more delicate as they go up.

March 10th

Tomorrow is my birthday. I'll be twenty-six. I have nothing against growing old that I can put my finger on except that I just don't want to. No peacocks again this morning. Elizabeth is better. Jane and Kenward have trouble sleeping at night. I am outside sunbathing. I want a good tan to show for my trip. Sometimes I have the feeling that I'm not really a very good artist. Most of the

time, I admit, I paint to keep busy. I hope that in the future I will rely more upon inspiration. Perhaps I've been swamping it.

March 11th

Today is my birthday. Tomorrow I will be back in New York City. Jamaica? I like it, but I'm not nuts about it. Next time I go someplace big I'd like to go to England. Right now I'm very anxious to get back to New York City and to all my friends. If you are one of my friends let me tell you right now that you are absolutely terrific. I know how lucky I am.

What Is Money?

(Words for the film Money *by Rudy Burckhardt)*

Money is a funny thing. It means many different things to many different people. Some people like it and some people don't. Most people do.

What is money? Money is what you buy things with.

There is an old saying that money is the root of all evil. There are two sides to every coin.

Mrs. R. P. from Salem, Arkansas says "Money is very important."

Mrs. N. S. from Hollywood, California says "I don't know what I would do without it."

Mr. J. H. from New York City, New York says "Money is the root of all evil."

Miss P. S. from Tulsa, Oklahoma says "Money is not the root of all evil."

Mrs. E. R. from Dayton, Ohio says "I like it."

Mr. J. B. from Watermill, Long Island says "There are two sides to every coin."

Mrs. T. C. from Calais, Vermont says "Money is a funny thing. It means many different things to many different people."

What is money? Money is what you buy things with. Today we use paper bills and metal coins to buy things with. But what did people of long ago use to buy things with?

Cows.

From the stories of Homer we learn that the ancient Greeks used cows to buy things with. "How many cows is this house?" a Greek man would say.

Cows, however, were not the only things people used to buy things with. The Chinese used fish. "How many fish is this house?" a Chinese man would say.

The American Indians used colorful beads to buy things with. "How many colorful beads is this teepee?" an Indian man would say.

Then as time went on people got tired of carrying around cows and beads and stuff and so they invented the metal coin much as we know it today.

Metal coins were fine for buying little things, but if you wanted to buy a house, or something expensive, it was very impractical. "How silly it is to be loaded down with all these heavy metal coins" they said. And so they invented the paper bill much as we know it today.

Even today, however, the natives on the island of Yap use large stone wheels to buy things with. Each stone wheel weighs 1000 pounds and will buy 10,000 coconuts.

Have you ever heard the expression "As queer as a three dollar bill"?

There is no such thing as a three dollar bill.

I once read about a rich man from upstate who went bankrupt and jumped out of a window. When they were digging his grave they struck oil.

There is an old saying that money is the root of all evil. I would say that the root of all evil is money . . . and bad women.

And sometimes even good women.

I once read about a pastor's wife from upstate, a good woman, Methodist, who won a cereal contest, bought a little printing press for Sunday school bulletins and song sheets, and ended up a counterfeiter. Rather than face ten years in jail she shot her husband in the head and jumped off the steeple.

Alexander Hamilton, the first Secretary of the Treasury, founded the first bank of the United States. It was called "The First Bank of the United States."

Money. What is money? Money is what you do with it. Some people save it and some people spend it. Some people invest it. Some people put it in the bank. I once read about a man from upstate who ate it. He died several years ago, donating his body to medicine, and they built a new hospital.

Money. What is money? Money is really very much like life. Nobody understands it. And death. What is death? Death is really very much like money. Nobody understands it.

I once read about a man from upstate who bought a rock for ten thousand dollars.

Little-Known Facts about People

Did you know that Kenneth Koch's wife Janice used to be an airplane pilot? Once she had to make an emergency landing on a highway.

When Kenward Elmslie was a kid he wanted to be a tap dancer. Did you know that Kenward's grandfather was Joseph Pulitzer?

Kenward once told me that Jane Russell is a dyke.

Andy Warhol wanted to be a tap dancer when he was a kid too.

D. D. Ryan wanted to be a ballerina.

Did you know that Pat Padgett was Ted Berrigan's girlfriend for years before she married Ron?

Ron Padgett and I were in the same 1st grade class together in school in Tulsa, Oklahoma.

Ron's father, Wayne, was a notorious bootlegger in Tulsa until Oklahoma went wet.

A few years ago Ron's father got divorced and married a beautiful Las Vegas showgirl younger than Ron's wife Pat.

Did you know that Bill Berkson was once bat boy for the Yankees?

Ted Berrigan married his wife Sandy after having only known her for five days.

Did you know that the first poems John Ashbery ever had published were published in *Poetry* magazine under the name of Joel Symington?

Did you know that Bill Berkson was on the "100 Best Dressed Men" list of 1967?

Rudy Burckhardt once dated Miss Vermont of 1938.

Donald Droll is in some way related to Daniel Boone.

Frank O'Hara once told me that what he really wanted to be was a concert pianist.

Did you know that Harry Mathews started out to be a composer? He studied at the Juilliard School of Music.

Edwin Denby was born in China.

Anne Waldman's father wrote a book called *Rapid Reading Made Simple*.

Tom Veitch's father writes Christmas card verse.

When I was a kid I wanted to be a fashion designer, a minister, and an artist.

Peter Schjeldahl's father is very famous in the plastic area. He discovered the new lightweight plastic used in Bufferin bottles. Soon he hopes to open a contraceptive factory in Red China.

Did you know that Bill Berkson was once on *I Remember Mama*?

D. D. Ryan went to see *The Boys in the Band* with Jackie Kennedy just a week before she married Onassis.

John Ashbery was a quiz kid.

Kenneth Koch once won the Glasscock Award.

Did you know that Ron Padgett has blebs on his lung which may explode at any moment? They have exploded twice already.

Tina Louise once sang "I'm in the Mood for Love" to Bill Berkson over London broils at P. J. Clarke's.

Did you know that Ted Berrigan did his thesis at Tulsa University on George Bernard Shaw?

Did you know that the Katz Tumor is named after Ada Katz who discovered it?

Edwin Denby once performed in Berlin's "Wintergarten" billed as "Der Amerikanische Grotesktaenzer Dumby."

Yvonne Burckhardt was the backstroke swimming champion of Connecticut for one week.

When I lived in Boston I used to panhandle on the street where all of the art galleries were, and I got my cigarette butts from the urns in front of the Museum of Fine Arts.

Did you know that Ted Berrigan's first book of poems, *A Lily for My Love*, was published by the Lenox Bar in Providence, Rd. Island?

Greta Garbo once called Bill Berkson her ice cream man.

I once went to a "come as your favorite person" party as Marilyn Monroe.

Did you know that John Ashbery once worked in a cherry canning factory?

Diary 1969

Sunday, March 30th
 The sun is coming out. Today is Sunday. I feel good today,
but sort of empty inside. Sundays often do this to me. I don't
know why. Sundays, actually, are no different for me than other
days of the week. But somehow there is a difference. It's more
quiet. There is a yard outside my window and usually I can hear
birds. Actually, there are several yards out there. A whole series of
yards. At any rate, I don't hear any birds this morning. I live on
Jane Street. Jimmy Schuyler and I went uptown yesterday to see
some shows. It made me realize how tired I am of art. I bought
a beautiful big blue and white marble which pleased me more
than any of the paintings we saw except for a Bonnard at the Met
which I had never seen before. Of three ladies and a lavender tree.
I don't mean to say, of course, that the marble is better than all
the paintings we saw except for the Bonnard. I just mean to say
what I said. That it pleased me more. My flu is gone. I wrote three
letters this morning. I don't like to talk against art, as it is now,
today, just because I don't, but something does bother me and
that is the more intellectual minimal stuff. Like earth works, etc.
I wonder who needs it? I am, at the moment, pretty much off art
for art's sake. I've had all I want. But I guess if you really love art
it makes sense, and is interesting. It surprises me tho that there are
that many people left who love art that much. I feel something
much lighter in the air. Fun. No bullshit. And lots of sex. I don't
mean to pick on art in general. Only when it starts taking itself
too seriously. I suspect that years and years from now people are
going to find themselves stuck with a lot of snotty art. As for me,
I love de Kooning. And his generosity. But there is one thing
about life I am sure of. There is always somebody to appreciate
anything and anybody. I really don't, you know, believe very much

in good and bad. I believe in what people need and I guess people need all sorts of different things. But I still don't think that art is all *that* interesting.

Monday, March 31st

This morning I got locked in Kenward's bathroom and couldn't get out. I practically kicked the door down when Jimmy heard me from the top floor and came down and let me out. Not a very good way to start the day. Today looks like another beautiful day. Sunny and cool. It is, I would say, about eleven o'clock. A lot of things are closed today because today is a national mourning day for Eisenhower. This means no mail today. Which means more mail tomorrow. For breakfast today I had an English muffin with honey. And a vitamin-B pill. Not much is new. I just feel like writing. But I'm afraid that I haven't much to say. Tomorrow is my day to teach. Tomorrow is April Fool's Day. Sunday is Easter. April 27th is Kenward's birthday. May the 29th is my brother's birthday. My older brother, Jim, who lives in St. Louis. We aren't very close. I can't wait for summer. Summer and fall to me are like new years. Fresh starts. Like beginning all over again. I do believe in fresh starts, even tho I know better. I *am* an optimistic person, partly, I am sure, by choice. This is better, tho, than being pessimistic. Both, of course, are silly, but, I suppose, necessary.

Tuesday, April 1st

Today is April Fool's Day. This morning for breakfast I had an egg and some cinnamon toast and some coffee. Tangerine-grapefruit juice and a vitamin-B pill. It is about nine o'clock now, and I am having another cup of coffee and writing this. When I finish writing this I'm going to work on the cover for Ron Padgett's new book of poems *Great Balls of Fire*. I like that title. This evening I'm not going to do anything that I know of. Tomorrow is Anne Waldman's birthday. And John Giorno's event-reading at the church. The other night, in bed, I was thinking about nothing in particular and I decided to try to visually realize how complicated and intricate the world really is. Like

every now and then, when you see a big modern apartment building, and you get a sudden flash of all that is going on inside the building. All the little rooms and all the many little people each with lots of thoughts going through each of their heads. Needless to say, I couldn't do it. (Visually realize all of this.) When I lived in Boston years ago I used to lie in bed, eyes closed, and try to concentrate on one color until that color was all I could see. Say, for example, red. You close your eyes and think about red until red is all you see. Red and yellow and orange are easy colors to see. Some colors, I remember, were impossible. Anne Waldman said the other day that if she died tomorrow she would feel as tho she had lived a very full life. I don't know why I'm telling you this. We were just chatting. It wasn't even a very serious discussion. There is nothing that gives me the creeps more than hospitals do. I don't know what I will do if I ever have to have an operation. It's the visual part that gives me the creeps. The off-white walls. The rubber gloves. And the silver instruments. I think I would rather die than have an operation. This, of course, is too easy to say. Let me tell you that it *is* a beautiful day today. Every day this week has been a beautiful day. Today, however, is only Tuesday. Usually I teach on Tuesdays but this Tuesday, today, is spring vacation. And so is next Tuesday. But today—I especially like today—it's cool and crisp, like autumn, and sunny, like summer. I like this combination. Actually, I suppose this combination is "spring."

Friday, April 4th

Have you ever noticed how much Allen Ginsberg uses "black" in his poems? I just read *T.V. Baby Poems*. And "white" too. But not as much as black. The other day, reading Jimmy Schuyler's new book I noticed how often he uses "rain" or refers to rain. The mood (moods) of rain. Ron Padgett uses blue a lot. Kenward Elmslie has used asparagus a lot. It makes your pee smell funny. So he says. I cannot remember exactly what today is called but it is the day Christ died. "Good Friday" comes to mind, but that doesn't make sense. At any rate, Sunday is Easter. It's a

beautiful day outside today, but I feel terrible. Depressed. There is a reason I feel this way, but I can't tell you. I really wouldn't mind being dead today. If one could be dead for a day. It would be nice to give my head a rest. It feels very full of "stuff." I'm being melodramatic. I'm sorry. But that's exactly how I feel. So, I'm not sorry. Too many hang-ups. I don't like that phrase "hang-ups." It's a phrase people I don't know use. This morning for breakfast I had a honeybun, some orange juice, and some coffee. There are people in the garden sawing. Otherwise it's a very quiet morning. Perhaps, because of what day it is, people who work are sleeping. I'm going to stop now, water my plants, and try to get some work done. I feel better already. Actually, I don't.

Sunday, May 4th

I wish that today was yesterday. So this weekend would be longer. I'm out here in Westhampton with Kenward at his beach house. Yesterday, Saturday, was too cold to sun, but today is just right. So—I'm out on the deck, sunning. It is eleven o'clock. I plan to sun until one. Not too much the first day. Don't want to peel. You know how, driving in a car, you think of things that you would never think of, unless you were driving in a car? I mean, that way your head gets empty. Open. At any rate, driving here from the city (Kenward drove) (I don't drive) it occurred to me that I think of myself as some sort of visitor here on earth. I mean like that everyone else belongs here but that I'm just passing through. What a bunch of shit that is. It is possible, of course, that we all think of ourselves this way. (As visitors.) I wonder. As always, I wonder just how much other people think the same things that I think. It really *is* a beautiful day today. I got up this morning at 7:30 and had an egg, a cinnamon twist, a half a grapefruit, and a cup of coffee. That is a big breakfast. Then, after breakfast, I did some drawings and started re-reading *The Sun Also Rises* until suddenly it all came back to me, loud and clear, and so I stopped. And then I read about half of *My Father and Myself* by J. R. Ackerley. It's less sensational than I thought it

would be, but I like it. I like it a lot. If this writing is a bit boring
it's because I'm in a very in-between state of mind these days. I
feel very much on the verge (at last) of being a little more free
of myself. But not quite. I mean like, more open, less nervous,
and more human. More vulnerable. It may be a perverse thing to
want, but that's what I want. I want to be more vulnerable. Frank
O'Hara. I think often of the way Frank O'Hara was. If I have a
hero (I do) it is Frank O'Hara.

Friday, May 9th

Today is a rainy day. Dark and cool. I feel good today. I
think that I would like to do nothing today. Something I rarely
do: nothing. But I'm too nervous. So I am writing. And after
I finish writing I'm going to try to finish the endpapers for the
Random House anthology. (An anthology of poetry Ron Padgett
and David Shapiro edited.) I have already finished the cover, and
I like it. It is a white cover with red words and objects. Float-
ing objects. Actually, the objects do not exactly float. They are
more stationary. But suspended. Suspended in space. A chair. A
cherry. A "modern design." And a butterfly. Somewhat by acci-
dent, I have broken every rule of good design. (Which pleases
me.) This happened, I think, because I did the cover very slowly.
Object by object. Over a period of five or six days. With no (or
little) finished product in mind. One object or one word told me
where the next object or word would go. Allowing little room
for "dash" or "inspiration." The result is clean and unprofessional
in a good way. And cheerful. The endpapers will also be red on
white. Red objects on white paper. There is (so far) a feather, a
pansy, a lipstick kiss imprint, and a boot. Each object cancels out
the other objects. But not too much. Only in importance. Each
object is equally important. (Visually.) Kenward and I plan to go
to Westhampton this weekend. I do hope it will be sunny. I can't
wait for summer. Summer and fall, to me, are like new years. And
I need a new year.

Sunday, May 11th

I am in Westhampton sitting at the dining room table in front of the big picture window overlooking the ocean. Today the ocean looks very gray and harmless. I am not afraid of very many things, but the ocean is one of them. Actually, I am not afraid of it, but you couldn't pay me to go into it. It's just one of those things I don't understand. Like electricity. It's just too big. It is beautiful tho. Today is not what I would call a beautiful day, and yet, it is. Beautiful. Quiet. Cold. And gray. A white gray. What I would really like now, tho, is some sun. I feel like I need it. Like, some mornings, I just feel like I need orange juice. This morning there wasn't any. For breakfast I had a glass of milk, a piece of chocolate cake, and a cup of coffee. Yesterday I did some brush and ink drawings of various objects I found on the beach. A rock. A feather. Some seaweed. Shells. And some other things. And then I took three long walks up and down the beach collecting pieces of wood and stuff for constructions I will never build. Then Kenward and I went for a drive to a few antique shops where I found a set of Maggie and Jiggs pepper and salt shakers. I collect figurines of comic characters. And then for supper we had chili. I made it. From a can. But I added real meat to it. And onions. Then we watched some T.V. So much for yesterday. For today I plan, as I am doing now, to write some. To walk some. And to read some. I want to talk about something more serious (personal). Like what I believe in. I don't know. Every time I try to figure out what I believe in—it's just too complicated. But I know what I like. I like people, and I like people to like me.

Saturday, May 17th

I haven't written at night in years. I work in the daytime. And writing is work. But it's nighttime now. Actually, it isn't, it's morning. Very early morning. 1:35 A.M. Which means that, actually, today is Sunday. At any rate—I just want to tell you that I feel terrible. Sad. Unhappy. And depressed. If I don't tell you this now you'll never know. By tomorrow it will all be too corny

to write about. So—I just want to let you know that, contrary to what I usually say, life is not always all that wonderful, and not always all that easy. Sometimes it really hurts. You know this. And I know this. And there is nothing to do about it, except write about it.

Tuesday, May 20th

This morning for breakfast I had a cup of coffee. Outside it is wet and hot. Sticky. The other day, as I think I told you, it occurred to me that I want to be more vulnerable. That is to say, more open to whatever happens. Well, I discovered that I *am* more vulnerable. More vulnerable, at least, than I used to be. And I'm not at all sure that I like it. I need it, but I'm not sure that I like it. I sure am talking about myself a lot. Of course, this is a diary, and that is what diaries are for. I guess. It is the only way I am able to write anymore. I just can't sit down and write a funny story anymore. I feel pretty good today. Better than I've felt for some time. And for no particular reason. I suppose that out of 365 days a year some of them have just got to be good, and some of them have just got to be bad.

Wednesday, May 21st

I feel good today, but a bit nervous. I'm going to read tonight with Bill Berkson at the St. Mark's Church. In fact, to tell you the truth, that is why I am writing today. To have more that is new to read tonight. I want this reading to be good because, just because I do, and because I feel a little bit bad about my show, and this reading, I hope, will help make up for that. (For it.) Not that I think my show was bad. I don't. I gave it everything I had. But it was rushed, and, basically, a bit false. I'm not really that interested in gardens anymore. (I just had a show of garden paintings and collages.) I *do* wish I didn't need to please people so much. But— to please other people pleases me too, and we all need that. To be happy. Actually, I believe pretty much in anything as long as it makes you happy. And there are some things that I believe in even if they don't make you happy.

Diary 1969 (Continued)

Friday, May 30th

I am out in Westhampton again. Not much is new. I just want to tell you how I feel. I feel good today. Calm. I feel as tho the world is not moving today (time out) and I don't care. I like it. It is about 12:00. I am outside on the sun deck, sunning. Today is Memorial Day. The groceries just arrived and Kenward (also sunning) went inside to tip the man. Whippoorwill is lying in the shade of the table. Two little boys are playing on the beach in front of me. Far enough away, tho, that I am not sure they are little boys. They may be little girls. I don't have my glasses on. The sun is hot. The wind is cool. For today there is nothing I want that I don't have. But there is a lot that I have that I don't want. It occurs to me today that the secret of life is to live as simply as possible.

Sunday, June 1st

Working on my Spanish construction again this morning it occurred to me how much I rely on "the work" itself to tell me what to do. So often when I work I just "do a lot of stuff" all over what I am doing (a painting, a collage, a construction, etc.) until something I do tells me what to do. That is to say, I just work off the top of my head until one flower, or one line, or one gesture gives me a clue as to what to do. Or, as to what I *am* doing. My work never turns out like I think it is going to. I start something. It turns into a big mess. And then I clear up the mess. This morning I didn't get up until 9:00. For breakfast I had bacon and eggs and coffee. I just remembered that I forgot my vitamin B pill. After breakfast I worked on my old Spanish construction

until 11:30. Now it is about 12:00 and I am outside in the sun. By "old" I mean that it is a construction I have been working on for several years. I don't really do constructions anymore, but this one I cannot give up on. It is made up of many beautiful things I got when I was in Spain. I only work on it when I am in Westhampton. That is not very often. Today is another beautiful day. Not so warm as yesterday. More windy. In fact, it is almost chilly. But, like I said, beautiful. Very clear. It would be hard to feel bad today even if I felt bad. The world seems so big today. Not in the "I'm just an ant" sort of way. But in a good way.

Monday, June 2nd

I didn't sleep too well last night. Because of my red back. Too much sun. And now I will peel. And have to start all over again. Today is a cloudy day. Heavy and wet. But not so dark. More white-heavy. I cannot complain, however, as the last three days have been so beautiful. (Sun.) Three days out of four. Can't ask for much more. (That rhymes.) This morning I got up about seven. For breakfast I had a soft-boiled egg, bacon, some sugar cookies, and coffee. After breakfast I tried to work on the Spanish construction, but no dice. It needs the sun. Or *I* need the sun. Today it looked very black. (The construction.) And it is. But not morbid. Today it looks morbid. I don't know what I am going to do for the rest of the day. Probably read some. And roam around a bit. (Outside.) Smoke a lot. And be nervous. Actually, I always smoke a lot. Tareytons. Very interesting. Kenward is in the bedroom reading *The Autobiography of Malcolm X*. And I am at the dining room table, facing the picture window, overlooking the ocean. But I cannot see it. All I can see is white. It is probably very thick ocean mist, if there is such a thing. Or ocean dew. (?) It is about 9 o'clock. I have been thinking a lot about what I want to do this summer. I'm going to make a list.

1. Oil paint
2. Gain weight
3. Exercise
4. Get a good tan

5. Do another issue of *C Comics*
6. Get together a manuscript for Lita Hornick
7. Try to let myself get closer to people
8. Keep this diary

Lita Hornick is "Kulchur Press." It is, I mean, her press. I think she wants to do a book of mine this spring or next fall. (Fall after next.) As of now I plan to call it *Self-Portrait*. That is because almost everything I write is about me. Even funny fiction stories I write are written in the first person "I." I must really be a conceited ass. But there is more to it than that. I want to tell you about myself. I need to *try* and tell you about myself. However, I don't seem to be succeeding. Sometimes, like right now, it seems that "the need to try" to tell you all about myself is perhaps all there is about myself to tell you. That I need to. (Tell you all about myself.)

Thurs. June 25th

I'm outside sunbathing in Calais, Vermont. I am lying on my stomach on a big white towel and all I can see is grass. Let me tell you now (and I'll try not to tell you again) that Vermont is beautiful. I'm so glad to be here. I can see a bumble bee every now and then, and some rocks. Vermont is so green. Like the reddest flower. This is what I had for breakfast this morning:

1 glass cranberry juice
1 poached egg
2 pieces oatmeal toast
1 bowl of wheat germ with fresh peaches and cream
2 cups coffee
1 vitamin B-12 pill

As I'm sure I told you, I'm trying to gain weight. Don't ask me why. (I just want to look better.) Vanity. Which, perhaps, is not such a bad thing really. Vanity. Some people would be better off if they had more of it. (?) I feel good today. The sun is out. This morning (it is afternoon now) I did some fuck drawings for a cartoon strip. I plan, this summer, to do one more issue of *C Comics*. Because two issues somehow doesn't seem complete.

(Enough.) Because I know I can do better. And because a lot of poets are going to be up here this summer, so it would be a waste not to. And because I find the new California comics coming out now very inspiring. Especially Crumb. Not always so good, perhaps, but inspiring. Especially sex. There *is* a new freedom. And I plan (slurp) to take advantage of it. As for painting, right now, I'm going to cool it. For once in my life, I'm just going to sit around and wait for inspiration. I'm not going to "make" any paintings. Painting is not going to be what I "do every day."

July 4th 1969

 I am outside sunbathing. Whippoorwill is stretched out on the grass to the left of my feet. In his own way I suppose he is sunbathing too. He does seem to love it. Anne and Lewis are here. (Anne and Lewis Warsh.) Anne is off to my right, sunbathing, on a green lounge chair in a leopard nylon bathing suit. (Two-piece.) She is reading a book. Lewis, too, is reading a book. Right next to Anne. On a big white towel. But he has all of his clothes on. Kenward is off at the cabin. I always assume, when he is at the cabin, that he is working, but I am sure he does other things there too. The sun is out. And very hot. It is a beautiful day. There are many birds. Today is the 4th of July. I plan to do nothing today, unless the sun goes away, except sun. Maybe take some pictures. And write. I have been here now for almost two weeks and I have not started oil painting yet. But I am not going to rush. Push myself. There is no reason to. Other than nervous reasons. That are no good. (For now.) Partly I am waiting for inspiration. Partly I am afraid. Partly I dread being a beginner again. Partly I look forward to it. (Starting all over again.) As much as one can. Which I hope is a lot. Lewis went inside and changed into a bathing suit too. (Turquoise.) Knit. Meanwhile, I have moved from the green lounge chair to a white towel on the grass. Why am I telling you all this? I know it is boring. I suppose I think that such boring details can sometimes be funny. Just because they are so boring and so totally unimportant. Well—I will try not to do this so

much. This putting you on. Whether on purpose or by accident. If I have nothing to say I just won't write. No, this isn't true. I'm going to try anyway. But I *will* try not to be coy. I promise.

Tues. July 15th, 1969

 This morning is a beautiful morning. A clear sky. Blue and hot. It is about 10:30. I am sunbathing. Drinking a Pepsi. Smoking a cigarette. And writing this. There are a lot of bees this morning. This morning, drinking my coffee on the front steps, I saw two bees flying together as one. One on top of the other. Some men are sawing wood not very far away. I can hear their saw buzzing. Or, an echo of their saw buzzing. Like a car trying to start. My painting is not going so well. Oils. So, that is why I am sunning today. Instead of painting. I need a break. What I have been painting are wildflowers. In cream jars. The kind you don't see anymore. Except in Vermont. And places, perhaps, that I haven't been. What I am trying for, I think, is accuracy. That is to say, "the way things look." To me. This is really very hard to do. And, I imagine, impossible. What I really hope for, I guess, is that, by just painting things the way they look, something will "happen." That is to say, a clue. A clue as to what I want to do. In much the same way, I am writing this diary now. I am telling you simply what I see, what I am doing, and what I am thinking. I have nothing that I know of in particular to say, but I hope that, through trying to be honest and open, I will "find" something to say. Or, perhaps what I *really* hope for, is that the simplicity of this writing will be interesting in itself. Whether I say anything or not. Anything, that is, of any importance. However, being "open" is not so easy. Nor is being honest. Nor is being simple. Or being direct. I am 27 years old, and it shows. (Complications.) I am not in love with innocence, but I suppose I am in love with youth. I miss the confidence of youth. The "I know where I am going." And the "I know what I want." Perhaps as one gets older one regains this confidence. This "I know what I want." Perhaps one eventually *has* to. In self-defense. Make certain decisions.

Whether with confidence or not. (I don't know what I am talking about.) What I mean is that perhaps sooner or later one has to decide what one wants whether one knows (what one wants) or not. That is to say, a decision for the sake of a decision. I make little decisions like this all of the time. (Blind decisions.) But I am talking about big ones. Now that I think about it, however, I cannot think of what the big decisions are. Too much sun. I love it tho. Even if it does destroy your brain tissues. And makes you grow old faster: wrinkles. I don't really believe that anyway. And I don't even care much. Old age is not to be believed. Can you imagine yourself 60 or 70 years old? I can't. I imagine, rather, that I will die young: 40 or 50. Not because I *want* to die young. But because I can't imagine being old. So there is nothing else to imagine. Except dying young. Also, it is a bit more romantic. To die young. I just want you to know that the things I talk about in this diary are things I would usually not even think about unless I was (as I am) outside in the hot sun, trying to write, and with nothing in particular to say. I am not apologizing. I just want you to know that this is, in a way, forced writing. Words and thoughts just don't flow from me too easily. In this diary, when they do, fine, but when they don't, I'm going to be pushing.

July 29th 1969

Bill is here. He has been here for many days. But I haven't written in many days. Because of the weather. No sun. And because I decided not to keep this diary anymore. I guess I changed my mind. Before I forget—I want to tell you something funny. When Anne was here she named Kenward's lake "Veronica." ("Veronica Lake.") I die laughing every time I think about it. Bill and I are outside sunbathing in black bathing suits on white towels draped over green lounge chairs. The sun is not really out today but it almost comes out every now and then. So—if it does come out we are ready. Ever since Bill arrived (I forgot to tell you that Bill is Bill Berkson) we have had no sun at all. All rain and gray. So—even a hint of sun, like today, is nice. I haven't been oil painting at all since Bill arrived. But we have been collaborating

on some cartoons. A dream cartoon. And a de Kooning cartoon. Also an advertisement for "Vanish." (Cleans toilets.) Collaborating on the spot is hard. Like pulling teeth. There are sacrifices to be made. And really "getting together" only happens for a moment or so. If one is lucky. There is a lot of push and pull. Perhaps what is interesting about collaborating is simply the act of *trying* to collaborate. The tension. The tension of trying.

August 1st

Today is the first day of August. Sniff. July is over. I got up this morning at 6:30. I don't know why. The dew was very thick and beautiful. All white. Now, however, the sun is out. The sky is blue. And it is going to be a beautiful day. It is eleven o'clock. Ted Berrigan and Donna Dennis drove up (to our surprise) yesterday afternoon. So—they are here. You know that Bill is here. Kenward is at the cabin. Bill, Donna, and Ted are in the process of getting up. We all got very high last night and stayed up late playing charades. It was fun. And now I am out here in the sun (I just spilled my Pepsi in the grass) on a white towel. Now I am going inside for a new one. (Pepsi.)——Got it. They are eating breakfast now. For breakfast I had two poached eggs, a bowl of Grape Nuts with peaches and cream, and a piece of toast with apple butter. Kenward, by the way, is *not* at his cabin working. I just heard his laugh from inside the house. Let me tell you—it is *very* hot today. Ted just came back from Europe. (London and Paris.) He liked London best. He says that London is crazy about "The New York School of Poets," and me too. Someone there might want to do a book of mine. New topic.——I can't think of one.——But I will.——Sex. I think that sex should get out of the bedroom more. Out into other rooms. Or, at least, off the bed. (Slurp.) It is too easy "in bed" to just keep doing the same ol' stuff. One gets too lazy "in bed." Or, I should say, *I* get too lazy "in bed." I have a slight butt problem. My hole (evidently) is very small. So— a dick, or even a finger up it hurts. Perhaps pain is supposed to be part of the pleasure of anal stuff. (?) But, if so, I just don't get it. Perhaps it is partly my fault, as I find it hard (when some-

thing is up my butt) to relax. As I understand it, relaxing is very important. I don't usually find anal smells very exciting. Except every now and then. When I really get carried away. Which I wish would happen more often. There is nothing I find more beautiful than a really beautiful butt. Bill Berkson has a beautiful one. Well—now I am probably embarrassing you—as well as boring you. (?) I don't know. I am not embarrassing myself. I guess I just have to assume that if I am not embarrassing myself, I am not embarrassing you. And, actually, being embarrassed isn't so bad. I don't mind it. Being embarrassed. So again I must assume that if I don't mind it you don't mind it either. (Being embarrassed.) However, I don't believe very much in assuming. One of the many important things I learned from Frank O'Hara is how dangerous (and wrong) assuming is. One, really, doesn't have the right to assume anything about anyone. We don't know that much about other people. Why they are the way they are. And why they do the things they do. People are too complex to assume anything about. Suddenly I find that I have lost all sense of what "assume" means. If someone is crying you cannot assume that he is sad. (Tho he probably is.) That is what assume means. This is stupid. In life one simply *has* to assume things. Sometimes. I guess the important thing is to *know* you are assuming. (When you assume.) Really, I don't know what I am talking about. I just know that assuming *can* be dangerous if one is not careful. I see a big blue bag on the front porch. Does that mean that Donna and Ted are leaving? I hope not. I hope they are not going to stay very long, but I hope they will stay longer than this. Ted is terrific. Also he is exhausting. Often he is a bore. But I *feel* very close to him. I don't really think I *am* very close to him anymore, but still, I feel that I am. And this, tho a compromise, is nice too. Just feeling close. Actually, Ted and I have seen so little of each other the past few years that we haven't even had the opportunity to *be* close. I'm going inside for another Pepsi.——Got it. No, it is not a blue bag on the front porch. It is the laundry. (I didn't have my glasses on.) So I guess they are going to stay a day or two

more. Good. I want to be around Ted more. (Tho he drives me up the wall.) I like Donna. Tho I find her hard to talk to, and almost impossible to look at. This I don't understand as I love looking at people. And she is, I think, very beautiful. I think she knows it, but I am not sure. A big cloud just went in front of the sun. It is only a temporary thing tho. Bill is typing in the parlor. (His work room.) I know because I can hear it. I don't seem to be gaining any more weight. I stay at 145. You would think by now that I would know myself pretty well. Well, I don't. Or, if I do I don't admit it. I think I think that most of me is just temporary. So I don't bother to figure it (me) out much. Or worry about the way I am much. This is not true. I think about myself a lot. But I think about myself as I am *now*, not really believing for a minute that this is the way I will always be. And, to be realistic, I am probably wrong. I am probably very much now the way I will always be. From now on out it is probably just a matter of putting things (me) in order. Throwing out a bit. (I hope.) And pulling out into the open the best of me. I'm getting depressed. I'm sorry about the anal stuff. But, probably, I'll just edit it out. Or, maybe I won't. Personally, I like to read stuff like that about other people. Even if it is pretentious. And embarrassing. I want your approval. It's depressing (to me) but true. I need it. I want to please every-body all at once, and this is impossible. If I'm going to talk about my butthole I'm just going to have to accept the fact that some people will enjoy what I am trying to do and that some people will think I am full of shit. Bill just came out in a white bathing suit. He is reading *Confidential* magazine. Ted and Kenward are laughing in the house. I don't know where Donna is. Now I do. They (Ted, Donna, and Kenward) just came out and said they were going for a swim in the lake. It is not a very big lake. And full of dead twigs and trees. (It's a new lake.) Two years old. And Kenward said he saw a snapping turtle in it. Bill, now, is reading the *New York Times*. I told you, didn't I, what Anne named the lake? (Veronica.) I think I did. Ted just came back up from the lake and said "I'm an indoor man." Now Ted is reading the *New*

York Times and Bill is reading *Life*. I certainly have written a lot today. I'm going to stop now. I'm anxious to read about Ted Kennedy in *Time*.

August 1st

Yesterday was not the first day of August. Today is. A free day. Bill and I tried to collaborate this morning but it didn't work out. I got off into doing some sex drawings and Bill got off into writing some words on a drawing I did of a de Kooning lady with a "Little Lulu" head. You remember her. And "Tubby." Her fat friend. At any rate——the words were good but I have never been able to accept "words on a drawing" unless there is somehow a reason for them being there. Like with Larry Rivers, for example, words on his paintings are a *part* of his paintings. Visually. I mean, it is all one thing, first, and then you can read the words, if you want to. But with my work this doesn't work. My work, I think, is solid. And complete. Tight. All space is taken, empty or not. That is why I like the cartoon form. A cartoon *is* a cartoon. A cartoon is made up of words and pictures. This makes sense to me. Doing cover designs and drawings for books and poems is something else entirely. This I love doing. And I do it very well. I know how to work with or against words in a good way. I don't think I ever fall into the "elegant" trap. Or the "arty" trap. (Too beautiful.) (For the coffee table.) (Etc.) There is always something slightly unprofessional about my graphic work. Which is probably the best thing about it. My drawings for words do not fly off into being too beautiful in themselves. Sometimes I do this by being a bit boring. (Very straight.) Like in *The Champ*. By Kenward. And *Living with Chris*. By Ted. Another ploy of mine is to set up a little tension. But not too much. Tension can make things work well together. A little tension. Not too much. One thing I always keep in mind when I do a cover design is how it will look in a bookstore. This, I think, is one reason why my covers always end up looking a bit crude. If you have ever seen *Stones* by Tom Clark in a bookstore you will know what I mean. It sticks out like a sore thumb. And a beautiful one. Well—I am really

giving myself a pat on the back today for a change. As most of my friends are poets, I wish that my paintings lent themselves more to actually collaborating. But they don't. Cartoons, tho, work out well for me. And "drawing for" words. I think I am especially good at this. I respect poetry very much. (More than I understand it.) And I think that, actually, poetry (in terms of illustrating it) needs respect more than it needs understanding. I don't like that word "illustrating." Ted and Donna left. Before they left, tho, we took some naked photos. I am going to put some of them in this diary. One of Ted and Donna together. One of Ted and me together. And one of Bill and Kenward together. I am outside sunbathing. It is, however, a cloudy day. But hot. Kenward is at the cabin. Bill is off to my right in the other good lounge chair. (There are two good ones and two broken ones.) Whippoorwill is stretched out near my feet. I really haven't much to say today.

Aug. 3rd

Actually I am not sure if today is the 3rd or not. It might be the 4th or the 5th. It really doesn't matter. Every day is very much the same up here. Even more so than in the city. This is not a comment on life. This is a comment on *my* life. And I consider this both good *and* bad. (That my every day is very much the same.) It makes working easier. But today I don't give a fuck about work. Today I care about me. And what I am going to *do*. I feel (and have felt for some time now) the need to do something drastic. Not destructive. Just something (anything) to shake things up a bit. You know how your stomach feels after a good vomit? That's how I want to feel. It occurs to me now that if I don't do something to change my life now, it will be too late. I can see myself as I am now, only 60 years old. That's pretty frightening. I feel very much the same way about painting too. That it is now or never. That I either "jump right in" now, or it will pass me by. So why am I sitting here talking about it? Because I want to. Because it is raining outside. Because "jumping right in" isn't so easy as it sounds. And because I don't feel very good today.

Sex

I like sex best when it's fast and fun. Or slow and beautiful. Beautiful, of course, can be fun too. And fun, beautiful. I like warm necks. And the smalls of backs. I'm not sure if that's the right word: small. What I mean is that part of the back that goes in the most. Just before your bottom comes out. I like navels. I like underarms. I don't care for feet especially, or legs. I like faces. Eyes and lips and ears. I think that what I like most about sex is just touching. Skin is so alive. I like cold clean sheets. I like breasts and nipples. What I'm a sucker for most is a round full bottom. I really don't like that word *bottom*. I think underwear is sexy. I like hair on heads, but hair on the body I can take it or leave it. Skinny builds don't turn me on as much as normal builds. Probably because I'm skinny myself. I have a weak spot for blonds. I like to fuck sometimes but I don't like to be fucked. What I really like is just a good plain blow-job. It's rhythm that makes me come the best. I don't think that, in bed, I take a masculine role or a feminine role. I guess I must be somewhere in between, or both. Sex-wise I'm not very adventurous. I am sure that there are a lot of things I like that I don't know I like yet. I hope so. So—now you have some idea of what I like in bed.

A Special Diary

Tuesday Night

 I want to tell you what I did today. Not because I did anything very exciting. But because I am drunk and I want something to do. And just because I do want to tell you what I did today. I just got home from eating at Aldo's. The Italian restaurant I always eat at when I eat out alone. (Queer Italian.) Because they have a good jukebox. Because the waiters are beautiful (pretty) and because I get some sort of mysterious buzz out of being mysterious to them. (I eat there a lot.) I delight in always ordering the same thing. A half bottle of white wine (French), I never can remember the name. Something like "polly-fuse," veal scallopine with lemon and butter sauce. Asparagus. And salad with oil and vinegar. Most of the waiters don't even have to ask what I want. They just bring it to me. This pleases me and (I hope) this pleases them too. I got up this morning late. (10:30.) I had breakfast at a Puerto Rican place on Hudson. Scrambled eggs. Bacon. A large orange juice. And coffee. Then I came back and worked most of the day on some wildflower cut-out gardens I am doing. There was a beautiful blond boy reading in the garden next door with his back to me. He teaches economics at N.Y.U. I did a lot of whistling so he would know that I was "here." Not that I expected him to do anything about it. I did my daily push-ups. I drank my daily can of Nutrament. I smoked a lot I am sure. And drank a lot of Pepsis. Mail came. I got a note from Tom Clark saying he had broken two ligaments in his leg. I got two invitations to two book parties at the Gotham Book Mart. And a pamphlet advertising girlie pornography. I went to the art store to get some more X-ACTO blades for cutting out more wildflowers. I called

Bill Berkson. Not home. I'm lonely. But I'm lonely by choice. So I can't complain. I can write about it tho. I'm lonely. What I wish is that some person would just knock on my door and say "Let's go to bed." I'd like to be with someone right now without any of the hassle of "getting together." What a shit I am. No new news to me. But I'm nice too. Now it is almost ten o'clock. I guess I will read some more of *Querelle of Brest* by Jean Genet. It isn't very good but I like it. And smoke some pot. Anne gave it to me. (Anne Waldman.) You know, I'm putting you on a little bit. I mean, this isn't exactly me writing. I'm just taking advantage of being drunk. I'm writing outside of myself really. I feel as tho I am watching myself write. I know that I will feel good tomorrow. I know what I am going to do (more or less) tomorrow. But I wish I didn't. I wish that life would really surprise me. I'm tired of "making" it surprise me. And I'm tired of being a bore. Because I'm not. And because I am.

Wednesday Morning

I feel great this morning. And for no particular reason. It's really great to wake up in the morning and feel great just because you do. I don't have anything to tell you because I just got up. I just wanted to tell you how great I feel. Because I feel so very much that way. I love extremes.

Wednesday Night

Here I am again. Not so drunk tonight. But feeling just as lonely and dramatic. Of course, I could walk down Greenwich Avenue and pick somebody up in no time flat. If I really wanted to. One good thing about me is that I never feel sorry for myself. Only thing is that I don't really know "how" to pick somebody up. And I'm afraid of being rejected. And it's five minutes after twelve and I'm going to get sleepy very soon. I hope. I wish I was in the middle of a good book. But I finished Genet last night and I'm not up to getting into a new one right now. I want to

live a very wild and exciting life. Why don't I? I guess I must be chicken. I can't think of any other reason for not living the way I want to. Unless, perhaps, to protect myself. I wish that nothing mattered to me except having fun. I wish that I wasn't afraid of being a fool. I wish that I was a stud. I wish that days wouldn't just evaporate. I hope that I don't grow old before I realize how terrific I am. I hope that tomorrow won't make this sound too corny. Tho I know that it will. That it is. And that, actually, I don't care. That's what this special diary is all about (a luxury).

Sunday Afternoon

I got drunk again last night. (On purpose.) So I feel a bit funny today. Not bad. I don't have a hangover. But I do feel a bit slow. Relaxed. A bit too relaxed. Drinking often does this to me the next day. Actually it's a pleasant feeling. Lazy. But I don't like it. This morning I worked some more on my wildflower cut-out pictures. Some are getting too "art nouveauish." Must watch myself. I stopped shaving. At first I was just being lazy but now I like the way it looks. So I'm not going to shave again until after the book party Monday. At the Gotham Book Mart. For *Fragment* by John Ashbery with drawings by Alex Katz. Where I got drunk last night was at Julius's. A light queer bar. I've been there three times now. Not to pick anybody up. Or to be picked up. But as practice at being comfortable in queer bars. It's a new thing for me. Queer bars. And it's exciting. In order to have something to "do" I pretend that I am looking or waiting for someone. Someone in particular. And it works. Most people stay away. And to the few that do try to get together I just say that "I'm waiting for someone." I feel that I am not telling you the whole truth. In fact, I know I'm not. But it's too complicated. And I don't want to think about it. And probably I don't even know what the whole truth is myself. All I know is that I'm out to make my life more exciting. I feel up to it now. Whatever it takes. I'm up to it. (I think.) I don't believe very much in words anymore. (Too easy.)

Thursday Night

It's so cold tonight. (I love it.) On my way to Aldo's (to eat) I overheard this conversation:

> *1st Woman:* It's so cold.
> *2nd Woman:* I'm wearing two sweaters.
> *1st Woman:* I wish I was. I need it.

For some reason this struck me as very funny. Perhaps it was the use of "it" in reference to two sweaters. Both ladies were old and fat. I'm sorry. But they really were. At Aldo's I had my usual veal and ½ a bottle of white wine. Plus, tonight, a glass of white crème de menthe on ice. Plus total jukebox music. Three dollars in quarters' worth. Music is great. Wine is good. It is eight o'clock. Soon I'm going back out to go around to queer bars. I found a new one that I like even more than Julius's. (Danny's.) But it's too early to go now. That's why I am writing. (Time.) Time is around too much these days. I am too aware of it. Spooky. Sometimes, tho, it can be pleasant. (Safe.) Being so aware of time. I don't know what I'm talking about. And I suspect that I am taking advantage of it. (Oink.) "Oink" is too easy. (And this diary is too easy too.) You know, I really am sorry that Jack Kerouac died. I liked him a whole lot. Will stop now. Maybe I'll write more after the bars. I'm sure that I will come back alone. That's my style these days. I hope that doesn't sound sinister. Sinister (thank God) I am not. I'm not about to give up. I'm just beginning. And I care.

SOME DRAWINGS

OF SOME NOTES

TO MYSELF

BY JOE BRAINARD

I HAVE ~~XXXX~~
WHAT PEOPLE WANT.

1.

NEW LIFE

ONE PACK OF CIG. A DAY

NO PILLS

NO LIQUOR EXCEPT WINE AT
DINNER

PUSH-UPS EVERY DAY

NO MORE THAN ONE MAGAZINE
A DAY

READ MORE

NO CIG. BEFORE BREAKFAST

ONE CAN NUTRIMENT EVERY DAY

NO CHEAP SEX NOVELS

2.

COFFEE WITH SUGAR & CREAM

USE DICTIONARY

MONDAY	MORNING
FLOWERS TO JOE	
DINNER AT 7	
VITAMIN B-12	
CALL KAI	

SHINE SHOES

QVARTERS IN BOTTLE

GENET

CUT OUT

Death

Death is a funny thing. Most people are afraid of it, and yet they don't even know what it is.

Perhaps we can clear this up.

What is death?

Death is *it*. That's it. Finished. "Finito." Over and out. No more.

Death is many different things to many different people. I think it is safe to say, however, that most people don't like it.

Why?

Because they are afraid of it.

Why are they afraid of it?

Because they don't understand it.

I think that the best way to try to understand death is to think about it a lot. Try to come to terms with it. Try to *really* understand it. Give it a chance!

Sometimes it helps if we try to visualize things.

Try to visualize, for example, someone sneaking up behind your back and hitting you over the head with a giant hammer.

Some people prefer to think of death as a more spiritual thing. Where the soul somehow separates itself from the mess and goes on living forever somewhere else. Heaven and hell being the most traditional choices.

Death has a very black reputation but, actually, to die is a perfectly *normal* thing to do.

And it's so wholesome: being a very important part of nature's big picture. Trees die, don't they? And flowers?

I think it's always nice to know that you are not alone. Even in death.

Let's think about ants for a minute. Millions of ants die every day, and do we care? No. And I'm sure that ants feel the same way about us.

But suppose—just suppose—that we didn't have to die. That wouldn't be so great either. If a 90-year-old man can hardly stand up, can you imagine what it would be like to be 500 years old?

Another comforting thought about death is that 80 years or so after you die nobody who knew you will still be alive to miss you.

And after you're dead, you won't even know it.

Autobiography

I was born in Tulsa, Oklahoma in 1942.

No, I wasn't. I was born in Salem, Arkansas in 1942. I always say I was born in Tulsa tho. Because we moved there when I was only a few months old. So that's where I grew up. In Tulsa, Oklahoma.

A lot has happened between then and now, but somehow, today, I just don't feel like writing about it. It doesn't seem all that interesting. And it's just too complicated.

What's important is that I'm a painter and a writer. Queer. Insecure about my looks. And I need to please people too much. I work very hard. I'd give my right arm to be madly in love. (Well, my left.) And I'm optimistic about tomorrow. (Optimistic about myself, *not* about the world.) I'm crazy about people. Not very intelligent. But smart. I want too much. What I want most is to open up. I keep trying.

Some Train Notes

Riding a train is pretty funny.

Especially when you don't really feel like you've "been" where you've been.

Especially when you don't know exactly what you are going back to. Or why.

Especially when you're totally stoned out of your head.

Only three cigarettes to last me from Southampton to New York City.

As the trees pass by none of them look very unusual so far.

That house still has its Christmas decorations up.

Being on a train makes me feel a certain way only being on a train does.

Being on a train is only where it's "at" when you're on it.

(I *told* you I was stoned.)

I don't think I'd want to know who lives in *that* house.

The snow is so blue today in the shadow parts.

All those cars out there are *really* crazy.

This train stop is a long one.

Smoking my first cigarette a woman just came over to me and said "This is a No Smoking Car."

I wish I had said to her "Oh, where are the cars that smoke?"

I wish I had said to her "Up the butt, lady!"

What I wish is that I hadn't have put the cigarette out.

Only two more cigarettes to New York City.

I like that lumber yard.

This train has really had it.

I think I'll dedicate this to Anne and Michael.

This piece is dedicated to Anne and Michael.

A lot of dead trees in this area.

I'll just hit the city in the middle of the rush hour.

That grown-up man was waving at this train.

That same woman who told me this was a no smoking car just got up and told another guy the same thing.

A man is staring at me.

Too bad he's not cute.

A woman just sat down across from me.

There were plenty of other seats.

Next stop: Jamaica.

"Bingle bangle bongo, I don't want to leave the Congo" (the song) just came into my head.

I sort of wanted to keep my ticket but the conductor *took it*.

It's getting dark.

I can see my own face now more than I can see what's outside.

I guess I'll stop now and try to read some Lillian Hellman.

Diary 1970–71

Friday, Nov. 27, 1970

Let me tell you about today. Kenward woke me up at 7:45 with a tray of breakfast. (Having a few problems these days.) Then I got dressed and headed for home. Picking up a container of coffee, four Dr. Peppers, and two packs of Tareytons on the way. Junk mail. Watered plants. Took a vitamin pill. And worked on a long prose piece I'm working on called "At This Very Moment." (Depressing.) Then for some reason (to cheer me up) I unpacked an art nouveau necklace that never got unpacked from the summer. Actually, it's not a necklace. It's one half of a belt buckle. But I'm going to have it made into a necklace. (One of these days.) Then I did some cutting out of an autumn weed cut-out. Then I went downstairs for a container of coffee and a french. The french I ate. The coffee I am still drinking. After I finish this I will either read some of Tony Towle's new book (*North*) or do some more cutting out. Depending upon how I feel. Then I'll do my exercises. Shave. Brush my teeth. Get dressed. And go out. Where I'm going I don't know yet. But I do know that I'm going out. (Most always do at night.) Each day is such a separate and complete thing to me. (A mini life.) I think maybe I'm a bit crazy. I *do* get a lot of work done that way tho. And if I'm not all that happy I figure "So, well—who is?"

Tuesday, December 8, 1970

Here I am. Up in the air. Drinking a Bloody Mary. On my way to Chicago.

The great thing about flying is that for a while I can make myself realize that nothing really matters.

This is not a depressing thought. I love it. (Feeling this way.) I wish I could feel this way all the time. Because it's the truth (even if it isn't very practical) that *nothing really matters!*

Now I don't know if I really believe this or if I just *want* to believe this.

No, I *do* believe this.

Nothing really matters!

Monday, December 28th, 1970

Listening to Procol Harum. A bit cheap, yes, but I like them anyway.

If I have anything to "say" tonight (a bit drunk) it is probably just this: to like *all* you can *when* you can.

Or, don't think about things too much.

I don't know who I think I am, giving *you* this advice. Actually, when I "talk" to you I am really talking to myself (mostly) but I guess I wouldn't be writing it down if I didn't think that——that you might want to know what is going through my head too.

No, the truth of the matter is that *I* want you to know.

Thursday, February 4th, 1971

It's snowing so very quietly outside, so nice. And so blue for night. For night in New York City. It reminds me of Christmas. How Christmas *should* be. And sometimes was.

It's a little after midnight now and I'm eating a box of raisins. Not so much because I like raisins as because they're good for you. So they say. If one can believe anymore in what "they" say. And I doubt it. And I'm drinking a beer and smoking a cigarette and listening to Janis Joplin's new album *Pearl*. (So beautiful.) I love it. Because it moves me. And so do you. You make me feel good, but sorry too.

Not sorry for you. You're dead and *that* doesn't hurt. And not sorry for myself really either. I'm not sure why I feel sorry.

Unless it's because it's so *logical* that you should have died the way you did. (So young.) So *infuriatingly* logical.

I mean—I don't want you in my pocket.

Everybody deserves more than that.

And especially, tonight, you.

Monday, February 8th, 1971

Brigid Polk said to me last night that I was the most honest person she knew. I wanted to say "No," but somehow more than just "No." I don't remember what I said, but this morning I was thinking about it and it came to me what I should have said. That honest is only something you can *try* to be. (If you want to be.) And I do. But I don't want to have to take credit for *being* honest. Because, even if it were possible, it would be too much to have to live up to. Another impossible weight.

Thursday, February 18th, 1971

Being as vain as I am I'm surprised that I'm not horrified by all the white hairs I keep finding in my hair these days. But I'm not. I just yank them out. Which means, perhaps, that I'm not going to grow old very gracefully. And that I may go bald before I go gray.

Today was a beautiful day outside but I spent it in doing drawings of Ted. (Ted Berrigan.) One is a good drawing but doesn't look much like Ted. And the other one looks a lot like Ted but it isn't a very good drawing. Then after Ted left I worked on the new *I Remember*, ate an apple, and began writing this. And now it is beginning to get dark already. Another day gone before you know it. And *that's* the way I like it.

Tuesday, March 23rd, 1971

I just knew this morning when I asked the deli man for three packs of cigarettes instead of the usual two that he was going to say something and he did. He said "You sure smoke a lot

son." And I said "Oh, I don't smoke all these." And he said "Well, who does?"

But by then everything was in the bag and paid for so I didn't have to continue my lie.

He'd really be shocked if he knew that at night I buy *more* cigarettes at a different deli.

Well, everybody deserves one or two things not to have to be careful about, I figure. And smoking is one of mine.

Too many things to do today and I really don't know why. I shouldn't even be sitting here writing but I *feel* like it, and somehow I can't face this day without first sorting it all out.

Larry Fagin arrives at eleven to sit for me (to draw) and to pick up the flyer Bill Katz did for my reading.

I got a beautiful purple rock in the mail this morning from Bill Berkson for my birthday. (Late.) And last night Brigid Polk gave me a necklace she made out of feathers in the shape of a heart.

But back to today. I should call the dope man about picking up the dope tomorrow instead of today. And J. J. Mitchell. And Kenward Elmslie. Call Kenward Elmslie about dinner.

Then new cut-out to take to Kulicke to be framed. I really should do that today.

And then 2:30 I go to do some drawings of Louis Falco and his company. In rehearsal. *That* ought to be interesting, as they never stay still for more than a second. So sexy, dancers, I envy them being so down to earth with their bodies.

I *do* wonder sometimes why I try to do all I try to do. (Too much.)

I mean—what do I *want*?

I guess I don't know. I guess I'm still trying to find out what I can *have*. Then maybe I'll know what I want. But I doubt it.

And surely what one wants is continually changing. (I should hope.)

Actually, if the truth be known, I think I just like to keep busy so I don't have to use my head too much.

And when you get right down to it, "want" isn't very important anyway. What's important is "need."

And what's *really* important is to make yourself need as little as possible.

Life can get pretty scary if you don't watch out.

December 22, 1970

One o'clock at night

Drunk (well, a bit)

Horny

Lonely

Writing

Smoking

Drinking a beer

So as to get more so

(More drunk)

To get more sleepy

(To sleep)

Listening to the Supremes

Almost Christmas

Almost a New Year

A fresh year

An empty year

A possible year

A year with more room

I *do* look forward to that

(More room!)

1971

This poem doesn't have much to do with "language."

I wonder how much longer I can keep writing poems and pretend
not to be a poet?

I wonder how much longer I can always be "a bit drunk"?

A song about Bill now

("Don't mess with Bill")

(Miss you Bill!)

In California

In Bolinas

Too much inside your head

But who isn't?

And so sweet about it

I *do* miss you Bill!

1970

1970
is a good year
if for no other reason
than just because
I'm tired of complaining.

Queer Bars

After an unsuccessful night, going around to queer bars, I come home, and say to myself, "Art."

Art

Looking through a book of drawings by Holbein I realize several moments of truth. A nose (a line) so nose-like. So line-like. And then I think to myself "so what?" It's not going to solve any of my problems. And then I realize that at the very moment of appreciation I had no problems. Then I decide that this is a pretty profound thought. And that I ought to write it down. This is what I have just done. But it doesn't sound so profound anymore. That's art for you.

Short Story

Ten years ago I left home to go to the city and strike it big. But the only thing that was striking was the clock as it quickly ticked away my life.

Life

When I stop and think about what it's all about I do come up with some answers, but they don't help very much.

I think it is safe to say that life is pretty mysterious. And hard.

Life is short. I know that much. That life is short. And that it's important to keep reminding oneself of it. That life is short. Just because it is. I suspect that each of us is going to wake up some morning to suddenly find ourselves old men (or women) without knowing how we got that way. Wondering where it all went. Regretting all the things we didn't do. So I think that the sooner we realize that life is short the better off we are.

Now, to get down to the basics. There are 24 hours a day. There is you and there are other people. The idea is to fill these 24 hours as best one can. With love and fun. Or things that are interesting. Or what have you. Other people are most important. Art is rewarding. Books and movies are good fillers, and the most reliable.

Now you know that life is not so simple as I am making it sound. We are all a bit fucked up, and here lies the problem. To try and get rid of the fucked up parts, so we can just relax and be ourselves. For what time we have left.

Rim of the Desert

"Did he see that, Portia?"

"No," she said. "I waited until the door was closed, Cleve."

"I'm awfully sorry." He tried to smile. "How long since he came here? A week—a month? And the whole damned country's changed. Mighty queer."

"You've changed too, Cleve. You know, I never used to like you. I guess you hid what you really were."

"Why," he said, "I guess I've grown up."

"That's a hard thing to do."

"Everything worth doing is hard."

She gave him a prolonged, interested appraisal. "Aren't you going down to Aurora's?"

She wished she hadn't said it, for she recognized the quick passage of hurt in his eyes, the rise of an old feeling and its dampening. "No, not tonight, Portia." He turned away. "When I was a youngster and came in wet and bruised my mother used to put me by the fire and make up a dish of popcorn. Funny how a childhood memory sticks. Whenever I feel tough I think of that."

"I'll make you some popcorn, Cleve."

How to Be Alone Again

Read

Drink

Don't think too much

Or else think a lot

Write

(This isn't a very good poem, I know, but it means a lot to me)

(Which, I guess, makes me think it might mean something to you too)

(Or why else would I be thinking I'll give this to Larry Fagin for his magazine?)

(Believe me!)

I (we) know more than I (we) understand

 or

If I'm a fool I don't want to think about it.

This is not poetry.

This is prose.

This is me feeling sorry for myself.

This is me thinking I assume too much when I say "we."

This is me loving myself and not loving myself both at the same
time.

This is me truly not understanding this moment.

This is me trying to write a poem.

This is me alone

(a bit drunk)

Taking advantage of both.

BOLINAS

JOURNAL

BY

JOE BRAINARD

1971

THURSDAY, MAY 2<u>ND</u>
AMERICAN AIRLINES FLIGHT #17
DEP. NOON AT KENNEDY
CHECK IN BY 11:30
1-WAY COACH $163
ARRIVE S.F. AT 2:44 P.M.

NEW SUITCASE (PIG SKIN) $12\frac{1}{2}$" X 20"
AND 5" DEEP

TRAVEL LIGHT!

Gandhi's worldly possessions at the time of his death

PACKING INSPIRATION

(AND LIVING INSPIRATION)

On way to airport. Cab driver wants to talk. I don't. Which seems to make no difference to him. Meter so far: $7.20.

At airport. Drinking a cup of coffee. Got ticket. This is the first time I've flown not first class.

For some reason I am an hour early. (Typical.) I hate rushing. However, I hate waiting too.

Similar types of people stare at each other in airports.

In my head I don't really mind flying, but my stomach does. (Butterflies.) Like just before you give a reading.

Inside gate 17 area now. Two beautiful (well, pretty) girls make me wish I was "straight." It'd be fun to flirt. And they deserve it.

Guess I'll read some now. *Keep the River on Your Right* by Tobias Schneebaum.

Up in the air now. (*Not* drinking a Bloody Mary.) We get served last. Other disadvantages of not flying first class are: Not enough leg room, not enough arm room, and just *not enough room*.

So amazing, flying. I wonder why I don't try to understand it. (The "how" of it.)

Like my own body. I don't even know how my own body works.

Maybe what we don't know somehow "means" as much as what we do know.

I doubt it.

For lunch, steak.

And it's more bumpy back here too.

I think I'll read some more.

Keep the River on Your Right is really great.

The steak, by the way, was cold.

The movie for this flight was supposed to be *Cold Duck*

with Dick Van Dyke but it was just announced that the video machine broke down. No love lost.

"Looks like a lot of little squares" the girl behind me just said. Looking out the window I assume.

Over some snow-topped mountains now she says it looks like powdered sugar. And I must admit that it does.

California. You know, I've never been to California before. Not that things will be *that* much different, but—well—one can hope. Wish. Try.

Friday, May 28th. Bolinas. A motel room. "Smiley's." Just had breakfast across the street. Very good french toast and bacon.

When I arrived in San Francisco yesterday afternoon Bill and Lewis were there to meet me. A good sight.

We drove around San Francisco a bit. (Really beautiful.) Had lunch. Went to City Lights. And then to Lewis's place. (Wine.) Where none of us knew exactly what we wanted to "do" so I suggested a drink in a bar.

Finding a parking place became a big ordeal but finally we did.

A Bloody Mary in a funny Hawaiian bar. (Right out of the movies.) With live music. With nobody in it except one drunk and us. Pretty weird.

Then we almost went to a movie until I realized that I was just in another big city and that what I really wanted was to be in the country. By the ocean. Bolinas. Where Bill lives.

Bill, by the way, is Bill Berkson. And Lewis is Lewis Warsh.

So Bill and I drove back to Bolinas where we had a few drinks at "Smiley's," the bar/motel I'm staying at now.

Bill. Bill seems in great shape. Eager. What a great thing to be. Eager.

Lewis. I don't know. I love Lewis, but I just don't understand the "way back in there" position he's in. I don't know if he's stuck back there, or if that's where he wants to be. And I don't understand the "why" of either case.

Last night in the bar a girl Bill and I were talking to especially stands out in my head. A "hippie" type. (Sorry, but that's what words are for.) Very sincere in what she believed in. But what she believed in was totally fucked up. But like I said, very sincere about it all.

It always bothers me, this combination. Of sincere *and* wrong. It doesn't seem fair. Sincere should always be right.

Pictures on my motel room wall: a twin set of teeny-boppers twisting on the beach with giant heads and even more giant eyes.

The daisies really grow big around here. In big clumps. Like big bushes.

I can hear every sound the family in the next room is making.

Everyone said I was going to love Joanne Kyger and I do, *I do!*

Bolinas is more like I thought Jamaica would be than Jamaica was. (So lush.)

And *fantastic* flowers everywhere.

A lot of talk about things I don't know much about. Like eastern religions. Ecology. And local problems. Sewer system problems in particular. And people I don't know. Strange names continually pop up.

The Creeleys are great, Bob and Bobbie. I really do like them both a lot.

A love possibility appears. Gordon Baldwin. Afraid to let myself be too optimistic tho. One thing in my favor is that this seems a very "straight" community. (Which means not much competition.) However—I don't even know if he's interested yet.

Vibrations tell me "yes." But experience tells me not to expect anything until it happens. Always better to be surprised than disappointed. Which has nothing to do with anything because the truth of the matter is that I *am* going to be disappointed if nothing happens.

Lots of dogs.

Lots of dope.

Visions of falling madly in love with Gordon continue to grow in my head. Unrealistically, I know, but what can I do?

At the same time (now) I realize, tho, that I just want to fall in love with *somebody*. So I'm not sure, really, how much Gordon has to do with it. I mean—if it wasn't Gordon it would probably be someone else.

But then, I sometimes wonder if *wanting* to fall in love isn't just as important as *who* you fall in love with. (Just as important, I mean, towards helping it happen.) And perhaps even more so.

I don't know. To tell you the truth—I'll consider myself lucky just to get a little sex out of him.

Really especially crazy about Bob and Bobbie and Joanne. So nice how some people just turn you on instantly. And so nice to feel that you do them too.

Tom and Angelica Clark look great. And Juliet. Great and healthy and comfortable and satisfied. As tho they don't need anything. Or anyone. (Why isn't this more attractive to me than it is?) I certainly don't resent it. Maybe it's just that I don't see how I can fit into all this. (?)

A lot of being inside your own head here. A lot of talk about it. And a lot of talk about inside other people's heads too.

And a lot of talk about houses.

It seems to me that there is a lot to be said for "finding" yourself in your head, as opposed to "being" there.

Does that make sense? (I *think* so.)

I really do admire Bob Creeley. So much alive ("in" and digging) and really trying.

Trying is great. And knowing you are trying must be even greater. I think Bob does. (Know it.) And if so, I hope he's proud of it. (Has the satisfaction of.)

I just rented a house for one month. Can't believe it. $250. I believe the $250. It's that I rented a house for a month I can't believe. So much for "seeing" California. Well—I'm not a very good traveler anyway. I like a clean shirt every morning. And work. I really need to work a lot. And that's hard to do when you're moving around. (And then there's Gordon.)

Tomorrow I move out of the Creeley house and in with Gordon for one night. (Until June 1st when I move into my own place.) A totally obvious move on my part, moving in with Gordon for one night, as I could just as easily stay with Bob and Bobbie one more night. I wonder what Gordon thinks about *that*.

Gordon's house. Late afternoon. Just moved in. (Well, I walked through the door carrying my little suitcase and sat down.) We talked a bit, Gordon and I, about nothing in particular, and then he said he had to go out and look for a rock. A rock to *do* something with. Didn't quite catch what. At any rate, that's where Gordon is now.

Obviously I make him nervous. Maybe this is a good sign.

I really don't feel very optimistic tho. (You just keep telling yourself that, Joe.)

But I *do* feel optimistic about being able to do some good work here. And being able to relax more here. And take things as they come more here.

I'm tired of fighting life. I'd just like to sink in a bit and get cozy.

Really don't know why I push myself so. God only knows life is short enough without rushing through it.

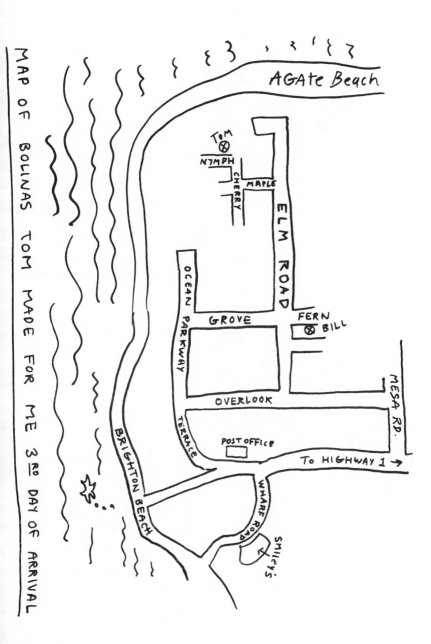

NASTURIUMS
ON
GORDON'S
TABLE

Gordon is still looking for a rock I guess.

I guess I'll go shave.

It wasn't easy, but we *did* finally end up in the same bed together last night. (Just messed around a bit tho, as we were both pretty stoned.) Well, in the same bed for *part* of the night. Until Gordon couldn't sleep so he ended up on the sofa. ("The caffeine in Pepsi.") Likely story.

Gordon *did* imply that we should get together again, but I think he was just being nice.

Maybe he's afraid he might be "stuck" with me for a whole month if he gets involved.

Or maybe he likes to confine his love/sex life to San Francisco. (This *is* a small town.)

Or maybe I just don't turn him on.

Well—I tried.

I like my new house. On Terrace Road. Half way up to the mesa. Nice view of the ocean. (Through some wires.) But already I don't even notice them. Inside the house is pretty plain. (Normal.) With lots of orange. And some Mexican stuff. Right next door that *I Hate to Cook* lady lives. And two houses down is a house Isadora Duncan danced in once.

And it's always nice to know you can take a loud shit without feeling self-conscious about it. (Should the occasion arise.)

And it's the only way I can be totally relaxed. (Damn it.) To be alone.

The sun isn't out today but, today, I don't really care.

If it's possible to feel good and bad at the same time that's how I feel today. And I do. So I guess it is.

Bob and Bobbie each exist individually so well. And together so well too.

It seems I am always looking for matches.

Bolinas dogs are so funny. Running around all over town. In and out of stores. Alone or in packs. Plain dogs most of them. Mutts. They seem to have a little Bolinas all their own. With rules and regulations I'm sure I couldn't begin to fathom.

Everyone seems to have a high school crush on Joanne Kyger. (Me too.)

Lots of weird dreams last night. Can't remember any of them tho. All I remember is waking up every now and then and saying to myself "*That* sure was a weird dream."

The bathroom keyholes in this house are stuffed with pink toilet paper. (No comment.)

Don't know if I want to work today or go to the beach with Bill.
Getting lazy about shaving.
Bill just called. It's the beach for me. Fuck work.

Did you know they have "english muffin" bread now? Like in a loaf. (Sliced.) *That's* how crazy the world really is. (Stoned again.)

Why do I find it a bit awkward being with Joanne and Bobbie together? Like I feel like I have to somehow avoid playing favorites. I'm not too good at dividing myself. And I guess I like to flirt. And you can't flirt with two people at once. But there's more to it than that. Joanne and Bobbie appear to be very good friends but, I don't know. I get funny vibrations between them sometimes. (I shouldn't be saying this, but—) (?)

Keep running into Gordon: cool. I guess I've lost. But at least I really tried. And a bit proud of myself for coming on so strong. (My usual tendency being too proud to risk rejection.)
It's not so bad, really, rejection. (Huh?) It's not so great either.

Gordon has an unlisted phone number. That's a funny thing to have in Bolinas I would think. An unlisted phone number.

Funny. Living in Bolinas is turning out to be very like living in New York City. It's the same ol' me at night:

Lonely.

Desperate.

Melodramatic.

How I can be so mature in the daytime and so immature at night is beyond me.

Today Bill sits for me (to draw) and tomorrow Gordon. Maybe I can win him over with my dashing talent. Looks aren't everything. (So they say.)

I have a feeling that maybe Gordon doesn't approve of himself too much. Whereas I, I think, appear to approve of myself a lot. Maybe this will prove attractive to him sooner or later. (Assuming that opposites *do* attract.) And assuming my assumption about Gordon *is* correct. (?)

Obviously I'm getting desperate.

But I only have 3½ more weeks!

Something just occurred to me. Something a bit embarrassing to admit, but—I think I am especially attracted (love wise) to people I think I can help in some way.

What that "means" I'm not going to stop and think about right now.

Joanne may move in with me for a few days while Peter is away at some animal conference. Hope so.

Tonight: dinner with Joanne and Bill at the local seafood place nobody likes.

Another thing around here nobody likes is the postmistress Rose.

Blonds are driving me up the wall!

Just read *1234567890* by Bob. With drawings by Arthur Okamura.

I like the poem and I like the drawings but I'm not sure I like them together.

The poem makes the drawings seem too much like "illustrations," and the drawings make the poem seem less "open" than, in fact, it is.

Tho I don't know why "illustration" should necessarily be a dirty word. Any more than why "open" should necessarily be a good word. (?)

All movies were great until I started thinking about them too much.

To enjoy as much as possible——
Avoid traps.

No, you don't avoid traps. You just try to stay as aware of them as possible. (So you can get out.) ((Out and into new ones.))
That's a depressing thought.

Dinner tonight at "The Gibson House." (Steak.) And too much wine. (Depending upon how you look at it.) Then I phoned up Gordon to come up and have a drink. (That's a good one.) He said no, that he was tired, or something. (Another good one.) So I called up Joanne. "She's at Bill's," Arthur said, so I called Bill. "Yes." So they're both coming over any minute now. Good. I really don't want to be alone tonight.

Tonight is even more of a *this is it* night than usual.

Friday morning. Beautiful. Breakfast in town. Wine, Pepsis, cigarettes at "Pepper's." Walking back up the hill I ran into that little boy who yells out "Is *that* Jerry Lewis?" every time he sees me. I smile. And wish the fuck he'd give it up. (Pretty embarrassing.)

The funny thing is that when I was in my early teens I really did look like Jerry Lewis. Or so people were always telling me. Never did figure out a proper reply. "Thank you" didn't seem

right. (To say the least.) I think what I usually ended up saying was "Oh, really?" or something like that. (But in a nice way.)

The drawing of Bill turned out pretty good I think. Especially considering how hard Bill is to draw. (I've tried before.)

Gordon. I thought drawing Gordon would be easier than it was. But a very nervous face, Gordon has. Which makes it hard to pin down.

It's not very satisfying, drawing people. I like the opportunity to *really* look at someone. And the challenge is fun while you are "in" it. But the results—the results are never very satisfying.

I mean, you can't *really* draw a person. All you can do is try.

Gordon returned my sweater when he came to sit. (Damn it.) Was planning to use it as an excuse to drop by sometime. (Tho I *didn't* leave the sweater at his house on purpose.) Nice when you can take advantage of an accident tho.

I was saying to Bob the other night how easy it would be to live in Bolinas if you were madly in love (a few minutes of silence while we could tell that we were both thinking the same thing) as one of us said "But, of course, that could be said of just about *any* place."

Nice when that happens.

About drawing people: A lot has to be put in before it can be taken out.

(Just occurred to me how maybe true that is of life too.)

I asked Joanne if she'd spend the night with me last night, and so we did.

Mainly I just wanted us to be close. Which was the kind of night it was.

I'm not sure how much sex was on my mind, except that it *was*. But we didn't.

Being queer isn't an easy habit to break. And usually, I have no desire to.

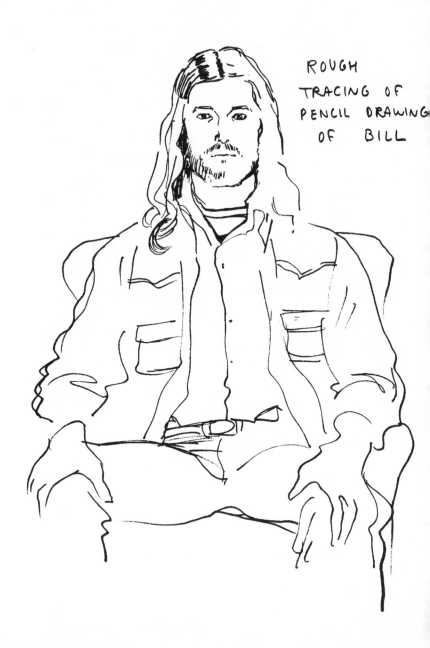

ROUGH
TRACING OF
PENCIL DRAWING
OF BILL

ON SEEING JOE'S SHOW

lift up your eyes

 & see these amazing works
 imitation of nature = creation of art
 (I suppose)

see
 incredible grasses
 & flowers
 & weeds
 some blowing in the breeze
 a feather
 or a butterfly
 perching delicately by

Just think of all the man hours
 (WORK)

 to make something so so so beautiful
 this must be art
 it *is* art
plain & simple & pure & beautiful art
 made by the god-artist-genius Mr. Joe Brainard
 Thanks, Joe

But Joanne is really something special. And I *do* think that being "queer" is as unnecessarily limiting as being "straight."

I remember when I was in my teens trying to figure out ways of standing and sitting that I thought looked good. (Masculine.) And that's probably how I sit and stand today. And to do otherwise would be very uncomfortable. (And perhaps even fake.) I mean—self-imposed habits *do* become genuine.

But genuine isn't always right. Anymore than sincere is.

If only I had more time with Joanne——

But I don't. Peter returns tomorrow. And you're probably just having a head trip. And God only knows what Joanne thinks (feels) about *me*.

News that Ted Berrigan is coming totally zaps my mind. (Help.) One of the nicest things about being here is not having a past to live up to. Or down to. I love Ted, but—

It occurred to me last night that I know a lot, but that I just don't know enough to know it yet. (Stoned again.)

The Creeley household is very funny. Three things are continually getting lost. Bob's hat. Bobbie's red checkbook. And hair brushes.

Tuesday. By the ocean. Drawing Bobbie today didn't go so well. I sometimes think I try too hard. Can't seem to get it through my head that a drawing is, first of all, a *drawing*.

Sitting here only a few feet away from the ocean it's hard to think of anything to say (except "ocean") so I guess I'll stop.

Poem by Anne about my show arrived today. So extravagant! (And I love you for it.)

Seems that Michael (a new love possibility in my head) is going with the Gibson House cook. Oh, well—

Overhearing a conversation tonight at the Gibson House about a cave man party where everyone wore burlap bags and the room was draped in brown sheets, it occurred to me once again how totally insane the world out there really is.

Actually, I can almost imagine myself in such a room, wearing a burlap bag.

What I can't imagine is the occasion that would call for it ever arising.

How I can be so shy and insecure, and such a conceited ass at the same time, is beyond me.

One Joanne contradiction occurred to me this morning. That of being so down-to-earth, and so romantic too.

I wonder if contradictions eventually work themselves out. Or if contradictions are what we are made of. (?)

It *does* seem to me that old people have fewer.

Joanne really hit me over the head last night when she handed Bob an already lit cigarette "Joe's style."

It's not being put in someone's pocket I mind so much. It's just that it doesn't *mean* anything to hand someone a personally lit cigarette if it's *expected* of you.

Today Bill and I worked on a ten-page cartoon to pass out at our reading in San Francisco this Tuesday. (A fuck cartoon starring Nancy and Henry.) *Very funny!* And a poster to hang downtown on the local bulletin board.

Right now I'm out on the terrace in the last triangle of sun. Drinking a glass of rosé. And wondering about what I'm going to *do* tonight.

This is a great place, Bolinas, but it isn't for me now.

Everything I fear will someday catch up with me would catch up with me too fast here. Like the "why" of art. And the "I give up" of finding love and happiness.

That's pretty corny, I know, to believe that love and happiness can be "found." But I guess I do. (Especially when I don't think about it I do.)

And I guess it's pretty corny to be proud of being corny. But I guess I am.

Bolinas is such a basic place. *The land* being so important. Survival seems to be the main issue.

But for me life is still very much a matter of day and night. Can't think much beyond that. And I don't *want* to.

I guess I'm not tired of playing games yet.

Or maybe I'm just afraid of what will be left if I ever do.

And maybe, just maybe, that's good. (Good, I mean, for me.)

Went over the hill today to do some shopping with Bob and Bobbie. Driving home, feeling abstractly sad, alone in the back seat (to great radio music up front). Bobbie gave me her hand for the rest of the way home. (Thank you.)

Nice to know that you can still be a bit embarrassed. (Thank you for that too.)

Dinner last night at the Doss'. (Margot and John.) Gordon was there. And Don Allen. (Nice.) And some other people. Got a bit drunk. And a bit stoned. And went walking on the beach with Gordon. I asked him if it was O.K. to say anything I wanted to, so long as it was true, about him in my journal. (For publication.) And he said yes. Then we went back to his house where I probably would have tried something except that I got more drunk and more stoned. (Totally.) So I tried to make a graceful exit, and stumbled home. (Literally.) And got sick. Vomited a few times. And then slept very well. It's good for you every now and then, a good vomit. Gets the poisons out of your system. (Or so someone told me once.) I think it was Ron. Ron Padgett.

Got up feeling great at eight. Plan to sun until eleven. Then work. "Work" today will be collaborating on a flyer and some

posters with Joanne and Bobbie for their reading a week from Tuesday.

Such a beautiful day!

Tonight dinner with Jack Boyce and Lynn. (Terrible with last names.) She's going to make a Chinese dinner.

Tomorrow night Bill and I read at "Intersection."

Wednesday night—nothing.

Thursday—lunch with Bob and Bobbie in San Francisco with Robert Duncan and Jess.

Small birds do a beautiful thing around here of circling around each other, in pairs, as they drop thru space. Really takes your breath away. Like "those" moments at the ballet.

Our reading went very well I think. Tho I was so nervous it's hard to know for sure. So nervous I almost converted back into studdering. (Or is it stuttering?) Which made me even more nervous.

Bill's work is so clean, and sincere. And if sometimes it seems to be trying too hard, "trying too hard" turns out to be a very nice thing.

As for me—I was a bit embarrassed by my New York City diaries. (So melodramatic.)

And I wonder about my being somewhat "primitive," and knowing it. And taking advantage of it.

Is that being smart? Or is that being *too* smart?

I've been painting dried (fallen) eucalyptus leaves collected off my terrace. I'm getting the colors very well (lavenders, purples, brick reds, and browns) but, painting them in a solid mass as I am, I'm having trouble giving each leaf its own "weight." I think maybe I'll try to do a cut-out one and see if that works.

A nice trip to Marshall this afternoon with Bob and Bobbie and Bill.

Lots of serious talk about life. Mostly about solutions tho, and I had trouble understanding what the problems were. So it got pretty abstract for me.

Funny that we four should all be so lucky and yet—well— the same ol' problems.

I suppose that *the* problem of life is how to be happy.

But then—something hits you over the head every now and then, just out of the blue, no matter how happy you *should* be.

Maybe that's the *real* problem.

Feel so close to Bill every now and then. Like today. (*Too* close.) If you know what I mean. And I'm sure that by now you do. (Slurp.)

Diane di Prima was in town today. Looking very relaxed and pure, almost in a severe sort of way, but not really.

I *do* admire her concern.

Today Bob sat for me. A bit nervous. (Me.) Don't know why. Except that I do especially want it to be good. And, I *did* get a nice start.

Must remember to send Jess some pictures for his collages. He uses them so well: with care and respect. (As opposed to most collagists who just "use" pictures.) ((For an effect.))

Nice house they have, Robert and Jess, tho all that heavy furniture and stuff would drive me up the wall.

Philip Whalen has arrived and I really do like him a lot. (Staying downstairs in this house, but we'll be sharing the kitchen.) Reminds me a bit of Santa Claus. And Buddha. (Somewhere in between the two.) And I suspect he's very wise. But that either he doesn't know it, or else he doesn't value it much. (The only two ways I find "wisdom" tolerable.) At any rate—I really do like him a lot.

Happy with drawing of Tom. It came so easy. And it's a "good drawing."

Sweet the way Philip seems to enjoy feeling put upon.

Philip said this morning that the lady who posed for the later version of the silver dollar was Wallace Stevens' wife.

Scenes of Life at the Capital, a new 75-page poem by Philip (still in proofs)—it's *totally great!*

I loved it.

"If you want something hold out an empty hand."

(From *S.O.L.A.T.C.*)

7:30 in the morning and I'm out on the terrace having breakfast. Feeling a bit proud of myself, as Philip isn't even up yet. (?) Well, if so he hasn't had breakfast yet. (No kitchen traces.) But then, he leaves so few behind. (*Very* neat.) And he makes great soups too.

Today is the longest day of the year and so a lot of us are going to take acid.

Possible Bolinas acid dangers: too many people, poison oak, sunburn, and *me.*

I've been very lucky so far tho.

It was fun, tripping. No poison oak. No sunburn. No too many people. And as for me—it was mostly visual.

So amazing to be "in" everything so much. So very way back deep in there, "being" with it all. Breathing with it all. So busy, the bugs, and each blade of grass. And those chills that run up and down your spine with the wind.

And the back and forth of tight hot active space (itchy) and big cool open space. (*So* nice.)

EUCALYPTUS LEAF

Dear Joe, Call me when it gets to be laundry time. P.

JOE —

there's Orange juice in the green bowl in the refrigerator — waes hael !

TWO HOUSEHOLD NOTES FROM PHILIP

A few rough moments with Bobbie when I just didn't want to hear her talk anymore. Partly because I didn't think she wanted to hear herself talk anymore either. (?)

Visually my own skin always gives me the creeps a bit. (So red and "busy.")

Joanne and I had fun eating miniature peapods from Bill's scotch broom bush. And admiring how very noble the eucalyptus trees were. (Are.)

Bill. I knew that Bill wanted to be having a more "heady" trip than he was having, so I was a bit anxious for him. But he was nice to be with anyway.

Such thick air you glide through.

Philip, what little I was around him, was just too loud for me. (Talk.)

So amazing not to be able to step aside and relax (turn the world off) as we are so good at doing in "real life."

Realizing how complex the world really is—well, it isn't very practical. (Is *that* what I meant to say?) No. Who wants to be practical?

(I'm *trying* to say something conclusive and constructive about acid.)

Well, it's fun. It's visually exciting. And, hopefully, realistic.

And it's nice to think you understand things, if only for a moment.

Must admit (no, *want* to admit) that I really do miss Kenward from time to time. (Like right now.) There is no doubt in my mind that I really love him. And need him. But no doubt also that it's not enough.

Now I know this doesn't make much "sense," but——but I don't know what.

Maybe the truth of the matter is that all this looking around for love is just an excuse. A way to avoid it. Maybe the truth of the matter is that, actually, I don't *want* to be in love.

For one thing, being in love sounds so final. And "final" *is* scary.

And I really enjoy being "available." Yes, I need that. It's the way I can enjoy people most.

You know, maybe I don't want to find out that life isn't going to be *everything*.

If I lived in Bolinas I would soon become the jerk-off champion of the world. Enough said about *that*.

You know, it's really funny this kind of writing. This "trying to be honest" kind of writing. For several years now I've been doing it, and getting better and better at it. Getting closer and closer to a point (a place) in my head I call the truth.

But now I'm beginning to doubt that very point. (That very place.)

I mean, what I've been working towards just isn't there anymore. (Zap.)

Do you know what I mean?

I mean, the closer I get to the truth the less I know what the truth *is*.

Wish I could make myself more clear, but————right now I can't.

At the Gibson House admiring the rainbows on the tablecloth. (Coming from the crystals hanging from the rose glass lamp.) A bit drunk.

Today a tour of the wine country with Margot and Bill. Exhausting. But fun. Well—interesting. And something more travel bookish to write about for a chance.

Pretty commercial.

Beautiful countryside.

Nice smells.

"Sebastiani" was my favorite winery. The most friendly. And the most dignified. In Sonoma.

Those little white morning glories that grow close to the ground looking up. I especially like them.

The impossibility of living here strikes again. (Night.)

I've been working on a series of small collages with stuff from the beach. Set into little wooden boxes you get in China-town. Fortune toothpick boxes. (Each toothpick has a dumb fortune wrapped around it.)

It's fun. And relaxing. As the materials used dominate the work. (The results.) I mean—what I choose to pick up off the beach is where I am "in" the works most. Otherwise they just more or less fit themselves together. Like a puzzle.

Making a few necklaces from beach stuff too.

Tomorrow Margot sits.

Cloudy day today. Surprising not depressing tho. Very pretty in fact.

Must start writing introductions for Joanne and Bobbie's reading today.

Always a problem, what an introduction should "do."

Warm up the audience for listening.

And set a good mood. (Friendly.)

Well, that wasn't such a problem. Now—to do it.

Like the way Bobbie, when explaining something, is continually saying "You dig?"

And Bob, Bob is always saying "not heavily, but" in reference to likes and dislikes.

Two more days in this house and then I move in with Gordon for a week. Then New York City. And then Vermont.

BOBBIE CREELEY

WHEN BOBBIE WAS A KID SHE WANTED TO BE SHIRLEY TEMPLE.

BETWEEN THEN AND NOW BOBBIE HAS BEEN A CAR-HOP. A DOOR TO DOOR MAGAZINE SALESMAN. AN USHERET. A DISC-JOCKEY. WORKED IN AN ADVERTISING AGENCY. MADE INDIAN JEWLERY WITH THE INDIANS FOR TOURISTS TO WATCH. AN ACTRESS. AND, AT 13 WAS A BAPTIST PREACHER.

WHAT BOBBIE IS IS A POET. A PAINTER. A NOVELIST. A WIFE. A MOTHER. A GRANDMOTHER. CAN REALLY WHISTLE GOOD. (SINGS TOO) INTELLIGENT. FROM TEXAS. A REALLY GREAT TALKER. AND "EASY TO CRY."

THAT BOBBIE HAS DONE "A LOT" IS STILL NOT AS INTERESTING AS WHAT WILL HAPPEN NEXT. AND THAT'S EXCITING.

I THINK IT IS SAFE TO SAY THAT BOBBIE IS NOT SATISFIED.

AND THAT'S A COMPLIMENT.

JOANNE KYGER

WHEN I WAS TRYING TO DO A PORTRAIT OF JOANNE I WAS SURPRISED TO DISCOVER THAT JOANNE ISN'T REALLY BEAUTIFUL.

BUT ___ SHE IS.

BEAUTIFUL. SEXY. A POET. (THREE BOOKS OUT) MARRIED TWICE. LIVED FOUR YEARS IN JAPAN. THINKS A LOT ABOUT WHAT IT'S ALL ABOUT. IS AFRAID SHE MIGHT TURN INTO AN ECCENTRIC. JUST BOUGHT A HOUSE. AND ___ VULNERABLE.

JOANNE SEEMS VERY VULNERABLE TO ME. AND NOT AFRAID OF ~~FEELS~~ BEING SO.

NOT THAT ONE NECESSARILY HAS A CHOICE. YOU FIND YOURSELF WHERE YOU ARE. BUT YOU CAN ADMIT IT, OR NOT ADMIT IT. (WHERE YOU ARE) AND JOANNE ADMITS IT.

I ALWAYS HAVE THE FEELING THAT JOANNE IS ON THE VERGE OF ASKING ME A VERY IMPORTANT QUESTION.

OR TRYING TO <u>TELL</u> ME SOME-
THING VERY IMPORTANT.

I'M NOT SURE WHICH.

PROBABLY, BOTH.

BOBBIE CREELEY AND JOANNE KYGER

(FLYER FRAGMENT)

Strange telephone call from Kenward last night. (Drunk and unhappy.) No, not strange. *Moving*. Had me drunk and unhappy too. And wondering just how much longer I can take it.

Heavy life!

The good heaviness and the bad heaviness.

It's just <u>*too much!*</u>

Don't think I deserve too much more of it. Can't take too much more of it. And I don't think I *want* too much more of it.

But this is only tonight.

You know what *really* scares me?

Is that maybe I'm no good. (Down deep.)

And that maybe I'm going to hurt somebody.

That I have the power to hurt somebody without meaning to totally infuriates me.

As for the reading, it was strange. But in a good way.

As they took turns reading (back and forth) it was hard sometimes to adjust to a different voice so quickly. And style. They both have a lot of individual reading style. Which sometimes complemented each other, but mostly it was jumpy.

If I wanted to be critical I could say that Bobbie was a bit "heavy" and that Joanne was a bit "bratty."

Now I've said the worst.

The best is that all this made for a very exciting reading. Powerful. And full. With both Joanne and Bobbie each coming off as very unique poets.

(And with so many poets around these days "unique" is a very good word.)

At the laundromat. Sitting out in the sun. In a big wooden picnic table-like chair.

A beautiful guy with long blond hair is leaning up against a car across the street. Looking at me, but not *at* me. I mean, I could just as well be a tree.

A little black dog is sniffing my sneakers.

A beautiful boy walks by with a guitar.

A little girl wants a quarter. Giving her a nickel she mumbles "motherfucker" and walks away.

Another beauty is heading for the hardware store.

Bolinas in the daytime can be too much too.

Another one (help) enters the laundromat.

Driving me up the wall.

I'm getting out of here. Maybe Bob and Bobbie will be up by now.

I've been building little houses in my head. Simple houses that even I could build. Which is what happens to you (evidently) if you stay here long enough. (House/land fever.) And evidently I have. (Been here long enough.) The one I like best is simply two pairs of steps, to be built on a slope, to be lived "on" and "under," depending upon the weather.

I'd better get out of here fast.

A vision of Lewis gliding through life touching things.

Gordon's blender is a "Lady Vanity." His icebox a "Coldspot." His stove a "Thermador."

The faucet is dripping.

The kitchen clock is *so* loud.

Gordon is still asleep. Which is why I'm in the kitchen. Boring you with kitchen details.

Would you believe I finally made out in this town? Last night. With a boy who lives on the beach. Tom.

Actually, it was sort of boring. Totally a one-way thing. I mean—to put it bluntly—he just wanted to be blown. "I really like girls better," he kept assuring me. (And they can have him.)

Very pretty boy tho. Like a Methodist version of Jesus. Only with strange gray blue eyes. A bit spooky really. Like ice.

Today at 12:30 I try to finish drawing of Margot.

And Susan arrives today. Bill's girlfriend.

THREE BEACH BOXES

(WOOD, FEATHER, PLASTIC, AND TAR)

O My Life

"It is important to keep old
hat in secret closets)."

Ted Berrigan
New Lebanon
7 June 71

TED GAVE ME THIS POEM TO
TRY TO MAKE INTO A VISUAL
BROADSIDE BUT ___ I DON'T KNOW.
IT SEEMS VERY VISUAL IN THE
HEAD ALREADY. IN FACT, ANY KIND
OF IMAGE MIGHT DESTROY IT. OR
WATER IT DOWN. (?) GUESS
I'LL TRY THO.

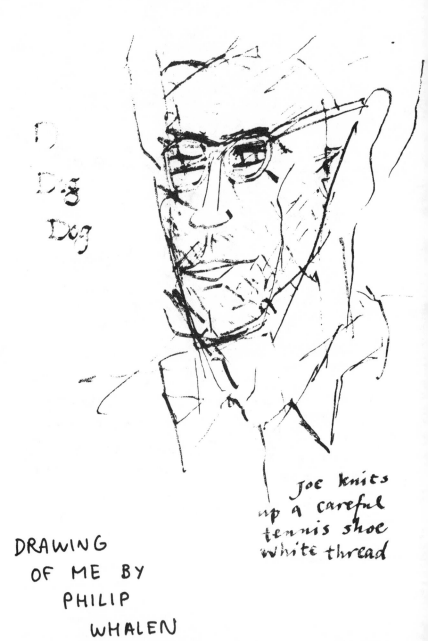

Dog
Dog
Dog

Joe knits
up a careful
tennis shoe
white thread

DRAWING
OF ME BY
PHILIP
WHALEN

(SIDE VIEW)

(WITH DOORS OPEN)

HOUSE "EVEN I COULD BUILD"
(I THINK)

The funniest things are hard to admit.

Pills. That's a hard thing to admit. That I take them.

No, that's not hard to admit. What's hard to admit is that I *need* them. (Sometimes.)

Thank God I'm vain enough not to let myself get carried away tho.

And I take them only for work.

I *do* take good care of myself.

Tho more and more I am in love with not.

But it's a hard habit to break. And I'm chicken.

And I want *both*.

Tuesday, July 6th I leave. At 10:30 P.M., "United," 2nd class, arriving at Kennedy at 7:00 P.M.

Susan: very pretty. Sweet. And young. The only problem being that I doubt if she knows what she wants yet. And Bill does.

Today, tho the 3rd, is the 4th of July parade.

Tonight Gordon is giving a dinner party: Joanne and Peter, Bill and Suzan, and Margot and John.

Phoebe is sick.

Do I really want to come back in the fall? I think so.

But will I? I don't know.

The parade, very red white and blue, ended up on the beach with potato sack races. And just plain running races.

A funny black dog wearing a white tee-shirt.

(And a beautiful blond boy wearing a pink tee-shirt.)

Two very fat ladies all dressed up in feather boas and stuff sold great chocolate cake.

A fire engine.

Majorette "twins" with lots of bubbling blonde curls.

A lot of people I never saw before appeared from somewhere.

It was fun.

Nice dinner party Gordon gave last night. (Lamb.)

At four this afternoon Zoe Brown is giving a big picnic. Not sure how much I feel "up" to that. Too many people to say "goodbye" to. And I hate "goodbyes."

Gordon is still asleep.

Lots of dishes in there from last night. I should go do a few. Yes, I will.

Did. (Some.)

You know, what I'd really like is to be in Vermont right now. It makes me nervous being in a place I know I'm not going to be in for long.

We were talking about life yesterday, Bill and I (yes, life) and Bill was saying how his idea of being happy was to spend the whole day in bed with someone. (Me too.)

To be *that* in love. To be *that* involved. And to be that *not* involved in everything else.

Some day yesterday.

Ran into Ted and Alice at Bill's. (A pep pill.) And off to R.C.A. beach with Suzan and Bill. *Fantastic wood*. Small oval and near oval pieces all smoothed and bleached by the ocean and the sun. (Two green corduroy coat pockets full.)

Then to Zoe Brown's party. Good food. Lots of wine. Lots of dope. And great people.

So strange (a shock) to see Philip across the room at a party. (As opposed to at home on the sofa.) I really am crazy about him.

Bobbie broke into tears at one point just because "drinking makes me do that." And I hope that was why. The more I get to know Bobbie the less I feel I know her.

That's not a bad thing to say about someone is it?

GORDON'S
KITCHEN

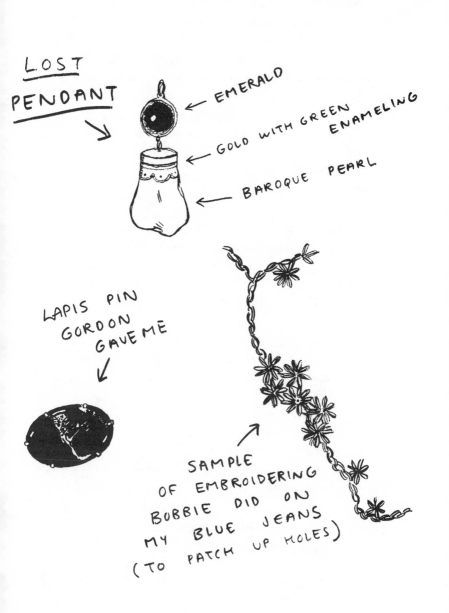

LOST
PENDANT

← EMERALD

← GOLD WITH GREEN ENAMELING

← BAROQUE PEARL

LAPIS PIN
GORDON
GAVE ME

SAMPLE
OF EMBROIDERING
BOBBIE DID ON
MY BLUE JEANS
(TO PATCH UP HOLES)

Someone said that Bob had his head all wrapped up in silver foil at one point during the party, but I guess I missed it. (No "guess" about it.)

Sometimes I do wish I could get that drunk. Just to not always know exactly what you are doing. What a relief that must be.

Well, I did get *pretty* drunk. And stoned. And walked down to the beach. (The blue just before night.) Down to the ocean. To see the fireworks. And to try to sober up a bit.

The fireworks were nothing more than you expect fireworks to be. And perhaps not even that.

At any rate—it was very dark by then. The tide was very high. I was wearing my baroque pearl and emerald pendant from the Italian renaissance. And still not too sure on my feet.

There is one place on the beach where you either have to jump down or push yourself up, depending on which direction you're going. (Me, up.) But I slipped, and slid down, crushing my pearl against the rock. Which fell off as the tide came in and swept it away.

Funny tho, instead of reacting to the loss, I somehow got outside of myself, waiting and watching to see how I would react. Which I didn't.

I mean—I just more or less said to myself "Well, it's gone."

Let me tell you that it really was a beautiful pearl. Very valuable too. And my most favorite thing.

At any rate—So I walked back to Gordon's wearing an empty chain and a bloody spot where the pearl had been.

(Secretly realizing all the way that I couldn't have asked for a more dramatic ending to this journal.)

Well, a good lesson in "having."

Gordon, in compensation (tho he said he was going to give it to me anyway) gave me an oval lapis pin from Italy. (Thank you in writing too.) It's very pretty.

Of course, maybe I don't *really* realize that it's gone yet.

TWO
REJECT FLYERS
AND THE ONE
THAT WAS USED

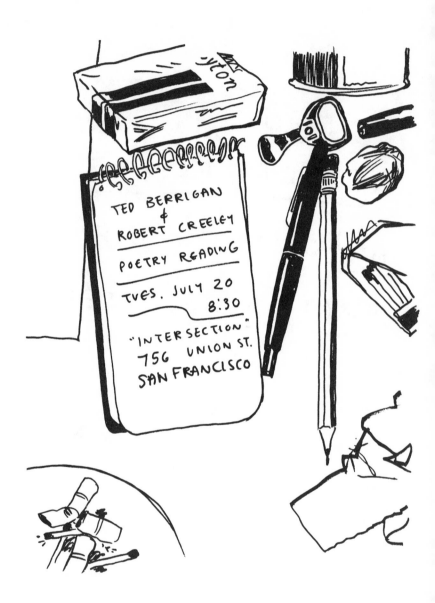

POETRY · READING

TED BERRIGAN ROBERT CREELEY

TUESDAY, JULY 20ᵀᴴ / 8:30
"INTERSECTION" / 756 UNION
—— SAN FRANCISCO ——

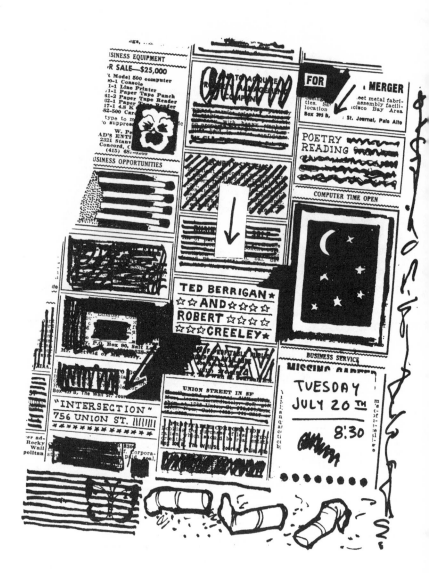

BUSINESS EQUIPMENT
FOR SALE—$25,000

...Model 500 computer
...-1 Console
...-1 Line Printer
...-1 Paper Tape Punch
...-2 Paper Tape Reader
...-1 Paper Tape Reader
...-1 4.8 K...
...-500 Card...

type to m...
to suppres...

W. Pe...
AD'S ENT...
2321 Stanv...
Concord, C...
(415) 68...

BUSINESS OPPORTUNITIES

FOR

MERGER

...eet metal fabri-
...assembly facili-
...cisco Bay Area

Box 395 B,

St. Journal, Palo Alto

POETRY READING

COMPUTER TIME OPEN

★ TED BERRIGAN ★
☆☆ AND ☆☆☆☆
ROBERT ☆☆☆☆
☆☆☆ CREELEY ★

BUSINESS SERVICE

MISSING

"INTERSECTION"
756 UNION ST.

UNION STREET IN SF

TUESDAY
JULY 20 TH

8:30

(The story of my life.) I mean—I sometimes think I'm not very realistic. (Unless that's being *very* realistic.)

I don't know what I'm talking about.

Lewis MacAdams comes to sit at eleven. Really doubt that I can get into drawing *a person* my last day here, but I'll try.

And I have a flyer to do today too. For Bob and Ted. Reading at "Intersection" July 20th.

And tonight—I suppose tonight will be saying goodbye to a lot of people I don't want to say goodbye to.

I'm going to miss Spot, the Creeley dog, who picks me up everytime I pass their house and walks me to where I'm going.

And that little boy who's dropped the "Lewis" and just says "Hi, Jerry!" now.

And very sweet Bob. And very mysterious Bobbie.

And Joanne.

And I'm going to miss people not knowing me so well. And vice versa. (More room.)

And all the things we didn't get done, Bill.

I keep telling everyone I want to come back in October (partly to convince myself of it) and I *do*.

But I know that it's partly just an excuse too. An excuse to say "See you in October" instead of "Goodbye."

My idea of how to leave a place gracefully is to "disappear."

Wednesday, July 7th, 1971

(A Greyhound Bus Trip)

Long legs *do* come in useful. Trying to make yourself look like you need a whole seat on a bus. (Greyhound.) Pulling out of the New York City bus terminal at this very moment.

I'm on my way to Montpelier, Vermont. Then to Calais. To Kenward Elmslie. To beautiful country. To work.

Just had a Bloody Mary at "The Coach House Bar," I think it was called, with Bill Elliot (slurp), a boy (a composer) staying at my place while I'm away.

12:30 now. I arrive in Montpelier at 10:30. Hope I can keep this whole seat to myself all the way.

It sure does feel good to be going someplace I know I'll "be" for awhile. (Rest of July and all of August.) And to see Kenward again. That'll be great. (I hope.)

Cut the shit, Joe. It *will* be great. (Two months since we've seen each other.)

Dinner last night with J. J. Mitchell. (Very "J. J. Mitchell.")

Going up 10th Avenue. Which somehow just turned into Broadway. Amsterdam Avenue now.

A totally *insane* city. (Just got back from six weeks in California.) It scares me. (N.Y.C.) But I suppose I love it too.

I should have had coffee instead of a Bloody Mary.

I want to really write good today.

Thinking about Jimmy Schuyler, who just had a breakdown, *I'm sorry.*

Harlem.

The Flying Red Horse.

Sexy construction worker.

I wonder if "too much" has anything to do with it. (?) *That* I can almost understand.

So strange, always, to be reminded how tentative everything is. (You are.) ((I am.))

I think I *will* take that pill. I want to really write. Get carried away. I want to think I'm great. And I want *you* to think I'm great.

I want—

(A real beauty with no shirt on driving a truck)

—I want (as usual) *too much.*

The ashtray says "ashtray" on it.

Factories.

Houses.

Rocks.

Cars.

Trees.

Lots of sky.

"CONSTRUCTION NEXT 11 MILES."

Traveling makes me want to try to figure out what everything is "doing" here. Houses. Cats. Cars. Trees. *Me.*

Just think—hundreds of people are living in *that* apartment building. Surviving. (Good luck.)

That's a *very* long Tropicana orange juice truck.

Chocolate donuts just came into my head.

Ted Berrigan.

"NO U TURNS."

I hope Kenward got my message of arrival.

I hope Joanne won't think too much about the pearl I lost in the ocean.

I hope we won't drive by *any* hospitals.

I hope people know I don't *want* to glance away, or down, sometimes, when we are talking.

A lot of those red dunce cap looking things on the road people going the other way are going on.

Yes, I *am* going to take that pill. At the first coffee shop.

"Forge Antiques." Not a very good name for an antique shop I would think. (——ry.)

I'm never totally convinced, riding a bus, that I'm on the right bus.

A sign just said "WRONG WAY." (White on red / WRONG over WAY.) For people on the other side of the road. If they were going this way.

The guy in front of me just pushed his seat way back. (Too way back.)

If that first coffee stop doesn't come soon I'm going to just take it anyway.

You know, I'm not really dumb. Just a bit scatterbrained. Smart enough to know it. And smart enough to take advantage of it.

Do you think this is cheating?

Or is this just "style," capitalizing on what you are?

I don't know. (I suspect I'd better be careful tho.) I don't want to turn into a parody of myself. A caricature. (I'm referring to my writing.)

I know what I ought to do. I ought to learn to type. And increase my vocabulary.

I think my limitations have worked in my favor so far, but—

Six guys in a car seem to think there's something funny about this bus.

You know I really don't understand this thing about life being so tough. Here I am, a *very* lucky person, and still life is tough.

I hope life isn't proportionately tougher for those not so lucky.

We're so amazing: people. Before long we'll probably figure out a way to live without air.

Maybe even without hurt.

(A vision of turning into vegetables being our fate.)

You know, I really have no idea what time it is.

No coffee break yet so I'm just going to take it.

Did.

Oh, a bank clock just said 4:04.

That makes me a little less than one third there.

We must be entering Hartford. Yes. I *think* he just said so on his speaker, the bus driver, which totally destroys words. (The speaker.) And something about "Springfield." And something about "15 minutes." (A 15-minute coffee stop in Springfield?)

It seems that there are at least six German kids (18 to 20 years of age I would say) on this bus. And one older couple, also German.

A bowling alley. (Well, *I* haven't seen a bowling alley in a long time.)

I find myself picking out the nice things I hope the Germans are seeing. Like that big brown barn we just passed.

Springfield. Plain donut and coffee. Pee. Face wash. Clean glasses. Just informed that I have to change buses at White River Junction.

I've been playing "the truth game" with myself for several years now (in my writing) but there are several areas I avoid talking about. (That I know of.) And no doubt some I don't know of yet.

They are: Kenward's money
 speed
 exaggeration

Kenward's money. I like it too much. And have gotten to need it too much. And am still embarrassed to admit to taking it.

Taking it doesn't embarrass me at all. Seems only natural, as he has lots and I have little. What embarrasses me is *admitting* to others I take it. I like for people to think I'm totally on my own. (And with no strings.) And, in most ways, I am.

Speed. I don't really approve of speed but I *need* it to do all I want to do. And that's a lot. So I take it.

Luckily, I'm vain enough tho that I don't let myself take too much. And I only take it for work.

I don't feel one bit guilty about this. But it does embarrass me to admit it. I guess I like the idea that people think I do all I do just on natural energy. I guess I like to impress people. I guess I want people to think I'm a genius.

I suppose this is a fault, this need to please. This need to impress. But at the same time I realize that, if I'm to be an extraordinary artist, it's this very need that will make it possible.

Exaggeration. I have a tendency to exaggerate. To make things sound better than they are. Once again, I suppose, to please and impress. There's nothing constructive about this, however, and I don't like it. (I *am* improving tho.)

Now this is something really embarrassing: not being able to make it with pick-ups, one-night stands, and people for the first time. (A recent development.) Just this past year.

I think I know where the trouble lies tho. Getting too drunk and too stoned. And feeling too self-conscious about my body. (Too insecure.)

I mean—I really don't think I'm very sexy. (Too skinny. Bad posture. And cock nothing to rave about.) Which makes me feel awkward. Self-conscious. Which makes me feel "outside" the situation.

Once I can relax with someone I have no trouble at all tho. (Once I know they like me too.)

This really drives me up the wall tho.

I want to be able to have more *fun*. Without having to worry about things like that.

This spring I went so far as to hire a very sexy hustler several times. (*Four* times.) (($25 a night.)) But, no dice.

But that, I think, is another story. Having to do with not being able to enjoy sex unless the other person is enjoying it too.

(Well, maybe it's *not* another story.)

It's a great system tho. (If only it worked.) A phone call and a little money instead of being lonely and horny. That's a bargain, in my book. (If only it worked.)

So now I'm leveling a bit, and now I'm wondering if maybe leveling, for you, isn't maybe a total bore.

I don't know.

I *don't* wonder why I'm telling you all of this. I wonder if *you're* wondering why I'm telling you all of this. (?)

I'm just not convinced that my problems are going to be all that interesting to a stranger. (And I *do* write for publication.) Except that I *do* feel like writing about my problems and I *do* believe in writing about what I feel like writing about.

That's my only hope.

That's the only thing about writing that I really believe in. (For me.)

Editing. I used to really edit a lot. Slashing details that might possibly be boring. Rewriting for clarity. Trying to pinpoint things. Trying to make the truth much simpler (clearer) than it is. But with this I'm not going to do this.

If this book is going to be about what's going through my head during a nine-hour bus ride—that's what it's going to be.

The funny thing about most "gems of truth" that instantly ring a bell is that they're total nonsense when you stop and think about them.

And—"the truth"—why is the truth so narrow-minded?

Like old people who get a sort of wise air about them. They drive me up the wall.

People are getting together behind me. (Lively talk.)

The countryside is improving. (More lush.)

Big red clay rocks.

Black-eyed Susans.

A blue State Police car.

I like it when those dead elm trees get covered with vines.

Little houses.

If the secret of life is not stopping I'm a winner. (But it's not that simple I'm sure.)

That time of day now when the shadows are really long. And sharp. Relaxing. And beautiful.

Ass getting a bit sore.

Another small town.

Sure would like a cup of coffee: *right now!*

That old German man across from me wants to know what I'm writing.

"A sort of notebook" I think is what I said.

"Oh."

Been writing like a madman ever since Springfield. Probably thinks I'm a genius of some sort. (As opposed to the dope fiend I am.)

You're not going to believe this but the German man just pulled out of a bag a cap with a miniature straw basket sitting on top bubbling over with miniature fruit. What's more—it's on his head, wobbling along with the movements of the bus. And nobody is even noticing it. Or perhaps trying not to.

The sun is in my eyes.

I *do* look forward to seeing Kenward a lot.

(You might be glad to know that he just took it off.)

And the comforts of sleeping with a body all night you know so well.

The same comforts that drive me up the wall when we see too much of each other.

The same comforts I'm afraid of. Because comforts *do* get boring.

And boring is dangerous. (And boring.)

My God—this is Vermont already. (Brattleboro.) And the Germans are getting off. More of them than I thought. (Half the bus.)

Brattleboro. Must be a ski place.

I wonder what time it is.

The blond boy behind me wonders if he's on the right bus. (Nice to know it's a common fear.)

"Gee, I don't know. You'd better go ask the driver. I would if I were you." (Don't know why I said that unnecessary, and false, last sentence.)

"Yeah, I think I will."

This bus is number 3087. (You'll be glad to know.)

Anne! I love you and miss you.

And you too, Michael, in a funny way.

(Funny = abstract)

(Abstract = less understandably)

(Less understandably = ?)

So much for *that* game.

Where did I get this voice from? (Bratty.)

Reminds me of Anne. (Who is *not* bratty, and yet—)
((Beautiful elements of.))

And Pat and Ron. And Joe. And J. J. (Tho God only knows why.) And—

No, I won't bore you with a whole list. (Of people I especially love.)

And besides, I wouldn't want to leave anybody out. And I wouldn't want to lie either. So—

(So now you know just how honest I really am.)

Hope you don't think I'm just playing games with myself. I'm not. I'm being silly. I'm trying too hard to say "something." I'm being self-indulgent. But I'm not playing games with myself.

First Vermont cheese sign I've seen so far.

That big red barn gift shop I'm sure I've seen before.

This may be a total fantasy but, if I could just spend one week all alone with Joanne Kyger—

Bellows Falls now.

Waterloo playing across the street.

A policeman.

A family of six eating ice cream cones in a black car. (Why don't they get out?)

"Tuttle Street." You can be sure a lot has gone on (happened) on Tuttle Street and *is*. At this very moment. Inside each house. Inside each head. At this very moment.

Entering another town. I bet it's White River Junction. (My transfer town.)

No.

It really is beautiful, Vermont. Makes so much sense to live here. (If only life made so much sense.) But it doesn't.

Really fantastic sunsets really *do* make you feel small. For a moment.

I must say I've done a very good job filling up this "ashtray" ashtray. (So obviously an ashtray it's almost embarrassing.) ((To say nothing of then labeling it "ashtray."))

Corn.

Cigarette butts. I bet I'm one of the few people in the world who appreciate cigarette butts. (Do works with them sometimes.)

Another town. (Now surely—)

"Odd Fellows Block" a sign on that building said.

Claremont. I can't believe it.

8:05.

Well, if I'm going to be in Montpelier at 10:05 and I still have a transfer to make it's *got* to be soon.

You know that in the back of my mind the fear is arising that maybe I missed it. (My transfer stop.) But I refuse to let myself turn into an old lady.

And, even if I did miss it, it wouldn't really matter.

And if I missed it, I already have, so thinking about it won't help any.

A picnic table.

Outdoor chairs.

A planter.

Bicycles.

Toys.

The way things seem "sprinkled" around a yard (even tho probably neatly placed) is somehow very moving.

The sun is a bright pink-orange now, and beautiful. And more amazing, I sense, than I am able to realize.

That's not fair!

Now if this isn't White River Junction—

Portland.

If the next stop isn't White River Junction I'm going to ask the bus driver about it.

Cute boy sitting all alone on "The Windsor House" lawn across the street.

I'm hungry.

I want to see Kenward.

My ass hurts.

Very opal-like now, the sky.

A lumber yard.

Portland. I didn't know there was a Portland in Vermont. (Don't think about it.)

This bus *is* supposed to turn off into New Hampshire at some point.

"White River Junction" a big sign just said.

Bad case of dandruff the guy in front of me has.

A cemetery.

A trailer court.

(Right next to each other.)

Looking surprisingly similar.

New bus. New driver.

Great. Only a 15-minute wait between buses. Just time for a donut and coffee. Not even time to pee. Wash my face. Etc. Or what have you.

Two giddy French girls on the bus. (Heavy giddy.) Laughing and talking a mile a minute. (In French.) With, I think, a radio. Or—*somebody* back there has a radio.

Really night now. Dark. Blue dark. That kind of blue dark that makes white houses glow. "Arabian blue" I think of it as. But I think I may have made that up. (Cornell blue.) Starry night blue.

Looking out the window is a bit confusing now as mostly all I can see is myself. My reflection.

Very little ashtrays on this bus. And very well hidden.

This little spotlight on me is making me feel conspicuous. (Can "they" read what I'm writing?)

Just heard someone say "sauna bath."

"Insurance."

Fuck. Just missed being able to read a sign saying how many miles to Montpelier.

Wish I didn't have so many books to do so soon. (Covers and drawings for.) But I *do* want to do them. And I *do* want to have done them.

I really can't see outside at all now. Think I'll turn out the light and see if I can still see to write.

I think if I write big enough I can figure it out later. (What I'm writing.) In other words—no, I can't see to write very well.

Actually, there's not much to see outside right now except endless black trees.

No stars out tonight.

I could sure do with a bath.

The French girls have quieted down.

"REST AREA 1 MILE."

Little modern house all alone.

Birch trees.

The moon tonight is either full or so close to full it looks full.

I want to do some big birch tree cut-outs this summer.

The French girls are up and at it again.

Don't know why I don't like radios but I don't. ("September Song" with 100 strings.) For some reason they remind me of the past. (Radios do.) Which, I guess, *is* why I don't like them.

Well, it's something to write about.

You know, I think the moon *is* full. And through these tinted windows, a bright chartreuse.

A man gets up to go to the bathroom.

The bathroom! What a dumb fuck I am. There's a bathroom right here on this bus.

As usual it took me awhile to figure out how to open it. (In, not out.) Peed. But no water to freshen face with.

Barre!

Well, it won't be long now.

This has really been a good bus ride. (With a little help from my friend.)

Whoever owns that radio is really a genius. (Roller skating music now.)

I remember those two big weeping willow trees.

One more bus cigarette.

"Anne's Motel" has expanded. New sign too.

People in houses at night. Always such a shock. Don't know why. I'll be doing it soon too. When I get off the bus. Such a *real* situation. Like a hammer on the head. When you're outside looking in. People in houses at night.

How's *that* for an ending?

But, no—we are now sitting at a gas station just a few minutes from Kenward while the bus driver is cleaning his (very dirty I must admit) windows.

They give "S & H Green Stamps."

Off again.

The sweater store. (A store that sells nothing but sweaters.)

Radio interference. (Good.)

The reindeer statues in front of "Howard Johnson's" which have been slowly sinking into the earth for two years (up to their knees last year) are now on top again.

House trailers for sale.

Lots of cars watching a movie.

More trailers for sale.

Hey, you know—I'm nervous!

A new restaurant.

A new car wash.

A new furniture store.

The same old river.

I guess this is it!

from Vermont Journal: 1971

TODAY

For once in my life, today, I dropped an open-faced peanut butter sandwich that landed right side up.

I'M SORRY

Jim Morrison is dead. "Light My Fire." (My favorite queer bar song.) If you knew how many quarters . . .

The world was full of people not like you, and now is.

I'm sorry, too.

TODAY

Big breakfast. Worked on *Bolinas Journal*. Raspberries with sugar and heavy cream for lunch. Sunbathed. Did my exercises. Took a shower. Washed my hair. Jerked off. And sent away for some old Indian trade beads.

KENWARD

Kenward just came up wet from the lake with three bright-orange mushrooms he insisted I smell. (Did.) In a few minutes they are going to be chopped up into scrambled eggs. "None for me, thank you."

THE BIRDS

I'd be just as happy if the birds around here wouldn't swoop down so low right at you. I keep having visions of——I mean, what if I were to suddenly stand up and——(beak in eyeball).

A MINI OBSERVATION

A green plastic mermaid in Kenward's martini last night at The Lobster Pot is, this morning, a giant memory.

JUST LIKE IN THE MOVIES

Kenward and I were standing out in the middle of the lawn, Kenward naked, and me all covered with cocoa butter in a black nylon bathing suit, talking about the telephone call Kenward made to me in Bolinas several weeks ago, when suddenly from out of the bushes came Jimmy Schuyler wearing pale yellow Bermuda shorts. (Silence.) As Jimmy headed for the house he said he felt like he was interrupting something. He was.

JIMMY

Jimmy confessed this morning that he's been hitting the blue satin glass candy bowl.

RIGHT NOW

Thinking about how blue the sky is, and how black and white the sun makes everything seem today, eating a peanut butter and honey sandwich on toast, and drinking a can of Nutrament (trying to gain weight). I'm thinking of you, J. J. Mitchell, *right now*.

TODAY

Sitting out here in the sun today in a black nylon bathing suit covered with cocoa butter in a lounge chair with clip board in lap I have a very clear vision of myself on this area of green around me called land. The exact amount of space I am taking up. And how I would look pretty strange to "something" that didn't know what I was. So different I feel from nature. Like art in a big white gallery.

LAST NIGHT

Lots of dreams last night but all I can remember is something about some guy who was always getting teased a lot because his name was Hudson Rock. (As opposed to Rock Hudson.)

LAST NIGHT

Last night, stoned out of my mind on three John Ashbery brownies, trying to write a letter while watching a movie* on T.V., I wrote down "judn't" instead of "didn't just."

THESE DAYS

Don't know how to say this without sounding like a total nut but—I find myself having to let out a giant scream or two every morning—like I have to brush my teeth every morning before I feel "ready" for the day ahead. You know what I mean?

TODAY

The best thing I can think about today (so far) to write about is how *very* orange Kenward's orange sweater looked tossed on the floor last night in a hurry to get to bed. (Tired and stoned.) And me with a hard-on. "Go away!" But it wouldn't. But it did. (Sleep.) Many dreams I remember nothing of. Then up at seven to rain. Hate the way electricity is so yellow indoors on days like today. And this white shirt, it just "hangs" on me. (Clammy.) And boring mail. I think I'll go kill myself.

Esther, with Joan Collins and Richard Egan and many Italians. Great movie. Well, the great brownies made the movie great. And so, yes, I guess it was a great movie. (If it was, it was.) And it *was*. Wouldn't go so far to say that it *is* tho.

Fear

A good life should be lived without fear.

On the other hand, trying not to be afraid of something you are afraid of is stupid.

Avoiding fear is no good.

The only solution is to give in to fear, and then try to overcome it.

Nothing can be understood from a distance. And nothing, of course, can be understood until it is understood.

Only by not being afraid of the lion, but of the fear in you that makes you afraid of the lion, can fear be overcome.

In this area I am a total flop.

White Spots

My white spots are appearing again. On my skin. Like every now and then these white spots appear that look like someone splashed some drops of bleach on me. It has a name but I can't remember it. I thought it had something to do with the sun (too much of) until two autumns ago I went uptown to see Dr. Brown about a blood test (clap) and he said, "What are those?" (pointing to the white spots) and I said, "Too much sun," and he said, "I don't think so." After he figured out what it was he said it was something that just comes and goes. And that, if you have it, you'll probably always have it. Then he handed me a prescription that turned out to be a giant brown bottle of something that looked like water. So I rubbed it on the spots twice a day (more or less) as I was supposed to and they *did* go away. But because of the medicine or just because it was their time to go away I don't know. All I know is that for two years now they've been appearing and disappearing *without* the use of any medication. But actually, I don't mind them. But I still think they may have something to do with the sun because when they appear most each year is at the end of the summer. (I said two years, but now that I think about it, these spots have been appearing for three years or maybe four.) But like I said, I've gotten used to them.

Which reminds me of a bad toenail I have that I don't like one bit. (From wearing cowboy boots.) You see, my right foot being a bit bigger than—no, it's too boring.

My Favorite Quotations

"There is something inside of me. What is it?"

Van Gogh

"I never smoked a cigarette until I was nine."

W. C. Fields

"Loneliness is boring."

Jim Morrison

"Get it while you can."

Janis Joplin

"I think kindness is the most important thing in a person, don't you? Gee, when anybody does anything nice for me, I just about fall on my face."

Betty Grable

"The only thing worse than Christmas itself are the people who hate Christmas."

Jimmy Schuyler

"Freedom's just another word for nothing left to lose."

Janis Joplin

"Grace to be born and live as variously as possible."

Frank O'Hara

"If it's inspiration you want, drop your panties!"

Francis Picabia

from Self-Portrait: 1971

AGE

Well, let's just say thirty years ago today I wasn't anything.

CHILDHOOD

I find it very hard to believe I was ever a child.

QUEER

The only thing that ever bothered me about being queer was that I thought maybe people wouldn't like me if they knew.

HEALTH

Now that there's a health food store just down Sixth Avenue I'm trying to be more aware.

ONE DUMB THING

One dumb thing that always makes me want to cry is "Some Day My Prince Will Come" without words.

WHEN I WAS A KID

When I was a kid my main desire in life was to grow up and get out and make everybody like me.

NOW

Now I'm out and as grown up as "grown up" means anything (not much) and still I'm trying to make everybody like me. The only difference is that now I know better.

WRITING

Writing, for me, is a way of "talking" the way I wish I could talk.

PRACTICAL

Actually, I *am* practical. It's just that, sometimes, being impractical seems practical to me.

ROMANTIC

I'm just sure I'm going to die young. Which, ten years ago, was now.

SELFISH

I am selfish, yes, but I think I'm selfish in a realistic way. Which, actually, is *not* being selfish.

EGOMANIAC

I guess I must be an egomaniac but, it's funny, I don't *feel* like an egomaniac.

WHY I AM A PAINTER

One reason I'm a painter is because I'm not a movie star.

CONCEIT

To tell you the truth, I don't think I'm as conceited as I have the right to be.

I MUST BE GROWING OLD

I've stopped yanking out gray hairs as they appear now. Now I just let them accumulate and every now and then I have a big yanking session.

MY BIGGEST FEAR

My biggest fear is that some morning I'm going to wake up to find that I don't like myself anymore.

FOUR O'CLOCK

When it gets to be around four o'clock and I have no plans for the evening I start getting nervous.

TOMORROW

I always know what I'm going to do tomorrow but (thank God) I'm often wrong.

WHY I LEAVE MY SHIRT OPEN

Many years ago Joe LeSueur made the mistake of telling me I have a terrific stomach.

SHY

If being shy is just a habit, it's a hard habit to find a replacement for.

TERRIBLE AT LEAVING

I say "Well, I guess I should be going" and nothing happens.

ART

Art to me is like walking down the street with someone and saying "Don't you love that building?" (Too.)

OPTIMISTIC

I guess I must be optimistic because (secretly) I think I'm going to be a *fantastic* person one of these days.

SKINNY

I complain of being skinny and people say, "Oh, you're not skinny" and I look in the mirror and *I am skinny*, God damn it.

WHERE I DRAW THE LINE

I *am* vain, yes, but you wouldn't catch me under a sun-lamp for a million dollars. Actually, I don't believe in drawing lines.

ME NOW

Funny, I don't remember having much to do with how I got this way.

I WONDER

God, when I think back——Am I still *that* transparent?

from N.Y.C. Journals: 1971–1972

Tuesday, December 28th, 1971
(Some notes on a trip to go see Alex Katz's show in Hartford with Anne Waldman and Michael Brownstein and Pat and Ron Padgett.)

Anne just called in the middle of shaving to say not to rush. They just got up.

Finding a pair of clean underwear no easy matter. (My last.) Around this time of year I become totally impractical.

In a taxi on my way to Pat and Ron's the driver has a lisp. Warm slightly damp weather. I hope this isn't a faint headache I feel in my head.

Michael informs us that our car is $12.00 a day and 11¢ a mile.

Our first coffee stop. "The Nutmeg Inn." Much talk about whether to take a pill or not. Anne and I do. Pat and Ron and Michael don't.

Ron takes over at the wheel. 55 more miles to Hartford.

A bag of dried apricots is brought out. (Yellow raisins were rejected.) And now peanuts. The plain health store kind.

Passing a negro man smoking a pipe in a car strikes me as funny (strange) for some reason. A pipe in mouth seems so "white."

Passing a graveyard I wonder why the world isn't literally *covered* with graveyards, considering how, over the years, so many people have died. (?) Ron and I discuss this, but with no conclusions.

Anne to Michael: "You're a different person from when I first met you."

Anne: "I was smoking dope when I was thirteen."

Almost at Hartford a big sign said "Brainard Road" which Anne said I ought to write down.

"And a Brainard Airport too," Ron just said.

At the museum now looking at *Upside Down Ada*, one of my all-time favorites.

How Alex all these years has remained so pure is beyond me.

Other all-time favorites are *Impala* (1968), *Bather* (1959), *Donald and Roy* (1965), *Private Domain* (1969), *Joe 1* (a cut-out of me six times), the Frank O'Hara cut-out, and *Self-Portrait with Sunglasses* (1969).

As slight headache continues I'm having a hard time (upstairs among the permanent collection now) seeing individual paintings individually. Even Pollock and de Kooning, today, seem dusty and a bit sad. (Old hat.)

Just can't seem to get beyond the big gold frames today. (Old Masters.) Which reminds me how extroverted Alex's paintings are by comparison. So easy to look at, as they come out and meet you half way.

A Goya with one of his large beautiful neutral areas of "no color in particular" that neither recedes or comes forward is the only painting upstairs that really touches me today.

Slight headache continues as I sit on beige carpeted steps waiting for Anne and Pat to come out of the Ladies' Room. What I need is a cigarette and a cup of coffee.

The old lady in the museum gift shop says she knew Wallace Stevens. And that one shouldn't believe everything one hears about him. (In response to Ron's saying that he was an old grouch.)

On our way now to look up Wallace Stevens' house. Such a pink sky. The Capitol building has a gold dome.

As we pass the insurance company Wallace Stevens worked for Ron says it "looks like" his (Stevens') poems.

"Asylum Apartments" (a new high-rise) gets a big laugh. Well, a chuckle.

As we only know the street and not the house number, we're having a hard time figuring out which house it is. We ask several people but nobody even knows who Wallace Stevens is.

Found it finally. A big white house with gray shutters partly hidden by many bushes. (118 Westerly Terrace.) Anne rang the bell and asked if this was the house. ("Yes.") "A very rude lady," Anne said, when she got back to the car.

On our way to check out Mark Twain's house Anne (reading a guide book) says that there used to be twenty publishing houses here. Pat adds that the first American cookbook was published here.

"There should be a fairly visible house up here somewhere," Ron says. (Apropos Mark Twain's house I suppose.) But no, we continue on.

We found it just in time to grab some postcards. From the outside, in the dark, it looks exactly like the house one would imagine Mark Twain would have lived in.

We are heading back to N.Y.C. now, by mistake (a wrong turn) looking for a way to turn around. We pass a big factory building with a beautiful Russian-looking blue and white dome with a white horse on top. "A glue factory, maybe," Ron says.

Heading back to N.Y.C. again, but this time on purpose. Smoking dope. The radio is on. After dinner in a sort of Greek-German (German mostly) restaurant called "The Marble Pillar." (A small marble pillar is in the front window among many other unrelated objects.) "A lot of lawyers eat here late at night," Ron said. Where he got his information from I didn't ask, tho I almost did. We began with very gray and very greasy potato pancakes with applesauce. I said, "What the fuck!" to myself and had my first Bloody Mary since hepatitis. And sole. Pat had sole too. Anne, bluefish. Ron, bluefish. And Michael, turkey. And for dessert Anne had cherry pie with maple walnut ice cream on top.

Over dinner we discussed what a tough painting Alex's *Lawn Party* is. (How "hard to like" it is.) My theory being that, like a painting by Pollock, it must be seen as a whole in order to

be seen at all. As tho, out of the bushes, you stumble onto this lawn party by mistake, a total stranger. (As opposed to being at the lawn party.) Or something like that.

And we talked about the big Paul Taylor and Company painting *Private Domain*. (Anne and Pat and Ron find it hard to like and I love it.) And I explained my theory about how it must be seen as an "abstract" painting *before* one can see it realistically. (That, at least, is how *I* got over the hump towards liking it.)

And we talked a lot about how "logical" Alex's development as a painter is: a straight line to clarity. With only possibly the paper collages and the cut-outs being "side trips."

We just passed three "Land-Sea" trucks one at a time.

We are turning off now to go see some old friends of Anne's. (New Haven.) Looking for George Street, which we just ran into without really looking for it. But it was a one-way street the wrong way so now we seem to have lost it.

We finally found it but a girl said the people we were look-ing for moved out the day she moved in so now we are sitting in the car outside a telephone booth while Anne is trying to find out where they live now. (*Why* am I telling you all this?)

Tea and cookies from an aunt with Kim Hunter's daughter and her husband, who looks a bit like Jim Morrison. (Both are lawyers.) Very nice. Their big-for-his-age son pretty much occu-pied himself with a large set of Christmas drums he didn't quite know what to "do" with. Anne did most of the talking, as we were tired. Two stuffed negro dolls lay on the floor with no faces.

The 25¢ Michael dropped in the toll box didn't make the green light go on so we all quickly rolled down our windows

(having just smoked a joint) but nobody came over, and nothing happened, so we drove on.

Silence inside the car now. The night is so black and the lights are so white. As we nearly end our trip. "The End" in the air.

Michael, afraid we might not quite have enough gas just turned off somewhere in New Jersey—a series of closed gas stations—but here we are now, getting one dollar's worth.

New York City looks pretty good over there. When I see the city from far away I like to try to imagine someone I know in the city, in their apartment, doing whatever they might be doing. It's a hard place to believe you live in if, at the moment, you don't.

Tuesday, December 30th, 1971
That Kenward is the only person I can sing in front of, IS "love" tonight, even if it isn't.*

1972
Thank God there is nothing to remember about 1972 yet.

JOE BRAINARD
FRIDAY
DECEMBER 31ST
1971

Saturday, January 1st, 1972
At this very moment I am in a taxi cab riding up Sixth Avenue one hour late for lunch with J. J. Mitchell and Ron Holland at "Charley O's" with two small paintings beside me on the

*What a prick I am!

seat as New Year's Day gifts for J. J. and Ron. This is unusual as I never eat lunch and I'm never an hour late. Well, maybe 1972 really *will* be a bit different!

Thursday, January 13th, 1972

The little blue flowers on my toilet paper this morning struck me as being more than a bit unnecessary. If not totally *insane!* When I buy toilet paper I just grab whatever kind is in front of me. (Which is to say that I didn't *mean* to buy toilet paper with little blue flowers all over it.) Evidently I haven't much to "say" today.

Tuesday, January 25th, 1972

French toast and bacon with Bruce this morning.

Spent most of today correcting *More I Remember* proofs. And writing a new center section. And a new ending. Still not too happy with it tho. More "forced" than the first volume. More boring details. And not as much personal stuff. I hope people aren't going to be disappointed.

Very happy with a drawing I did of Alex Katz yesterday.

Tomorrow I have a *World* cover to do (No. 25). Perhaps, Anne said, the last (sniff) issue.

I'm doing so much work!

Really feel wonderful. And crazy. And "tentative."

I feel very strongly that in all areas of my life I am walking on *very* thin ice.

I know it can't go on for much longer, but—

These are crazy days and I am going right along with them, so help me God.

Wednesday, February 16th, 1972

The only good thing I can think of to say about *El Topo* is that it made me think that maybe I had been too hard on *Satyricon*.

Friday, March 10th, 1972

Today I dropped a giant green bottle of pink (and I *do* mean pink) (shocking pink) Vitamin B-12 pills all over my dirty bathroom floor: a mess I wish to make a point of totally ignoring (not picking up) until after my 30th birthday tomorrow.

Saturday, March 25th, 1972

The negro man at the health food store (always complaining about being so busy that he never has time to go down to the basement for "new stock") said to me this morning, upon my buying my usual six Tiger's Milk candy bars, "You're going to turn into a tiger!"

(Well, not every story is funny.)

Only five more days to work on my show.

J. J. called yesterday to tell me I might have syphilis.

Shiny Ride (two cartoons by Kenward and me) just came out.

This morning I finished my fourth etching (egg over easy with two strips of bacon) but I don't like it.

Tomorrow I draw Anne.

Tonight is Chris.

Sunday, April 2nd, 1972

If you want to know what it's like to have a rug pulled out from under you (don't bother) (and besides, I'm sure you already know) try having a show. I've never felt so totally empty in all my life. So empty I don't even feel bad (?). Actually, I do. I feel like *shit!*

Wednesday, April 26th, 1972

Tonight (stoned out of my mind again) I just a few minutes ago found myself walking up and down (back and forth) in my loft, madly eating a bag of dried apricots, feeling sorry for myself (lonely and bored) not enjoying them one bit. (The apricots.) Then I said to myself, "How stupid can you be! *This* is life! Eating these apricots! Right now!" So, having convinced myself that taking advantage of the moment is all there is, I tried focusing all my attention upon the pleasures of eating dried apricots. And it worked! For a few minutes. But then I started thinking about how I should write all this down. As I am doing now.

This strikes me as a bit "cheap" somehow, but—but I guess I just don't care.

The "so what?" in me wins again.

Monday, May 8th, 1972

This morning (Westhampton) I wrote some letters and worked on that old red beach construction until I ran out of Elmer's glue. Now it's 1:30 and I guess I'll try to tackle that *Paris Review* photo cartoon, even tho it's the last thing in the world I feel like tackling. But I *do* believe in discipline, I guess. And besides, there is nothing else I especially want to do right now. Except maybe write. But I'm finding it very hard these days, writing. You know, the older I get the more I believe in *nothing*. (Like, for example, discipline.) But discipline *is* practical. (Practical, to me, means "less hurt!")

This gray weather is going to get to me if I don't shut up.

Tonight after supper we go back to the city.

Sunday, May 21st, 1972
The radio is predicting a sunny and warm day tomorrow for Nixon's visit to Moscow.

A Hungarian who says he is Jesus Christ took a hammer to the *Pietà* in Rome yesterday, knocking off an ear and an arm, and I forget what else.

Got up this morning at nine.

A great article in the *Sunday News* magazine section about how neurotic dogs have become, written by a dog psychiatrist.

Some sketches again today for Anne's book.

It's four o'clock now and at five Harris Schiff reads at "Remington's."

Guess I'll go get cleaned up.

(You know, I'm trying to talk about something besides myself but, is *this* any improvement?)

Tomorrow morning I draw David Hockney!

Wednesday, June 7th, 1972
I thought I was slipping into my thirties very gracefully, but (to make a long story short) evidently not.

Saturday, June 10th, 1972
Flash floods last night in South Dakota.

"Impossible to estimate the damage."

"I saw a man hanging on desperately to his wife for as long as he could, then he just had to let go."

While on 9th Street I was feeling very much *with* Steve.

And the rain—it was so nice. In a dark room. Not alone. (Thank you.)

(Saying "thank you," it does mean a lot. Just to be *sure*.)

And I know absolutely nothing about South Dakota. Except that it's right under North Dakota, I think.

Yesterday was really hot. Way up in the 80s. And today, this morning, it's cool and gray.

Janis Joplin on the radio now.

"Bobby McGee."

"Freedom's just another word for nothing left to lose."

(No, Joe, that was last year!)

Who in the fuck wants to be free?

(Tho I can't think of a nobler thing to try for.)

You know, we really *are* so sweet, all of us!

So—what am I going to do today?

I'm going to try to finish up work on the cover for Kenward's *Orchid Stories* I hope.

Mail this morning was a postcard from Bill. The Elliott Bill (slurp) in Italy.

Boy do I look forward to Vermont.

This head needs a rest.

Tonight is dinner with Yvonne and Rudy at Steve. I mean, seven. *Seven* o'clock.

Friday, June 16th, 1972

At the Port Authority Bus Terminal half an hour early, as usual. (Hate to rush when traveling.) On my way to Vermont. Bus leaves at 10:30 a.m. and arrives in Montpelier at 7:00 p.m.

A chunky (sexy) boy in a navy blue tee shirt walks by and I say to myself, "I'll take two."

In line now I am flirting with the idea of flirting with a blond youth right in front of me but, of course, I won't. I love being "alone" on a bus.

A very neat-looking pregnant lady in a bright turquoise sack dress is passing out fliers of some sort.

Holy shit!

Are you ready for this?

Hello. My name is Gloria

I have a very beautiful message to give you and I would appreciate your attention.

I have been very blessed to see God here on Earth in the Roman Catholic Church on the Altar during Mass in the human form of priests.

I have also seen Him in the Protestant Church in England.

God is Three Divine Persons, Our Father, Jesus and The Holy Spirit.

God has sent me to tell you that this Christmas He will appear on Earth in all His glory.

When He appears we will have no more wars. We will have a long beautiful era of peace here on Earth with God living among us.

God's Kingdom will be here on Earth.

God will also remove from the Earth all sickness, all pain and all suffering.

People who have had incurable diseases for many years will be completely cured.

People will never get sick again. The blind will see and the crippled will walk.

God is sending a sign very soon. The sign will be seen by the entire world at the same time.

It will be such a tremendous and convincing sign that even Russia and China will be converted.

The sign will be Our Lady of Fatima appearing in the sky.

Every country in the world, every person in the world will believe in God as Three Divine Persons, Father, Son and Holy Spirit because of this sign.

All God asks in return for all these wonderful gifts is your love.

He wants you to love Him with all your heart, all your soul and all your mind and to love your neighbor as yourself.

God loves you very much. God Bless You.

On bus now. (Fuck!) Too many people. Which means no seat alone. Which means it will be hard to write. Fuck!

The creep sitting next to me (with a very large head) is returning from four years of service in California ("too many hippies") to his hometown of Windsor, Vermont. (A surprise to his father for Father's Day, as they don't know he's coming yet.) He has a 3½-year-old sister he's never seen. He complains of having gotten a shave at a barber shop in the bus terminal that cost him $4.50.

This bus, I just found out, is an express to Springfield (gulp) and I had no breakfast!

Connecticut. So green after a rain. I always forget how green green can be. Each time, you have to see it to believe it. That's nice.

I'm starving!

Finally. Springfield. Ten minutes. Cherry pie and coffee.

Not much is more beautiful than birch trees. They seem somehow to have just shot up. (As opposed to trees that appear to have grunted their way up, inch by inch.) And so white. And so weightless. A beautiful "weed" of a tree. (Sorry, folks.) I'm getting carried away.

As uncomfortable as it is to try to write all crunched up, I *am* getting a kick out of making the guy next to me nervous. He's dying to ask me what I'm writing, but he's too "polite" to ask.

Light pink clumps of wild roses growing alongside the road, don't seem very wild, but I suppose they are.

Vermont!

Brattleboro. And the creep just got up and changed his seat! (To a window seat.) However, a lot of new people are waiting

outside to get on. Well, I'll spread my legs, madly smoke a ciga-
rette, and try to look as crummy as possible.

It didn't work. A big fat French Canadian lady with two big
shoulder bags, a "bulky" sweater over her arm, and an *enormous*
thermos bottle just sat down beside me.

(Some people *do* travel.)

The world's largest basket store is coming up on our right.
God damn it! I can hardly move.

And the worst part of it is that she's sitting on my left jacket
coattail, which I don't dare try to yank out from under her for
fear it might start a conversation.

And I was so hoping to get some "serious" writing done
today. But evidently it's not in the cards.

Bellows Falls. The French Canadian lady got off only to be
replaced by a hairy man of 40 or so in a pink shirt. *Some* improve-
ment (as he's skinny) but——

I forgot to get my coattail back when the lady left so still I
am "trapped."

For some reason we are not in Vermont anymore, but in
New Hampshire. (?) I refuse to worry about it tho because I *know*
I'm on the right bus.

Ah, Vermont again. Windsor. And lots of people are get-
ting off. Alone, at last, with my coattail back. Now maybe I can
do some writing. The only problem is that it's 4:30 already, and I
have a slight headache, and my butt hurts from so much sitting,
and I'm just plain ol' *tired*.

Will try tho.

Summer!

First I'm going to try (again) to do an *Orchid Stories*
cover that I like. Then I'm going to do the cover for the 70th-
anniversary issue of *ARTnews*. (September issue.) And then I'm

going to get all my recent journal pieces (including this piece, I hope) together to send to John Martin (Black Sparrow Press) for a book.

And then *nothing!*

No cigarettes.

No pills.

No painting.

No writing.

Etc.

The "etc." part I haven't quite figured out yet. I just know that I need a total rest for awhile. To get into good shape physically. And to clean out my head a bit.

And science. I'm going to read a lot of science books. (An area I am totally dumb in.)

And I'm going to concentrate on making myself as good-looking as possible. (Gain weight.) (Build up arms.) (Etc.)

(Sometimes I am afraid you won't understand that, when I complain about my looks, what I want to look like is James Dean.)

Which is to say that you're going to be in for a lot more complaining, unless the continual repetition bores one of us to tears (as it *is* beginning to do me) and you stop reading, or I stop writing.

If my crushes are rarely as serious as I want them to be on paper, I am *not* lying, I am trying too hard.

You know, knowing that this is going to be the last journal entry in my book I feel I should make up somehow for being so "flat" all year. (A deliberate move on my part, as I was getting a bit suspicious of so much gush.) But now I'm not so sure that gush isn't more fun. (To read.) And that, after all, *is* why I write.

But (let's face it, folks) I need you more than you need me.

And I thank the stars for that.

TUESDAY, JULY 11TH, 1972

AFTER WASHING MY HAIR
THIS MORNING IN THE SINK
FOUR HAIRS SPELLED OUT
MY NAME!

What I Did This Summer

When people ask me what I did this summer I say, "Nothing," but of course, this is not entirely true. What I mean by "nothing" is that I gave up smoking and pills and all work for the summer. Which didn't leave me with too much to do. So I did a lot of reading. Sunning. Exercising. And T.V. So, it was a very relaxing summer. The result of which was that I gained 20 pounds. Built up my arms a bit. Got a good tan. And I got to where I could just relax and take things as they come more. However, I've been back in the city for a week now, and my 20 pounds, I can feel them going. And I'm just as nervous with people as before. And as for all that reading: my head seems to have no place for information. A bad case of "in one ear and out the other." But I *enjoyed* the reading I did. And the being able to relax. And being with Kenward, I enjoyed that. So, for a "nothing" summer, it was a very good summer. And if I expected more permanent results (self-improvements) and I did, I had no right to. But, that I expect too much out of life is no big secret. And that I've done pretty well at getting "too much" is no big secret either. But, no satisfaction here.

It seems to me that we just keep learning the same fucking things over and over again.

I must say tho, that for a hopeless situation, we do pretty good at taking advantage of it.

Washington D.C. Journal 1972

Thursday, October 12th

Ron just called to say that the trip to Washington is on. (Ron and Pat and Wayne Padgett.) In a borrowed Mercedes. Tomorrow night after dinner we leave.

I remember reading somewhere that Washington has a higher crime rate than New York City.

I really must find out what D.C. (as in Washington, D.C.) means.

My only vision of Washington is lots of white marble.

Friday, October 13th

Got up early. Breakfast. Went to bank. Took raincoat to be cleaned. Picked up laundry. Bought small containers of shaving cream and tooth paste. (One word or two?) Postage stamps for postcards. And I got a hair cut. (One word or two?) So now I'm ready to go. I hope my bad toe nail (one word or two, I couldn't care less actually) won't give me trouble.

Friday the 13th!

Saturday, October 14th

We drove straight down the New Jersey Turnpike to 95, and straight down 95 to Washington.

Lots of trouble finding a motel, but we did. A "Quality Inn." A "rip-off" as Pat said, but comfortable. Color T.V. Comfortable, that is, except that we were right next to a series of train tracks. But I was so tired I could have slept through anything, and did.

Driving around Washington (eleven or so) last night: a bit spooky. Lots of very impressive "official"-looking buildings. No street trash. And few people. Except a few Negro pedestrians. And a few white cops. Actually quite a few cops. And I was right about the white marble: *tons* of it. All lit up with floodlights, some with a very slight pink tint.

Right now I am sitting on the bed of our motel room, having just returned from breakfast, waiting for Pat and Ron and Wayne to get ready.

This morning, zipping up my left boot, the zipper (fuck) broke.

Ron says we are ready to go.

The National Gallery!

At the National Gallery now having a cup of coffee in the cafeteria. After having zipped through the Italian, Venetian, Spanish, Flemish, and German sections, we are going to split up now for closer examinations. Me, I plan to eyeball in on Titian, Goya, Rubens, and Van Dyck.

Sitting in a sort of indoor garden with a fountain now. *Can't see any more paintings today!*

As museums often do to me, I am reminded of my lack of patience. (As a painter.) My lack of focus. And perhaps even my lack of dedication. Although I work all the time, do I really work that *hard?*

What I mean is that I feel I am more of an "artist" than a "painter," which is O.K. except that, secretly, I want to be a painter.

And although I feel the choice is mine to make whenever I feel like making it, I may be kidding myself. Not that I believe in "too late," no, I don't. But I *do* believe very much in "now." (Which is to say that if you're not doing it now, you're not doing it.) ((Uh?))

I think I am beginning to believe more and more in making definite decisions.

At the Corcoran Gallery I was supposed to have 15 small works up, but we couldn't find them. And I didn't feel like asking about them. I just thought it would be fun to bump into them. But, like I said, no dice.

Then lunch (a fish sandwich) at a drug store.

Then a drive around Georgetown (pretty). And a nice relief from downtown (cold). And I don't mean the weather. The weather, by the way, is being fantastic. Cool and crisp and very clear. "Indian Summer," I believe, is what you would call it. *Really nice.* And you can see so much sky here.

In Georgetown we had ice cream cones, and I got some new shoes.

Now we are at the Roger Smith Hotel, in the downtown area, where we have a suite of two nice rooms. Not so "motel-y" as last night. And cheaper.

Ordered two Bloody Marys for Patty and me half an hour ago but—still no Bloody Marys. Will try again.

(The operator says that everything is very messed up "down here" but she'll try again.)

Guess I'll write some postcards now. And then, soon, dinner.

Throughout this entire day my toe nail has been *killing* me!

Dinner at a nearby steak house where we got a bit drunk. (Well, "high.") Then we went for a short walk, where, lying on top of a trash container I found a sack of gay porn magazines.

I keep getting very sweet vibrations from Ron of an "I'm trying harder" nature, which I choose to take as a personal compliment. (I say "choose" because I realize I am assuming a lot.)

Then, back at the hotel, we watched a movie on T.V.: Humphrey Bogart is a painter who gets "turned on" by death. As he is slowly poisoning his first wife with something in her nightly glass of milk he is secretly doing a painting of her as "the black angel of death." Then he marries Barbara Stanwyck but she finds out everything, and is saved at the end. (All a bit more complicated than this, but I'm getting tired.)

Then I thumbed through my porn.

And now, bed.

Sunday, October 15th

Breakfast downstairs in the hotel restaurant found us discussing the decline and fall of the United States. All of which began with Pat being shocked over two eggs costing $1.70. (When ordered à la carte.) Pat is right to be mad, of course (it *is* a rip-off) but I'm surprised that she doesn't expect to be ripped-off, as we are right in the middle of a national tourist attraction.

At any rate—the restaurant, obviously rather grand at one time (high ceilings, mirrored columns, heavy drapes) even though now freshly painted, is obviously on its last leg.

But I feel we are very little in control of things as they come and go. And I don't find this *too* sad. Tho I suppose I should.

Now—off to the National Gallery again. Today is 17th and 18th and 19th century French, and British, and American.

A Raeburn painting of a colonel in a red jacket really impresses me: the way it is painted. Slick, and accurate, and minimal, and without the device of too much style. In my head, this is how I want to paint.

Toulouse-Lautrec remains (tho I rarely think of him) one of my favorite drawers.

I'm being cruised by a nice-looking guy in a maroon sweater, but it all seems too complicated. I can't resist flirting back just a little tho.

At the Museum of History and Technology, a cold hamburger in the cafeteria.

One strange thing: a jukebox machine from the 40s. Somehow *enormously* impressive. As an object it literally glows with a

positive presence. Isolated, and tough. As it had been chosen as *the* object most representative of our society, the weight of which it carries very well.

At the Museum of Natural History now. (Stuffed animals.) Wayne is happy. A giant elephant makes me wonder if female elephants have tusks too. Pat and I think no. Ron thinks yes. But none of us, we admit, knows for sure.

A little boy is crying because he wants to go see "the bones." Which, evidently, is not in the cards.

We try to see the Hope Diamond but (Sunday) too many people.

This would be an interesting place to "trip."

At the National Gallery again. At the cafeteria again. Coffee, a Coke, and a fruit cup. And off to see the rest of what we didn't see this morning.

I'm beginning to get a clearer picture of Courbet's "contribution," though still, I'm not crazy about him. I expect one day to be though.

Two big paintings by David (*Napoleon in his Study*) and Ingres (*Madame Moitessier*) leave me surprisingly cold. I like the postcards of them better. When a painting doesn't "need" to be as big as it is, it sometimes bothers me.

Manet.

Manet has always been one of my favorite painters, and still is.

Nobody, for me, is more realistic.

To pinpoint why is hard, but, I think it may have something to do with a basic "black and white"-ness in his color: it hits home hard.

Manet must have had somewhat the same impact on painting as Godard did on film.

The seated woman on the left-hand side of *Gare Saint-Lazare* is not just looking out at me: her head was down, she looked up, now she is looking up at me. Or so one feels.

As we walked out of the National Gallery, Washington was black, against a sky of rich hollow blue, blue to peach at the bottom. Quite a sight. (6:00 or so.) Dead tired, all four of us, we headed for the car, to go home.

A half an hour or so out of Washington I, for some reason or another, have a vision of those fancy pink cookies, and green cookies, sprinkled with little silver balls.

Wayne, in the back seat, is talking about Mexican jumping beans, and I remember how disappointing they always were. (Lazy.) A few flip-flops, and that was it.

Washington, I'd like to say something conclusive about Washington. As conservatively decadent as 1972. (?) Or as decadently conservative as 1972? (I'm tired) and words lose me.

After dinner in a very noisy and scary cafeteria (back on the road again) we have a "heart to heart" talk about all the people we know. Conclusion: nobody's perfect, and that's fine and dandy.

Oh, and about "D.C." (just in case I'm not the only dumb-bell in the world) it means "District of Columbia."

The Gay Way

(A Play)

The curtain rises to reveal a typical New York City "Village" bedroom of the mid-Fifties. Two young men (BOB and DICK) are in bed together, asleep. Arm in arm, their bodies are covered from the waists down with a white sheet. Morning sunlight is streaming through the window as BOB begins to stir.

BOB *(Yawning)*: I guess I'd better be getting up.

(As BOB begins to pull back the sheet the curtain quickly drops because, you see, male nudity was not allowed on stage in the mid-Fifties. And homosexual themes were heavily frowned upon.)

As the indignant audience storms out of the theatre shouting "God damn pansies!" *and* "We want our money back!" *the play continues behind the curtain as DICK gets out of bed and joins BOB on the floor for some very wild love making (use your imagination here) much to the amusement of the stagehands who, you see, are the* real *audience.*

SOME NOTES ON "THE GAY WAY":

Unfortunately, only a limited number of "seats" will be available due to Union Laws pertaining to a "fixed" number of stagehands allowed on stage per performance.

The author has nothing against a male and female production so long as a homosexual "audience" is used and the title be changed, appropriately, to "The Straight Way."

Should your production be raided, the author recommends that you try to accept the raid as "part of the play."

MATCHES

IF I STRIKE SAY 60 MATCHES A DAY (AND I DO) IN A YEAR'S TIME THAT WOULD BE ___ ___ LET ME SEE ___ THAT WOULD BE ___ I HATE MATH.

SELF- PORTRAIT

(AS A WRITER)

IF I WAS

OLD AND

FAT

AND WORE

HATS

DIRTY PROSE

IF

IF I SEE JUST ONE
MORE OF THOSE ROUND YELLOW
FACES WITH A BIG BLACK
SMILE ON IT I THINK

I'LL

THE

FRIENDLY WAY

BY JOE BRAINARD

"What a beautiful spring day this has been! I went to the cemetery where my mother is buried and the tiny squirrels were so thick I could hardly drive without hitting one."

"I have many memories of the old pump—some good, and some bad—but that is the way of life."

"Things we see from car windows are remembered for many years."

"When day is done one finds too frequently that not much else is."

"At times I'd get discouraged, but Dr. Comstock would poo-poo me with 'You're living today, aren't you?' He had a keen sense of humor."

"Our swordfish just had eleven babies and I'm not at all sure what to do with them."

"One lady was picking up a newspaper when the quake started. She was looking across the street and she could see a big sheet of water coming over a house and then go back again. That was water from the swimming pool."

"Well here we are in the country. It really is beautiful here, no noise or congestion, just beautiful trees, flowers, and the river. T.V. reception is lousy, but the cable is supposed to be in soon."

"I became almost totally disillusioned with books and travel brochures when I found snow covering the Mojave desert!"

"About forty years ago, the former Secretary of the Treasury, Mrs. Florence Knapp, baked a cake for me."

"California—hot and burning—forest and brush fires—added to the uncomfortable smog condition. Temperatures were over a hundred. People were fighting with garden hoses to save their homes. Others watching theirs burn, too helpless to fight back. These sights were definitely not beautiful."

"I dress in bright colored clothes so people in cars can see me quickly. I feel I am safer this way."

"We became acquainted with a Canadian couple in the seat ahead of us. She was pale and sweet, he was dignified and austere. They played cards for hours on end to while away the time."

"Into the far celestial, an eagle was soaring against the azure blue sky. The majestic pines were whispering an echoing symphony, and dropping pine cones down on us."

"Do any of you ladies have any smashing ideas for using driftwood?"

"Am hoping to eventually write a few hundred pages of fiction concerning military wives."

"My wildest dreams would be to move to a warmer climate."

"We have a black cocker-poo, which is a cocker and poodle mixed. She, Midnight, shares our attentions with Prince, a white, seven toed, one green eye and one blue eyed cat."

"A minute is cruel."

"I promise myself to be too large for worry."

"Shoes—yes, shoes. Pretty ones to go with pretty headgear. Not for the feet of the mad hatter of Ohio Mills who lives on Route

Six. No siree—the shoes are on her head! Not only are they on a hat, but they are positioned upside down. She exclaims, 'Anyone can place them right side up!'

"Snowtime is a happy time for children and a hat scavenger. Especially when she is staring dreamily over the onions in the display case—concocting another brainstorm. With an armload of onion skins in a grocery box now she's contentedly humming the outdated tune—I'm a lonely little petunia in an onion patch, and all I do is cry all day."

"I'm sort of a would-be cowgirl without a horse."

"I got bit by the needlework bug in Tokyo."

"If you happen to have a dead tree, turn a blue glass bottle down over each limb. The results are rather eye catching."

"A friend had a pile of bricks they didn't want so naturally we took them."

"I wonder if the drive and ambition which is synonymous with mankind is channeled correctly."

"Making the right decision sometimes takes so long that by the time I've reached it, times have changed, and, it's wrong."

"I was cooking up a pan of sausages in the caravan when suddenly we were surrounded by three huge tour buses."

"How can I remain unhappy with a smile splashed across my face?"

"When you are the hammer, strike."

"I probably have more irons in the fire than my fire will heat, but that's what keeps us going, isn't it?"

"I am a barbed wire collector. My wife, Cora, collects postage stamps. I started collecting postage stamps but couldn't get interested too much so I took up collecting barbed wire."

"I have a recipe I think is unusual called radio pudding."

"For a good dark tan, burn oleo, rub on skin, go out in sun, then when you come in the house, rub a wet tea bag over your skin."

"When my mother was living, we spent holidays and vacations on the Pacific coast beaches to rest, but our constant combing for driftwood, agates, and shells kept us frazzled most of the time."

"Annagene Schmitt's career began in 1961 with six aprons blowing in the breeze in front of her Ridge Road home."

"I think, in writing, one must feel it inside to do the best."

"I wish I had a home on the ocean, where I could watch the ocean wash the beach."

"I figure the world will give me just about what I deserve."

"Beautiful big sailboats go by our front window every day heading for all parts of the world."

"Each of our lives is like a book, and as in memory, we turn the pages."

"Our Pepi is registered with the American Kennel Club under the name of Prince Pepper, but to us he is just 'Little Buddy.'"

"Wild fruit has become a scarce item most places where modern building programs have taken over."

"I like to keep my hands busy. I dabble in watercolors and water soluble pencils. Get some striking effects."

"Can you picture a flustered husband climbing gingerly down from the roof of the house on a rickety ladder, with a glass 'vase' clutched in both hands while a frantic wife below wrings her hands and moans, 'Be careful! Ca-a-areful! Don't drop my priceless antique!'"

"To the lady who thinks it's illegal to sell white chocolate: California does not violate any laws."

"The writer's life is lonely and depressing at times. The rejections are many and the road is long. If you want it, go after it. Those who must write, do."

"I love to embroider, but that's about as far as I go."

"I don't dare be idle. I might get in an argument with myself."

"My husband is a descendant of the Bismark family in Germany. They left Bismark in Germany on the sailing ship 'Bismark' and settled in New Zealand at a place called Bismark."

"My aim is to someday be notified that I am a grand prize winner of a nationwide contest."

"I would just love to have an African violet, but I'm afraid it would die on me."

"When we get up in the morning we have two choices: to be optimistic and cheerful or to be pessimistic and gloomy."

"Howling February winds blew around our house on the bank of the Rock River when I planted my first packet of giant single gloxinia seeds."

"One of my rocks is shaped like a pork chop. No kidding!"

"Years ago a plane landed near McChard Field in Tacoma, Washington, selling rides to folks. Since I never had a plane ride, I was begged to go up. As we rode towards the field, we saw my mother. How she begged to go with me and my son. You see, I told her we were going shopping as she was 79 years old and we thought she was too old to have a plane ride. However, we couldn't persuade her not to go.

"We flew up and around 200 feet, among the pine trees, and heard a big noise, and down we came. The wing flew off, landed across my mother and killed her.

"Me? Well, I was in a badly mashed shape. I landed in the black oil and sure was a black old lady. What a mess!

"The worst part was, the man had no plane insurance!"

"I don't let myself get down in spirit. If I did, I'd be down all the time."

"One evening each year I burn dinner."

"Any self-respecting bedroom dresser would have dropped through the proverbial knot-hole in the floor if they did not repose thereon."

"My hobby is pine cones."

"A word in anger is better left unsaid because the person whom you may vent your anger upon may be innocent and may be proud and depressed at the time and this will kick him down further."

"Three years ago a special ambition was realized by Edith Marie. She got a job!"

"Spring is when the pregnant earth erupts into greenery."

"Others have already written what I would like to write."

"There are inscriptions carved on a huge rock here. Strange carvings and childlike pictures. They call it 'Newspaper Rock.' An ancient people left a message—begging to be remembered— but no one can decipher it—so it is part of the mystery of this ghostly forest."

"The lady told of taking a picture of a small antique shop—then later looking, and it had moved quite a distance from the spot."

"They had good screens on the windows that would turn most of the grandparents of the mosquito into clouds but the smaller ones would crawl through any screen and stay up all night sing- ing 'cousing cousin' till they put you to sleep."

"New Orleans is just 3 feet above sea level so all folks who die there are put away in tombs. The cemeteries are just filled with these tombs."

"Everything that has ever existed has been reproduced in minia- ture by someone, at sometime."

"They preferred buried bottles to blowing balloons."

"While eating brunch (I call it that because it's a combination of lunch and breakfast) we noticed two red canoes pushed over the ice around the bend, to open water, and saw the men climb in and paddle away."

"Serafettin Uzuner has also been to Jordan, Syria, and Iraq. He found most of the residents of those countries quite poor and lazy. Another one of his trips took him to Kuwait, where he found the climate unbearable. He has also been 30 miles across the Soviet border but claims there was not much to see."

"It isn't what happens to us, it's how we adjust to it."

"Each year, as I walk home from the last house, I catch myself smiling."

"It was a bright October morning, I being a grandmother nearing my 70th birthday, lagged about drawing my window draperies. As when did, a flash of yellow reflected upon my window. I moved closer as to what I saw, a big yellow school bus."

"Last night my son and I attended a fine doctor's talk on drug abuse. We listened with great interest."

"Perhaps we should return to the hair-receiver and then orbit the historical merry-go-round from nowhere to nowhere."

"I shall go through this world but once."

"Don't take my word for it—ask any seal hunter."

The Friendly Way (Continued)

"It all started one afternoon when I was looking around for something unusual to wear on my head."

"Evidently the use of seashells is as varied as you care to make it."

"Now we are in autumn, and the leaves are falling. We would be glad to have spring instead, with its brighter days, of course, but the choice is not ours."

"In the Renauds' living-room, with its bright red and green floral patterns on white wrought iron furniture, which overlooks the Grand River, she has a sign hanging on the wall reading '*Think Christmas.*'"

"I work on the theory that if you have materials, you may as well use them."

"It's like I tell those who are afraid to try papier-mâché— if you make a mistake, so what?"

"My husband works in a glass bottle factory. He makes mostly beer bottles. It seems there's a great demand for them."

"I always enjoy sticking little notes into cards, even if I don't know the person."

"Right now I have over fifty letters from would-be Turkish pen pals. However, they are written in Turkish, and so it is impossible for me to answer them."

"Altho Dee arranges flowers mostly for shows and weddings, she plans to get into funerals soon."

"I really don't know what people do without cats."

"I hope that ladies take advantage of library facilities."

"A new wave of chain letters is apparently moving across the country."

"Once in a while the mood strikes, and I sew up every piece of material in the house."

"With the cooler weather approaching, I find I care less for the iced drinks of summer."

"I'm the mother of five and the wife of a man who claims he's always out of socks and can never find his crescent wrench. His socks are always in the dresser drawer, but I hid his wrench: a plumber suggested I should."

"We aren't worried about tornadoes, blizzards, hurricanes, or tidal waves, but we do have rattlesnakes, scorpions, and sonic booms from the planes at Edwards Air Force Base that shake the fillings out of your teeth—so I guess we all have something to be thankful for, one way or the other."

"With a little 'vision' you too can convert T.V. dinner trays into clever boutique organizers."

"Making exotic mini-pedestals for miniature Christmas symbols is so fascinating there is no way to stop."

"With an abundance of willows in this area my thoughts have centered on baskets."

"I remember the Indians would sometimes come in our home to get warm and then go on their way. One day Grandma had some loaves of bread on the oven door to raise, a big Indian walked in and stuck his finger in each loaf!"

"Perhaps I should explain that Mike got the urge to dance a few years ago and has been going strong ever since."

"Needlework, like life, is just a matter of going in and out with a strand of wool."

"Occasionally a beer bottle is tossed into my yard, and some of them are *beautiful!*"

If I Was God

If I was God
up there in heaven
looking down at us
I think
I'd find it hard to believe
that I'd actually done it.

Ponder This

How far down
in the hole
must we go
before we lose the light?

Actually
not far at all;
we can lose the light
just by closing our eyes.

Grandmother

Once when grandmother was sick in bed, and I was all alone with her, she had to go to the bathroom. So I picked up her 80-pound body and started to carry her. But when I got into the hall, I dropped her. I just stood there and laughed and laughed. And grandmother cried and cried. There was always something very special between us.

Night

Day, you have gone
and done it again.

Neck

When I asked Dr. Brown the other day if he had any idea why I often have a sore neck he said that every time he's seen me my head has been tilted slightly to one side. Which causes—"undue stress on neck"—I believe is how he put it.

Ron Padgett said the other night that he's noticed that when I start stuttering I tilt my head to one side and then I stop stuttering.

Complaining of a sore neck one morning not long ago J. J. Mitchell said he wasn't surprised I had a sore neck, "The way you sleep."

One thing I've noticed is that I tilt my head a lot in bars.

If tilting my head "means" anything, I don't think it means anything very important.

Just another self-conscious mannerism to confront people with.

Well, sometimes I *do* feel awfully naked.

30 One-Liners

WINTER
More time is spent at the window.

SUMMER
You go along from day to day with summer all around you.

STORES
Stores tell all about people who live in the area.

WRITING
Others have already written what I would like to write.

TODAY
Today the sky is so blue it burns.

IN THE COUNTRY
In the country one can almost hear the silence.

THE FOUR SEASONS
The four seasons of the year permit us to enjoy things.

RECIPE
Smear each side of a pork chop with mustard and dredge in flour.

BOOK WORM
Have always had nose stuck in book from little on.

THAT FEELING
What defines that feeling one has when gazing at a rock?

COSTA RICA
It was in Costa Rica I saw my first coffee plantation.

HAPPINESS
Happiness is nothing more than a state of mind.

MONEY
Money will buy a fine dog.

OUR GOVERNMENT
A new program is being introduced by our government.

EDWARD
On the whole he is a beautiful human being.

LAKE
A lake attracts a man and wife and members of a family.

THE SKY
We see so many different things when we look at the sky.

A SEXY THOUGHT
Male early in the day.

POTATOES
One can only go so far without potatoes in the kitchen.

MOTHER
A mother is something we have all had.

MODERN TIMES
Every four minutes a car comes off the assembly line they say.

THE OCEAN

Foamy waves wash to shore "treasures" as a sacrifice to damp sand.

TODAY

High density housing is going on all around us.

REAL LIFE

I could have screamed the day John proposed winterizing the cottage and living there permanently.

ALASKA

I am a very cold person here.

THE YEAR OF THE WHITE MAN

The year of the white man was a year of many beads.

LOYALTY

Loyalty, I feel, is a very big word.

SOMETHING TO THINK ABOUT

Perhaps in our mad scramble to keep our heads above water we miss the point.

HUMAN NATURE

Why must we be so intent on destroying everything we touch?

COMPANY

Winifred was a little relieved when they were gone.

THE CIGARETTE BOOK

BY JOE BRAINARD

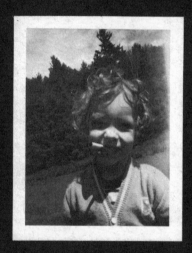

WAYNE PADGETT
AGE 2½
SMOKING HIS FIRST
CIGARETTE

SMOKE MORE

The only thing that is wrong with people is that they don't smoke enough. I smoke four packs a day and am proud of it. Why not? We all know that we are not going to die of cancer tomorrow, or the next day, and/or the next day as a matter of fact -- so what is all the worry about?

I've been smoking four packs a day ever since I was fourteen years old and am proud of it. And even if I did get cancer it wouldn't really matter. If you are going to do something you may as well do it right.

Another thing I can't stand are people who smoke menthol cigarettes. I don't know exactly why but there is something wrong about it.

There are so many different kinds of cigarettes that it is hard to know which kind to smoke. It is easier to decide if first you discard the possibility of menthol and then decide between filters and non-filters. It is mostly a matter of taste. I smoke filter cigarettes, but as I said, it is mostly a matter of taste.

If there is one thing I can't stand it is people who don't smoke at all. There is no excuse. Some people say that it is too expensive but if someone really wants to smoke bad enough they can and will.

MY BRAND
MAY 20TH, 1967

Joe Brainard

BABE RAINBOW

LIGHT UP

SMOKE

BURN A FEW HOLES IN THE BLANKET

BURN A FEW HOLES IN THE YELLOW BLANKET

BURNING

SMOKING

READING

BY TED BERRIGAN

"I NEVER SMOKED A CIGARETTE UNTIL I WAS NINE."

W.C. FIELDS

CIGARETTE BUTT

DRAWINGS

BY

LEGER

DAVIS

DE KOONING

AND

BRAINARD

F. LÉGER

Stuart Davis

BRAINARD-72

Inhaling

for Joe

Dottie Flanagan taught me to inhale. It was one summer night at her house and she said, "You're not inhaling!"

Dottie was very luscious with long dark abburn hair -- a pageboy bob, I guess. I took her to the senior prom. She wore a strapless dress of electric blue satin and had gold dust brushed through her hair. Her mother was a hairdresser so Dottie knew all about cornmeal shampoos and setting hair with stale beer. She once helped her mother do the hair on a corpse at a local mortician's. She said it didn't faze her. I'm sure it didn't.

Funny, I can't remember one song they played at that prom. But I can guess: "Deep Purple" and the one about "Am I the guy/who turned out a lover?" and something about "blue diamond rings...."

Dottie was about the first girl in our class to get married. But that was in 1941 and with war in the air a lot of kids got married sooner than they otherwise might have.

Actually I had tried to inhale once before that. It was up in the attic and I must have succeeded because I can still see the rough wood and window panes suddenly spin around. It was rather scary.

That summer Clayton Nestle -- it was at his house, of course -- gave me a pipe to smoke. "Don't inhale," he said, "puff it." I in-

haled anyway and got good and sick. I still don't like the smell
of pipe tobacco, especially Snow Apple.

One thing I forgot to mention: Dottie had an aunt, or a great
aunt, who had an eccentricity. She saved all her used tea bags
and dried them. When she had a good bundle she would send it
to one of her relatives, since she considered each bag was good
for a second cup.

-- James Schuyler
Calais, Vermont
1969

"I REMEMBER MY FIRST
CIGARETTE. IT WAS A KENT.
UP ON A HILL. IN TULSA,
OKLAHOMA. WITH RON PADGETT."

FROM "I REMEMBER"
(BY ME)

DRAWING OF THE LAST
CIGARETTE I SMOKED BEFORE
I GAVE UP SMOKING FOR THREE
MONTHS DURING THE SUMMER OF
1970.

POST CARD

Dear Joe,
 London is absolutely
great, absolutely
and we're digging it
absolutely also.

Love,

Joe BRAINARD
CALAIS, VT.
 USA

AIR MAIL

S.S. MATTHEW AND MARK
Full-page illustration from a late seventeenth century Ethiopic manu-
script of the Octateuch, Four Gospels and Synodos.
Oriental MS. 481: f. 125v.
THE BRITISH MUSEUM C/OPB/48 (Copyright)

POST CARD FROM RON PADGETT
 RECIEVED THAT SAME SUMMER.

Congratulations -- Non-Smoker -- Joe!

Not everyone is strong enough to fight
Against the slogan "Have a light!"
It takes will power and a strong desire --
To keep yourself from puffing fire!
You've given them up with no regrets --
There's no health nor wealth in cigarettes!
Heart trouble and cancer in a pack --
Causing your throat and lungs to hack --
And if **you contact the** virus flu --
It could be the end of you!
You'll be saving lots of dough --
With greater pleasures for you -- Joe!
Air Pollution is no joke --
It's good to clear your lungs from smoke!
Your taste and smell will come back --
Free at last -- from a cigarette pack!
Congratulations -- "non-smoker" -- Joe --
From a good friend whom you know --

By Mrs. Jessie Bryington
Route 2
Canton, Penna. 17724

POEM COMMISSIONED BY
KENWARD ELMSLIE FOR
THE OCCASION

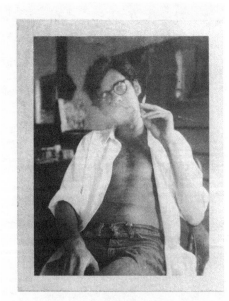

← ME IN
1971
SMOKING
UP A
STORM
AGAIN!

PLAYBOY

will address achievement of optimized commonality, compatibility and standardization with available resources." Translation: "Use the equipment you already have."

With the world series upon us, it's time to make excuses for the teams that didn't make it. One explanation for the Houston Astros' showing might be suggested by a story that appeared last summer in the Paris edition of the *Herald Tribune*. Questioned by persistent sportswriters about his strengths and weaknesses, Houston third baseman Doug Rader replied: "I think smoking is the thing I do good and most consistently. I just hardly ever have an off day smoking. I smoke good and I smoke consistent. I can't think of anything else I am as consistently good at."

Catchy sign in the window of The Feline Inn on Chicago's Wells Street: SUPPORT YOUR LOCAL CAT HOUSE.

...inging group calls itself the ...t performing, the

of a
nalı
ers fo
"freed
for th
nists' ...

E...

The Ch...
baroque c...
conies rea...
is not the...
'n' roll. ...
Stooges an...
there rece...
hear their...
lived up ...
Stooges, w...
Stooge, a ...
black lea...
while per...
other ...
grou...

TUESDAY, MARCH 23RD, 1971

I just knew this morning when I asked the deli man for three packs of cigarettes instead of the usual two that he was going to say something and he did. He said "You sure smoke a lot son." And I said "Oh, I don't smoke all these." And he said "Well, who does?"

But by then everything was in the bag and paid for so I didn't have to continue my lie.

He'd really be shocked if he knew that at night I buy *more* cigarettes at a different deli.

Well, everybody deserves one or two things not to have to be careful about, I figure. And smoking is one of mine.

Too many things to do ...
... he sitting here ...

Poem

Sometimes
everything
seems
so
oh, I don't know.

No Story

I hope you have enjoyed not reading this story as much as I have enjoyed not writing it.

Journals

Thursday, February 15th, 1973

I (God am I tired of "I") just called up to see if my new suit was ready, only instead I dialed my own number: a good example of where I'm "at." (Only one more day till Paris!) But when I travel I'm half way there way before it's time to leave: another good example of where I'm "at."

The Valentine's Day reading at the church last night was a disaster. I read a few of those pornographic movie plot capsules, which went over like a lead balloon. As did everything in the first half hour of the reading, which was as much as I could take. (Something very "heavy" in the air) and *I hate big group readings*.

At any rate, after re-dialing, my suit "yes" was ready, and so I went and picked it up.

And now I'm waiting for Donald Evans (who'll be staying here while I'm away) to pick up a set of keys.

You know, I'm getting about as discouraged with writing as I was/am with painting. I just want——I just want to be clean-cut and direct. Now why that should be so hard is beyond me. But something happens——something happens somewhere in between my head and paper: a big gap that gets all ornate and twisted, and I fall right in.

At any rate——tomorrow night I leave for Paris, where, as things stand now, you won't be hearing a peep out of me.

Tonight——tonight I just want to have a quiet dinner out alone, get drunk, and fall fast asleep. That truly sounds like heaven to me right now.

Tuesday, March 13th, 1973

Home! (And I'm glad.) Tho it was great. Paris. And especially the Louvre. And being with Maxine and Harry. Kenward. And strange Sicily. All in all a very neat "package" of a trip. (It *snowed* in Sicily!) Reading *Father and Son* by Edmund Gosse. Uptown tonight to a Lowell Nesbitt opening in hopes of bumping into somebody cute. (Horny as hell!)

Wednesday, March 14th, 1973

Finished today *Father and Son* and got well into *Places to Go* by Joanne Kyger. (Strange.) Strange to read her because I can only do so by somehow pretending to *be* her. (Otherwise I am driven up the wall in a thousand different directions.) Tonight is dinner with Anne. And then movies by Red Grooms and Rudy Burckhardt at the church.

Sunday, March 18th, 1973

Woke up this morning (noon) with a pretty boy and a white cat on the floor surrounded by Tibetan paintings with a slight hangover on the upper West Side snowing outside!

Then breakfast at a nearby dairy restaurant (good) then downtown (home) and then back uptown to get some stuff from John's pusher (who has the same birthday as I do) and we instantly hit it off (messed around a bit) and now I'm down back home again, waiting for our six o'clock "date" we made. And still it is snowing outside.

My one dream last night was discovering that my recently purchased bottle of Listerine was all of a sudden almost empty. (?)

Reading Ann Charters' new Kerouac biography, which is not especially good, but I love biographies, and I'm a sucker for Jack Kerouac. So, I'm enjoying it.

Pretty much all "set up" for oils now. Just waiting now for a clear day and a clear head.

Giving a reading this Thursday with Ron at the Paula Cooper

Gallery, with very mixed feelings. About readings in general. (Too many!) About my work. (Too messy!) And about reading with Ron: I fear we may somehow cancel each other out.

Monday, March 26th, 1973

Reading has been *Put Out More Flags* by Evelyn Waugh, *I Am Elijah Thrush* (tacky-tacky) by James Purdy, and now *Kathleen and Frank* by Christopher Isherwood (terrific) which is probably why I am bothering to write today: it's restoring my faith that *everything* is interesting, sooner or later. And so that I have nothing in particular to say right now doesn't seem to be the issue. The issue seems to be (today) to *keep at it*. And *to be accurate*, even if accurate is "nothing in particular to say." (Or something like that.) And so——here I am. Gray day. Our reading (Ron and me) it went well I think. Kenward and I are somewhat on the rocks again: the "Z–Z–Z" rocks. *Great* interview with Allen Ginsberg in *Gay Sunshine*. *More I Remember More* proofs have been corrected and so it should be out in about two weeks, which means, of course, about four weeks. Funny stomach these days (queasy) and distant foggy head. Something, it seems, is "wrong" inside. Tomorrow, Franco, an Italian ex-soccer player friend of John Ashbery's, is coming over to build me a long shelf for paints and brushes, and to store canvases under. (A not very necessary device, but——but it *will* come in handy.) And besides, he's cute, John said.

I just looked up from my table and the sun is out.

Tuesday, March 27th, 1973

> "The world of Nature for every man
> is the phantasy of himself."
> —Carlyle

Reading Isherwood——I am thinking about the difference——the possibility of the difference——of writing about yourself as "me" as opposed to "a human being." And I suspect

that yes, there is a difference. And that, tho I pretend to write about "me," I am secretly more aware of myself (writing-wise) as "a human being." And that this may well be my salvation!

Did I tell you that I got robbed a week or so ago? They took Anne's typewriter and at least two thousand dollars worth of my jewels. Plus three old francs I brought back from Paris for Larry Fagin to use in subway gate slots. They got in through the bathroom window rather mysteriously, as I *do* have permanent bars on the bathroom window. So it was a *very* small person. I feel rather lucky about it all tho: that they didn't take everything. (Very valuable ancient rings were tossed aside.)

Thursday, March 29th, 1973

Well, I just wiped out my first oil painting attempt today. Which is not to say, however, that I am "finito" for the day, no, I'm just taking a breather. And you are it.

My problems with oils at this point are so elementary that I won't bore you (us) with them.

Ted read well last night: heavy and sweet, and very "demanding." And *long*. And so I just couldn't face any more words, and so I didn't stay for Dick's half. (Why there is always something to prevent me from hearing Dick read is beyond me.) Or, rather, I have no special interest in giving the "why"s much thought. Too often, the fact is enough for me.

What I already feel myself trying for (oil-wise) is something accurate and slick; as heavy as a glance. (As heavy as a heavy glance.)

Tonight Ted reads again. At the 98 Greene Street Loft. And I'm going to read too: a train notes piece I wrote that inspired Ted to write one too, which he's going to read tonight after I read mine.

Well——back to asparagus. (My subject matter of the day.) A tied-up bunch.

Friday, March 30th, 1973

Our train notes went over very well, as did *Memorial Day*, a book which Anne and Ted wrote together, and last night read together. *Very moving.* (Watery eyes.)

Things went a bit better today (painting) even tho the weather (dark) was very much against me.

And now (with an ounce of satisfaction in me) I'm feeling as horny as hell! With no immediate prospects.

So it's more *Kathleen and Frank* for me.

Saturday, March 31st, 1973

Today was dashing off a red pepper with such amazing ease I tore it up: now is *not* the time to avoid problems. And reading some more *Kathleen and Frank*. But (back to the red pepper) I am pleased with such a dramatic exit from March. (The phone is ringing.) It was Ed Baynard, with a show opening this after-noon, with dinner in little Italy to follow. ("Yes.") It's a bit hard to believe but, it may be that Kenward and me are really through. (Hard hurt.) But not half so hard hurt, I imagine, as when (if) the actual reality of it becomes a reality. (Which is to say that, as I am writing this down, I don't *really* believe it.) Kenward, and the securities of love, and money, are so much a part of my life by now that I'm just not sure I'm strong enough. (As tho one has a choice.) We *do* rise very well to occasions. But, damn it——today——today I'm bored with being strong.

(Will you please pardon all these dashes I've gotten so heavily into using: it's childish, I know, but *I need them*) and I——

No, no more words for today.

Tuesday, April 3rd, 1973

The air today, the radio said, is "unsatisfactory."

(Aren't we amazing!)

I feel very perky today, not because I feel especially good, but because I don't feel especially bad, which is how I've been

feeling these past two days, which I suppose is why I haven't written. Partly because of solid rain (dark and heavy) but mostly because of a bad tooth infection (better today) and so I'm on antibiotics until my 3:15 appointment with Dr. Swee tomorrow afternoon. And so I haven't been painting either. Which means I've been doing a lot of reading. Finished ("alas" and "at last") *Kathleen and Frank* and now reading *Green Hell* by Lucien Bodard: all about the massacre of the Brazilian Indians.

Yesterday was Anne's birthday and, primarily because of the meat strike, we (Anne and Michael and Kenward and me) went to a Chinese restaurant. (One of our dishes, however, was chicken.) Personally, I find it all very silly. We eat too much meat anyway. And I think there are much better causes to concern ourselves with. In fact, on T.V. last night I found it downright disgusting: all those women finally getting riled up about something: *meat!*

Out the window it looks like more rain soon.

Dinner tonight with Jack Brusca.

Seeing Kenward again (last night) was "O.K." It appears that we will keep on seeing each other, even if a bit "ho hum," for lack of an alternative, if for no other reason. But of course, there are other reasons. Number one reason being that *we are very close*, regardless. And that's a very hard thing to throw away, as I hope you know too.

Wednesday, April 4th, 1973

Three guesses who got fucked last night?

Mr. Tight-Ass, yours truly, me!

More rain.

And dentist.

Bob and Bobbie Creeley are in town and so tonight is dinner with them at Bill Katz's place before their first reading together ever. (At the church.)

Thursday, April 5th, 1973

Lunch (lunch!) today with Anne and Bobbie at a nearby place I've often been curious about called The Old Chelsea House ("since 1805" it says on the sign): fried scallops, white wine, and apple pie and coffee. Conversation was mostly about Bob and Bobbie troubles. Which doesn't leave one with much to say. Because Bob and Bobbie *are* Bob and Bobbie, and only an outsider can afford to realize that. (And marriage *is* marriage, etc.) All of which, of course, has nothing to do with that they are both terrific.

After the reading went home with Craig, and, neither of us being in a very decisive mood (stoned) we just jerked each other off, which was fun (such beautiful light blue extroverted eyes I find pleasantly embarrassing to confront!). Strange boy. Sweet. But sweet as a nice snake, I suspect.

In life——the people we just bump into——it is a thing I value very much, regardless.

Working on an "I Believe" piece: a manifesto of sorts, which I think is going to be very good, and perhaps surprisingly profound. I feel my ability to cut right through the mustard very sharp these days. And with no smugness. (So far.) And with no (so far) infuriating simplifications. My only real problem (so far) is that once I have written down what I think I believe in I find that often I don't anymore. And so there is no chance of its being a "toss-off" work (which is what I am best at) and so chances are it will never see the light of day. But I really am going to try to stick with it tho.

Tonight Kenward reads from *The Orchid Stories* at the 98 Greene Street Loft (9:00) and so that is where I'll be.

Friday, April 6th, 1973

Terrific insane mind-boggling beautiful reading Kenward gave last night from *The Orchid Stories*.

Today was more *Green Hell*, and a *very* short hair cut.

Tomorrow is a dope connection and a dentist appointment. Tonight is dinner out with Arlene Ladden and Kenward. And Sunday (I hope, I hope) is re-re-entering oils again!

Sunday, April 8th, 1973

Would you believe that it's snowing?

The other day at lunch with Anne and Bobbie I was saying how hard reading Gertrude Stein was for me, and Anne suggested that I try reading her out loud, and so this morning I started *Everybody's Autobiography* again (out loud) and, yes, it's much easier.

Pablo Picasso died today of a heart attack on the French Riviera at 91.

(And Debbie Reynolds was arrested for "illegal possession" of a gun!)

My biggest problem with the "I Believe" piece (which I worked on some more today) is that words are just too definite, and so now I find myself getting too mushy with lots of "but"s and "however"s and "on the other hand"s, which, of course, is a bloody bore.

I am sorry about Picasso but——my God, what a beautiful full life!——91!——And so, no, I am not too sorry. We should all be so lucky.

Monday, April 9th, 1973

This morning after breakfast I picked up two small plants to paint. One, with slightly "lacy" yellow and green and purple spotted leaves, and the other a pink geranium. And so after my daily few pages of Gertrude out loud, I gave the first one a try. And I *do* mean "a try." (No luck.) Tho, of course, one always learns something. (I *do* believe that.) But the problem today——aside from "paint" problems——was that——well, a lack of inspiration. I have a very strong desire to paint right now, but I am lacking in any strong desire as to "what" to paint: a void I am hoping the beauties of Vermont will supply. (I mean like it's very hard to

get turned on to a potted plant plopped down on a white table indoors.) This sounds like a cop-out, I know, but if so, it is only about 50% so. (Inspiration "from" is just as important as inspiration "within.") Well, almost as important. (Maybe.)

D. D. Ryan called to invite me to a preview showing of two documentaries by those two guys who did *Gimme Shelter*: one on Christo (wrapping up a mountain) and the other, an interview with Marlon Brando. At three o'clock. And so yes, I'm going.

And then at five o'clock is a book party at the Gotham Book Mart for Carter Ratcliff's new Kulchur Foundation book, *Fever Coast*.

And then, afterwards, dinner with Kenward.

(And then sleep / morning / dentist / etc.)

"Etc." *Everything*, I feel, is going to be very much "etc." until Vermont.

Tuesday, April 10th, 1973

Strange day so far. Semi-sun. A bit of painting. A bit of letter writing. And a bit of Gertrude. Followed by a very strong desire for some "Oreo" cookies and a glass of milk, so I went out and got some, which I ate with a banana I had previously bought for perhaps painting.

Am finding Gertrude easier and easier to read but, the easier she becomes, the less I am impressed with her intelligence, which seems to me rather hit or miss. This, however, has nothing to do with that she is still very interesting.

Mail this morning was a telephone bill and a postcard from Anne in Albuquerque, New Mexico. ("Beautiful snow-splattered mountains, blue sky and puffy clouds. I'm drinking iced tea. It's 3:45 P.M.")

It's 3:20 P.M. right now. Guess I'll read until my 5:45 dentist appointment.

Dinner tonight with Kenward.

Before I Die

One thing I want to do before I die is to make it with Anne Waldman, without offending Michael Brownstein. The old have your cake and eat it too bit. The story of my life. And now that I think about it, making it with Michael Brownstein, without offending Anne Waldman wouldn't be bad either.

Right Now

Out in the sun. "Coppertone" suntan oil on. Vermont. Calais. (1973.) With a yellow bathing suit on: one of three I got in Paris this spring, which, actually, are underwear. One brown. One red. And this yellow one.

A big white towel draped over a lounge chair is what I am on.

What I am writing on is a "National" clipboard under a tablet of such very thin blue lines resting on the arm of this chair with a black "Flair."

(It is not my purpose to bore you. It is my purpose to—well, I want to throw everything out of my head as much as possible, so I can simply write from/about what "is," at this very moment: *Right Now!*)

Right now, looking up from this page, I see much blurry green: (I haven't got my glasses on.) How strange that in so doing, I completely overlooked my two feet (?) which I can see quite well even without my glasses on. They are a bit bigger than one (me) might wish. And the two little toes have obviously spent too much time inside not very good for them shoes. The new big toenail (right) is much nicer than the old one that got ripped off on a rock in the lake last summer.

Feet: looking real hard at feet right now I am wondering "why toes?"

Life

The life of a human being is——

That's a very good question.

But let us begin again, on a slightly less ambitious scale.

The life of an ant is——full of danger.

The only difference (a very fine point here) is that the ant doesn't know it.

And now here we are faced with an even finer point: why?

In humanistic terms, is it simply a matter of *total stupidity*?

With some hesitation, one must assume so.

But let us take time out now to delve a bit into the abstract.

If the life of an ant is full of danger . . .

The life of a closet is full of hangers.

Often we find the abstract not so much fruitful as interesting.

And usually not so much interesting as tempting.

Which is perhaps about as close as we can ever hope to come to *the basic key* of life.

But in conclusion, let me state as emphatically as possible that *temptation is not a thing to be taken lightly.*

It is from temptation that our cave dwelling ancestors ventured out of their caves.

It is from temptation that self-protective laws became necessary.

And it is from temptation that we reach out, and fall on our faces.

Which is *the* basic process of learning.

Which is *the* basic process of growing.

Which is *the* basic process of living.

Which *is* what the life of a human being is.

Stoned Again

Actually, you know, I *do* have a lot of confidence in myself. It's simply that I haven't quite enough confidence in my confidence. Which, if one can assume logically (bet your boots!) probably means that I don't have enough confidence in my confidence in my confidence either. (Stoned again!)

A Depressing Thought

That a fantastic flower develops from just a little tiny seed—that knowing that doesn't totally rip us out of our minds—that's a depressing thought.

Thirty

When you get to be thirty—you begin to wonder—
you begin to wonder if maybe it doesn't just all boil down to
"chicken."

Ten Imaginary Still Lifes

IMAGINARY STILL LIFE NO. 1

I close my eyes. I see a light green vase. A very pale light green vase. Right beside it sits something black. Something small. It is a small black ashtray. Getting smaller by the moment. Until—really—it is hardly more than—now—a tiny speck.

IMAGINARY STILL LIFE NO. 2

I close my eyes. I see white. Lots of white. And gray. Cool gray. Cool gray fabric shadows. (It is a painting!) With no yellow. By a very old man.

IMAGINARY STILL LIFE NO. 3

I close my eyes. I see bright orange. Almost red. A touch of purple. A speck of black. And a thick blueish stem. An exotic flower of some sort. Driftwood. Bamboo. A figurine. Chartreuse. (1953!) This is a Polynesian still life.

IMAGINARY STILL LIFE NO. 4

I close my eyes. I see a white statue (say 10" high) of David. Alabaster. And pink rose petals, sprinkled upon a black velvet drape. This is a sissy still life. Silly, but pretty. And in a certain way almost religious: "Eastern" religious. This still life is secretly smiling.

IMAGINARY STILL LIFE NO. 5

I close my eyes. I see a charming nosegay of violets in an ordinary drinking glass. That's all.

IMAGINARY STILL LIFE NO. 6

I close my eyes. I see old fruit. Pots and pans. And various and scattered utensils. Brown. Art. Dutch. By nobody in particular. (Museum.) And so, on to the Frans Hals.

IMAGINARY STILL LIFE NO. 7

I close my eyes. I see a lazy guitar. A little potted cactus plant. And the rainbow blendings of very bright colors woven into a poncho, slung across a hand-painted wooden chair. (1955!) This is a "tourista" postcard still life.

IMAGINARY STILL LIFE NO. 8

I close my eyes. I see pink. And green. And gold. All mixed up together. But now slowly evolving into three distinctive shapes. (...) It is a pink kimono, gently discarded upon the corner of a green dressing table, which enters the picture frame at a very sharp angle. Behind it stands a gold screen of three panels. In this particular Japanese still life one gets the impression that something is going on that cannot be seen.

IMAGINARY STILL LIFE NO. 9

I close my eyes. I see . . . upon the corner of a black lacquered end table I see a clear crystal ashtray, containing a long white cigarette butt, crushed up into the figure "Z." Pink smears along the filter's edge implicate a woman. And now I can smell blue smoke in the air, lingering from a most recent exit, perhaps in a huff. A dozen dark red roses in a very tall vase complete this elegant—if icy—still life. A still life with a story. And probably a sad one.

IMAGINARY STILL LIFE NO. 10

I close my eyes. I see something copper. (A tea pot with missing lid.) And dried cornflowers in an earthenware pot. Against a brown velvet drape. "Sniff": I can smell last week's clay still in the air. As Mrs. Black (my high school art teacher) leans over my shoulder, trying not to be too impressed with the dashing highlights I have no doubt overindulged in, to impress her with.

from 29 Mini-Essays

PEOPLE

People are the most interesting books in the world.

THE BEACH BOYS

"The Beach Boys" are worth feeling old about liking.

T.V. DINNERS

Sometimes progress takes too big a bite and ends up with indigestion.

VAN GOGH

He dared look the sun squarely in the face and steal its radiance.

OPTIMISM

Perhaps it is enough to know that nothing will ever be as it was before.

AMERICA

That a giant economy-size box of "Supreme-Three-Ply-Extra-Soft-Deluxe" cleansing tissues costs only 39¢ ought, it would seem, to restore one's faith in *something*.

IMAGINATION

Imagination is the mother of reality.

PRIDE

Pride creates its own banana peels.

RECIPE

When in doubt, sprinkle with cheese and bake.

GARDEN

When in doubt, mulch.

FREUD

From Freud we learn that when a wife smashes a vase to the floor it is really her husband's head that lies there broken into many pieces.

THE ERA OF MIND

Geology, which is the story of rocks, finds its climax in history, which is the story of man . . . if you get my drift.

WOMEN'S LIB

A woman can do anything she puts her pants to.

GARBAGE

As I was saying to my garbage on the way out the door the other night—"Why should I carry *you* down three flights of stairs? I don't even *like* you!"

EARLY ATHLETE'S FOOT

There is an old Indian saying not to judge a man until you have walked in his moccasins for two moons.

YOU CAN'T LOSE FOR WINNING

He who would give his right arm to be a free man is a free man with one arm.

REMEMBRANCE OF WOMAN PAST

The echo of an interesting woman can be an ordinary scarf.

MOTIVATION
"Some day my prince will come . . ."

THE TRUTH
It may just be—you know—that "the truth" is far too obvious to risk the comprehension of.

SIGN OF THE TIMES
Would you believe a new Revlon fingernail polish color called "Burnt Toast"!

HISTORY
What with history piling up so fast, almost every day is the anniversary of something awful.

PEOPLE
If I'm as normal as I think I am, we're all a bunch of weirdos.

The Outer Banks

Those silly seagulls up in the sky over there remind me of

a particular local postcard of many seagulls in the sky that
could go on and on forever were it not for the edges

reminds me of a particular Southampton postcard of *a*
seagull soaring high: the only Southampton postcard simplistic
enough to be commanding enough to survive the horrors of
photochrome technicolor

reminds me of you—Jimmy—out in Southampton in the
big Porter house in your little room of many books it takes game
strategy to relocate now, as then

until recovering the wildflowers on the wallpaper peeling off
the long narrow corridor that leads up to your door

It is not closed
upon your window of green
"in" from the yard
of the sick tree
in so many paintings
by Fairfield Porter

That was the summer of . . . not knowing how many years
ago is just how it ought to be remembered, and is.

Out trekking up South Main Street
you are:

a pair of thick white legs
sporting Bermuda shorts
(of a *most* unusual length)
and plain blue sneakers so "you"
they are.

That was the summer of Campari and sodas . . . remember?

Out trekking up South Main Street
in the pattern of the leaves
from the shade of the trees
that align South Main Street
most daily is us:
trekking up South Main Street
on our way to the drugstore
with all the sunglasses
on racks that whirl so fast
where you got your newspapers from
where I got my magazines from
where we both got our seagull postcards from
to send to each other, mostly
when in the future(s) apart.

And remember the store on the corner with all those
plain—(the kind of plain you pay for)—English sweaters of every
imaginable color, that—surely—any respectable movie star would
have a whole walk-in closet full of, that we bought a few from
too?

Or if but two
baby blue, I see for you
and raspberry sherbert, for me
(easier to buy than to wear)
especially when thrown over the shoulders
like "they" did

with no socks on
in Italian loafers
(If money can buy such nice ankles: where?)
with sunglasses up in their hair!
"Ah, the good old days!"

If gobbled then—digested now.
(clarified by time—romanticized by mind)
for today's re-past remembered.

Out along these outer banks
of North Carolina
for no reason whatsoever
except "ocean."

Towards a Better Life (Eleven Exercises)

EXERCISE NO. ONE

From your head pick out the one person you would most like to make out with. Now call this person up for a date. He or she will probably say "No," but at least you will have tried. Will have the satisfaction of having tried. And then you can blame "life" for your frustrations, instead of yourself.

Conclusion: When you have nothing to lose, gamble.

EXERCISE NO. TWO

Once a month poke your finger down your throat until you vomit.

Conclusion: The symbolic gesture is a practical tool.

EXERCISE NO. THREE

Bake a cake, and eat it.

Conclusion: From work cometh reward. From reward cometh "No promises."

EXERCISE NO. FOUR

Before going to bed one night, drink lots of beer, eat lots of ice cream and pickles, and smoke a joint. You will have fantastic dreams, which you must concentrate upon remembering. First thing in the morning, write these dreams down as accurately as possible. Then tear them up and throw them away.

Conclusion: Mental masturbation, to be of any intrinsic value, must know who's boss.

EXERCISE NO. FIVE

The next time you are making out with someone, try casually suggesting that perhaps it might be fun to adjourn into the closet.

Conclusion (for straights): New areas break down old fences.

Conclusion (for gays): Everything is a full circle.

EXERCISE NO. SIX

If you drink black coffee switch to regular (or vice versa) until you find yourself enjoying your new way of coffee just as much as your old way. Or, if you simply *cannot* make the adjustment, you will find yourself drinking less coffee, which is O.K. too, because, you know, it's not very good for you.

Conclusion: Sometimes to lose is to win.

EXERCISE NO. SEVEN

The next morning you don't feel like getting up, don't get up.

Conclusion: Conclusions cannot always be drawn.

EXERCISE NO. EIGHT

On a piece of paper with a pencil, close your eyes, and do a drawing of a conclusion.

Conclusion: He who delves into the abstract is asking for it.

EXERCISE NO. NINE

This exercise is especially for painters. If you are a painter, stop painting for one year. At the end of this year, have an exhibition.

Conclusion: Art is not always in the eye of the beholder.

EXERCISE NO. TEN

Pick up the current issue of *Time* magazine and circle with a pen every "t" throughout the entire issue.

Conclusion: To take time is to understand time for only the time it takes you to do it in.

EXERCISE NO. ELEVEN

Sit down and write your mother a long letter revealing all your deepest and darkest and most perverse secrets.

Conclusion: Behind every horrified mother is an honest son.

Twenty-three Mini-Essays

CHOCOLATE

The story of chocolate is sweet and bitter and sometimes nutty.

GRASS

That which appears greener on the other side of the fence is usually grass.

LOSER

He was at the airport when his ship came in.

TOKEN GESTURE

One step is but a tiny ladder.

ARTISTIC SURRENDER

Perhaps the ripples upon a body of water can best be understood when stooped to squinting.

HUMOR

The man who slips on a banana peel may not think it's very funny, but it is.

DANCE

Dance, according to the United States Post Office, is "Poetry in motion."

POETRY
Poetry is that certain something we so often find missing.

PHOTOGRAPHY
A child on the beach may be important.

THE UNITED STATES POST OFFICE
Some of the best things in life come in a plain white envelope through all kinds of weather—eventually—except on major and minor holidays, if there isn't a strike on, except on Sundays, if it doesn't get lost.

PICNIC
A picnic is a moveable feast, with paper napkins, ants, and—if you're lucky—deviled eggs.

HOW TO KILL TWO BIRDS WITH ONE STONE
With a large stone, a bit of luck, and no membership card to the Audubon Bird Society, you'll stand a much better chance.

CHERRY PIE À LA "707"
That old expression "pie in the sky" finally hits home.

INSTANT DIVORCE
The marriage was so brief they had nothing to fight over but cake.

SOMETHING TO THINK ABOUT DURING THE HUNTING SEASON
For all we human beings know, a reindeer may go through life believing he is of absolutely no use to anything or anybody, except a few other reindeer maybe.

ETHNIC ETIQUETTE

Picking your nose with chopsticks in a Chinese restaurant won't win you any "majority group" friends either.

ORAL FIXATION

The proof of the pudding is in the mouth.

BLOND

Being blond is more than hair.

PEOPLE

They seem to get younger every year.

MUSIC

There's an old story about a music professor in Vienna who once told his students that music should be seen and not heard who lived on to a ripe old age in total poverty.

GRAVITY

A man gazing at the stars is secretly at the mercy of his own two feet, silently gripping the earth, in homage to that which most vividly recalls to mind a lovely red apple.

LIFE

If you snooze, you lose.

DEATH

Que sera, sera.

Religion

I think I genuinely try to keep an open mind about religion. Not, however, so much because of religion as because of keeping an open mind.

Knowing very little about Tibetan Buddhism, I'll grant you that it's a lot more interesting than Protestantism.

But "interesting" (let's face it, folks) is a slightly dubious compliment.

And so, to tell you the truth, I just can't quite buy it.

As a way of life, I believe a more truly accurate source (or means) can be found totally, if somewhat abstractly, from within each of us as individuals.

Religion as a "device" towards this discovery I can certainly understand, but, like psychology, not especially admire.

I guess you might say that I believe in the wind, as I believe in the stomach, as I believe in you. As I believe in me. As *I believe*, period. And (taking advantage of feeling so "up" ((pill)) today) I shall venture to say that I believe in a perhaps almost nonexistent form of believing: as pure as gold, without people.

All of which (believe it or not) has something to do with *total cancellations*!

And I believe in the fullness of the/this resulting void.

Out in the Hamptons

Red and green and yellow
orange and purple
rust
and the silvers of gray:

the late colors of autumn
subdued into subtle combinations
too intricate and transitory to pin down
unless perhaps with paint
all mixed up together
into one long streak
from a car window seen

passing a pair of young lovers
(cute as buttons)
out for a walk
hand in hand

as the sound of dry leaves underfoot
rustles through my head
from out of the past
like a stab in the heart
quick and blue with envy
for a possibility lost
to the age of 36
in its utter simplicity:
as stupid and beautiful as a movie
I thought might really "happen" someday
but evidently not

as these words on paper erase
that it hardly matters anymore
into the presence of this poem
I don't know how I'm going to get out of

as (thank you) the secret formation of birds in flight
flows across the sky
(wide and white)
towards the out-of-sight
of never to know
what might have been
a different tomorrow today

in this dream of being awake
(past and present)
and silly with being alive

Nothing to Write Home About

ART NOTE

Painting a pear today, it occurs to me that what painting is really all about for me (at its best) is discovery. The discovery of that third slight "bump" alongside the disappearing edge of the pear, which I had originally assumed to be an almost straight line. However, the work itself eventually involved a sacrifice. And so what I ended up with was an almost straight line again. An almost straight line again, but with a very particular difference.

ON BEING A GAY PAINTER

Actually—I can't see that being a gay painter makes any difference whatsoever, except that every now and then my work seems shockingly "sissy" to me.

MONEY

My idea about money is similar to the gypsy idea about money: that a man's wealth is based not so much upon how much money he has, as upon how much money he has spent.

A SIGN OF THE TIMES

"A sign of the times" are posters plastered up all over West Broadway announcing a new magazine called *No Magazine*. (Can hardly wait for the first issue!) Seriously though—and aside from finding it all a bit silly—it's kind of sweet too—don't you think?—that we care so much, as to try so hard, irregardless of . . . but then why bother?

BREAKFAST OUT

Out having breakfast this morning, over coffee, in some-
what of a slump, I was thinking to myself: "Holy shit, Joe—you'd
better do something (anything!) to shape up your life a bit, or
else." And so I decided that—for starters—I'd try to be more
outgoing with my waitress: (other than just giving my usual
order, and saying "Thank you" as it arrives): and so—as she was
standing right in front of me, cleaning out a large white plastic
container of some abstract sort—I opened up my mouth to issue
forth "What's that?" But—(silence)—I guess she didn't hear me.
Nevertheless, I gave myself a pat on the back on my way home.
Just a tiny "E" for a tiny effort. But with total faith that any step
in the right direction is secretly a giant one.

ROACHES

Let me tell you how I feel about roaches. I'm not crazy
about roaches (!) Of course I'm not crazy about roaches. But I
don't hate roaches either. Just so long, that is, as they do what
they're supposed to do. I mean like—it really doesn't bother me
much to find them scurrying around when I come home and turn
the lights on. But when I come home and turn the lights on and
they *don't* scurry around, that really pisses me off!

NEW PLANT

I like it. I can't say I love it. But I do rather like it. It's quite
large. I mean tall. Almost as tall as I am. Shooting straight up
out of a dark green plastic pot is a thin brown trunk that goes
up and up until it finally "pineapples out" into many seemingly
random directions. "Decidedly tropical" is the impression it gives.
(One can easily visualize it living a comfortable existence in the
corner of a not too fancy restaurant or hotel lobby.) But as I was
saying—(though not a plant person myself)—I *do* like it. Just
the idea of having a plant around—(another living thing!)—I
like that. And then too, they're supposed to be good for the air.
Though I've heard tell that *too* many plants in a room can eat up

too much oxygen: hardly a pertinent problem as yet, however. And although it doesn't exactly fit in with the bachelor image I seem to have of myself, it's certainly well worth dropping at this point anyway. How I came by it (just in case you're wondering) was as a gift from a friend who decided to try the gypsy life for a change; though more or less not by choice, to hear *him* tell it. At any rate—one particularly nice thing about it is that—having chosen Sunday as its watering day—I now have something in particular to do every Sunday. Which is a slight improvement over Sundays past. (Ugh!) *Easter* Sundays were great though, as a kid. The whole Easter egg bit. Chocolate Easter bunnies. Usually a new suit. And from up in the balcony, a whole congregation full of flowery pastel hats that made the sermon go a whole lot faster. None of which—alas—has much to do with my new plant, but . . .

SUNDAY

This particular rainy Sunday (since you know how I feel about Sundays, you can imagine how I feel about *rainy* Sundays) finds me torn: torn between wishing I was spending the day in bed with someone cute and cuddly, and probably blond, or—then again—some horny hot butch piece of meat. However, what I *am* in bed with is *Daniel Deronda* by George Eliot, which is awfully good really. And I didn't forget to water my plant today. And that tomorrow is Monday is reminding me of how lucky I am that my time is my own (no job) and so tomorrow morning (thank God) won't find me wishing it was Friday again. And so now I can go back to *Daniel Deronda* with fewer complaints. Gee—how nice of you to be in my head to write to is!

MINOR FREAK-OUT

During Chapter 37 of *Daniel Deronda* my mind abstractly swerved onto (and bumped right into) the first time I distinctly remember hearing myself referred to as a man. I was "fishing." And Frederick did it. He said "Well, *I* think you're a very handsome man." (Gasp!) Let me tell you—if it weren't for that we were in bed—I would have fallen on my face.

THANKSGIVING

It seems to be that Thanksgiving Day is nearly upon us. And I am wondering (and curious) as to what (if anything) Thanksgiving Day really "means" to me. Or, rather, what it makes me think of. Recalls to mind. And so now—(emptying out my head)—let's see what pops up. Well, first is turkey. Second is cranberry sauce. And third is pilgrims.

IMAGINARY SEXUAL FANTASY

I'm looking out my back window, into the window across the way, a bachelor man in his late thirties is standing in the middle of the room—legs slightly spread apart—feet flatly on the floor—wearing a pair of white jockey shorts. His back is to me. And as his weight shifts over to one side, ripples or wrinkles run up the crack of his ass, deliciously defining a pair of fine full buns. Though he just left the room, he is already returning. With a can of beer in one hand, his crotch in the other: "scratching" his balls with casual enthusiasm. Now—giving the enlarged bulge in his shorts a friendly flip, he sinks down into a low stuffed chair, right in front of the T.V. set. I can see him on the screen: a vague and exotic reflection, which when focused upon, becomes as vividly demanding as a movie: a movie of some real humpy number, with his shorts down around his ankles, playing with his meat: big and hard and hot. And all shiny with spit, as he glides a tight fist up and down his shaft—real slow like—with an extra tight squeeze at the base, so the veins bulge and throb—with a little shiver of a shudder every time his fist encompasses his dark pink head—the piss hole glistening with a tiny drop of sticky stuff: that of more to come. Really getting into himself now, his strokes are more regular and speeded up. (His breathing increasing into rhythmic pants.) As, tossing his left leg up over the arm of his chair, he reveals a dark hairy asshole, just begging for the finger-fuck it's soon to get, all juicy with spit from just out of his mouth. (Such big full lips, and he hasn't shaved for days!) Gliding it in and all the way up now, he arches his body out straight, flopping his head back upside-down at me with a big grin on his face, as a volcanic

shudder darts through his body, and he shoots his heavy load. As ivory streaks of cum fly through the air, I leak all over my feet—a trembling mass of rubber—as I suddenly awake to crumpled sticky sheets, and white morning light.

QUAALUDE

Beauty and sadness and "landscape." The flow of time is so jerky, except in retrospect. Outside the window I fall on my face in the snow: this is what I saw. And—suddenly—the whole sky goes blue: this is what I see. Beauty and sadness "as" landscape: this is how I feel.

INSOMNIA

Now I lay me down to sleep . . . or so I thought. Until my head began to open out into everything and nothing in particular. Re-living random moments of this busy and evasive past, I feel cheated somehow. What it all adds up to is . . . not very much. These and those—("those" I'll kindly spare you)—were my thoughts, until I zeroed in on the inadequacies of this my particular pillow: too soft or too hard? And now neither my left nor my right side seems quite "right" to lie upon. At least not for long. And arms—what to "do" with arms? And so now—(Fuck it!)—I'm up and out of bed. Walking back and forth. Up and down. Gliding my hands over random surfaces from time to time. Like the cold hard wood of a table top, in passing. And I like being naked, inside the large dark space of my loft. (Like a cave man!) I like my bare feet on the bare floor, as they spread out to grip, step by step, with contact. And I like the way my balls feel swinging back and forth so freely, as I pace my space. Why—out in the woods—I feel as though I could squat for a shit as gracefully as any wild animal! But back in bed now, under cooler sheets, my eyes have found a place to rest. Upon the view outside my big front window: so silent and otherworldly out there tonight. And the sky . . . it's so oddly colored: all greenish and lavender, with maybe—yes—a touch of orange. The color is "mud," but reassuringly translucent somehow. And so now—having somehow found

some comfort in all this—I feel more myself again. "Available" to recall how mysteriously the "soon" of tomorrow will erase the "now" of tonight. Like a silent "zap." And a rather kind one at that, it being far too elusive to fall into. All of which is going to sound pretty corny in the morning, I suspect. But well worth buying tonight, if but for the price of a good night's rest.

RIGHT ON!

Today I made a "patience" sign to hang up on my wall. And tomorrow I plan to do a "confidence" one. Because these are the two things I want and need most in my life right now. And if I can't come by them honestly—(Fuck it)—I'll learn to fake it. As in "Right on!"

OH MY GOSH!

Oh my gosh . . . the gray hairs . . . they are streaming in at a most alarming rate. Though by the light of the bathroom mirror, they gleam like silver. (Now how's *that* for trying to grow old gracefully?) Seriously though, I do have rather mixed feelings about this aging process. (That range mostly from horror to total despair.) But—help!—is *nothing* to be taken seriously anymore? Like would you believe I can't even confront myself in the mirror for a good bawling out session these days without a foreign grin slipping into my face? Which perhaps ought to be funny, except that it's just too creepy. I mean like—just who *is* that person? And so yes, another birthday has just come (37) and went. And yes, I am milking it. (Subject matter!) And so I do plead guilty, if but to jump the gun on being accused of it.

But let me tell you what is *really* freaking me out these days: that the person I always thought I was simply isn't anymore: *does not exist!*

And the rug I have pulled out from under myself is . . . (gulp) . . . a sentence I can't quite complete just yet.

But for sure the sky is no longer the limit. There is *time* and *integrity* and *fate* to deal with: a heavy load to shoulder from underneath. Where the temptation to wallow in one's own muck—to simply surrender—to give up—is far too appealing. And far too realistic a possibility for comfort. (And I *don't* want to lose!)

And I can see myself all too clearly now as a finished product I don't want to feel *that* responsible for, because I don't. And so I resent it. And I have no patience with spoiled brats. I think we ought to feel lucky—be grateful—simply for being alive.

(And yet—just how seriously can I take myself when I still secretly believe—well, sometimes—that if I just had a big dick everything would be . . . er . . . real fine?)

But—(sob)—courage, and motivation, and stamina—where are they to come from? Where *do* they come from?

Evidently, tonight, from you, as I sit here at my desk, fishing for approval and support and empathy:

the green light I need. For acknowledging together the fact that—indeed—life *is* full of humps and bumps. As predictably so as . . . whatever. As ultimately important as . . . absolutely nothing. And as full of contradictions as that I—actually—rather like my gray hairs sometimes too.

(Whew!)

New York City

Vermont

THE 4TH OF JULY

Pat and Ron and Wayne are coming up for dinner tonight: salmon with sorrel sauce, the first peas of the summer, and strawberry shortcake: my "job." And one I plan to enjoy, thanks to

recent Colette reading: i.e. finding pleasure in the doing of little domestic chores (of an eventually oral nature!). However—though not in particular to change the subject—the shortbread part is just going to be biscuits. And supermarket biscuits at that. You know—the kind you bang across the edge of the counter top, and out pop the biscuits. The strawberries, however, are homegrown. And just as delicious as that implies. Especially when picked right off the plant, and popped into the mouth—so warm and juicy— after a day out in the hot sun of (thank you!) today.

EVELYN WAUGH

What's so funny about reading Evelyn Waugh today is not really laughing out loud until page 249. And then over a line so out in left field as "They said Captain Marino was no gentleman in the hospital tent."

MINUTE OBSERVATION

Out sunning on the lounge chair in a black bathing suit, with one leg up on the knee of the other—through the triangle of space in between my legs—I spy a butterfly in the process of eating up some invisible specks of God only knows what, right down there by my foot. Now let me fill you in on the details: a long black tongue, as thin as a thread, emerges out of what I assume to be a mouth, and rapidly scans the woven plastic strips of this "Grand Union" lounge chair, in the dart-like motions of anteaters in cartoons. His wings are brown and black with lesser specks of orange and white, though by no means at random of course (. . . Z-Z-Z . . .). Well all I can think of to say is that we probably learn something new every day, even if we can't always put our fingers on it.

WORRY-WART

Let me tell you about my mother and car doors. Well, with *my* mother in the car—("Now are you *sure* the door is locked?")— it didn't really matter if the door was locked or not, because you couldn't lean up against it anyway, because "you never know."

A total lack of faith in car door locks is what it would all seem
to amount to, except that—believe me—it didn't stop with car
door locks. My mother, she had a real nose for danger in many
other areas of life's activities as well. Such as petting stray dogs.
Getting pneumonia from catching colds. (From various combina-
tions of wet hair, drafts, bare feet, not enough sleep, and so on
and so forth.) None of which is by any means meant to knock my
mother. (Sweet as a button. And wouldn't hurt a fly.) And you
can hardly blame a person for being how they are. And besides—
by the time you're my age, you can only blame yourself for any
kinks you've yet to iron out in yourself, is the way I see it. Like
take for example—balls: which I still have an instinctive fear of.
Especially when they are flying through the air right at me at a
rapid rate of speed. Due in part, I suspect, to this very vivid vision
I seem to have of ball making contact with face, the gory details
of which I'll kindly spare you. Except for—(I can't resist)—shiny
slivers of glass flying into your eyeballs from out of smashed spec-
tacle frames, dangling down from what used to be a nose. And
so—optimistically speaking—I still have "ball" to look forward
to someday, should my interest ever warrant the minor effort it
would require. At any rate—and to get back to car door locks—
let me assure you that I now *love* leaning up against unlocked car
doors *immensely*: gee thanks, Mom!

WHILE READING THE *STAR*

I can't wait to tell you what I saw this afternoon, while read-
ing the *Star* at the dining room table, right in the middle of this
story all about how Suzanne Pleshette and her husband—(who
isn't very cute at all)—were vacationing out on their yacht in the
middle of the ocean somewhere—(not that looks are everything,
of course)—when suddenly an airplane came swirling down from
out of the sky right at them, when suddenly I glanced up from the
paper, and there right in front of me, but inches away, were two
flies fucking! They didn't seem to be enjoying it much though.
But it was interesting to watch. At least for a while. How they do

it (just in case you're wondering) is rather like how dogs do it: one humping the other from behind. Well—so much for X-rated insect life in Vermont. However—(and just in case you're wondering what happened to Suzanne Pleshette and her husband)—it was a *very* close call. The airplane crashed down into the ocean, but yards from the yacht, out of which climbed two pilots in floating devices, who turned out to be dope smugglers (!) and were eventually turned over to the "proper authorities," much to the relief of Suzanne Pleshette and her husband, who—(I forgot to tell you this part)—were celebrating a much needed second honeymoon.

BIRD LIFE IN VERMONT

A thrilling and tragic thing happened this morning on the front porch, where some sparrows built a nest under the eave, to lay their eggs in, which hatched into babies, that kept getting bigger and bigger, until finally this morning, right in front of my very eyes, they just got up and flew the coop! As though there was nothing to it. (Or as though they'd been sneaking out at night, secretly rehearsing behind our human backs.) And so as though by some prearranged signal—like "One, two, three, go!"—they got up and went. Fanning themselves out, each into a different direction, each into a life of its own. All except for one, that is, who flew right into the side of the house with a tiny "thud" and—alas—is of this particular world no more.

HOW JANE AUSTEN DROPS A BOMB

". . . she could not help feeling a small pang of something which could only be described as jealousy."

TRUE LOVE

It's the little things that you do . . . like filling up the ice trays: the special way you have of putting the unmade tray on top of the made tray, so that when I go for ice, I spill water all over myself, that really drives me up the wall most fondly, in retrospect.

THE ZUCCHINI PROBLEM

The zucchini problem, if you don't have a garden, does not exist. And if you have a garden, you know all about zucchini. But still—having brought up the issue, I must say *something*. Well, the plant itself is certainly impressive, to say nothing of aggressive. As are—too—the vegetables it bears. And you wouldn't believe how many unusual zucchini recipes are running about, if not amuck, around this time of the year when—(now here's where we come to the *real* zucchini problem)—you can't even *give* them away!

TODAY

What a beautiful and violent day today is! What with the trees all twisting and tumbling about in the wind. Twirling down to the ground those recent invasions of yellow and orange and red "specks" that sink the heart into the pit of the stomach—all aflutter with butterflies—as though just around the corner is yet *another* first day of school. Over there is purple in the browns of distant brush. While overhead, big puffy clouds are zooming about, revealing from time to time large patches of the most blue-blue of skies. (As the eventual probability of steel gray and deadly silence simultaneously lurks.) Autumn is in the air. Though it's only flirting today. It is just the kind of day I can imagine Vlaminck might have painted well, had his color been more particular and pertinent, had his "vision" been less preconceived. (Conceptual?) But then I'm partial—though simply a matter of taste—to artists who "stoop" more to the moment. Because I find the idea of it more exciting, I suppose—(for the risk involved?)—and grander a stance. Though when reduced to a stance, just as predictable as "conceptual," I suppose. (Do I suppose too much? And why should "predictable" be a dirty word?) . . . And so from out of this corner I have written myself into, am I going to conclude (Gulp!) that (No!) it all boils down to the same thing? With apologies (P.S.) to Vlaminck: a painter much too easy to knock, to knock.

MY FRIEND

There's this one little bug—so tiny really—say an eighth of an inch long, and as thin as a sliver—with a very simple and symmetrical design finely enameled upon the shell of his body in red and green—as sophisticated as a zinnia bud, or an Art Deco cigarette case—that is just so beautiful—so worthy in my enthusiasm of being glorified into a central window of a major European cathedral—that has been living upon a particularly large sunflower leaf for over a week now. I check him out daily. Never really expecting him to still be there, as with each day more so, it does seem to be a lot to expect. But there he still is—(or was this morning)— : my friend. And like a rock by chance encountered, all mine. To microscopically indulge in. To romanticize. (To write about!) Passing on to you, what I find to be so very special— a snapshot—to make life more realistic and rememberable, for me too.

A State of the Flowers Report

(Vermont 1979)

—For him who grew
and grows them—

Well, the apple blossoms are gone of course. No more tulips.
No more daffodils. No more dandelions. (Such big ones I've
never seen before.) Nothing left of them now but random white
balls of fuzz, lurking in obscure corners the wind finds hard to
get at, evidently. And the forget-me-nots are decidedly on their
way out. Though not to be forgotten. As we love them just that
much. Some modest lavender irises have just bloomed. Though
they fade from mind considering a single new sturdy one—frilly
of petals—of the particular color you get when mixing orange
and purple together, if the proportions are just right. (A brown
so rich it deserves another name, all its own.) And the rose hip
bush is beginning to bloom. Just two or three so far, but many
buds. Which is going to be awfully pretty, the past informs me,
laden with heavy clusters of pink wild roses, of not too many
petals, with yellow straggly centers. Which instantly scatter onto
a table top, if picked into a bouquet. Stems literally packed with
tiny thorns of a relatively harmless nature. (As opposed to those
sparser sharp ones that jut out of long-stemmed roses—dark red
buds—wrapped up in green waxy tissue, in a long white box,
from a city florist, on special and rare occasions, with a card
enclosed, or sometimes excitingly not, that more often than not
droop their heads before given a chance to open out.) Though

most spectacular of all right now are the poppies. Especially
the big bright red floppy ones, which "glow" from a hint of
inner orange. With petals so deceptively vulnerable to the wind
(though not the rain) they so wildly surrender to. Each petal with
a dark black velvety spot, that narrows down into a large purple
"button," like an intricately tied and tried—(into a "high art"
form)—oriental "knot." Though the pink and white ones, alas,
recall to mind much too vividly those toilet paper flowers stuck
into the chicken-wire holes that floats in local parades are made
out of for me—personally—to like very much. Like hollyhocks,
they seem too artificial to be "of the earth." And the chives,
which are taking over the patio (for lack of a better word) with
clover-like flowers the bees like to suck so much, are really going
bananas. As are the devil's paintbrushes, across the way, quite
presumptuously heading towards a total takeover of the large
expanse of green that edges and defines the woods. A wildflower
I only know the name of thanks to Jimmy Schuyler, that grows in
clusters of three to five or more blooms to a single tall fuzzy stem,
bluish in hue. Each bloom a tiny "sunburst," inwardly bleeding
from bright yellow, out into a burnt-orange so rich you could grit
your teeth. And lastly and perhaps leastly—though appropriately
enough so—is the old snowball bush by the corner of the house.
Quite tacky with dignity, as a real survivor. From out of the earth
a mass of naked bare stalks, as gray as brown hair becomes, with
here or there a green sprig of a token gesture, branch up and twist
around and out, into sudden bouts of youthful activity: large
white balls composed of simple white flowers, that petrify them-
selves into beige, remaining intact for early autumn to scatter, as it
does, and will.

Jimmy Schuyler:
A Portrait

Let me be a painter, and close my eyes. I see brown. (Tweed.) And blue. (Shirt.) And—surprise—yellow socks. The body sits in a chair, a king on a throne, feet glued to floor. The face is hard to picture, until—(click!)—I hear a chuckle. And the voice of distant thunder.

January 13th

Mozart is coming out of the machine—real soft—just for company. Like that of a cat, in a room. A bright red Campari and soda sits off to my right, just within arm's reach. A moment away from the ashtray: a deep blue enameled disk, inlaid with a sliver of white moon and sprinkled with silver specks of something, to represent the stars. All somewhat obscured by three cigarette butts, snuggled up close together—spoon-style—that each says "TRUE" in tiny blue letters, if you look real close. My left leg, over the arm of the chair, swings back and forth, and back and forth. (Shoes overhead cross room.) Outside my window snow is falling down, against a translucent sky of deep lavender, with a touch of orange, zig-zagged along the bottom into a silhouette of black buildings. (The icebox clicks off, and shudders.) And it's as simple as this, what I want to tell you about: if perhaps not much, everything. Painting the moment for you tonight.

Interviews

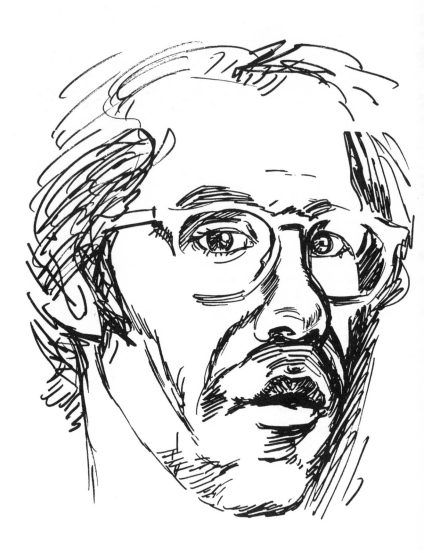

The Joe Brainard Interview

by Tim Dlugos

TD: *September 26, 1977 . . .*

JB: Oh, I'd better close the window.

TD: *. . . on 8 Greene Street in the loft of Joe Brainard. This is an interview.*

JB: Are you comfortable? There's more pillows, too, if you want them . . .

TD: *This is fine. I'll sit straight up in my zen position. All right . . . you were born in Salem, Arkansas. Where's that?*

JB: It's in Arkansas. (Laughs.) It's over in the upper right-hand corner, more or less.

TD: *So it's like . . . it's not the mountains, right, it's not the Ozarks?*

JB: Well, it's sort of on the edge of the Ozarks.

TD: *Why did you go to Tulsa when you were a baby?*

JB: I don't know. My parents moved there, but I don't remember at all. (Both laugh.)

TD: *Tell me about Tulsa. I've never been there.*

JB: I can only tell you about Tulsa when I was there, but it's changed a lot, 'cause I haven't been there since 1960.

TD: *That's what I want to hear about.*

JB: It's very new, and it's a very sweet city, 'cause everyone's sort of like the way people are in the Middle West. You know how that is?

TD: *I've only been to Ohio, that's the only part of the Middle West . . .*

JB: Well, they don't cause trouble. Everything's smoothed over,

so it's a very pleasant life. And it's surprisingly smooth, I mean there's no drama, it seems to me . . .

TD: *So you had no childhood traumas?*

JB: No I didn't. I mean, I had my own traumas, but they didn't have anything to do with Tulsa.

TD: *What were yours?*

JB: Well, stuttering was the big one. And just a general inferiority complex, like most artists, probably.

TD: *Were you "popular" in school?*

JB: No. (Laughs.) Well, I think I was popular when I was a kid, before, like in grade school. I was popular, and it was very nice, and I was a good artist and everything. But then I got to the early teens, and was pretty out of it. I was homely as a board fence, skinny, stuttered, and a total misfit.

TD: *How did you meet Ron Padgett and Dick Gallup?*

JB: In my high school.

TD: *Were they all out of it too?*

JB: Yeah, they were out of it in different ways. They were out of it because they thought everyone was very silly and dumb, and they were intellectual. So they were out of it in that way, which was totally not the way that I was out of it. I wanted to be in the social clubs, and everything. But then since I was out of it, I could get together with them. It was strange, it all worked out. We were all in the same position. So we started a magazine. Or, rather, Ron did. I was just the Art Editor really.

TD: *What was it called?*

JB: *The White Dove Review.* We published people like Allen Ginsberg . . . and it was all Ron's doing, he could write . . . e e cummings . . .

TD: *e e cummings?*

JB: Yeah . . . LeRoi Jones . . .

TD: *When was this?*

JB: Around 1959. And then Ted . . . we published Ron and Ted and Dick a lot too.

TD: *How did Ted [poet Ted Berrigan] fit in, where was he?*

JB: He was in college at the same time.

TD: *How did you meet him?*

JB: I don't remember. I met him through Ron, but I don't know how Ron met him. (Pause.) But the first time I met Ted, I was working in a snack bar at a country club, outdoors by the swimming pool. And he had a crush on one of his students—he was teaching English—and he had a crush on this little, like, twelve-year-old girl, whom he happened to be with, I suppose, because she belonged to the country club. So she brought him to the country club, and he tried to get me to give him a free hamburger.

TD: *To give you, or to get her?*

JB: To give *him* a free hamburger.

TD: *Oh. What did you say?*

JB: No. (Both laugh.) I apologized, but I didn't know . . .
(BREAK FOR TEA)

TD: *So how did you become reconciled, after you wouldn't give him a free hamburger?*

JB: Oh, he didn't take it personally.

TD: *Did you guys kind of follow him to New York?*

JB: Actually, we came first. Ron and I came to New York in 1960 when we got out of high school. Ron went to Columbia, and I was going to go to the Dayton, Ohio, Art Institute. I got a scholarship to go there. But I didn't really want to go there. I just wanted to get East. So I used that to get East.

TD: *Why did you want to go East, rather than go to, like, California?*

JB: I don't know . . . I just knew what I wanted was in New York. I don't know if I got that from movies, or what.

TD: *So you lived with Ron when you came to New York?*

JB: No. It's sort of a boring story. He went to Columbia, and I came up with him, but then I went back to Dayton, Ohio, and I went there for about a month. And then I told them my father was dying of cancer so I could leave.

TD: *He wasn't?*

JB: No. But I just didn't want to quit; I felt bad about quitting because I had a scholarship. And also they were all very nice, I didn't want to hurt their feelings, so I just said that . . . then I moved to New York, and I got an apartment on Second Avenue for $23 a month. Second and Sixth. And Ron was living up at the dorms all this time. And then about a year later Ted came to New York, and I lived with him for awhile, in a storefront, on Sixth Street right next to a meat factory.

TD: *Did he have a lot of influence on you, on your work, do you think? On your sensibility, your way of looking at life . . .*

JB: Yeah, he had an enormous influence. In fact, I don't think I'd be in New York . . . because he had this thing where—he's a teacher, that's the thing, but at the time he was terrific for somebody who was a little weak, in terms of just doing whatever you want to do and fuck what people think. So that was sort of his message, which I'd never learned. I had the instinct for it, but I didn't really have the guts.

TD: *Did your family put up a great protest when you came to New York?*

JB: No, they thought it was terrific.

TD: *Do you have any brothers and sisters?*

JB: Two brothers. I have a brother in New York now. He's a commercial artist.

TD: *Is he younger, or . . .*

JB: Younger. He just got out of college.

TD: *Are you the oldest?*

JB: No, I've got another, older one. He teaches art in St. Louis.

TD: *Is your father an artist?*

JB: He used to be. When he was young, he was an artist. Then he got married and had kids, and got a job in an oil company.

TD: *So you guys were encouraged, growing up, to . . .*

JB: No, not really encouraged . . . but we weren't discouraged.

TD: *But you all turned out to be artists.*

JB: Yeah, but we're doing it all different ways. I'm not sure it makes that much distinction, but . . . it might.

(BREAK FOR A JOINT)

TD: *You said that you didn't have sex until well after school?*

JB: I didn't come out until I came to New York; I mean after I'd been here I'd say three years. I must have been twenty or twenty-one.

TD: *How'd that happen?*

JB: I just didn't look anybody in the eye. (Both laugh.) It was that simple. I tried.

TD: *You came to New York in '59? '60? What was it like? What was your early work like? What did you do when you first came here? May I have a cigarette? (Both laugh.) Thank you.*

JB: The first things I did in New York were inspired by being on the Lower East Side. I don't know if they still have them, but they used to have all these Puerto Rican religious . . . junk . . . and Catholic, because in Tulsa they have very few Catholics, and it was always very exotic to me, like some secret organization . . .

TD: *Like the Masons, to us Catholics . . .*

JB: Anyway, it was all over the streets in New York, and I got hooked on it. I started making altarpieces. They were three-dimensional, they were made out of objects, and some of them were very big.

TD: *When did you meet Frank O'Hara?*

JB: Frank O'Hara I met the first time on the street. We already had started *C* magazine—Ted and Ron and I, but it was mainly Ted. And he was a big fan of . . . we were all big fans of Frank and Ashbery and Koch and Kenward and that group. So we were walking down the street with Ron and Ted, and Ted had just gotten a poem accepted in the first or second issue of *Locus Solus*, so he was in fifth heaven, this was his first recognition from the peers. So we were walking down the street and Ted said, "There's Frank O'Hara." So we ran up and stopped him and told him how great we thought he was. So, somehow we got invited to a party in Larry Rivers' loft in the Chelsea Hotel in the very top—he had

this incredible place. And that's where I met Joe LeSueur, who I thought was absolutely a dreamboat. He sort of reminded me of football players in high school, the sort of short, blond football players—sort of short and chunky. I couldn't believe he was Frank O'Hara's lover, he looked so straight to me. So I instantly had a crush on him. Then, through Tony Towle, who had gotten involved in *C* magazine . . . he was looking for someone to share Frank O'Hara and Joe LeSueur's old place, they were moving to a loft. So Tony and I took their old place, and we lived together for a couple of years. Tony was a good friend of Frank's, and they liked to play bridge. I didn't know how to play bridge, but I learned how to play bridge. (Both laugh.) So we all four played bridge a lot. It took me a long time before I got together with Joe. I always thought Frank and Joe were lovers, but then when I found out they were just living together—they had been lovers, but they weren't— so then I was instantly after Joe. It had been going on for a long time, and was very embarrassing to everyone, until one night we were all watching T.V., and Frank said he was tired, so why didn't we take the T.V. into Joe's room. It was all a set-up, of course. Anyway, Joe and I ended up in bed, watching T.V., and made it. So we started a big affair. I used to be there all the time; I used to go over there every night. That's how I got to know Frank. I sort of got closer to Frank a lot later, but everyone did at one point or another. It was inevitable. He sort of expected it. When I was there, he'd go to bed with somebody different every night, and a lot of the time with people who just wanted to try it, because he sort of gave you the space. A lot of . . . I can name some totally straight poets who went to bed with Frank just once because that seemed their one chance, because he was that kind of person. So he just took it in his stride; that was just where it was. He said, Okay, I'll go through with it. I'm sure he enjoyed it sometimes.

TD: *Where did you meet Anne Waldman?*

JB: I really don't remember.

TD: *Where did you meet Kenward Elmslie?*

JB: Oh, I remember meeting him. Joe LeSueur took me to a birthday party of Kenward's, and Joe was invited, and Joe took me. I thought he was terrific. I thought he was very handsome, and rich, and I was really impressed by that. And I loved his poetry, which I'm not sure I even understood at that point. But I knew that Ted and Ron did. So I knew he was good. Then we started doing some cartoons together for *C Comics*. But there's something in between . . . yeah, I was staying with Jimmy Schuyler at Southampton and Kenward came out—he had a house in Westhampton—and he asked me if I played tennis. I said Sure; I didn't play tennis, but I wanted to get to know him better. So I went out and played tennis with him. It was disastrous. Then we started collaborating on cartoons, after that. And then we got together.

TD: *It takes you a long time. (both laugh)*

JB: I'm better now than I used to be. (both laugh) I always find it hard to believe—this is going to sound ridiculous— I always find it hard to believe anyone . . . I mean I didn't know I had any charm at all.

TD: *Do you now?*

JB: I know I have some. I don't think I have a lot. My confidence wavers quite a bit; I can go higher than I should, and I can really sink. I've learned it's a lot of faking, anyway. You can sort of fake yourself into looking good, and I've learned to do that sometimes. I can't always do it, though. If the situation's right, I can do it.

TD: *When did you have your first gallery show, and how did you get it?*

JB: I got it through John Gruen, actually. As soon as I got some work together, and—not that I wanted to have a show or anything immediately—I started going around to galleries. I did the thing where I'd walk around to galleries and just

walk in and say "Would you like to see my work?" Some of the galleries were actually nice, and there were a couple that were sort of half-interested. Then there was a show at Finch College called "Artists Collect," and people picked the work of a younger artist. Larry Rivers picked me—I think it was through Frank's influence, because I don't think he really knew my work—or Joe's, or somebody's—anyway, I got in that show. And John Gruen saw it and liked it a lot, so he sold Charles Alan of the Alan Gallery on the idea of seeing my work. He saw it and he liked it, and gave me a show, around 1964, I think.

TD: *You were still mighty young.*

JB: Yeah, I was, to have a show of my own.

TD: *Were you an instant success?*

JB: No. I just sold a few things in the first show. I never had a big success . . . except maybe last year or maybe that collage show a couple of years ago . . . and in Paris last year I had a big success. But it's been very even, sort of gradual. It's a hard thing to measure, anyway.

TD: *Your first show was sort of toward the tail end of the Pop Art phenomenon, right?*

JB: No, it was toward the beginning. There was a big Sidney Janis show, which was the first big Pop Art show in New York. It happened in '63. So I knew Andy already.

TD: *What was that like?*

JB: He was the same as he is now. I think he was probably a little easier . . . he's always been very nice. Completely weird, but . . . but he's always been nice to me. I think a lot depends on whether or not you know him. He's always one (indistinguishable) around me. It's always the same. There are always a lot of people around, and he doesn't have as much time . . . It's just his presence, that's all.

TD: *Do you like his work?*

JB: Yeah, I love his work. Don't you?

TD: *Yeah, I do. Did you feel part of Pop Art?*

JB: I felt it a little bit, although in retrospect, it was totally

different. 'Cause before I was doing the altars I was doing a series of paintings of 7-Up bottle labels, just the labels, with the big 7 and the little bubbles. I'd never really seen any Pop Art, then I looked in *Time* magazine and there was an Oldenburg 7-Up—sort of drippy and wet, you know—and a Warhol soup can, and I was kind of shocked. (Both laugh.) But that was just a phase; I've never really been a Pop Artist; I was in Pop Art shows.

TD: *Who are your big influences? Was it people around that time, or . . . do you have big influences?*

JB: In the last ten years I can think of lots, but before that I was sort of oblivious to influence. I got turned on by things, and they'd stimulate me, but not directly—just the energy. On the other hand, I think I've been influenced by everybody. I sort of imitate in a way, but I don't do it directly.

TD: *Like who?*

JB: I think just about everybody I like. If I had all my works here I could show you drawings or paintings that remind me a little of Bonnard or de Kooning or just about everybody. I like style, I guess.

TD: *How involved were you in the "counter-culture" thing in the Sixties? I know you were a signer of the Timothy Leary Manifesto, or something . . .*

JB: I was? I did cartoons for the *East Village Other*, but I was never . . . I mean I'm not anti-anything, really. If I don't like something I just tend to ignore it. I don't claim at all that that's good . . . but I've never really felt strongly about a cause. It's always been different than reality for me, I think. I can get much more . . . you know . . . over a person, an individual. That's real. I've given paintings and things . . . but that was generally because I was asked, and I thought it would be a nice thing to do, rather than the fact that it would help a cause. I wasn't very political.

TD: *Did you know Leary?*

JB: Mm-mm, never met him.

TD: *When did you become a national figure?*

JB: You've got to be kidding.

TD: *You've been in* People *magazine! (Both laugh.) Listen, you've done the Christmas book for the Museum of Modern Art, you're probably the most successful young artist in the country . . .*

JB: Oh no, not at all.

TD: *Who else is?*

JB: Oh there are a lot of painters who . . . I don't have a definite commodity, and that's the only way to make money. I change every year, and it's very slow. A lot of people would know who I am, but they wouldn't really know what I did. I mean, they'd have some fuzzy idea, because I've been so spaced out all the time. I've had oil-painting shows that were very realistic, then I've done jack-off collages, cut-outs one year and drawings . . . it's all been very different. And the writing too confuses people. So I'm really not that . . . I mean, I make a decent living, which I think is amazing.

TD: *Well, you're certainly one of the best-known young American artists.*

JB: It *might* be true in New York, but I've never had much luck outside . . . I've given shows around the country and I've never had that much luck. People want to buy a Warhol or a person instead of a work. My work's never become "a Brainard." People outside of New York don't really understand that, I think. All the shows I've had have been flops, except in Paris and New York.

TD: *When did you start writing?*

JB: I started writing around the time of *C* magazine, but I didn't write very much. I had no intentions of being a writer; everything was against me. I had no vocabulary, I can't spell, I'm inarticulate. I have sort of learned to use that. But this happened because all my best friends were writers. I wrote a short story, the first thing I remember writing, and I showed it to Ted and he said, "It's very good." So I kept at it.

TD: *How did you decide to do* I Remember? *You're remembered for* I Remember . . . *(Both laugh.)*

JB: My only major work. How did I do it?

TD: *Yeah, how did you decide to . . . is that a dumb question?*

JB: No, I mean . . . it's very appropriate to how I decided to do it. A lot of times when I'm not painting—or even when I'm painting—I set up something for me to do. Like I'll say, "I'm going to paint a peach" or "I'm going to paint a pear," or if I'm writing I'll say "I'm going to sit outside and describe what's around me," or "I'll try to write very short stories," or some kind of project. And that was a project. I decided one day that I would lay out in the sun and close my eyes and try to remember and just write down whatever I remembered, free-floating. So I did that one day and I loved it, but I still thought it would be one piece, one big piece. Then I showed it to Jimmy Schuyler who was staying up there . . .

TD: *Where was this, Vermont?*

JB: Vermont, yeah. And he flipped over it and said I'd better keep going. So I kept going. He was an instant audience; I would do it all day and show it to him, and he would tell me how terrific it was, which was all I needed for the next day. After a few days I was stuck; then I realized it was something I wanted to carry through. I started finding out all kinds of different things about one's head.

TD: *How so?*

JB: Well, I have a terrible memory, for one thing. I can't remember anything. But then I began to realize that beyond that point there is another level of knowledge that could be triggered off. It wasn't really useful knowledge unless it was triggered off; then I sort of used up that and there kept being more and different layers of things that were hidden. It isn't really there spontaneously. So I got into that. I was unaware of it, for one thing, that all that was retained.

TD: *So you weren't haunted by your past?*

JB: Oh no, I totally erased my past; I'm very cold-blooded. But it was amazing to me that it was still there. It isn't nostalgic at all, because I'm not nostalgic. It's just really about the

memory more than anything else, because that's what I relied on. (Pause.) It's really fascinating how things trigger something else off. And it's fascinating how much gets twisted, too. There's an awful lot of stuff in there that's wrong, in retrospect. People said, "That didn't happen that way at all." I mean, I'm assuming they're right and I'm wrong. That was one of the hard things about the final version, whether to stick to what was true, or stick to my memory.

TD: *What did you do?*

JB: I pretty much stuck to my memory.

TD: *What other writing projects do you either have in mind to do or do you want to do?*

JB: To write a novel, for sure, because I'm a novel freak. And also I'm just at the point now where I sort of feel like I have enough patience, and that I could—though I'm probably going to focus more on the painting—that I could throw everything into one big time period and really focus it. I think it will be a painting. But I still want to write a novel very much. A love story, about guys. It's already an old-fashioned idea, but I still want to write a gay novel that doesn't apologize at all—I mean, that could be read by straights just as well, and it wouldn't make any difference whatsoever. I just think that would be terrific.

TD: *Is there anything like that that you've read?*

JB: Well, Mary Renault, but that's a whole other area, to write like that. But I think she—I mean, it just pops up, with no big to-do. It's a big to-do, but it's not a big to-do because it's two guys instead of a guy and a girl.

TD: *Your latest book of erotic drawings is* Gay B Cs, *drawings to a poem by Jonathan Williams. You don't use models?*

JB: Oh, I do, but not enough.

TD: *You do? I didn't know that.*

JB: It's sort of what my next show is going to be, big oil paintings of nudes . . .

TD: *Anyone I know?*

JB: I haven't started yet. (Both laugh.) That's my plan. And portraits, too.

(BREAK TO TURN OVER CASSETTE)

TD: *Are you having fun?*

JB: Yeah, I like to talk.

TD: *Do you consider yourself a "gay artist"? Is there such a thing as "gay art" outside of subject matter? Is there a "gay sensibility" that infuses your work or infuses the work of poets you know?*

JB: Does a gay sensibility exist?

TD: *Does it exist in your work, and does it exist at all?*

JB: I think it does in mine, but I think it's sort of closing out. I think that kids are coming up now . . . I don't think it's that important to most kids now. I mean it's not that much of an issue, while at one point, in my life, it was an issue.

TD: *You mean personal?*

JB: Yeah. Isn't that what you mean?

TD: *Well, is it a matter of subject, or what's it a matter of?*

JB: It's a matter of being aware of it, I think, but that doesn't answer your question. Sometimes it's a subject matter, obviously; with a drawing of two guys fucking it's obviously subject matter. But I think it's more than that. Most artists are very straight, I mean straight in their seriousness and in what they're trying to do. I think I'm a lot more sensual, I mean I'm a lot more ga-ga than that—but on purpose. No, not on purpose.

TD: *Sort of a ludic quality, playful?*

JB: Yes. (Pause.) I'm not really sure that has anything to do with being gay, though, 'cause I think my work is very sensual, very lush and all that, but I'm not sure that has to do with being gay. If I was straight it might be that way too. I don't know.

TD: *Who are the great artists of your time? I don't mean Picasso; I mean people who are alive and, say, within thirty years of you . . .*

JB: Well, that's sort of an assumption that I find hard to swallow, anyway. To me, an awful lot of it is just taste. But I can tell

you who my favorite painters are. De Kooning is my all-time favorite . . .

TD: *Do you know him?*

JB: I've met him twice. I think Andy's terrific, and Jane Freilicher, and Fairfield Porter, and Elizabeth Murray.

TD: *I don't know her work at all.*

JB: She shows at Paula Cooper Gallery. It's hard to describe— it's like a tough abstract, sort of worked over, like you started out with an incredible mess and tried to make some serene sense out of it. It gets very heavy, but it's very nice. And Joan Mitchell . . . I can go on and on, but beyond that it's an enormous list.

TD: *A couple of those are people who are well known as Abstract Expressionist painters. How does that connect with your work?*

JB: I think I'm sort of the reverse of that. I think of Abstract Expressionist painting as high seriousness. It's spilling out your guts all over. You think, and you work from an area that has no boundaries, so it's very tough and you've got to be very serious about it, and dedicated to an ideal. I like to start with nothing and just surprise myself. But it's not—it doesn't come out of gut emotions or a high sense of color or something as a source. I may use it, but it's not the source.

TD: *I want to pretend that I'm the interviewer for* 16 Magazine *and ask you all the questions that* 16 Magazine *asks its superstars.*

JB: Do you know them?

TD: *Yeah. (Both laugh.) What's your favorite color?*

JB: I don't think I have any, but I know what I'd say. I'd say red. But I think it's an intellectual choice. Color's my one really strong point. No color exists except in the particular way it exists. But I like the idea of red.

TD: *Doesn't sound like a Troy Donahue answer. (Both laugh.)*

JB: I didn't know I had to sound like that. Otherwise I'd have just said red.

TD: *What's your favorite food?*

JB: Well, I have a favorite dish. It's a baked potato with sour cream and black caviar which I really love.

TD: *What's your favorite book?*

JB: *Anna Karenina.* I'd really like to say a book of poems, but that would be stretching the point. I really love *Anna Karenina.*

TD: *What's your favorite TV show? You don't have a TV, so this will be really interesting . . .*

JB: I love Carol Burnett. I think she's really terrific. I like Mary Tyler Moore, too. I can't imagine why I like her so much. I didn't at first. There's certain awful things about the show, but somehow I think it has incredible backbone that's very hidden. And also I liked Gracie, Allen and Gracie . . .

TD: *George?*

JB: Gracie and George, when they were playing. Old *I Love Lucy*s I used to love, but not so much now. I used to love *Candid Camera*, it used to be terrific.

TD: *Who's your favorite male vocalist?*

JB: If I had to pick, I guess I'd say Charlie Rich. Do you know that song "A Very Special Love Song"?

TD: *No. Dare I ask, who's your favorite female vocalist?*

JB: I might say Judy Garland. In a way, I hate to say that, but there are a couple of songs—that one from *Meet Me in St. Louis*, "Have Yourself a Merry Little Christmas," totally tears me up. But on the other hand, I don't want to say she's my favorite female vocalist. I'm not really—I don't think I'm all that much into music, 'cause it's never been a big part of my life. I've always had just a radio, and I listen to the country-western stations. It's comfortable, and that's all I demand of music. If I'm at somebody's house and they have a great set, I enjoy listening. But it really doesn't fit into my life that much. I hope it will some day.

TD: *What's your favorite movie?*

JB: *Some Like It Hot*, and the one I can never remember the title

of, with Montgomery Clift and Elizabeth Taylor . . . something about the sun . . .

TD: *A Place in the Sun.*

JB: Yeah, *A Place in the Sun.* And *How to Marry a Millionaire, Singing in the Rain* . . .

TD: *Who's your favorite poet?*

JB: That would be really hard, too . . .

TD: *I know. That's why I asked you. (Both laugh.)*

JB: I'd say Frank O'Hara. And John Ashbery, too, though he's, you know, over my head, though every now and then I can get into him, and he sweeps me away and I love it, although sometimes he's impossible. My mind wanders off. And Ted [Berrigan], especially *The Sonnets*, but that's probably because I know that whole period. They're incredibly beautiful. And Ron [Padgett]. Of course Kenward [Elmslie] and a lot of people, too.

TD: *We left your biography off at your signing the Timothy Leary Defense Committee . . .*

JB: I don't even remember signing it, but I'm sure I did, 'cause anything I got in the mail I'd sign. If all it takes is a signature, it seems the least one can do.

TD: *How have you changed in the last ten years? You're what now, 35 . . .*

JB: Yeah. I've changed a lot, but I hadn't any choice. It would be hard to go into, though; I'm afraid it would be very tedious and boring. I'm so much older, and I think I'm much more realistic about what to expect. It's been a total freakout for the last two years for me.

TD: *What, at the end of your youth or something?*

JB: No, I like being 35. But I don't like myself as much as I used to, and that makes it hard. And also I'm not as blindly ambitious as I used to be.

TD: *Are you ambitious? You're certainly successful, but part of your charm, I guess, is that you seem terribly modest, and modesty and ambition don't seem to go together.*

JB: I think I am a little modest. But it goes together. But it's easy enough to be modest, because you never know what people think or you never know where you are—I mean, it's hard for me to assume that if I go to an opening anyone's going to know who I am. I still can't do that. It's always a surprise when someone says "I love your work," just out of the blue. I think I'm aware there are people who do, but I can never quite accept it as a fact, so it's still like starting all over every time. But I don't believe it as much as I used to, which is not depressing, but it makes things a little harder.

TD: *You don't believe in your work as much as you used to?*

JB: I don't believe in things I want, like being famous and making money. All that stuff is—I'd like to do it, but I don't believe in it as much as I used to. I don't have that force, which, even though it may be a perverse force, it's still a force, and it gets your shit together. But I already know it's not going to make a damn bit of difference.

TD: *What do you mean, ultimately?*

JB: Yeah. I mean I know that however much money I make or how famous I get, it's not going to change my life that much. I'm not going to be the same. It's not going to be easy street. I can tell that 'cause I've gone from having no money at all to being relatively comfortable, and I'm not any more happy now than I was then. I don't feel any more famous now than I was then, though maybe I've gotten used to it. So I don't have that as an excuse anymore, which is probably a good thing, though sometimes I miss it. (Pause.) And the older you get, every now and then you get this feeling that you're going to be alone all your life. At the same time, I'm not sure I could cope with the possibility of This Is It and nothing else. So I'm torn between those two alternatives. But then, I think everyone is. But the older you get, you realize you're getting a little less chance. In my head I think what I'd love to do is fall madly in love with someone. I still think it might happen. I can still see it, you instantly set up house and it's

terrific. But I don't know if it's realistic or not. Plus I think I'm already too much into a certain way of life, that for me to change it would take someone to knock me over. I mean, I'd have to go really bananas. And I think the chances of meeting someone that you go bananas over like that are slim. So the odds are against you, though I'm sure it's possible. And there are always places where, if you wanted to lead that lifestyle, you could find somebody in two seconds, and have a good life instead of holding out for this incredible ding-dong . . .

TD: *Johnny Angel?*

JB: Yeah.

TD: *You're very prolific. You do an enormous amount of work.*

JB: Yes, I do. It sort of runs in my family. I've taken speed off and on too, and that makes you prolific. I don't know how people can get—people who don't work, I don't know how they fill up the day. You can read, I guess . . . I'd hate to sit around and think all day.

TD: *I want to do this thing as a realistic, Bockris-Wylie interview. Do you know those guys, Victor Bockris and Andrew Wylie? When I was in Philadelphia, they lived there, and they used to sit around in restaurants and tape-record their conversations with each other, then publish it as a magazine. They had a certain . . . quality . . . a certain spontaneity I always admired, although it was a little light on subject matter.*

JB: They're funny guys.

TD: *How did it feel to be in* People *magazine?*

JB: I really looked forward to it, I mean I couldn't wait to get a copy. But you know how it is when it happens . . .

TD: *Not on that level I don't.*

JB: I mean, if I had been anyone else I would have been pissed off. They made incredible goofs, and they said things that I didn't say at all. The headline was, "Brainard Says, 'Think Small.'" I was doing small works, but I didn't say that. But I sort of expected that—I mean they have to find the story. But the whole line of the story was . . .

TD: *". . . Miniaturist Joe Brainard . . ." (Both laugh.)*

JB: It isn't my message at all.

TD: *Do you have a message?*

JB: I could probably think of one. It would be fun to pinpoint this point. There is one thing: I sort of have the feeling that most people don't take seriously enough that we're animals. That always bothers me. People tend to see things on such a grand scale, it always amazes me. And they take their lives so seriously. But that's a common idea.

TD: *Are you a religious man?*

JB: I wouldn't say so. That shocks me, too. Any religion shocks me. It all seems too transparent to me. I can see getting into it for the pleasure of it but I can't see really believing it, in terms of something to base your life on. That seems completely fraudulent. I can see emotionally, as a pleasure or gratification, but not as a source.

TD: *Do you base your life on anything?*

JB: I suppose I base it on what I try to be, or want to be. But I wish I didn't.

TD: *Why?*

JB: I'm not sure that's the point. I suppose it is if it gives you pleasure. But I have a definite goal which is totally unrealistic: I'd like to look like James Dean, I'd like to be a genius painter, be rich—I mean I really have this idea—I'd like to be charming and socially love everybody and have everybody love me. I sort of make small steps in an attempt to be that person . . .

TD: *When you spend your summers in Calais, do you work there?*

JB: Usually. Except two summers I haven't. One summer I gave up smoking, and work, and everything. I slept a lot. I just wanted to do something positive, prove to myself I could do it.

TD: *When did your mid-life crisis start?*

JB: It sort of started when I was taking too much speed. I was working on the collage show and—it's hard to describe why, but when you get into collages at the level I was at, to keep

up with it I either had to cut it off or just go bananas. And I went bananas, in terms of work. In order to have that much material, in that much space, with that many possibilities—I mean, I was just living in a big mass of papers, and collages would form themselves all over the place, and I was keeping track of all this. And there was no way to do it except by taking speed or ups. And I kept that up for about a year, but that made me a little crazy—I mean the combination of all the work and the ups. I was feeling very tentative; I was really walking thin ice for a long time. Then I had dinner with Kenward one night and he said, "I don't want to see you anymore." And I hadn't realized what a position I was in; I hadn't realized I had nothing to hold onto, and I went bananas. I've never been possessive of Kenward; he has boyfriends and I have boyfriends. But at a weak point, he wanted to cut it off completely. I wouldn't have thought it would be that much of a shock, but it was.

TD: *So what happened?*

JB: I begged, for a long time, to get back. I mean, it seemed to me that that was the only thing that meant shit, that was worth living for. I suddenly realized that he was the only person in the world that I knew that well, that I could relax with completely. We'd been going together for ten years; there's nobody in the world I know that well. That's a great, incredible thing, especially when you lose it, I realized. "Love" is such a dumb word; it's certainly a grand aspect of it, although it isn't the most appealing. But it was then. I worked to get it back together. But it changed me in a lot of ways. I'm not sure I know all the ways.

TD: *What do you see yourself doing in ten years, twenty years, thirty years?*

JB: I really don't, much. I'm not outrageously optimistic. But I'm optimistic about there being possibilities. I'm just not that optimistic about being able to carry them out. I'm not as optimistic as I wish I was. I sort of recognize Fate . . .

An Interview with Joe Brainard

by Anne Waldman

AW: *Do you think one has a choice about being an artist?*

JB: Oh yes I think one always has a choice.

AW: *When did you make that choice?*

JB: I don't think I ever made it but I think I have a choice. I think I could stop it now.

AW: *Isn't it too late to stop?*

JB: No I don't really think so, I think I could stop tomorrow, I really do.

AW: *I don't believe it.*

JB: I'd do something else. I think I could. I've fantasized about being a novelist or I've fantasized about doing some kind of social work—give up everything and devote your life to making other people happy in some way or doing some good in a more direct way. I think I'd enjoy it. Except you have to work with other people which I don't like doing.

AW: *What jobs have you had in the past?*

JB: Working for audits and surveys. Doing graphs for business presentations for quite a few months. Working at a snack bar.

AW: *Where was that?*

JB: In Tulsa. I've had a lot of jobs. I can't even remember them all.

AW: *You never felt anxious about getting home to your real work?*

JB: Never. Most of the jobs I've had I've been able to work at night and on weekends. I don't think I'd want to but I could do it again if I had to.

AW: *What have been influences on your visual work?*

JB: Everything that's visual. Magazines or T.V. or landscape or paintings by other people. I'm influenced by everything because I'm so aware of everything visually. It would be hard to pinpoint one thing. I can go to a party and remember what everyone wore without being conscious of it, without thinking about it. On the other hand, I can read a book but forget it right away. I enjoy reading but that isn't where my focus is. When I'm reading my focus is there, but my general focus isn't at all with words. My brain doesn't have compartments to make order of words or something.

AW: *But it does with images?*

JB: Yes, I'm sure it does with images 'cause I can see things and it all makes sense in my brain and I can recall things in an order that I could never do with words. It's all scrambled with words.

AW: *What do you think that's due to?*

JB: I think I was partly born with it. I know I was that way as a child but I don't think I thought about it. I didn't realize I was different from everyone else right away but then at a certain point I realized I was sort of lopsided.

AW: *Can you give some examples of these compartments? I know when I've visited your loft when you're working on collages you'll have piles and piles of materials arranged according to images, color, texture . . .*

JB: It even happens in my head. If I see a piece of paper I instantly think of another piece of paper in my mind or I can put together an instant collage in my head. It's a real problem with collages at this point.

AW: *Why?*

JB: Well I don't really need to do them and there's not that much pleasure in doing them because it's too much. I got into it too deeply. I mean this in terms of *material* so that it's a flood that I can make sense of, but it completely takes over which turns out to be more of a nightmare than anything

else. So that's why I shy away now. I'd like to approach things with a much more empty head in terms of space, but it's hard so I've been laying low in terms of work.

AW: *Do you have a vivid dream life?*

JB: I do sometimes, sometimes I don't. Dreams to me are sort of a bonus. I see them as entertainment. I write them down and use them for source material in writing but not visually. Except when I was really heavy into collages I would do them in my dreams too. Which is frustrating because you do a great collage and then it's not there.

AW: *Some of your collages tell wonderful stories. I like to fantasize about the little red flamenco dancer on the red stage made from the book image on the cover of the Yellow Pages. She also makes me think of Gertrude Stein's "Preciosilla." Do you have ideas before you start these?*

JB: I don't ever have an idea. The material does it all. You have a figure and a flower and you add a cityscape and it makes the story. You have control if you want to take it but that's something I never wanted to do much. I mean if a story came out I'd sort of follow it, but I never want to read or make a story deliberately. In fact I don't think I could. It's the same trouble I'd have if I wanted to write a novel. I know I could never plan a plot because the only kind of plot in any sense of the word in either writing or painting that I've ever been able to present has come of itself from one word to the next or one thing to the next. It's probably unfortunate because I'd like to be able to plan out something and do it in a grand style.

AW: *Do you think you would sustain a character for a hundred pages?*

JB: I doubt it. It would have to come to me or I'd have to base it on a real person. By "come to me" I mean come from what I'm doing, not come from my head. Come from the involvement of writing. Like if you make a line on a piece of paper (draws a line) all sorts of ideas can come. You can make it

that way (draws), you can extend it (extends it), curve it (curves it). I'd never have a vision in my head of a line that went this way and curved. It simply wouldn't come to me, but it would come to me as a logical development from what I'd already done.

AW: *Would you talk about your relationship to writers—it seems closer than your relationship to other artists—and also your own writing?*

JB: I think I'm closer to writers in terms of understanding, in terms of attitude. Painters are kind of straight ahead. They see in one direction—well that's not always true, of course. And I think I write because I know a lot of writers.

AW: *But you're the one who's influenced other writers. You certainly influenced my early little prose works—the ministries in* No Hassles.

JB: That's hard for me to believe. It seems like that form already existed.

AW: *Well it's more the attitude with the material. You're very original.* I Remember, *for example.*

JB: Well *I Remember* is not an original idea. What's original perhaps is that I actually did it and hopefully I did it well and that counts for a lot.

AW: *Also what* you *would remember is, admittedly, special, but also speaks to and about everyone at a particular time.*

JB: But there was no idea to do it. I just started one day while lying out in the sun in Vermont. It was another attempt to let my head be free and see where it would take me and then I just did it for one day and I showed it to people and they liked it so then I just kept going. But I hadn't planned to write a whole book.

AW: *You don't often illustrate your own writing, why?*

JB: I think illustrations sometimes destroy writing. It makes it too specific. You want to make the visions in your own head. When I do illustrations for other people's work I try to do it factually and not necessarily even relate directly to what it is but it's just in the same vein, or with the same attitude.

AW: *What about working collaboratively with other writers?*

JB: It's fun. It's very arduous. You have to compromise a lot. You have to be willing to totally fail and not be embarrassed by it. That's the main thing which is very good for you.

AW: *What have been successful collaborations?*

JB: I think almost all of them have been successful one way or another. They're always different. *Living with Chris* I like a lot. Even though that wasn't exactly a collaboration. I mean the poem was already written. But I illustrated it the way I was saying about relating in the same vein but not illustrating. Same with *Vermont Notebook*. I divided it up by pages and I started in the middle and just tried to add to the poem but not to illustrate it. I tried to relate at certain points but in factual ways not in emotional ways.

AW: *What paintings do you look at?*

JB: I like de Kooning and I like Alex Katz—I mean I don't always like Alex Katz but I find him interesting—and I'm partial to painterly paintings: Jane Freilicher, Fairfield Porter, Manet, and Goya.

AW: *Why is that?*

JB: 'Cause I like paint and also it's similar to my attitude where what comes out has a lot to do with your involvement in the process of painting as opposed to the execution of something in a mechanical way or in a definite style.

AW: *But Alex Katz doesn't come under this category.*

JB: No he doesn't but I still like him.

AW: *He has a real method.*

JB: Yes he does have method but he has the upper hand somehow.

AW: *What amuses you the most?*

JB: Being stoned and the Marx Brothers.

AW: *Would you say something philosophical here?*

JB: Well these are weird times, that's for sure. There's just too much information. There are just too many possibilities.

AW: *That hasn't been true in the past?*

JB: No, I really don't think so. I think in the past, generally speaking, there have been limitations on one's life. Like

people got married more. That was it, that was their life, and there wasn't all this possibility—great pornography around everywhere—and you couldn't go to Europe in five minutes. But you can do anything now. But it's hard on us, all these choices. Emotionally hard too. There are so many decisions to always be making. But I'm speaking from my own standpoint, which is being free and in New York. And I don't have a 9–5 job so I can make decisions every minute. Whether to go outside or go to a movie or go to Europe, whether to paint or cruise or write. Whether to eat Indian food or Italian food or American food. It's nice to be in the country—in Vermont. There are fewer possibilities.

AW: *What about sexuality?*

JB: Well role-playing is dubious right now so that puts fewer pressures on people to live up to a certain standard and because there really is no standard and you take away the imposed standard one flounders a bit.

AW: *And what about your prediction that men will be wearing skirts in two years?*

JB: That's just style. It'll happen gradually. First like an Indian skirt that's pulled up still with legs. Clothes are just getting looser and the idea of suits at this point is so absurd. Just think abstractly: a suit as uniform doesn't make sense anymore 'cause it doesn't have the counterbalance of a woman wearing a dress. A suit was originally a complement to what a woman would wear but that's all broken down now.

AW: *Do you feel close to Joseph Cornell's work?*

JB: It's funny, a lot of people think I must. I like him, but his things are not painterly. Even my collages are painterly. He also has a set set of symbols to tell stories with. I have symbols too, but they aren't a set set. They come with the materials.

AW: *And where do your materials come from?*

JB: From everywhere. The street, the dimestore, in the mail . . . I'm still tempted to collect them, but I resist.

AW: *What's the longest work stretch you've ever done?*

JB: I went for three days once, with the help of a little speed, of course, but I got crazy. I was seeing little people. On the third day I went out to get some glue and I had already started seeing little people in the apartment in odd places and then I saw two people down on the corner doing things, fucking. Two little people fucking. And I sensed people behind me doing things. I was just over-extended, but I'm sure it's awfully close to going bonkers. I could have believed in what I saw instead of not knowing what it was, and I suppose if you go to that point it makes you incompatible with society. If you didn't feel like coping with life, you could give in to this kind of thing.

AW: *Did you ever become so absorbed by the collages that they became more real than your "everyday" life?*

JB: It only happened once. When you're involved in work, that's all there is—by choice, I mean. But one time—which I still don't understand—I spent a whole night working and doing these works and I know I was awake and doing them, but the works don't exist. I don't understand it to this day and I swear to god that I did them.

AW: *Do you remember the works?*

JB: The whole thing is very fuzzy now. It was a lot realer than usual. I know I was awake. I wasn't here, but I know I was awake and working. This was very different from dreaming that I'd done works. This would be the time when I'd say doing collages "took over."

AW: *It seems like the details, the various images could take over. That you might fall into the reality of the images, so to speak. That it's incredibly obsessive mentally. Painting seems a more physical activity.*

JB: I'm not sure if that's true. When I was at my pitch I'd be all over the floor. I'd be orchestrating all over the place. At a certain point there were so few confinements it was really mindblowing. After a while I had trouble with my eyes.

AW: *Would you go back?*

JB: Never again. I could never get into it that deeply again. I wouldn't want to if I couldn't go whole hog. There are thousands of collages that are not quite finished. I would carry them so far and I would see them completed in my head and then I would lose interest and start something else. I'd have so much material going with the ideas that the beginning came much faster than I could keep up with.

AW: *Do you feel an affinity to any particular time in the past?*

JB: Romantically I'm attached to the Greeks.

AW: *What advice would you give a younger artist or poet?*

JB: The main thing is, and what I keep telling my students, is to approach painting as an activity and to be open to things that happen and not decide to do a painting but decide to experience something and leave something open. Then painting is very pertinent to your life. A lot of kids are very confused about why they should bother, and in the way painting is such a process there really is no reason except to make more paintings, which the world certainly doesn't need. But it could be a way of learning something and being involved and a way of discovery and as a way to keep you from going bonkers.

AW: *Have you ever violently destroyed something you've made?*

JB: I've destroyed a lot of things but not out of violence. I've always done it in a positive sense. I've destroyed things because I didn't think they were good enough and just because I've wanted to erase my past and not be burdened by them. To me, one should throw away and tear up a lot, that's always been a positive thing for me.

AW: *What's coming up for you?*

JB: People, on a grander scale. And a few paintings I'm really proud of. I've done an awful lot of works that rely on raw energy. I'd like to do a masterpiece or two before it's too late.

AW: *What's your favorite color?*

JB: Red.

AW: *Why?*

JB: I wouldn't miss the chance to say "red" for one thing. I'd say "red" even if it weren't my favorite color.

AW: *What if everyone said "red"?*

JB: I think everyone should say "red."

Chronology

1942 Joe Howard Brainard born March 11 in Salem, Arkansas. Shortly thereafter, family moves to Tulsa, Oklahoma.

1947–1960 Attends public schools. Wins numerous art awards.

1959–60 With schoolmates Ron Padgett and Dick Gallup, edits independent little magazine, *The White Dove Review*. Meets poet Ted Berrigan and Patricia Mitchell.

1960 Visits New York City in September with Padgett, before beginning study at Dayton (Ohio) Art Institute. In December, drops out and moves to New York, renting a storefront apartment at 210 East 6th Street. Shortly thereafter, Berrigan joins him. Paints, works part-time in Lower East Side junk/antique store, sells his blood.

1961 Returns to Tulsa in April, then spends two months in Guanajuato, Mexico, with artist Nylajo Harvey and her husband Bob. Solo exhibition opens in Tulsa in late May. Returns to New York very early June. Summer, moves to $23 per month cold-water apartment at 93 First Avenue (top floor), with no gas or electricity.

1962 Begins writing, encouraged by Berrigan and Padgett. In summer, visits Tulsa with Padgett and Mitchell.

1963–1992 Designs covers and does illustrations for many literary magazines and books by poet friends.

1963 Moves to Boston in January. Rents a room in a shabby rooming house at 231 West Newton. Completes "breakthrough" collages and begins making small assemblages. Intermittent jobs in layout and graphic design. Periods of intense poverty and loneliness. Fall, returns to New York, staying for a few months with Ron and Pat (Mitchell) Padgett. Eventually meets writers (Joe LeSueur, Frank O'Hara, Kenward Elmslie, Edwin Denby, Kenneth Koch, John Ashbery, and James Schuyler), artists (Alex Katz, Andy Warhol, Jane Freilicher, Fairfield Porter, Larry Rivers, Jasper Johns), and composers (Virgil Thomson and Ned Rorem). Late in the year,

moves into poet Tony Towle's apartment at 441 East 9th Street, sharing it with him. Makes collages and assemblages, continues writing.

1964 Designs décor for LeRoi Jones's play *Dutchman* and Frank O'Hara's *The General Returns from One Place to Another*. Late in year, begins sharing loft with sculptor Michael Steiner at 21 Bleecker Street, creating larger assemblages. Begins relationship with poet Kenward Elmslie.

1964–65 Produces *C Comics 1* and *C Comics 2*, collections of his comic strip collaborations with poets (O'Hara, Berrigan, Elmslie, Koch, Padgett, Bill Berkson, et al.).

1965 Moves to apartment at 240 East 2nd Street. Inspired by the color scheme of Jacques Demy's film *The Umbrellas of Cherbourg*, paints the walls in various pastel shades, but when result disappoints him, moves to apartment at 40 Avenue B. First New York solo exhibition (assemblages), at Alan Gallery. First group exhibition, at Finch College Museum, selected by Larry Rivers. Summer, goes by car to Tulsa with the Padgetts. Returns to New York by plane, his first time in one. Tours Italy, Spain, and France with Elmslie.

1965–1979 Participates in forty-five group shows.

1965–1992 Produces fifteen collaborative books with poets (Elmslie, Anne Waldman, Berrigan, Padgett, Robert Creeley, et al.).

1965–1993 Spends almost every summer with Elmslie in rural Vermont.

1967 Solo exhibition at Landau-Alan Gallery, New York, of paintings and assemblages of flowers, dolls, and shrines. Designs cover for *ARTnews*. Receives grant from the Copley Foundation. Spends summer at Fairfield and Anne Porter's house in Southampton, New York, with Elmslie; fall in Vermont. Moves to 74 Jane Street. Teaches at Cooper Union.

1968 Ten-day vacation in Jamaica with Elmslie, Jane Freilicher, and Joe Hazan. Solo exhibitions at Gotham Bookmart, New York, of drawings, and Jerrold Morris Gallery, Toronto. Designs cover of *ARTnews Annual XXXIV: The Avant-Garde*. Spends summer in Southampton with Elmslie at Porter house.

1969 Solo exhibition at Landau-Alan Gallery of flower garden paintings and collages. In November moves to loft at 664 Sixth Avenue.

1970 Solo exhibitions at Benson Gallery, Bridgehampton, New York,

of flowers, and Phyllis Kind Gallery, Chicago. Publishes first of *I Remember* series of books.

1971 Spends two months in Bolinas, California. First solo exhibition at Fischbach Gallery, of cutouts of weeds and flowers. Publishes *Bolinas Journal, Selected Writings, 1962–1971*, and *Some Drawings of Some Notes to Myself*.

1972 "102 Works on Paper (1966–1972)," solo exhibition at Utah Museum of Fine Arts, Salt Lake City. Publishes *The Cigarette Book, The Friendly Way, The Banana Book*, and *I Remember More*. Designs cover for *ARTnews*. Solo exhibitions at Fischbach (drawings and collages of friends, Nancy, tattooed torsos, grids), New York Cultural Center (paintings and grass cutouts), and School of Visual Arts (drawings). Begins teaching at School of Visual Arts.

1973 Tours France and Italy with Elmslie, Maxine Groffsky, and Harry Mathews. Publishes *New Work* and *More I Remember More*. Museum of Modern Art publishes his *I Remember Christmas*.

ca. 1973–74 Costume and set designs for Louis Falco Dance Troupe.

1974 Fischbach solo exhibition of landscapes, still lifes, and paintings of Whippoorwill, Elmslie's whippet. First show entirely of oil paintings.

1974 Moves to loft at 8 Greene Street.

1975 Last Fischbach exhibition, of around 1500 small paintings and collages. Publishes *Twelve Postcards* and the collected *I Remember*.

1976 Solo exhibitions in Philadelphia; Kansas City, Kansas; Newport, Rhode Island; Paddington, Australia; and Paris.

1978 Solo exhibitions in Bridgehampton and Hamilton, New York. Publishes *29 Mini-Essays*.

1979 Begins relationship with actor Keith McDermott.

1980 Decides to stop exhibiting new work, but allows solo exhibition at Long Beach Museum of Art. Publishes *24 Pictures and Some Words*. Designs costumes and décor for Joffrey Ballet Co.

1981 *Nothing to Write Home About* published.

1981–1994 Despite opinion of others, remains dissatisfied with results of sporadic art production. Reads enormously. Coaxed by writer friends into doing a few cover designs and collaborations for books.

1983 His comic strip collaborations appear in a German edition.

1985 Does sixty drawings for *Sung Sex* (text by Elmslie), published in 1989.

1987 Solo exhibition of selections from the Butts Collection (later renamed the Joe Brainard Collection), Mandeville Gallery, University of California, San Diego.

1988 Spring, trip to Venice with Elmslie. Summer, extended trip to Hawaii with Elmslie. Remainder of summer in Vermont.

1994 Dies of pneumonia, induced by AIDS. Ashes scattered in Calais, Vermont.

Note on the Texts

The text of *I Remember* in the present volume has been taken from the complete and corrected 2001 edition published in New York by Granary Books. The first edition of *I Remember* (New York: Angel Hair, 1970) proved immediately popular, and Brainard wrote several sequels: *I Remember More* (New York: Angel Hair, 1972), *More I Remember More* (New York: Angel Hair, 1973), and *I Remember Christmas* (New York: Museum of Modern Art, 1973). In 1975, Brainard gathered, rearranged, and added to these initial versions of his work in a new edition of *I Remember*, published in New York by Full Court Press. The 2001 Granary Books edition reprinted the text of the 1975 Full Court edition with minor corrections.

The texts in the *Self-Portrait* section of this volume—a collection of Brainard's other writings—have been taken from Brainard's manuscripts and typescripts, his published books, a variety of little magazines, and in one instance a posthumous biography. They are presented in approximate chronological order of composition. Six of Brainard's books—*Some Drawings of Some Notes to Myself* (New York: Siamese Banana, 1971), *Bolinas Journal* (Bolinas, CA: Big Sky Books, 1971), *The Friendly Way* (New York: Siamese Banana, 1972), *The Cigarette Book* (New York: Siamese Banana, 1972), and *Nothing to Write Home About* (Los Angeles: Little Caesar Press, 1981), hereafter abbreviated as *NTWHA*, have been included in their entirety, along with extensive selections from his *Selected Writings, 1962–1971* (New York: Kulchur Foundation, 1971) (hereafter *SW*) and *New Work* (Los Angeles: Black Sparrow, 1973) (*NW*). In cases where multiple versions of a given work exist, Brainard's later versions have generally been preferred. The texts have been minimally regularized—punctuation associated with quotation marks and parentheses made consistent, titles rendered in italics, misspellings and minor grammatical or typographical errors corrected—but they are otherwise presented without change. Some items, marked with an asterisk (*) in the list of sources that follows, are believed to be published here for the first time. The approximate date of composition of each item is listed in italics.

*Self-Portrait on Christmas Night: typescript, Estate of Joe Brainard.
 December 1961
Back in Tulsa Again: *SW* 14–19. *May 1962*
*Saturday July 21st 1962: typescript, Estate. *July 1962*
Diary Aug. 4th–15th: *SW* 12–13. *August 1962*
The China Sea: typescript, Estate. *1962–63?*
*Picnic or Yonder Comes the Blue: typescript, Estate. *1962–63?*
*A True Story: typescript, Estate. *April 1963?*
*I Like ["A happy glory to sky!"]: hand-corrected typescript, Estate (in a
 letter to Pat and Ron Padgett). *Spring 1963?*
*I Like ["I Joe"]: typescript, Estate. *Spring 1963?*
*The People: Ron Padgett papers (Uncat MSS 1194, Box 7), Beinecke
 Library, Yale University. Included in sections in two undated let-
 ters, the first to Pat and Ron Padgett, the second to Pat Padgett.
 July 1963?
Andy Warhol: Andy Do It: *SW* 20–21. *December 1963?*
The Man: *Wagner Literary Magazine 4* (1963–64): 86–87. *December
 1963?*
Marge: *SW* 30–31. *December 1963?*
Johnny: *SW* 23. *December 1963?*
Nancy ["It was coffee time"]: *SW* 25–26. *December 1963?*
Nancy ["Nancy was always handing me"]: *SW* 46–48. *December 1963?*
May Dye: manuscript, Estate. *January 1964*
Colgate Dental Cream: *SW* 27–28. *1964?*
Brunswick Stew: *SW* 29. *1964?*
Sick Art: *SW* 39. *1964?*
Sunday, July the 30th, 1964: *Kulchur* 5.18 (Summer 1965): 56–58. *July 1964*
*Saturday, December the 11th, 1965: manuscript, Estate. *December 1965*
Van Gogh: *SW* 73. *1965?*
People of the World: Relax!: *C Comics No. 2* (New York: Boke Press,
 [1965]). *1965?*
Ron Padgett: *SW* 40. *November 1966?*
January 26th, 1967: *SW* 38. *January 1967*
Pat: *SW* 24. *No later than June 1967*
August 29th, 1967: *SW* 34–35. *August 1967*
Jamaica 1968: *SW* 41–45. *March 1968*
What Is Money?: *SW* 64–66. *No later than Winter 1968–69*
Little-Known Facts about People: *The World* 13 (November 1968): not
 paginated. *November 1968?*

Diary 1969: *SW* 49–59. *March–May 1969.* (Entry for Sunday, March 29th corrected to Sunday, March 20th and moved in chronological sequence; entry for Saturday, May 18th corrected to Saturday, May 17th)

*Diary 1969 (Continued): Kenward Elmslie Papers (MSS 521, box 88, folder 27), Mandeville Special Collections Library, UCSD Libraries, University of California, San Diego; selected entries. *May–August 1969*

Sex: *SW* 71. *No later than October 1969*

A Special Diary: *The World* 17 (November–December 1969): not paginated. *October 1969*

Some Drawings of Some Notes to Myself (New York: Siamese Banana, 1971). *October 1969?*

Death: *SW* 102–03. *1969–70?*

Autobiography: *SW* 121. *1969–70?*

Some Train Notes: *SW* 104–06. *March or April 1970?*

Diary 1970–71: *SW* 107–115. *November 1970–March 1971.* Tuesday, February 18th, corrected to Thursday

December 22, 1970: *SW* 98–99. *December 1970*

1970: *SW* 91. *1970*

Queer Bars: *SW* 95. *No later than February 1971*

Art: *SW* 94. *No later than February 1971*

Short Story: *SW* 90. *No later than February 1971*

Life ["When I stop and think"]: *SW* 101. *No later than February 1971*

Rim of the Desert: *SW* 93. *No later than February 1971*

How to Be Alone Again: *SW* 96–97. *No later than February 1971*

Bolinas Journal (Bolinas, CA: Big Sky Books, 1971). *May–July 1971*

*Wednesday, July 7th, 1971 (A Greyhound Bus Trip): manuscript, Estate. *July 1971*

Selections from "Vermont Journal: 1971": *NW* 14–17. *Summer 1971*

Fear: *NW* 19. *1971?*

White Spots: *NW* 21. *1971?*

My Favorite Quotations: *SW* 120. *1971?*

Selections from "Self-Portrait: 1971": *NW* 9–13. *1971*

from N.Y.C. Journals: 1971–1972: *NW* 42–62. *December 1971–June 1972*

*Friday, June 16th, 1972: manuscript, Estate. *June 1972*

*Tuesday, July 11th, 1972: manuscript, Estate. *July 1972*

What I Did This Summer: *NW* 67. *September 1972?*

Washington D.C. Journal 1972: *Z* 1 (1973): 82–88. *October 1972*

The Gay Way: *NW* 20. *Winter 1972?*

Matches: manuscript, Estate. *1972?*

Self-Portrait (As a Writer) If I Was Old and Fat and Wore Hats: manuscript, Estate. *1972?*

Dirty Prose: *Big Sky* 4 (1972). *1972?*

Fantastic Dream I Had Last Night!: manuscript, Estate. *1972?*

If: manuscript, Estate. *1972?*

The Friendly Way (New York: Siamese Banana, 1972). *1972?*

The Friendly Way (Continued): *Paris Review* 16.62 (Summer 1975) 139–42. *1975?*

If I Was God: *NW* 29. *1972?*

Ponder This: *NW* 31. *1972?*

Grandmother: *NW* 32. *1972?*

Night: *NW* 35. *1972?*

Neck: *NW* 41. *1972?*

30 One-Liners: *NW* 63–66. *1972?*

The Cigarette Book (New York: Siamese Banana, 1972). 1972. "Smoke More," reproduced in facsimile, was originally published in *Selected Writings* and written c. 1963

Poem ["Sometimes"]: *NW* 33. *1972?*

No Story: *NW* 36. *1972?*

Journals: *The World* 28 (May 1973): not paginated. *February–April 1973*

Before I Die: *Oink!* [Chicago] 6 (May 1973): 13. *May 1973?*

Right Now: *Stooge* (Oconomowoc Lake, WI) 9 (1973): not paginated. *Summer 1973*

Life ["The life of a human being is"]: *Telephone* 11 (1975): [5–6]. *October 1973?*

Stoned Again: *Telephone* 11 (1975): [10]. *October 1973?*

A Depressing Thought: *Some* 3 (Winter 1973): 54. *Winter 1973?*

Thirty: *Some* 3 (Winter 1973): 54. *Winter 1973?*

Ten Imaginary Still Lifes: *NTWHA* 15–24. *1973–78?*

from 29 Mini-Essays: *29 Mini-Essays* (Calais, VT: Z Press, 1978). *1973–78?*

The Outer Banks: *NTWHA* 34–36. *1978?*

Towards a Better Life (Eleven Exercises): *NTWHA* 7–12. *1978?*

Twenty-three Mini-Essays: *NTWHA* 25–33. *1978?*

Religion: typescript, Estate. *1978?*

*Out in the Hamptons: manuscript, Estate. *1978?*

Nothing to Write Home About: *NTWHA* 37–55. *1978?*

*A State of the Flowers Report: manuscript, collection of Kenward Elmslie. *November 1979*

Jimmy Schuyler: A Portrait: Ron Padgett, *Joe: A Memoir of Joe Brainard* (Minneapolis: Coffee House Press, 2004), page 292; originally included in a letter to Bill Berkson. *August 1991*

January 13th: manuscript, Estate. *January 1978*

This volume concludes with two Brainard interviews. The first, conducted by Tim Dlugos in 1977, was originally published in *Little Caesar*, volume 10, in 1980; the second, with Anne Waldman in 1978, in *Rocky Ledge*, number 3, in November–December 1979.

In addition to the works collected in this volume, other writings by Joe Brainard can be found in the following periodicals: *Adventures in Poetry* no. 9 (Spring 1972); *Big Sky* no. 4 (1972); *C* nos. 2 (1963), 8 (1964), and 9 (Summer 1964); *Contact* no. 5 (February 1, 1973); *Gegenschein Quarterly* no. 1112 (1975); *Harris Review* (Poultry Season Issue, 1971); *Juilliard* no. 9 (Pinecone Supplement, Winter 1968–69); *Lines* no. 2 (December 1964), 3 (February 1965), and 4 (March 1965); *Little Caesar* no. 4 (November 1977); *Milk Quarterly* nos. 2 (August 1972) and 11/12 (1978); *Nice* no. 1 (1966); *Oink!* nos. 3 (1972) and 6 (1973); *Paris Review* no. 53 (1972); *Poet's Home Companion* (1969); *Some* no. 3 (1973); *Telephone* no. 11 (1975); *Tzarad* no. 2 (October 1966); *The World* no. 23 (Summer 1971); and *Z* no. 1 (1973). This list is not exhaustive, as a definitive Brainard bibliography remains to be compiled.

Glossary of Names

Donald Allen (1912–2004). Editor at Grove Press and publisher of Grey Fox Press, responsible for the influential anthology *The New American Poetry 1945–1960* (1960) and for Frank O'Hara's *Collected Poems* (1971).

Sandy Alper (b. 1942). First wife of poet Ted Berrigan and friend of JB.

John Ashbery (b. 1927). Poet and friend of JB, with whom Joe collaborated on several projects, including *The Vermont Notebook* (1975).

Gordon Baldwin (b. 1939). American artist living in Bolinas, California, when JB met him.

Bob Bartholic (1925–2009). Tulsa artist who influenced the young JB and gave him two exhibitions at his gallery in Tulsa.

Ed Baynard (b. 1940). New York City artist and friend of JB.

Dave Bearden (1940–2008). Intense, "outsider" poet whom the young JB met in Tulsa around 1959. Friend of Ted Berrigan and Lauren Owen.

Bill Berkson (b. 1939). Poet and longtime friend of JB whom Joe met in New York City in the early 1960s and with whom he collaborated on many book and magazine projects. Berkson published JB's *Bolinas Journal* (1971).

Ted Berrigan (1934–1983). Poet and friend of JB, whom Joe met around 1959 in Tulsa. Perhaps the single strongest personal influence on Joe as an artist and writer. The two were frequent collaborators, especially in the early 1960s in New York City. A number of Berrigan's poems are dedicated to or about JB.

Paul Blackburn (1926–1971). Poet JB met in New York City around 1963 at the Le Métro Café poetry reading series, which Blackburn directed.

Jack Boyce (1932–1972). Artist and husband of Joanne Kyger. JB met him in Bolinas.

Zoe Brown. Graphic designer and artist JB met in Bolinas.

Michael Brownstein (b. 1943). Poet, fiction writer, and friend of JB, with whom Joe collaborated on comic strips. Brownstein spent

time with Anne Waldman, Kenward Elmslie, and JB at Elmslie's home in Vermont.

Jack Brusca (1939–1993). New York artist.

Rudy Burckhardt (1914–1999). Underground filmmaker, photographer, artist, writer, and friend of JB. Joe wrote the script for Burckhardt's film, *Money* (1968). Burckhardt emigrated from Switzerland in 1935 and spent most of his life in New York City and rural Maine. A lifelong friend of Edwin Denby.

Yvonne (Jacquette) Burckhardt (b. 1934). Artist, wife of Rudy Burckhardt, and friend of JB.

Susan Burke. Bill Berkson's girlfriend in New York City and Bolinas.

Angelica Clark. Wife of Tom Clark, who met Joe in NY in the mid-1960s and later knew him in Bolinas.

Juliet Clark. Young daughter of Tom and Angelica Clark.

Tom Clark (b. 1941). Poet and friend of JB, whom Joe met in New York City around 1966 after a transatlantic correspondence. Clark was an early publisher of JB's writings and art. Joe designed the covers of Clark's first two major books, *Stones* (1968) and *Air* (1970).

Jess (Collins, 1923–2004). Artist based in San Francisco. Companion of Robert Duncan.

Chris (Cox?, 1949–1990). In JB's "NYC Journals. 1971–1972," "Chris" is probably Chris Cox, photographer and friend of Edmund White.

Bobbie Creeley (Bobbie Louise Hawkins, b. 1930). Poet, fiction writer, and friend of JB, who got to know her in Bolinas, and continued to see her in New York City.

Robert Creeley (1926–2005). Poet and friend of JB, with whom Joe collaborated on *The Class of '47* (1973). JB got to know him in Bolinas.

Edwin Denby (1903–1983). Poet, dance writer, and friend of JB. Denby's somewhat ascetic lifestyle and lucid conversation set an example for Joe. Denby's friends over the years had included Willem de Kooning, Aaron Copland, Virgil Thomson, George Balanchine, Frank O'Hara, and Rudy Burckhardt.

Donna Dennis (b. 1942). Artist and friend of JB who for a time was the girlfriend of Ted Berrigan. JB and Dennis met in New York City in the 1960s.

Diane di Prima (b. 1934). Poet, small press editor, and off-off Broadway theater producer whom JB met in the early 1960s.

Tim Dlugos (1950–1990). Poet (*A Fast Life: The Collected Poems of Tim Dlugos*, 2011) and friend of JB.

John Doss. Physician and husband of Margot Doss, whom JB met in Bolinas.

Margot Doss (1920–2003). *San Francisco Chronicle* journalist and hostess of poetry salons in the 1960s and '70s, whom JB met in Bolinas.

Donald Droll (1927–1985). Art dealer, part of the Frank O'Hara social circle, and acquaintance of JB.

Robert Duncan (1919–1988). Poet and acquaintance of JB. Companion of Jess Collins.

Ella. In JB's "A True Story," a fictional character whose name was probably derived from Ella Rengers, who had befriended Joe when he was a student at the Dayton Art Institute briefly in late 1960. Rengers appears in *The Friendly Way* as "E. R."

Bill Elliott (1944–1985). Composer whom JB met through Kenward Elmslie.

Kenward Elmslie (b. 1929). Poet and JB's companion for thirty years. The two spent virtually every summer at Elmslie's home in rural Vermont from 1965 to 1993, and collaborated on an enormous number of projects. Elmslie's Z Press published Joe's writings and art. Probably the single most important person in JB's adult life.

Donald Evans (1945–1977). Artist and friend of JB.

Larry Fagin (b. 1937). Poet, small press editor, and friend of JB.

Louis Falco (1942–1993). Dancer/choreographer and friend of JB. In 1974, Falco created a dance piece based on JB's *I Remember*.

Jane Freilicher (b. 1924). Artist and friend of JB. Freilicher and her husband, Joe Hazan, vacationed in Jamaica with Kenward Elmslie and JB, who admired both her wit and her paintings.

Carol Gallup (b. 1942). Married poet Dick Gallup in 1964. Editor of *Poet's Home Companion* magazine. JB met her when she was an undergraduate at Barnard.

Dick Gallup (b. 1941). Poet whom Joe met in Tulsa around 1959. Along with Ron Padgett and JB, Gallup edited the little magazine *The White Dove Review* while the three were in high school. JB did the cover design of Gallup's first collection, *Hinges* (1965).

John Giorno (b. 1936). Poet and friend of JB.

Morris Golde (1920–2001). Congenial arts patron and friend of JB,

famed for his parties in his small Greenwich Village apartment, filled with art- and music-world luminaries.

Maxine Groffsky (b. 1936). Editor of *Paris Review*, literary agent, and friend of JB. Groffsky and Harry Mathews traveled in Italy and Sicily with Kenward Elmslie and JB.

John Gruen (b. 1926). New York art writer, composer, and photographer. Gruen was instrumental in getting JB his first solo exhibition in New York City, at the Alan Gallery, 1965.

Duayne Hatchett (b. 1925). Abstract sculptor whom JB knew in Tulsa around 1959–60 and who was an example of a "real artist" for the young Joe.

Elizabeth Hazan. Young daughter of Joe Hazan and Jane Freilicher.

Lita Hornick (1927–2000). Publisher of *Kulchur* magazine and Kulchur Press, art collector, and friend of JB. Her collection included a major oil painting by Joe, *Nancy*. Kulchur published his *Selected Writings 1962–1971*.

Japanese City. A large, delicate, and complicated assemblage by JB, the largest he ever did, which was shown only once, at the Landau-Alan gallery in late 1965. Later JB cannibalized it for other assemblages.

Alex Katz (b. 1927). Artist and friend of JB. Katz did numerous portraits of JB, who admired his work enormously.

Bill Katz (b. 1942). Interior designer, architect, and friend of JB. Katz designed the installations of the 2001 Joe Brainard retrospective at the Berkeley Art Museum and NY's P.S. 1.

Anne Kepler (1942–1966). Flutist and high school classmate of JB in Tulsa. Then friends in New York City as well. Perished in a fire in 1966.

Marge (Margie) Kepler. Cousin of Anne Kepler. She sometimes worked as a model for Tulsa artists, including JB.

Janice Koch (d. 1981). Wife of Kenneth Koch.

Kenneth Koch (1925–2002). Poet and friend of JB, who collaborated with him. JB designed the cover of Koch's groundbreaking book, *Wishes, Lies and Dreams* (1970).

Joanne Kyger (b. 1934). Poet and friend of JB, based in Bolinas and associated with the San Francisco Renaissance and Beat poets. First wife of poet Gary Snyder.

Arlene Ladden (b. 1946). Writer and acquaintance of JB.

Joe LeSueur (1924–2001). Writer, editor, and first lover of JB. Companion of Frank O'Hara. Cousin of actress Joan Crawford.

Lewis MacAdams (b. 1944). Poet and acquaintance of JB. Joe published in MacAdams's little magazine, *Mother*, and did a cover design for it.

John Martin (b. 1930). Publisher of Black Sparrow Books, which issued JB's *New Work* (1973) and two collaborative books, *The Champ* (1968) with Kenward Elmslie and *The Vermont Notebook* (1975) with John Ashbery.

Harry Mathews (b. 1930). Fiction writer, poet, and friend of JB. Mathews and Maxine Groffsky toured Italy and Sicily with JB and Kenward Elmslie. Mathews told his friend Georges Perec about JB's *I Remember*, which inspired Perec's *Je me souviens* (1978). Marie Chaix, Mathews' second wife, translated *I Remember* into French.

J. J. Mitchell. Part of the Frank O'Hara social circle and friend of JB.

Tibor de Nagy Gallery. New York City art gallery where artists admired by JB—Rivers, Freilicher, Porter, among others—showed their work in the 1950s and '60s, and the gallery that has shown his work since his death.

Lowell Nesbit (1933–1993). Artist.

Alice Notley (b. 1945). Poet, second wife of Ted Berrigan, and friend of JB.

Frank O'Hara (1926–1966). Poet and friend of JB. Joe once described O'Hara as his hero. The two did some collaborations and played a lot of bridge. After O'Hara's death Joe wrote that he had been O'Hara's secret lover, a claim doubted by some. In any case, O'Hara was a huge influence on Joe, as he was on many others.

Arthur Okamura (1932–2009). Artist JB met in Bolinas.

Lauren Owen (b. 1941). Friend of Dick Gallup and Ron Padgett, who met him in elementary school in Tulsa, and of Dave Bearden and Ted Berrigan, who met him at Tulsa University. JB met Owen around 1959. Owen lived for some years in New York City with his wife, poet Maureen Owen.

Pat Padgett (Pat Mitchell, b. 1937). Close friend of JB from their meeting in Tulsa around 1959 until his death in 1994. She and JB grew up in the same neighborhood. Wife of Ron Padgett.

Ron Padgett (b. 1942). Poet and longtime friend of JB. Padgett and

Brainard were in the same first grade class in Tulsa. After high school they came to New York City together, where they worked on many projects over the years, as described in Padgett's *Joe: A Memoir of Joe Brainard* (2004).

Wayne Padgett (b. 1966). Son of Ron and Pat Padgett. But also Wayne Padgett (1922–1991), the father of Ron Padgett, described in JB's piece "Back in Tulsa Again."

Brigid (Berlin) Polk (b. 1939). Artist of the Andy Warhol circle and friend of JB.

Carter Ratcliff (b. 1941). Poet, art writer, and acquaintance of JB who has written perceptive essays about him.

Larry Rivers (1923–2002). Artist and friend of JB. Rivers picked the young JB to show alongside him in Joe's first New York group show, at Finch College (1965).

D. D. Ryan (1928–2007). Fashion expert, photographer, and friend of JB.

Harris Schiff (b. 1943). Poet and acquaintance of JB. Editor of *The Harris Review*.

Peter Schjeldahl (b. 1942). Poet, art writer, and friend of JB. Brainard published in Schjeldahl's little magazine, *Mother*, in the mid-1960s.

James (Jimmy) Schuyler (1923–1991). Poet and friend of JB. The two collaborated on art works and maintained a lively correspondence.

David Shapiro (b. 1947). Poet and friend of JB.

Johnny Stanton (b. 1943). Experimental fiction writer (*Mangled Hands*, 1985) and performance artist JB met in New York City in the early 1960s. Stanton was the publisher of JB's *Some Notes of Some Drawings to Myself* (1971), *The Banana Book* (1972), *The Cigarette Book* (1972), and *The Friendly Way* (1972), at Siamese Banana Press.

Tony Towle (b. 1939). Poet and friend of JB. The two shared an apartment on East 9th Street in New York, which had been inhabited by Frank O'Hara and Joe LeSueur, then Towle and poet Frank Lima.

Tom Veitch (b. 1941). Fiction writer and acquaintance of JB. Joe designed the cover and inside images for Veitch's first published book, *Literary Days* (1964).

Anne Waldman (b. 1945). Poet and longtime friend of JB. The two worked together on any number of projects and spent a lot of time together, especially in the 1960s and '70s. Waldman was the first publisher of JB's *I Remember*.

Lewis Warsh (b. 1944). Poet and friend of JB. First husband of Anne Waldman. Warsh and Waldman were a dynamic artistic duo who ran a small press, edited two little magazines, organized poetry readings, and held an open salon at their apartment on St. Mark's Place in New York City in the 1960s.

Peter (Warshall, b. 1943). In *Bolinas Journal*, an ecologist, activist, and boyfriend of Joanne Kyger.

Philip Whalen (1923–2002). Poet whom JB met in Bolinas. The two became fast friends.

THE LIBRARY OF AMERICA SERIES

THE LIBRARY OF AMERICA, a nonprofit publisher, is dedicated to publishing, and keeping in print, authoritative editions of America's best and most significant writing. Each year the Library adds new volumes to its collection of essential works by America's foremost novelists, poets, essayists, journalists, and statesmen.

If you would like to request a free catalog and find out more about The Library of America, please visit www.loa.org/catalog or send us an e-mail at lists@loa.org with your name and address. Include your e-mail address if you would like to receive our occasional newsletter with items of interest to readers of classic American literature and exclusive interviews with Library of America authors and editors (we will never share your e-mail address).

To subscribe to the series or to order individual copies, please visit www.loa.org or call (800) 964.5778.

This book is set in a digital version of Garamond
Premier, a font designed in the 1990s by Adobe
senior type designer Robert Slimbach based on
the roman typefaces cut by Claude Garamond
and the italic typefaces of Robert Granjon, both
in the mid-1500s. The display type is Sweet Sans,
designed by Mark van Bronkhorst of MVB Fonts.

The paper is off-white Glatfelter B-18, an acid-free,
eggshell-finish stock certified by the Forest Stewardship
Council and meeting the requirements for permanence
of the American National Standards Institute.

Printing and binding by Malloy Incorporated.
Book design and composition by David Bullen.